부산비엔날레조직위원회
Busan Biennale Organizing Committee

www.busanbiennale.org

목차

CONTENTS

바다미술제 소개

설립 목적

바다미술제는 1987년 88서울올림픽의 프레올림픽 문화 행사의 일환으로 시작되어, 해운대해수욕장, 광안리해수욕장, 송도해수욕장 등을 거치며 대중적인 전시로 매년 개최되어 왔다. 2000년부터 2010년까지는 부산비엔날레 행사에 통합 개최되어 왔고, 2011년부터 독자적인 문화 브랜드로 성장시키기 위하여 분리하였다. 2011년부터 매 홀수 년마다 개최되었으며, 독립 개최된 지는 이번에 3회째이다. 대중 친화적이면서도 부산의 지정학적 여건을 반영하는 친환경적인 야외 미술 축제로 시작되어 현재까지 이르고 있다.

연혁

1981	부산청년비엔날레 창립
1987	제1회 바다미술제 : 해운대해수욕장, 33명 32점, 바다미술제 운영위원회 주최
1988	제2회 바다미술제 : 해운대해수욕장, 2개국 34명 28점 한국미술협회 주최
1989	제3회 바다미술제 : 광안리해수욕장, 2개국 36명 26점, 부산미술협회 주최
1990	제4회 바다미술제 : 광안리해수욕장, 2개국 48명 29점, 부산미술협회 주최
1991	제5회 바다미술제 : 광안리해수욕장, 61명 28점, 바다미술제 운영위원회 주최
1992	제6회 바다미술제 : 광안리해수욕장 및 아트타운, 부산미술협회 주최
1993	제7회 바다미술제 : 해운대해수욕장, 동백아트센터, 2개국 68명 61점, 부산미술협회 주최
1994	부산국제야외조각심포지엄 개최
1995	제8회 바다미술제 : 해운대해수욕장, 부산문화회관, 파라다이스 비치호텔 공연장, 12개국 58명 50점, 부산미술협회 주최
2000	2000PICAF 국제바다미술제 : 해운대해수욕장, 5개국 37점
2002	2002부산비엔날레 바다미술제 : 해운대해수욕장, 10개국 80명 39점
2004	2004부산비엔날레 바다미술제 : 해운대해수욕장, 11개국 45명 34점
2006	2006부산비엔날레 바다미술제 : 해운대해수욕장, 16개국 140여점
2008	2008부산비엔날레 바다미술제 : 광안리해수욕장 일원, 금련산지하철역, 미월드, 26개국 77명(팀)
2010	2010부산비엔날레 : 부산시립미술관, 요트경기장, 광안리해수욕장, 부산문화회관 등, 23개국 252명 338점
2011	2011바다미술제 : 송도해수욕장, 12개국 29점, 부산광역시, (사)부산비엔날레조직위원회
2013	2013바다미술제 : 송도해수욕장, 11개국 34점, 부산광역시, (사)부산비엔날레조직위원회
2015	2015바다미술제 : 다대포해수욕장, 16개국 34점, 부산광역시, (사)부산비엔날레조직위원회

Introduction of the Sea Art Festival

Purpose

The Sea Art Festival, launched in 1987 as part of the pre-Olympic cultural events of the 1988 Summer Olympics in Seoul, has been annually held mainly as public exhibition at Haeundae Beach, Gwangunri Beach and Songdo beach. The festival was integrated into the Busan Biennale as one of its events between 2000 and 2010, but separated from the biennale to grow into a freestanding cultural event. Since 2011, it has been held every odd year and this is its third incarnation. This event has been a public-friendly outdoor art festival reflecting Busan's geopolitical conditions.

History

1981 Established the Busan Young Artists Biennale
1987 The 1st Sea Art Festival : Haeundae Beach, 32 works by 33 artists, Hosted by the Sea Art Festival Steering Committee
1988 The 2nd Sea Art Festival : Haeundae Beach, 28 works by 34 artists from 2 countries, Hosted by the Korean Fine Arts Association
1989 The 3rd Sea Art Festival : Gwanganri Beach, 26 works by 36 artists from 2 countries, Hosted by the Busan Fine Arts Association
1990 The 4th Sea Art Festival : Gwanganri Beach, 29 works by 48 artists from 2 countries, Hosted by the Busan Fine Arts Association
1991 The 5th Sea Art Festival : Gwanganri Beach, 28 works by 61 artists, Hosted by the Sea Art Festival Steering Committee
1992 The 6th Sea Art Festival : Gwanganri Beach & Art Town, Hosted by the Busan Fine Arts Association
1993 The 7th Sea Art Festival : Haeundae Beach & Dongbaek Art Center, 61 works by 68 artists from 2 countries, Hosted by the Busan Fine Arts Association
1994 Busan International Outdoor Sculpture Symposium
1995 The 8th Sea Art Festival : Haeundae Beach, Busan Culture Center & Paradise Beach Hotel, 50 works by 58 artists from 12 countries, Hosted by the Busan Fine Arts Association
2000 2000 PICAF International Sea Art Festival : 37 works from 5 countries
2002 Sea Art Festival, Busan Biennale 2002 : Haeundae Beach, 39 works by 80 artists from 10 countries
2004 Sea Art Festival, Busan Biennale 2004 : Haeundae Beach, 34 works by 45 artists from 11 countries
2006 Sea Art Festival, Busan Biennale 2006 : Haeundae Beach, 140 works from 16 countries
2008 Sea Art Festival, Busan Biennale 2008 : Gwanganri Beach & Geumryeonsan Subway Station, 77 artists (teams) from 26 countries
2010 Busan Biennale 2010 : Busan Museum of Art, Busan Yachting Range, Gwanganri Beach & Busan Culture Center, 338 works by 252 artists from 23 countries
2011 Sea Art Festival 2011 : Songdo Beach, 29 works from 12 countries, Hosted by Busan Metropolitan City, Busan Biennale Organizing Committee
2013 Sea Art Festival 2013 : Songdo Beach, 34 works from 11 countries, Hosted by Busan Metropolitan City, Busan Biennale Organizing Committee
2015 Sea Art Festival 2015 : Dadaepo Beach, 34 works from 16 countries, Hosted by Busan Metropolitan City, Busan Biennale Organizing Committee

예술의 싹을 틔우는 2015바다미술제

부산의 가을 바다! 생각만으로도 눈앞에 아름다운 장면들이 파노라마처럼 펼쳐지는 것 같습니다. 바다는 해양 도시 부산과 떼려야 뗄 수 없을 정도로 소중한 자원이자, 오늘날 부산이 글로벌 문화 예술 도시로 성장할 수 있게 한 원동력이자 부산을 가장 부산답게 표현할 수 있는 자랑스러운 보물입니다.

바다미술제는 이러한 부산의 바다를 현대미술로 더욱 아름답게 만들어 온 부산의 대표 미술 축제입니다. 1987년에 처음 개최된 이후, 해운대와 광안리, 송도해수욕장을 배경으로 다양하고 실험적인 미술적 시도를 통하여 시민들에게 잊을 수 없는 감동과 즐거움을 선사해 왔습니다. 올해에는 특히 송도에서 장소를 옮겨 낙동강 하구의 자연 환경을 고스란히 담고 있는 천혜의 해수욕장인 다대포해수욕장에서 개최하게 되어 그 의미가 각별합니다. 광활하고 아름다운 다대포해수욕장을 배경 삼아, 이제껏 경험하지 못했던 창의적이고 실험적인 현대미술의 매력에 흠뻑 빠질 수 있을 것입니다.

아울러, 2015바다미술제의 성공적인 개최를 통하여 서부산권의 문화적 가치와 미래 발전 가능성을 재확인하고, 서부산권의 문화 융성 시대를 여는 출발점이 되기를 기대해 봅니다.

9월 19일부터 10월 18일까지 한 달여 동안 개최되는 2015바다미술제에서는 세계 각국을 대표하는 국내외 유명 미술가들의 초청 작품 34점이 선보일 예정입니다. 이념과 국적을 초월하여 조각, 설치 작품뿐만 아니라 회화, 미디어아트, 퍼포먼스 등 다양한 장르의 작품으로 구성되어 있어 그 어느 때보다도 풍성한 볼거리를 제공할 것입니다.

무더웠던 여름을 뒤로 하고, 결실이 영그는 계절이 왔습니다. 즐거운 마음과 가벼운 발걸음으로, 2015바다미술제에 오셔서 예술이 주는 영감과 추억을 마음껏 즐기시기 바랍니다.

(사)부산비엔날레조직위원회 조직위원장
부산광역시장

서병수 *서병수*

Sea Art Festival 2015 to germinate Art

The autumn sea of Busan! Just thinking about it seems to unfurl a panorama of beautiful scenes. The sea has been a valuable resource that is inextricably bound up with Busan, a marine city. It is both the driving force that has enabled Busan to grow as a globalized cultural and artistic city and the proud treasure that characterizes it.

The Sea Art Festival is an art festival typical of Busan that makes the sea of Busan seem more beautiful with contemporary art. Since its inauguration the art festival has left an indelible impression on the minds of citizens and has given lots of pleasure through diverse experimental artistic endeavors on the backdrops of Haeundae Beach, Gwanganri Beach and Songdo Beach. This year's festival is of special significance as it will be held at Dadaepo Beach, a beach blessed by heaven that embraces the natural settings of the mouth of the Nakdong River. You will be riveted by the creative and experimental contemporary art the likes of which you have never experienced before at the vast, beautiful beach of Dadaepo.

In addition, the Sea Art Festival 2015 is expected to be the starting point for the flourishing of Western Busan District's culture, reassuring its cultural worth and possibilities for cultural enhancement through the festival's success.

The Sea Art Festival 2015 will be held for about one month from September 19 through October 18. The festival will bring together 34 art works by domestic and foreign artists, representing each country under the same roof. As the festival will include not only sculptures and installations but also paintings, media artworks, and performances transcending ideology and nationality, it will provide citizens with more affluent visual treats than any other event.

The season of fruition has come with the passing of a hot summer. I hope that you will fully enjoy the inspiration and reminiscences art will provide at the Sea Art Festival 2015.

Byung-Soo SUH

Chairman of Busan Biennale Organizing Committee
Mayor of Busan Metropolitan City

2015바다미술제를 열며

바다미술제는 1987년부터 시작되어 지금까지 개최되고 있는, 우리 부산 고유의 역사성을 가지고 있는 자연환경 미술제입니다. 2000년부터 2010년까지는 부산비엔날레의 행사로 통합 개최되어 오다가, 2011년부터 다시 분리가 되어 홀수 해마다 개최되고 있습니다.

해양 도시를 배경으로 하는 바다미술제는 지역의 자연환경 및 여건을 반영한 부산 미술의 독자적이고 특성화된 행사로서 세계적으로도 유사한 사례를 찾아보기 힘든 독특한 형태의 자연환경 미술제입니다. 세계 유수의 미술 축제들과 어깨를 나란히 하고 있는 오늘의 바다미술제가 있기까지는, 셀 수 없이 많은 부산 지역 미술인들의 헌신과, 부산 시민을 비롯한 국민들이 꾸준히 보여 준 성원과 지지라는 자양분이 있었습니다. 뿐만 아니라 바다미술제만이 가지고 있는 대중친화적 요소와 소통성은 공공미술과도 자연스럽게 연계되어 보다 대중에게 친근한 이미지를 구축할 수 있는 원동력이 되었습니다. 부산비엔날레조직위원회는 이러한 바다미술제를 통해 시민들과 더 가까이에서 소통하고 예술로 인해 풍요로워지는 사회를 만들고자 합니다.

이번 바다미술제는 '보다 — 바다와 씨앗(See — Sea & Seed)'라는 주제로 개최됩니다. 산포되고 발아하여 자라는 씨앗과 바다라는 각각의 스토리텔링에 걸맞도록 16개국 34명의 우수한 작가들이 만들어 낸 작품을 선보이게 될 것입니다. 넓고 탁 트인 다대포 해변가 전시 공간에서 예술의 씨앗을 뿌리는 미술인들은 물론이고 모든 시민들이 함께 하는 예술 향유의 기쁨을 나누고자 합니다. 전시는 행사 내내 개최되는 각종 학술 행사들과 더불어 특별전, 상상발굴프로젝트, 시민 참여형 예술과 퍼포먼스 등 예술가는 물론 시민을 위한, 시민에 의한 다양한 행사들이 30일간 바다미술제를 빛낼 것입니다. 아름다운 다대포의 미술 축제를 통해서 많은 사람들에게 새로운 추억을 만들고 예술과 가까워지는 따뜻한 자리가 되었으면 좋겠습니다.

현재 우리는 산업혁명 이후 가장 큰 혁명인 디지털 혁명의 시대를 살아가고 있습니다. 부산비엔날레조직위원회도 이와 같은 변화의 바람에 맞추어 주도적이고 혁신적인 방향으로 나아가고자 합니다. 매년 번갈아 개최하는 부산비엔날레와 바다미술제를 통하여 세계가 주목하는 문화 도시 부산을 만들고, 부산 시민이 자부심을 느낄 수 있는 부산만의 고유한 문화자산으로 한층 더 성장시키겠습니다. 부산국제아트페스티벌이 탄생되던 그 때의 초심으로 돌아가, 미술인뿐만 아니라 시민들이 함께 교류할 수 있는 세계적인 부산비엔날레, 바다미술제로 제2의 도약을 시작합니다. 여러분의 따뜻한 지지와 열렬한 성원이 가장 큰 힘이 될 것입니다.

예술의 씨앗이 척박한 다대포 해수욕장의 모래에서 발아해, 부산이 세계적인 예술 도시로 성장할 수 있게 하는 큰 발판이 되기를 기원하면서 2015바다미술제가 개최될 수 있도록 많은 지지를 보내 주신 서병수 부산광역시장님, 이해동 시의장님, 이경훈 사하구청장님을 비롯한 부산광역시, 시의회, 관계자 분들과 김성호 전시감독과 참여 작가님, 스텝들 그리고 부산 시민 여러분께도 깊은 감사의 말씀을 전합니다.

(사)부산비엔날레조직위원회 집행위원장

임동락

At the hosting of the Sea Art Festival 2015

The Sea Art Festival, launched in 1987 and still being held today, is a nature-based environmental art festival loaded with Busan's intrinsic historicity. Between 2000 and 2010 the festival was integrated into the Busan Biennale but later separated from the program. Since 2011 it has been held biannually.

Held in the backdrop of an ocean city, this festival is Busan's freestanding, specialized art event reflecting the local natural surroundings and conditions. It is a distinctive environmental art festival that is almost unprecedented in the world. The commitment of countless Busan artists and the constant support and encouragement of its citizens have allowed this art festival to stand shoulder to shoulder with some of the best around the globe. In addition, its own affinity with the general public and its communicative quality have allowed it to become something familiar to the masses and thus naturally affiliated with public art. Through this art festival the Busan Biennale Organizing Committee tries to interact with its citizens more closely and enrich society with art.

The Sea Art Festival 2015 is presented under the theme of 'See – Sea & Seed'. The works of 34 artists from 16 countries will be displayed, reflecting the storytelling, scattering, germinating, and growing of seeds. We will share the joy of art alongside the citizens and artists who sow the seeds of art itself at Dadaepo Beach. The festival will consist of a plethora of activities including various academic events, the special exhibition, the Imaginary Excavation Project, and other participatory occasions and performances for citizens that are to be held throughout the event. I hope that this art festival will leave many with indelible memories and will provide them with an opportunity to become intimate with art.

These days we are living during the digital revolution, the most sweeping period of innovation following the Industrial Revolution. Keeping up with the wind of change, the Busan Biennale Organizing Committee would like to seek innovation and become a leading force of development. With the Busan Biennale and the Sea Art Festival being held each year by turns, we will make Busan a cultural city that draws the world's attention and grows Busan's cultural assets into something that will give citizens a sense of pride. Getting back to the basics, when the Busan International Art Festival came into being, we begin the second step of making the Busan Biennale and the Sea Art Festival into world-class art events in which citizens as well as artists are able to make exchanges with one another. Your warm encouragement and ardent support will serve as a great energy and help.

I hope that the seeds of art germinate at Dadaepo Beach and create a foothold for Busan to grow into a world-class art city. I would like to express my heartfelt thanks to those concerned from the Busan Metropolitan City and City Council including Suh Byung-soo, the mayor of Busan, Lee Hae Dong, chairman of the Busan Metropolitan Council, and Lee Gyoung-hun, the mayor of Saha-gu, for offering their unsparing support, as well as Sung-Ho KIM, the artistic director, the participating artists, the staff, and also the citizens of Busan.

Dong-Lak LIM

Executive Director of Busan Biennale Organizing Committee

보다 — 바다와 씨앗
See — Sea & Seed

전시감독 김성호

I. 들어가는 글: 바닷가에서

이제 가을이다. 여름 한철의 낭만이 끝나고 사람들이 하나둘 떠나간 바닷가에 우리는 다시 왔다.《2015바다미술제》가 펼쳐지는 다대포해수욕장. 이곳에는 뜨겁던 지난여름의 부산했던 흔적들이 하나둘 사라지고. 어느새 스산한 바람을 타고 다른 옷으로 갈아입은 해변이 우리 앞에 나타났다. 여전히 남아 있는 바닷물과 모래사장 그리고 바람 속에서 우리가 갈아입은 새 옷은 무엇인가?

부산에서 비교적 문화 소외 지역으로 평가되는 부산의 서쪽. 그리고 대중에게 덜 알려진 다대포해수욕장. 이곳에서 처음으로 바다미술제를 개최한다. 우리는 부산 시민들과 더불어 다대포해수욕장을 찾는 사람들에게 선보일 새 옷을 준비하기 위해 여러 차례 거울 앞에서 옷을 입고 벗기를 반복했고. 다른 분들의 품평도 경청하면서 옷매무새를 가다듬었다.

그럼에도 우리는 그간의《바다미술제》가 견지해 온 현대미술의 실험성과 더불어 대중의 참여와 소통이라는 합치하기 어려운 투트랙을 끝까지 버리지 않고 목표로 삼아 나가기로 했다. 미술가들이 아틀리에에서 땀을 흘리고 있는 것도 언젠가는 누군가에게 자신이 창작에 열의를 쏟았던 작품들을 선보이기 위한 것이듯이. 관객은 언제나 참여 작가와 더불어 바다미술제를 완성하는 주요한 주체이다. 작품을 출품한 초대 작가들과 그들의 참여를 준비한 이들. 그리고 관객들은 이번 행사에서 '우리'라는 복수형 주체로 '하나'를 이루는 임시적 공동체에 다름 아니라 할 것이다.

자! 이제 우리는 이곳의 바닷가를 찾는 모든 분(또 다른 우리)에게 설레는 마음으로《2015바다미술제》를 펼쳐 보이고자 한다. 전시감독이 초대한 16개국 34인(팀)–한국 19인(팀). 해외 15인(팀)–의 작가들은 '보다 — 바다와 씨앗(See — Sea & Seed)'이라는 주제 아래 저마다의 예술 세계를 펼쳐 보이며 한 달 동안 우리와 함께 예술적 동행을 할 것이다.

II. 주제 소개: 보다–바다와 씨앗

바다와 씨앗! 참 안 어울리는 조합이다. 소금기 가득한 해변에. 푸석푸석한 모래 위에 씨앗이 자리를 잡고 뿌리를 내리기란 쉽지 않다. 씨앗의 입장에서 바다와 모래사장은 보금자리가 아니며 바다의 입장에서 씨앗은 그다지 반가운 손님이 아니다. 씨앗은 이곳에 뿌리를 내리기 어렵고 바다는 씨앗을 돌보는데 신경을 쓰는 것이 버겁기 때문이다.

각기 따로 보아 오던 바다와 씨앗을 우리는 이제《2015바다미술제》에서 함께 보고자 한다. 둘이 대화를 나누거나 어깨동무를 하고 함께 놀이를 하고 있는 모습을 말이다. 그것은 불가능한 일일까? 아니다! 실제로 다대포해수욕장 끝자락에 조성했던 인공 습지가 세월이 흘러 어느덧 자연 습지를 이루고 있는 모습에서 보듯이. 이 둘의 만남은 결코 불가능하지 않다. 보라! 모래 속에 뿌리를 내린 씨앗들의 발아와 성장! 그것은 기적이 아니다. 그것은 흔하지 않은 상생일 따름이다. 우리는 상생할 것 같지 않은 둘이 상생하고 있다는 것을 확인하고. 앞으로도 지속적으로 이러한 상생이 이루어지길 희망하는 바람을 이번《바다미술제》에 담는다.

따라서 바다와 씨앗은 올해의《바다미술제》를 소개하는 은유의 텍스트로서 존재한다. 그것은 올해《바다미술제》의 장소인 다대포해수욕장의 공간성에 대한 키워드이자 은유이며. 예술과 사회에 대한 우리의 지속적인 질문을 풀어 가는 화두이자 은유이다. 그렇다! 바닷가에 예술의 씨앗을 뿌리고 이곳에 관객을 초대하는 일은《2015바다미술제》의 야심에 찬 출발 지점이자. 모험심 가득한 실험이다.

주제어	구조	지각		의미	해설
		시각	청각		
See 보다	V	See	씨[siː]	봐요!	관람의 청유
—	;	해변(——)	——	() / . 〈 .	하이픈(—)=잇거나 분절하는 공간, 괄호()를 대신하는 공간 세미콜론(;)=마침표(.)보다는 가볍고 쉼표(,)보다는 무거운 시간
Sea 바다	O	Sea	씨[siː]	바다를	전시 공간
&	Conj	함께(&)+ 휴식하는 인간(&)	앤[ən]	그리고	함께의 네트워크 = 전시 공간 & 미술 작품 + 미술 작품 & 관람객 + 사람 & 사람
Seed 씨앗	O	Seed	씨드[siːd]	구조	다대포에서 처음 시작하는 바다미술제 + 다대포에서 발아하는 씨앗으로서의 작품들 + 다대포 모래사장에 뿌리를 내리는 것이 불가능해 보이지만, 끝내 생명을 키우고 마는 문화예술 창작과 향유의 씨앗

〈표1〉 주제 소개와 해설

상기의 도표에서 확인할 수 있듯이, 《2015바다미술제》 전시 주제인 '보다 — 바다와 씨앗(See — Sea & Seed)'은 다음의 의미들로 제시된다. 다대포(SEA)의 수평적(—) 전시 공간에 예술의 씨앗(SEED)을 뿌리는 《바다미술제》에 미술인들은 물론이고 모든 시민들이 함께 하고(&), 예술 향유의 기쁨을 나누는(&) 관람으로 기꺼이 초대(SEE)한다. 이 행사를 통해서 '그리고(&)'의 관계 지형이 다대포로부터 모든 곳으로 확산되길 기대하는 바람을 담는 것이다. 달리 말해 이곳에서 사람과 바다, 예술과 지역, 미술가와 시민들이 따뜻한 관계를 만들고 확인하는 네트워크의 관계 지형이 펼쳐지길 기대하는 것이다. 상쾌하게 '씨[siː], 씨[siː], 앤[ən], 씨드[siːd]'라고 부르면서 말이다.

III. 행사와 전시 구성: 씨앗들이 머무는 곳

《2015바다미술제》는 해운대해수욕장, 광안리해수욕장, 송도해수욕장을 거쳐 올해 새롭게 시작하는 다대포해수욕장에서의 특별한 공간성에 주목한다.

특별한 공간성이란 143,000㎡(길이 900m, 폭 100m)에 이르는 드넓은 모래사장 그리고 해안에서부터 300m의 바다까지도 1.5m 안팎인 얕은 수심을 지닌 바다만을 의미하지 않는다. 습지와 모래사장이 한데 어우러진 독특한 지형, 부산의 다른 해수욕장들과 달리 상권으로부터 이격된 천혜의 자연이라는 상황 역시 빠질 수 없다. 게다가 내년 완공을 목적으로 진행되고 있는 인근의 지하철역 공사 현장의 어수선한 풍경과 같은 현재적 맥락까지 모두 아우른다. 여기에 덧붙여, 관객이 다대포해수욕장 중앙에서 바다를 보고 섰을 때, 앞에는 드넓은 남해가, 뒤에는 고층 아파트들이, 좌측에는 이전에 섬이었으나 현재는 육지로 연결된 몰운대가, 우측에는 남해와 낙동강이 서로 만나는 바닷물과 민물의 접점 공간이 있다. 이 모든 것은 전시 구성을 위한 공간 연구에 있어 흥미로운 지점이다.

전시는 감독으로부터 초대된 참여 작가들이 만드는 본전시와, 감독으로부터 초대된 한 기업의 특별 출연작이 만드는 특별전으로 구성된다. 본전시는 이러한 공간에서 펼쳐지는 하나의 스토리텔링을 따라 전개된다. 어디선가 씨앗들이 날아와 자리를 잡고 발아하여 식물로 자라는 일련의 '자연 성장'의 내러티브가 그것이다. 아래의 도표에서 보듯이 '1)산포하는 씨앗 → 2)발아하는 씨앗 → 3)자라는 씨앗 → 4)자라는 바다'는 이러한 '자연 성장'의 내러티브를 가시화한다.

구분	섹션 번호	섹션명	출품작
본전시	1	산포하는 씨앗 Scattering Seeds	미디어 파사드, 조각, 설치, 퍼포먼스
	2	발아하는 씨앗_상상발굴프로젝트 Germinating Seeds_Imaginary Excavation Project	발굴프로젝트(컨테이너), 미디어아트, 조각, 설치, 퍼포먼스
	3	자라는 씨앗 Growing Seeds	조각, 설치, 퍼포먼스
	4	자라는 바다 Growing Sea	키네틱아트, 조각, 설치, 퍼포먼스
특별전	–	나는 바다 Flying Sea	대형 연 설치 퍼포먼스 이벤트

〈표2〉 전시 구성과 해설

그러나 '자연 성장'은 '성장 뒤의 성장'을 의미하기보다 '성장 뒤의 소멸'이 뒤따르는 '자연의 순환적 운동'임을 천명한다. 밀물과 썰물의 지속적 운동이 만들어 내는 바닷가의 풍경은 이러한 순환적 운동이 실현되는 상징적인 공간이다. 산책로를 점유하는 '섹션 1. 산포하는 씨앗'은 유목주의 세계 그 자체이다. '섹션3 자라는 씨앗'은 또 어떠한가? 이 섹션은 해수변 위에 기념비적인 조각은 물론 지하철 공사가 한창인 어수선한 다대포의 풍광을 연장하는 공간을 구성하고 그곳에 실험적인 설치 위주의 작품들을 배치한다. 그것은 미려한 완성이기보다는 에너지가 충만한 미완성을 지향한다. 다른 섹션들도 마찬가지이지만, 특히 우리의 마지막 종착지 '섹션 4. 자라는 바다'는 생성/소멸의 순환적 운동을 끊임없이 일렁이는 시공간 속에서 창출해 낸다. 이러한 차원에서 '섹션 4. 자라는 바다'는 현실적인 종착지이지만 이번 주제와 관련하여 이내 새로운 출발점으로 변환된다.

'생성/소멸/생성'의 순환적 지속을 가시화하는 이번 공간 구성에서 특히 '섹션 2. 발아하는 씨앗_상상발굴프로젝트'는 다대포 지역의 과거로 거슬러 올라가 지금의 모습과 비교, 고찰하는 통시적(通時的) 모험을 선보인다. 1930년대 다대포 지역에서 발굴된 '다대포패총'으로부터 신석기 시대의 빗살무늬토기와 청동기의 무문토기 등 각종 유물이 발견되었던 사실은 우리로 하여금 이 지역의 시원으로 거슬러 올라가게 만든다. '섹션 2. 발아하는 씨앗–상상발굴프로젝트'에 참여하는 작가들은 각기 다른 조형 언어로 다대포 지역의 역사적 사실(fact)을 추출하고 그것을 자신의 예술적 상상력으로 해석(interpretation)하여 허구(fiction)의 발굴프로젝트를 벌인다. 그런 면에서 이들의 작업은 사실과 허구가 만나는 팩션(faction)에 다름 아니라 할 것이다.

망각으로부터 과거의 기억을 길어 올리듯, 우리는 역사 속에 묻힌 기억의 맥을 찾아 땅을 파고 발굴프로젝트를 벌인다. 발굴프로젝트가 이루어지는 모래사장의 반지하 공간은 따라서 중력이 이끄는 '수직의 공간 아래'(|)로 깊숙이 잠입해서 과거의 역사와 그것에 관한 우리의 기억을 '지금, 여기'의 '수평의 현실 위'(—)로 끌어 올리는 곳이다. 또한 미디어 파사드로서의 수직 공간(|)과, 중력에 저항하면서 직립한 많은 수직적 조각들(|)이 이루는 현실적 지평을 보라! 그 뿐인가? 우리가 보게 되는 몇 개의 '고원으로서의 수직의 공간'(|)은 '지금, 여기'의 작가, 즉 《바다미술제》를 낳은 부산 지역의 출신 작가에 대한 오마주를 헌사하는 곳이다.

이 모든 수직(|)과 수평(—)의 공간은 다대포해수욕장이라는 장소 안에서 그리고(&)라는 연결체를 통해 함께 어우러짐을 펼쳐 낸다. 즉 하나의 장소성 안에서 통시성과 공시성을 함께 드러내는 것이다. 예를 들어 한 개의 언덕(| & —)은 이 시대의 '살아 있는 한 전설의 미술가'에 대한 경외를 보내는 곳이며, 몇 개의 언덕들(| & —)은 이 시대에 여전히 남아 있는 반상업적인 미술의 가능성과 그것의 희소적인 가치에 대해 갈채를 보내는 곳이다.

야외미술제의 특성에 부합하는 설치, 조각 뿐 아니라, 미디어아트, 퍼포먼스를 두루 포함하는 다양한 장르의 작품들을 초대한 까닭은 이번 《2015바다미술제》를 단순한 환경조각제나 설치미술제로 자리매김하려는 시도를 처음부터 거부하려는 이유에서이다. 전시의 결과가 어떠하든, 기획자의 입장에서는 나름대로 야외에서의 미술제에 대한 일련의 조형적 실험을 시도한 것에 대한 자족(自足)이 있었던 것은 사실이다. 그렇다고 기획자로서 이번 《바다미술제》가 야외에서 펼쳐졌던 기존의 다른 전시들에 비해 공간 해석이나 전시 구성에 있어 훨씬 낫다고 우길 생각은 없다. 본전시, 특별전 구성의 형식이나 특별 강연, 축제 및 시민 참여 프로그램 등 행사 구성에 있어 타전시들과 특이점 역시 별반 없다고 할 수 있겠다. 다만 기획자로서는, 올해의 《바다미술제》가 그간의 정형화된 조각, 설치 위주의 틀에서 벗어나는 실험적인 연출 방식을 부단히 찾으려고 했던 노력들을, 관객들이 관심 있게 지켜봐 주었으면 하는 바람이다.

IV. 출품작 소개와 해설: 씨앗들의 과거-현재-미래 그리고 운명?

'보다 — 바다와 씨앗(See — Sea & Seed)'이라는 주제를 풀이하는 스토리텔링을 따라 배치된 작품들을 모든 관객들이 순서대로 관람하길 기대한다는 것은 처음부터 요원한 것일 수 있다. 전시란 늘 기획자의 의도와 관람자의 욕구가 상반되게 대립하면서 어떠한 비평거리가 자라는 곳이지 않던가? 그럼에도, 기획자는 전시를 원래의 기획 의도대로 읽어 주길 바라면서, 여기에 초대 작가들의 출품작의 면면을 기획의 내러티브에 따라 순차적으로 소개한다.

《본전시_섹션 1. 산포하는 씨앗》

섹션 1은 《2015바다미술제》의 문을 여는 프롤로그이다. 이 섹션은 주로 산책로와 해변 입구 사이의 경계에 위치하고 더러는 해변의 좌측과 우측 사이의 접점에 자리한다. 각기 다른 곳으로부터 발원하여 다대포 인근에서 흩뿌려지는 씨앗들은 유목의 시간을 마치고 이곳에 씨앗의 뿌리를 내린다.

① (구)시설관리공단 건물 외벽에 그림을 그리는 마티아 루리니(Mattia LULLINI, 이탈리아, 1985~)의 벽화 작업이나,

② 같은 건물의 다른 벽면에 비디오 영상 프로젝션을 선보이는 이경호(Kyng-Ho LEE, 한국, 1967~)의 미디어파사드는 모두 '섹션1. 산포하는 씨앗'이라는 주제뿐 아니라 《2015바다미술제》의 전시 주제를 드넓게 해석하여 선보인다.

③ 앤디 드완토로(Andy DEWANTORO, 인도네시아, 1973~)의 작품은 자연을 찾은 관객들의 얼굴을 촬영하여 산책로에 위치한 나무들에 기념품처럼 매달면서 완성되는 관객 참여형 작품이다. 최종적으로 한 달간의 전시 기간 중 100명의 인물 사진으로 완성되는 이 작품은 관객들이 만든 사진 방명록이자, 오늘날 '사회적 인간'에 대한 의미심장한 은유가 된다.

④ 또 다른 산책로부터 해변으로 나서는 길에는 신원재(Won-Jae SHIN, 한국, 1971~)의 작품이 자리한다. 이것은 하나의 터널이다. 안과 밖이 통하는 기다란 구조의 동양적 건축 공간! 이것은 마치 본전에 이르는 일주문(一柱門)과 같은 안내 표식이자, 전경을 감추고 사찰 마당으로 길을 안내하는 '누하진입(樓下進入)'처럼 해변의 본전시 공간을 가린 채 그곳으로 인도하는 훌륭한 길잡이가 된다. 이것은, 마치 벤야민이 '쉬벨러(Schwelle)'로 풀이했던 건축물의 아케이드 혹은 파사쥬(passage)처럼, 차안(此岸)과 피안(彼岸) 사이의 중간계(intermediate world), 주체와 타자 사이의 사이 공간(interspace), 주체와 대상 사이의 접점(interface)이 된다. 경계 사이에서 꿈틀대는 생명체처럼 말이다.

⑤ 오태원(Tae-Won OH, 한국, 1973~)은 시인 고은(Ko Un, 한국, 1933~)과의 협업 작업을 선보인다. 주 전시 공간에서 해변에 이르는 산책로에 위치한 이 작품은 낮에는 물의 터널이자 밤에는 빛의 터널이 된다. 1,000개에 이르는 물방울 형상이 조명등은 주된 전시 공간으로 이끄는 프롤로그이자 '산포하는 씨앗'이라는 섹션의 내러티브를 상징적으로 보여 주는 기제가 된다. 여기에 고은 시인의 동사형 시어들이 아크릴 거울판에 아로새겨져 우리의 몸과 마음을 서정적인 전시 공간으로 인도한다.

⑥ 해변 입구에 위치한 김원근(Won–Geun KIM, 한국, 1971~)의 작품 역시 입(入)과 출(出)의 중간계에 있다. 그것은 한 쌍의 연인일 따름이지만, 기획자는 그것을 현대적인 장승의 모습으로 풀이한다. 즉 경계 사이의 경계표, 이정표의 역할과 마을 초입의 수호신 역할을 맡은 장승인 현대적인 천하대장군과 지하여장군으로 바라보는 것이다.

⑦ 노주환(Ju–Hwan NOH, 한국, 1960~)의 작품은 관객 참여형 작품이다. 1,000명의 어린이가 만든 바람개비를 모아 완성되는 이 전시는 관객/작가, 비미술인/미술인, 너/나/그(녀)들/우리가 네트워크로 하나가 될 수 있음을 선명히 보여 주는 프로젝트이자 사회적 공동체의 의미를 성찰하게 만드는 유의미한 사회적 예술이다.

⑧ 이이남(Lee–Nam LEE, 한국, 1969~)의 작품은 '산포하는 씨앗'을 미디어파사드로 선보인다. 이전에는 섬이었으나 바다에 밀려드는 낙동강 하류의 퇴적으로 인해 이제는 육지가 된 몰운대라는 커다란 능선 위에 레이저아트를 선보인다.

《본전시_섹션 2. 발아하는 씨앗_상상발굴프로젝트》

섹션 2는 《2015바다미술제》의 전시 주제를 특별한 관점에서 해석하여 선보인다. 이 섹션은 바다를 보고 섰을 때 우측의 공간에 군집으로 배치된다. 이 섹션은 과거의 시공간을 오늘의 시공간에 건져 올리는 작업들로 구성된다.

⑨ 도릿 크로시어(Dorit CROISSIER, 독일, 1944~)의 작업은 다대포 '응봉봉수대'라는 실재를 다대포해수욕장에 가상의 이란성 쌍둥이의 모습으로 유적화한다. 그것은 타국의 침입으로부터 다대포를 지키고자 했던 이 지역의 파란의 과거사를 서구 미술인의 상상 언어로 엿보게 하는 것이 된다.

⑩ 조덕현(Duck–Hyun CHO, 한국, 1957~)는 다대포 지역에 애니미즘으로서의 '개 신상'이 있었다는 가정 하에, 그것을 상상으로 발굴하는 프로젝트를 선보인다. 작가의 허구적 상상이 실재처럼 현실화되는 팩션(faction) 작업이라 하겠다.

⑪ 동아대 대학원 미술학과와 부산대 대학원 고고학과의 협업으로 컨테이너 내부에서 펼치는 그룹 아키스트(Group Archist, 한국)[2]의 작업은 다대포패총이라는 실재하는 과거의 '사실(fact)'로부터 추출한 '허구적 상상(fiction)'을 선보인다.

⑫ 경성대 대학원 미술학과의 그룹 세라에너지(Group Cera–energy, 한국)[3]의 작업은 한국 고대의 가마라는 사실을 허구화한다. 컨테이너 내부의 무수한 도자기 설치물과 더불어 컨테이너 외부에서 가마터를 재현하는 퍼포먼스는 오늘날의 캠프파이어와 같은 축제의 형식과 연동하면서 인류 공동의 역사를 상상 발굴한다.

⑬ 반면 사라웃 추티옹페티(Sarawut CHUTIWONGPETI, 태국, 1970~)의 작업은 통시적 공간으로부터 공시적 공간으로 눈을 돌린다. 다대포라는 지금, 여기의 시공간에서 찾아 나선 '발견된 오브제(found object)'를 컨테이너 내부에 가득 설치하고 자신만의 '백색의 동화 왕국'을 건설한다.

⑭ 최선(Sun CHOI, 한국, 1973~)의 작업 역시 '지금, 여기'의 사회 공동체의 도움을 받아 자신의 '회화 퍼포먼스'를 실현한다. 그는 워크숍이라는 이름 아래 컨테이너 밖에서 《바다미술제》를 찾는 수많은 사람들의 생생한 '숨'으로 도움을 받아 자신의 회화를 완성한다. 우리는 그것을 하나의 숨과 또 하나의 숨이 무수히 만나 이루는 '공동체 회화 만들기'라 할 것이다.

⑮ 스테펜 올랜도(Stephen ORLANDO, 캐나다, 1983~)의 사진 작업은 바다라는 공유의 장소를 지금, 여기의 다대포에 건져 올린다. 카약이라는 작은 배의 노에 엘이디(LED) 전구들을 매달고 노를 젓는 궤적을 느리게 포착한 신비로운 그의 사진은 '서구/동양의 바다'라는 물리적으로 별리된 공간을 '지금'이라는 동시대성으로 컨테이너 안에서 하나로 묶어 낸다.

⑯ 친탄 우파드야이(Chintan UPADHYAY, 인도, 1972~)의 작업은 컨테이너 내외부에서 지역 공동체의 참여로 완성된다. 20개의 화분을 지역민에게 나눠 주고 한 달간 기르게 한 뒤, 작품 설치에 다시 참여하게 하는 방식의 커뮤니티아트도 그러하거니와 폐차와 더불어 컨테이너 내외부에서 실행하는 다양한 단계별 퍼포먼스는 관객의 참여에 의해서 이루어지는 '현재적 발굴프로젝트'로 자리매김한다.

1) 김등용(1983~), 김나륜(1993~), 유규영(1987~), 이찬민(1981~), 백근영(1985~), 김효영(1991~) 이가윤(1993~), 박성진(1987~), 지영배(1984~), 정철(1991~)

2) 강미라(1987~), 김혜라(1989~), 박종환(1959~), 심희정(1990~), 임혜지(1991~), 정혜주(1983~), 조승연(1991~)

마지막으로 ⑰ 차기율(Ki-Youl CHA, 한국, 1961~)의 작업은 '만약이라는 가정'으로부터 한걸음 보폭을 더 내딛는 '허구적 상상'으로 '다대포 왕릉'에 접근한다. 실제로는 있지도 않는 다대포 왕릉은 컨테이너 내외부에서 전개하는 그의 상상발굴프로젝트에 의해서 비로소 현실계에 현실화된다.

《본전시_섹션 3. 자라는 씨앗》

섹션3은 《2015바다미술제》의 내러티브를 전개하는 중심의 장이다. 이 섹션은 해변의 중심에서 동심원을 그리는 공간들에 자리한다. 발아하는 씨앗들이 썩어 비로소 새로운 생명들을 잉태해 나가는 성장의 공간인 것이다.

⑱ 리그돌 텐징(Rigdol TENZING, 티벳계 미국, 1982~)의 작품은 자연에 자리를 잡고 '자라난 씨앗들'을 '흙더미'의 모습으로 다시 자연에 돌려준다. 그는 인천공항에 도착한 이후부터 다대포해수욕장에 이르기까지 2박 3일의 일정 동안, 전시감독이 예비한, 인천공항→인천→강화→파주→양평→속초→강릉→포항→울산→부산→다대포해수욕장에 이르는 여행 장소를 거치면서 각 장소에서 20개씩의 흙 포대를 담아 와 최종적으로 다대포해수욕장에 총 200개의 흙 포대를 설치한다. 작가는 한국이라는 낯선 이국의 땅에서 서해-내륙-동해-남해에 이르는 여정에 초대를 받고, 처음 보는 한국의 미술가들을 마중자/배웅자로 만나고 헤어지기를 반복, 지속하면서 다대포해수욕장에 이르러 그의 노마딕프로젝트를 마감한다. 바다를 향해 꼬리를 물고 가게 설치한 200개의 흙 포대는 단지 흙일 따름이지만, 한국의 분단 상황과 미술 공간들, 미술가들에 대한 그의 기억을 고스란히 담아 우리에게 선보인다. 그의 이러한 기억은 앞으로 어떤 모습으로 자라날까?

⑲ 김정민(Jung-Min KIM, 한국, 1982~)의 작업은 다대포해수욕장의 습지에서 실제로 자라고 있는 꽃과 식물 5종을 모델로 삼아 만든 거대한 식물 군집체이다. 실재가 변형, 재창조이 된 채, 현시되는 조각인 셈이다.

⑳ 전원길(Won-Gil JEON, 한국, 1960~)의 출품작은 씨앗이 자라 식물로 성장하는 과정 자체를 가시화하는 개념적이고 과정적인 작업이다. 20미터에 달하는 나지막한 수평적 언덕 위에 일렬로 자라고 있는 '보리' 모종은 한 달의 전시 기간 동안 서서히 자라나 최종적으로 관람자의 위치에서 벼의 끝부분이 바다의 수평선과 일치하는 순간에 이르러 전시를 완성한다. 자연의 성장 속도를 이해하는 치밀한 계산과 연구가 전제된 이 개념적인 미술은 '자라는 씨앗'의 본질적 의미를 우리에게 되새기게 한다.

㉑ 페르난도 알바레즈 페레즈(Fernando ALVAREZ PEREZ, 스페인, 1975~)의 작업은 거대한 5개의 씨앗들 혹은 그것들이 만들어 낸 5개의 거대한 생명의 구릉지이다. 그것은 서구의 방위 개념에 하나가 덧붙은 5방(五方)의 개념으로 자라난다.

㉒ 전시의 스토리텔링을 따라 하나의 서클을 그리고 돌아온 해변의 한 가운데 오노 요코(Yoko ONO, 미국, 1933~)의 작업이 자리하고 있다. 그것은 그녀가 1996년부터 평화를 기원하며 시작한 〈소원나무(Wish tree)〉이다. 관람객이 저마다 자신의 소원을 빌면서 기록한 작은 종이쪽지가 하나둘 걸려 거대한 '종이 나무'를 만들어갈 때까지, 지금까지 오랜 세월을 묵묵히 지켜 온 거대한 한 그루 나무는 그들의 모든 소원들을 말없이 넉넉히 받아 준다. 요코 오노의 소망과 함께 말이다

㉓ 이종균(Jong-Kyun LEE, 한국, 1971~)의 작업은 자연-인간-환경 사이의 자라남의 결과가 초래한 환경 오염의 심각한 문제를 한바탕 즐거운 축제로 풀어낸다. 물고기 모양의 배낭을 메고 다대포 지역의 쓰레기를 수거하는 퍼포먼스를 벌이면서 작가는 커다란 물고기 모양의 쓰레기통을 설치해 놓고 한 달의 전시 기간 동안 차곡차곡 분리수거를 통해 쓰레기를 모으는 과정미술을 선보인다. 인간 문명의 배설과 쓰레기를 통해 벌이는 작가의 블랙유머는 이 시대에 대한 통렬한 풍자이다.

㉔ 정찬호(Chan-Ho JEONG, 한국, 1979~)의 작업은 바닷가 불꽃놀이가 축제를 연상시키듯이, 폭죽이 터뜨려지는 순간을 조각으로 포착한다. 마치 다대포해수욕장(1970년대~)이 《바다미술제》(1987~)가 청장년기로 훌쩍 성장했음을 기념하는 축하 행사도 벌이는 것처럼, 작품은 온통 희열에 가득하게 차 있는 모습이다.

㉕ 김영원(Young-Won KIM, 한국, 1947~)의 작업은 자연을 발판으로 삼아 8m에 이르도록 우뚝 서 있는 거대한 인체 조각이다. 부조와 환조가 어우러진 이 조각에는 음과 양이 공존하고, 유와 무가 뒤얽혀 있다.

《본전시_섹션 4. 자라는 바다》

섹션 4는 《2015바다미술제》의 전시 주제에 대한 내러티브를 마무리한다. 이 섹션은 바다를 보고 섰을 때 바다에 속하거나 그것과 매우 근접한 전경 혹은 좌우 해수변의 공간에 자리한다. 이 섹션은 현재 진행형의 내러티브를 지속적으로 현재화하거나 혹은 미래로 투영하는 작업들로 구성된다.

㉖ 윤영화(Young-Hwa YOON, 한국, 1964~)의 작업은 바다를 떠다녔던 실제의 목선을 바닷가에 세워 올린다. 오랜 유영의 세월을 마치고 폐선이 되어 돌아온 실제의 '목선'과 그것을 재해석한 또 다른 '철선' 그리고 현대적인 배로 변신한 '철선'이라는 세 종류의 '배'가 차례로 쌓아 올려져 '자라는 바다'의 개념을 자신의 조형 언어로 풀어 놓는다.

㉗ 조셉 타스나디(Joseph TASNADI, 헝가리, 1960~)의 작업은 실제의 바다 위로 스테인리스 스틸로 만든 배 한 척을 띄워 올리는 것이다. 키네틱아트인 이것은 수면 위에서 부유하면서 바다의 물결을 따라 노 젓기를 자동으로 지속한다. 관객은 맞은 편 해변에 위치한 또 다른 배의 노를 저어 가면서 바다 위 배 한 척과 시각적 대화를 지속할 수 있다.

㉘ 손현욱(Hyun-Wook SON, 한국, 1982~)의 작업은 모래사장 위에서 한 강아지가 실제의 바다 위로 자신의 소변 줄기를 보태는 위트 가득한 메시지를 담은 조각 작품이다. '자라는 바다'를 자라게 하는 강아지의 모습이 무척이나 귀엽지 않은가?

㉙ 그룹 VGABS의 작업은 '자라는 바다'를 〈상상염전〉으로 해석한다. 이 그룹은 앤드류 아나다 부겔(Andrew Ananda VOOGEL, 미국, 1983~), 갈드릭 플뢰리(Galdric FLEURY, 프랑스, 1985~)과 앙투안 퐁텐(Antoine FONTAINE, 프랑스, 1985~)으로 구성된 '그룹 속 또 다른 그룹'인 플뢰리 퐁텐(Fleuryfontaine), 배성미(Sung-Mi BAE, 한국, 1971~), 그리고 마리아 사모르체바(Maria SAMORTSEVA, 러시아, 1992~) 등 총 5인의 다국적 미술가로 구성된다. 이들은, 미국 샌프란시스코만(San Francisco Bay)의 화려한 색들로 이루어진 염전(salt pond)에 주목한 전시감독의 출품 제안을 수락하고 이 프로젝트를 위한 새로운 그룹을 결성했다. 주지하듯이, 샌프란시스코만 염전은 그곳에 서식하는 조류(藻類), 브라인 쉬림프(brine Shrimp)와 미생물들이 염분의 농도, 일조량, 공기가 제각기 다른 상황 속에서 서로 만나 환상적인 색들을 창출한다. 이 염전은 시간의 흐름에 따라 차츰 다른 색들로 변모해 간다. 이 화려한 염전들은 다시 갯벌과 습지대로 전환하려는 캘리포니아주의 사우스만 복구 프로젝트(South Bay Restoration Project)로 인해서 훗날 사라질 예정이다. 자연의 생태적 복구를 위해서는 분명코 환영할 일이지만, 자연이 만드는 신비로운 염전의 색들을 앞으로 보지 못하게 된다는 것은 아쉬운 일이기도 하다. 그룹 VGABS는 〈상상염전〉이라는 이름의 작품을 통해서 이것에 대한 미술적 재해석을 실천한다. 이들 모두는 어떠한 인공적 물감이나 안료를 사용하지 않고 유기적인 자연물을 재료로 삼아 자신의 염전을 각각 검은색, 붉은색, 노란색, 녹색으로 착색하는 실험을 거듭한다. 그런 차원에서 이 공동 작업은 샌프란시스코 베이 염전에 대한 미술적 재해석이자 오마주가 된다.

㉚ 코넬 알베르투스 오우엔스(Cornelis Albertus OUWENS, 네덜란드, 1958~)의 작업은 가장 자연다운 파도의 물결 속에 가장 인공적인 철로 된 조각품을 설치하고 그것이 스스로 자라도록 내버려 두는 작업이다. 철조각은 시간에 따라 벌겋게 녹이 슬면서 자라는 바다의 섭리를 한 몸에 체득한다. 바람으로 말 걸기를 시도하는 바다의 대화 요청에 그의 조각은 와이어에 매달린 무수한 리본들을 흔들면서 화답한다. 그래, 함께 이야기하자고.

㉛ 이명호(Myung-Ho LEE, 한국, 1975~)는 해변을 보고 섰을 때 좌측의 몰운대 근처에 자리한 바다의 암초들을 주목한다. 그것은 바닷물을 먹고 자라거나 바닷물에 깎여 모양새가 다음어진 바다의 자녀들이다. 이명호는 이 중 몇 개의 암초/암석을 선택하고 주위를 프레임으로 둘러싸게 만들어 이것을 암초로부터 암석 혹은 바윗돌로 정초시키면서 다대포해수욕장의 주인공으로 만들어 준다. 이것은 만조 시에는 여전한 암초이지만, 간조 시에는 바닥까지 자신의 모습을 드러내는 암석이 되기 때문이다. 그런 면에서 이 작업은 바닷가의 흔하디흔한 하나의 '돌'이 작가의 선택을 받아 다대포의 주인공으로 등장하는 것에 다름 아니다. 이 전환의 순간을 지켜보면서 작가는 그것을 사진으로 남기는 사진행위프로젝트를 정기적으로 진행한다.

㉜ 조나단 폴 포어맨(Jonathan Paul FOREMAN, 영국, 1992~)는 반대로 다대포해수욕장의 그 어떤 것들도 주인공으로 만들 생각을 갖고 있지 않다. 그는 그저 산책하듯이 해변을 돌아다니면서 그저 나뭇가지로 허술한 뼈대를 세우고 그 위에 조약돌을 아슬아슬하게 올리면서 중력에 순응하는 자연의 원리를 체험하려는 시도를 하릴없이 지속할 따름이다. 그는 필자가 아는 한, '돌 평형 잡기(the stone balancing)' 장르에 있어서 최연소 신진 작가로 이번 《바다미술제》 참여 작가 중에서도 가장 나이가 어리다. 물론 그는 전시감독으로부터 정식으로 초대를 받은 참여 작가이다. 그럼에도 그는 이렇게 말할지 모른다. "나는 그저 '자라는 바다'를 체험하고 배우러 왔을 따름이다"라고 말이다.

㉝ 루드위카 그라지나 오고르젤렉(Ludwika Grazyna OGORZELEC, 폴란드, 1953~)의 작품은 이 섹션에서 바위와 바위를 인공의 얇은 끈으로 무수히 잇는 매개체들의 연합으로 풀이된다. 그녀의 작품은 인공이되 자연으로 변환되는 '변환 지점' 혹은 그 경계점에 위치한다. 작품 읽기에 따라 그것은 한국 전통의 마을 수호신 '서낭'을 모신 서낭당 내 신목(神木)에 걸쳐 놓은 무수한 천 조각들이 전하는 주술적 메시지로 풀이될 수도 있겠다.

이처럼 《2015바다미술제》를 구성하는 본전시의 모든 섹션들은 결국 다대포해수욕장에 잠입하는 씨앗들의 과거-현재-미래 그리고 알 수 없는 미래적 운명에 대해서 이야기한다. 여기에 초대된 모든 작품들은 이러한 주제 의식을 공시적이고 통시적이고 시공간을 넘나들면서 저마다 자신들의 조형 언어로 멋지게 재해석해 낸다.

《특별전_나는 바다》

㉞ 피터 린 카이트(Peter Lynn Kites Ltd, 뉴질랜드)라는 기업을 초대하여 선보이는 《특별전_나는 바다(Flying Sea)》는 '대형 연 설치 퍼포먼스 이벤트'로 꾸며진다. 15m에 이르는 흰수염고래(Blue Whale)와 30m의 가오리(Stingray) 그리고 8m가 넘는 게(Crab) 등 3종의 대형 연이 참여한다. 다대포해수욕장의 하늘에 멋들어진 특별 이벤트를 선물해 준 이 기업의 CEO 피터 린(Peter LYNN, 뉴질랜드, 1946~)과 특별전 디자이너로 한국에 와 참여해 준 디렉터 크렉 한센(Craig HANSEN, 뉴질랜드, 1960~)에게 감사의 인사말을 전한다.

V. 나오는 글: 다시 바닷가에서

《2015바다미술제》를 펼쳐지는 가을 바닷가에 다시 나와 있다.
《바다미술제》를 진행하는 사람들의 분주한 움직임들이 보인다. 지금도 이렇게 바삐 움직이고 있는데. 이 행사를 위해서
저 사람들은 그동안 얼마나 많은 '소소한 전쟁들'을 치렀을까? 알 만한 사람들은 다 안다. 적(敵)이 특별히 보이지 않고 승
리의 목적만이 보이는 길에서 맞닥뜨리는 '소소한 전쟁들'이란 얼마나 힘들고 어려운 일인지를 말이다. 기획자도 그들과
함께 있었고, 지금도 함께 있으니 그것은 결코 남들의 이야기가 아니다. 무모하게 일 벌리기를 좋아하는 기획자와 함께 여
기까지 올 수 있도록 힘을 보태 준 모든 이들에게 감사를 드린다.
보자! 바닷가를 거니는 관객들의 얼굴은 평온하고 즐거워 보인다. 그들 역시 희로애락의 일상으로부터 날마다 '소소한 전
쟁들'을 치르고 있을 테니. 이 《바다미술제》가 그들에게 안위와 희망이 되길 간절히 바란다.
이번 《바다미술제》에서는 일반 대중이 쉽게 이해할 수 없거나 동의하기 쉽지 않은 실험적인 현대미술이 등장하기도 하지
만. 기획자는 이것이 그동안 우리의 삶을 새롭게 변화시켜 온 하나의 동력이었음을 끝까지 이야기하고 싶었다. 그것은 '재
기발랄한 잔꾀가 예술로 둔갑하는 치기(稚氣)' 혹은 '쓰레기가 예술로 둔갑하는 마술'을 선보이려는 의도가 결코 아니었음
을 밝혀 둔다. 그것은 분명히 예술 창작에 대한 예술가의 진지한 사유가 곧 예술이며, 소소한 일상 자체가 예술 작품이라
는 것을 말하려는 것이었다. 물론 '현대미술의 실험성'과 더불어 '대중의 소통과 참여'라는 합치하기 어려운 화두를 이번
《바다미술제》에서 풀고자 했던 기획자의 바람은 여전히 '답'이 아니라 '질문'으로 남는다. 그 질문들을 함께 생각해 보려는
이번 《바다미술제》의 '청유 혹은 초대'가 많은 분께 전해지길 기대한다. 다시 바닷가에서!

See—Sea & Seed

Artistic Director, Sung-Ho KIM

I. Prologue: On the Beach

It's fall now. We are returning to the seashore where beachgoers left one by one after enjoying the romantic days of the summer season. Dadaepo Beach, the venue for the Sea Art Festival 2015 — As the signs of bustling summer days vanish one by one, the seashore in different attire emerges before our eyes alongside a chilly wind. What clothes have we changed in the natural surroundings of the sea and sandy beach that have remained unchanged?

This year the Sea Art Festival will be held at Dadaepo Beach, a location less known to the public as it lies in the west of Busan in what has been regarded as a culturally alienated area. We constantly put on and take off the clothes we have arranged for the citizens of Busan and the visitors of the beach, readjusting the clothes while carefully listening to the reviews of others.

We have intended to go forward, until the end following the two paths that prove difficult to join together: contemporary art's experimental quality which the Sea Art Festival has so far pursued, and public engagement and communication. As an artist works up a sweat to show his works to viewers, the viewers always play a key role in completing the festival alongside the participating artists. The viewers, invited artists who have submitted their works, and those who have helped their participation are nothing short of a temporary community in which they become one.

We are thrilled to begin the Sea Art Festival 2015 and look forward to seeing everyone who comes to the beach. 34 artists and teams from 16 countries – 19 Korean artists and teams and 15 foreign artists and teams – who have been invited to the art event will accompany us for one month, sharing their creations under the theme of *See – Sea & Seed*.

II. Introduction to the Theme: *See – Sea & Seed*

Sea and seed! Those are a mismatch. It is not easy for a seed to take roots on a salty, sandy beach. The seaside cannot be a home for a seed while the seed is not a welcome guest for the sea since it would be too burdensome for the sea to take care of the seed.

We have seen the sea and seeds separately, but now we should try to see them together at the Sea Art Festival 2015. Is it impossible to see the two of them talking with one another and enjoying a game together? No! As we see an artificial wetland turn into a natural one over time, an encounter of the two is in no way impossible. Look at the germination and growth of seeds spreading their roots in a sandy field! This is not a miracle but just a rare coexistence. We hope that such a coexistence would have been consistently made in this exhibition, confirming that the two unlikely to coexist actually can do so.

The concept of see and seed are metaphors adopted to introduce this year's Sea Art Festival, as well as keywords to represent the specialty of the Dadaepo Beach, the venue of the festival, and topics for resolving our constant

Keywords	Structure	Perceptions		Connotations	Descriptions
		Sight	Hearing		
See	V	**S**ee	[si:]	Look!	Request for viewing
—	;	Beach(-)	—	() / . ⟨ ,	Hyphen (—) = Space for connecting or dividing / Space replacing a parenthesis () Semicolon (;) = Time lighter than a period (.) and heavier than a comma (,)
Sea	O	**S**ea	[si:]	Sea	Exhibit space
&	Conj	Together + Man taking a rest	[ən]	And	Network together = exhibit space & artwork + artwork & viewer + man & man
Seed	O	**S**eed	[si:d]	Structure	The Sea Art Festival launched from Dadaepo + Artworks as the seeds germinating at Dadaepo + the Seeds of creation and enjoyment of art and culture that seem impossible to take root but eventually breed life

<Table 1> Introduction to and comments about the theme

As assured by the table above, the theme of the Sea Art Festival 2015, *See – Sea & Seed* is loaded with the following connotations. The Sea Art Festival 2015 will sow the SEED of art in a horizontal (—) exhibition area called Dadaepo (SEA).The exhibition will share (&) joy with citizens as well as invited artists and provide a unique experience for viewers (SEE). Through this art event, it is expected that the relative topography of "and" (&) will spread to all places from Dadaepo Beach. In other words, it is hoped that the network of the relations between man and sea, art and region, and artist and citizen will be formed here, pliantly calling <si:>, <ən>, and <si:d>.

III. Events and Exhibit Composition: a Place Where Seeds Stay

The Sea Art Festival 2015 brings the spotlight to the special spatiality of Dadaepo Beach, in the wake of Haeundae Beach, Gwangalli Beach, and Songdo Beach.

The sandy beach extending over 143,000 m2 (length 900 m, width 100 m) and the shallow sea whose level is less than 1.5 m to the underwater area 300 m from the coast are not all that makes up its special spatiality. Its special spatiality also includes a unique topography with a combination of wetlands and sandy beaches and a natural environment blessed by heaven detached from the commercial district unlike other beaches of Busan. It also encompasses the present context of this region with the construction site of the subway station scheduled to be completed next year. If a viewer stands at the beach, facing the sea, visible in the front is the vast South Sea, behind are high-rise apartments, on the left is Molundae that was an isle before but is presently connected to the land, and on the right is the contact area between sea water and river water of the South Sea and Nakdong River. All are intriguing points in studying the space of this festival.

The festival consists of the main exhibition featuring works of the artists invited by the director and the special exhibition featuring a work specially presented by Peter Lynn Kites Ltd. (New Zealand) for a week. The main exhibition spread out in accordance with a narrative. The narrative is about "natural growth": seeds flew from somewhere to settle, germinate, and grow into plants. As seen in the table below, the sections of the exhibition are 1) *Scattering Seeds*, 2) Germinating Seeds, 3) Growing Seeds, and 4) *Growing Sea* visualizing a narrative of "natural growth."

Classification	Section No.	Section Names	Artworks
Main Exhibition	1	Scattering Seeds	Media Façade, Sculpture, Installation, Performance
	2	Germinating Seeds _Imaginary Excavation Project	Excavation Project (shipping container), Media Art, Sculpture, Installation, Performance
	3	Growing Seeds	Sculpture, Installation, Performance
	4	Growing Sea	Kinetic Art, Sculpture, Installation, Performance
Special Exhibition		Flying Sea	Giant kites installation performance

<Table 2> Exhibit Composition and Description

But "natural growth" clarifies that it is "a cyclical movement of nature" followed by an "extinction after growth" rather than meaning "growth after growth." A beachscape formed by the constant movements of the flood and ebb tides is a symbolic space in which such cyclical movement is achieved. Section 1 Scattering Seeds occupying a coastal walk is a realization of the world of nomadism. Section 3 Growing Seeds displays not only monumental sculptures but also experimental installation works in a space extending from the messy area around Dadaepo due to the subway construction that is underway. They seek incomplete work full of energy rather than exquisitely completed work. As in other sections, Section 4 Growing Sea brings about the cyclical movement of creation and extinction in ceaselessly undulating space and time. In this sense, this section is a realistic destination but soon becomes a new departure point in regard to the theme of this exhibition.

In the exhibit composition to visualize the continuance of the cycles of creation and extinction, the Section 2 *Germinating Seeds_Imaginary Excavation Project* demonstrates a diachronic adventure through which the past of the Dadaepo area is compared with its present. We look back on the origin of this region with a variety of artifacts such as Jeulmun pottery of the Neolithic Age and Mumun pottery of the Bronze Age unearthed from shell mounds in the Dadaepo area in the 1930s. In this section, participating artists conduct an imaginary excavation project in which they draw out historical facts of this region with their own modeling language and interpret them with their artistic imagination. In this respect their works is nothing short of "factions" in which reality meets fiction.

We perform an excavation project to explore our history and raise past memories from oblivion. The semi-basement space where this project takes place is thus a place where we infiltrate deep into a vertical space (|) and draw up past history and our memories of this history to a horizontal reality (—), the here and now. The horizon of reality is shaped with vertical space (|) as a media façade and vertical sculptures standing erect against gravity. A few vertical spaces (|) as plateaus are places where we pay homage to the native Busan artists who gave birth to the Sea Art Festival.

All these horizontal(—) and vertical(|) spaces are in harmony with one another on Dadaepo Beach through some connecting body (&). That is, synchrony and diachronic emerges in a single place. For instance, one hill (| & —) is a place where we pay respect to "a living legendary artist," whereas a few hills (| & —) are places where we explore the possibilities of anti-commercial art and pay tribute to its scarcity and value.

A variety of genres, including not only installation and sculpture that fit the features of an open-air art festival but also media art and performance, will be on display with the intention to reject attempts to fix the identity of the Sea Art Festival as merely an environmental sculpture or installation art festival. Whatever the result, I am content with the fact that I could make a foray into some modeling experiments at an outdoor art festival. As one of the curators of the festival, I do not intend to insist that this Sea Art Festival is much better than others in terms of space interpretation and exhibit composition. There is nothing special in its composition made up of the main and special exhibitions and other events such as special lectures and citizen engagement programs. This year's festival strives to explore experimental modes of escaping the standardized frame of highlighting to only sculpture and installation. As a planner of the show, I hope viewers view our efforts with interest.

IV. An Introduction and Description of Works on Display:
The Past, Present, and Future of Seeds and Destiny

The last thing we can expect is that visitors will view the exhibits in order in accordance with the flow of the story that explains the exhibition theme *See – Sea & Seed*. An exhibition is always a place where a curator's intent is in confrontation with viewer desire and something to be criticized grows. Regardless of if it is or isn't, I would like to address each aspect of the artworks presented in order according to the curatorial narrative.

Main Exhibition - Section 1. *Scattering Seeds*
Section 1 is the prologue of the Sea Art Festival 2015. This section is located on the border between the promenade and entrance to the beach. Seeds from different places are scattered around Dadaepo Beach and take root here, terminating their period of nomadism.

① The painting on an exterior wall of the Busan City Facilities Management Corporation building is the work of Mattia LULLINI (Italy, 1985-).

② The media façade by Kyung-Ho Lee (Korea, 1967-) is a video projection on another wall of the same building. These pieces show an extensive interpretation of not only the theme of Section 1, *Scattering Seeds*, but also the exhibition theme of the Sea Art Festival 2015.

③ The work of Andy DEWANTORO (Indonesia, 1973-) is a viewer participatory piece that is completed when viewers hang their photographs like souvenirs on the trees located at the promenade. This work, finally finished with 100 portraits during the one month exhibit period, acts as a photographic visitor's book, conveying a profound connotation of the 'social man' today.

④ The work of Won-Jae SHIN (Korea, 1971-) is placed on the path from the promenade to the seashore. This work is a tunnel that looks like a long Eastern architectural space whose inside interacts with its outside. Like an

iljumun, the first gate at the entrance to the main building in a Korean temple, or a *nuhajinip* that guides visitors to the yard of a temple, this work is a superb guide to the main exhibit space while covering it. Like the arcade Walter Benjamin interpreted as a *schwelle*, or a passage, it becomes an intermediate world, an interspace between the subject and the other, an interface between the subject and the object. It is like an organism wriggling on the border.

⑤ Tae-Won OH (Korea, 1973-) presents an installation work he executed in collaboration with poet Ko Un (Korea, 1933-). On show on the promenade, this work extends to the seashore from the exhibit space and turns into a tunnel of water during the day and a tunnel of light at night. Approximately 1,000 light bulbs in the form of water droplets act as a prologue leading to the main exhibit space while symbolically showcasing the narrative of 'scattering seeds.' Un Ko's poetic verbs are imprinted on the acrylic mirror, ushering our minds and bodies into the lyrical exhibit space.

⑥ The work of Won-Geun KIM (Korea, 1971-) set at the entrance of the seaside is located in an intermediate world between the entrance and exit. This work features a pair of lovers but I interpret them as modern *jangseung* that act as both a landmark and tutelary posts, each carved with a male or a female face and standing at the entrance to a village.

⑦ The work of Ju-Hwan NOH (Korea, 1960-) is a viewer participatory piece. This work consists of pinwheels made by 1,000 children and is a project that clarifies how the viewer/artist, non-artist/artist, and you/I/he/she/we all become one through networks. It also functions as a social artwork that enables us to contemplate the meaning of a social community.

⑧ The work of Lee-Nam LEE (Korea, 1969-) represents the concept of 'scattering seeds' with a media façade. He presents laser art at Molundae, an isle bridged to the land with sediment at the mouth of the Nakdong River.

Main Exhibition - Section 2. *Germinating Seeds - Imaginary Excavation Project*
Section 2 interprets the festival theme from a special perspective. As one faces the sea, this section is located on the right. It consists of works that bring past space-time to present space-time.

⑨ Dorit CROISSIER (Germany, 1944-) depicts Dadaepo's 'Eungbong Beacon Mound' as imaginary fraternal twins. We catch a glimpse of this region's past turmoil of defending itself from an invasion in a Western artist's imaginary idiom.

⑩ Duck-Hyun CHO (Korea, 1957-) conducts an imaginary excavation project on the assumption that dog deity statues have been buried in the Dadaepo area. This project is a faction in which his fictitious imagination is realized as true.

⑪ Group Archist[1] (Korea) presents in a shipping container a fiction drawn out from a past fact of Dadaepo shell mound in collaboration with the Dong-A University Graduate School Department of Fine Arts and the Pusan National University Graduate School Department of Archeology.

⑫ The work of Group Cera-energy[2] , a team comprised of students from the Kyungsung University Graduate

1) Deung-Yong KIM (1983-), Na-Ryun KIM (1993), Gyoo-Young YOO (1987-), Chan-Min LEE (1981-), Keun-Young BAEK (1985-),
 Hyo-Young KIM (1991-), Ga-Yun LEE (1993-), Seong-Jin PARK (1987-), Young-Bae JI (1984-), Cheol JEONG (1991-)
2) Mi-Ra GANG (1987-), Hea-Ra KIM (1989-), Jong-Hwan PARK (1959-), Hee-Jung SHIM (1990-), Hye-Ji LIM (1991-), Hye-Joo JUNG (1983-),
 Seung-Yeon JO (1991-)

School Department of Fine Arts, demonstrates a fictionalization of an ancient Korean kiln site. The group conducts an imaginary project unearthing mankind's common history through the performance of reproducing a kiln site outside of a shipping container along with innumerable ceramic installations in its inside in connection with a form of the festival.

⑬ Sarawut CHUTIWONGPETI (Thailand, 1970-) turns his eyes from diachronic space to synchronic space in his work on display at the exhibition. The artist sets objects he discovered in the space-time of Dadaepo in a shipping container, thereby constructing his own 'white fairytale kingdom.'

⑭ Sun CHOI (Korea, 1973-) has achieved his 'painterly performance' with the help of the social community. He completes his painting using the breath of innumerable visitors at the festival outside the container under the name of the workshop. This work can be described as creating a community painting through an encounter of one breath with many.

⑮ Stephen ORLANDO (Canada, 1983-) captures the sea of Dadaepo, a shared place in his photographic work. His mysterious photograph capturing the light trails of kayak paddles attached with LED lights combines the Eastern and Western seas separated physically from each other with the contemporary characteristic of the 'here and now.'

⑯ The work of Chintan UPADHYAY (India, 1972-) is completed with the local community's involvement at the interior and exterior of a shipping container. This work is executed in a form of community art: 20 flower pots are handed out to local residents which they must take care of for one month before joining the project. A variety of phased performances involving a disused car have been 'a current excavation project' achieved by viewer participation. With his fictitious imagination.

⑰ Lastly, KI-Youl CHA (Korea, 1961-) approaches Dadaepo's 'royal tomb' with an assumption. This inexistent royal tomb is actualized in reality by his imaginary excavation project conducted inside and outside a shipping container.

Main Exhibition - Section 3. *Growing Seeds*
Section 3, located in the middle of the beach, is the central forum for unfolding this narrative. This is a space of growth where germinating seeds carry new life forms.

⑱ Rigdol TENZING (Tibetan American, 1982-) returns the seeds growing in nature to nature again. Immediately after arriving at Incheon International Airport, he began his two-night and three-day journey. Going through Incheon International Airport→Incheon→Ganghwa→Paju→Yangpyeong→Sokcho→Gangneung→Pohang→Ulsan→Busan→Dadaepo Beach, he prepared twenty bags of soil from each place and finally brought them to Dadaepo Beach. He installed two hundred bags of soil in total there. He was invited on a journey from the Western Sea to inland areas, the East Sea, and the Southern Sea. He met many Korean artists for the first time along the way and completed his nomadic project at Dadaepo Beach. The two hundred soil bags whose tail recedes toward the beach are nothing but earth yet hold his memories of the Korean reality of division, art spaces, and artists. What will his memories look like in the future?

⑲ The work of Jung-Min KIM (Korea, 1982-) shows a cluster of enormous plants modeled after five species actually growing in the wetlands of Dadaepo. It can be interpreted as a sculptural piece attained through a modification, recreation and manifestation of reality.

⑳ The work of Won-Gil JEON (Korea, 1960-) is a conceptual piece visualizing the process of germinating seeds

and growing them into plants. In this project barley sprouts are grown in rows of box-shaped frames on a low hill ranging 20 meters. The barley sprouts gradually grow over the course of the one month exhibit period and this project is at last completed when their height coincides with the horizon. This conceptual artwork presupposing a thorough calculation and study on the growth speed of a natural object has us meditate on the underlying meaning of 'growing seeds.'

㉑ The work of Fernando ALVAREZ PEREZ (Spain, 1975-) shows five gargantuan seeds symbolizing five giant hemispheres of life. It denotes the concept of five directions which is similar to the four cardinal directions of the West with an extra direction added.

㉒ The work of Yoko ONO (USA, 1933-) is in the very middle of the venue. She previously commenced this work, *Wish Tree*, in 1996 while wishing for peace. Viewers write down their wishes on pieces of paper and as they hang the notes up one by one an enormous paper tree is created. The tree embraces all of their wishes in silence alongside ONO's wish.

㉓ Jong-Kyun LEE (Korea, 1971-) interprets the problem of severe environmental pollution caused by the relations between nature and man. He demonstrates the art of process in which he sets up a giant fish-shaped garbage can and collects trash during the one month exhibit period. He conducts a performance in which he gathers waste in Dadaepo while wearing a huge fish-shaped backpack.

㉔ The work of Chan-Ho JEONG (Korea, 1979-) is suggestive of fireworks at the seashore and manages to capture the moment when fireworks explode. Just as the artist holds an event to celebrate the striking growth of the Sea Art Festival (1970-) and Dadaepo Beach (1970s-), this work is brimming with joy and ecstasy.

㉕ The work of Young-Won KIM (Korea, 1947-) is a towering human body sculpture measuring eight meters tall standing against the backdrop of nature. In this sculptural work made in relief and carving in the round, yin and yang coexist and something and nothing are in accord with each other.

Main Exhibition_Section 4. *Growing Sea*

Section 4 wraps up the narrative of the exhibition theme. The site for this section includes some part of the sea or the edge of the beach contacting the sea. This section consists of works representing the ongoing narrative of the present or projects this into the future.

㉖ Young-Hwa YOON (Korea, 1964-) sets up an abandoned ship that was actually in use before. He translates the concept of 'a growing sea' in his own modeling language with three boats: an actual 'wooden boat" abandoned after many years of use; another 'steel boat' reinterpreting this; and a 'steel boat' that is a modern transformation of the wooden boat.

㉗ Joseph TASNADI (Hungary, 1960-) sets a stainless steel boat afloat on the sea. Floating on the water, this boat is a piece of kinetic art that paddles itself automatically. Viewers may have a visual conversation with this boat from another boat opposite the seashore.

㉘ The work of Hyun-Wook SON (Korea, 1982-) shows a puppy on a the sands urinating into the sea. The puppy that makes the sea grow in size appears very cute but this sculpture also conveys a message full of wit.

㉙ The work of group VGABS depicts 'a growing sea' in *Imaginary Salt Pond*. This group consists of four multinational artists and one team including Andrew Ananda VOOGEL (USA, 1983-), Galdric FLEURY (France, 1985-), Antoine FONTAINE (France, 1985-) of Fleuryfontaine, a group within the group, Sung-Mi BAE (Korea, 1971-) and Maria SAMORTSEVA (Russia, 1992-). They had accepted a proposal made by the artistic director

who took notice of the colorful salt ponds in San Francisco Bay and formed a new group for this project. As is widely known, the salt ponds of San Francisco Bay engender the fantastic colors of seaweeds, brine shrimps, and microorganisms with different levels of salt concentrations, sunshine, and air. The salt ponds gradually turn into different colors over time. These showy salt ponds are scheduled to disappear with the South Bay Restoration Project that will restore them into mudflats and wetlands. This will be welcomed as an ecological restoration of nature but it is regrettable that we will no longer be able to see the salt ponds' mysterious colors. VGABS conducts an artistic reinterpretation of these hues in their project *Imaginary Salt Pond*. They repeat experiments to turn their salt ponds black, red, yellow, and Green using only organic materials free of any man-made pigments. In this respect their joint work is an artistic reinterpretation of and homage to the salt ponds of the San Francisco Bay area.

㉚ Cornelis Albertus OUWENS (Netherlands, 1958-) sets a steel sculpture among the natural waves of the ocean and lets it grow by itself. The steel sculpture learns the principle of a growing sea, becoming rusty over time. His sculpture responds to the sea's request for conversation through its countless ribbons dangled from wire. Yes, let's talk together.

㉛ The work of Myung-Ho LEE (Korea, 1975-) seen on the left when facing the sea takes note of sunken rocks growing near Molundae. They are children of the sea that are nourished and honed by the sea water. Lee selects a few of them to encircle with frames, making them the protagonists of the beach. They remain immersed in the water at high tide and are revealed at low tide. In a sense this project is nothing short of a direction that allows common 'stones' to take the lead role at Dadaepo. Lee regularly conducts a photographic performance in which he takes photographs of this scene while observing the moment of this shift.

㉜ On the contrary, Jonathan Paul FOREMAN (UK, 1992-) has no intention of turning anything at Dadaepo Beach into a protagonist. While simply roaming around the beach, he sets up a fragile frame made of twigs and tries display how nature adapts to gravity. As far as I know, he is the youngest rising artist in the field of stone balancing and is also the youngest among the artists participating in the festival. Of course, he is one of the artists officially invited by the artistic director. He remarked, "I came here just to experience and learn about 'a growing sea.'

㉝ The work of Ludwika Grazyna OGORZELEC (Poland, 1953-) can be interpreted as a coalescence of countless artificial thin strips connecting rocks to other rocks. Despite being artificial, this work is located at a turning point between nature and art. It can also be translated into a shamanic message conveyed by innumerable pieces of cloth suspended from a divine tree in a *seonangdang* (a shrine dedicated to a village's guardian deity).

All the sections of the main exhibition narrate the past, present, and future of the seeds infiltrating Dadaepo Beach and their unknown destiny. All the works of the artists invited to this exhibition superbly interpret this theme in their own idioms, crossing borders and flying through time.

Special Exhibition - *Flying Sea*

㉞Special Exhibition - *Flying Sea* is a large-scale kite installation performance event presented by Peter Lynn Kites, Ltd. Three kites are on display at this event: Crab measuring over eight meters long, Blue Whale measuring fifteen meters long and Stingray measuring thirty meters long. I'd like to express my thanks to Peter LYNN (New Zealand, 1946-), the CEO of Peter Lynn Kites, Ltd. for presenting this lush special event in the sky of Dadaepo and Carig HANSEN (New Zealand, 1960-), Show director for joining the exhibition as the designer of this special show.

V. Epilogue: On the Beach Again

I have returned to the beach where the Sea Art Festival 2015 is taking place.

Many are busy working here now. Just how many 'trifling wars' have they fought for the event? The man to know knows how tough such 'trifling wars' which lack a visible enemy can be. As I was and am together with them, this is in no way somebody else's business. I want to thank everyone for lending their support and staying here with me despite my recklessness in taking on jobs.

Look! The viewers walking along the beach look peaceful and delighted. As they have also gone through trifling wars of their own, I hope this festival will bring comfort and hope to them at a time wrapped up in joy, anger, sorrow and pleasure.

Although some experimental works of contemporary art are hard for the general public to understand and agree on, I'd like to state that they can be a driving force to change our lives. They are obviously not the results of my intent to present a 'childish endeavor to transform tricks into art' or 'magic to disguise trash as art.' They are products of my attempt to show how an artist's serious contemplation on creation is art in itself and trivial quotidian affairs can be works of art. My wish to resolve hard-to-reconcile issues like 'contemporary art's experimental quality' and 'the public's engagement and how to communicate with them' still remains a question, not an answer. I hope the festival's invitation to meditate on this question together will be accepted by many.

2015바다미술제에 대한 미학적 고찰

임성훈(미학, 미술비평)

들어가면서

자연은 그 자체로만 존재하지 않는다. 아득한 그때부터 자연은 인간의 삶에 다양한 방식으로 상응하는 것이었다. 자연은 상상력의 장소이자 동시에 예술의 근원이다. 그러기에 자연과 문화의 관계는 대립적으로 파악될 수 없다. 독일 철학자이자 미학자인 게르노트 뵈메(Gernot Böhme)는 자연은 고립된 '타자'가 아니라 "문화적 산물(ein kulturelles Produkt)"이라고 주장한다. 달리 말해, 자연이란 "사회적으로 구성된 자연(sozial konstituierte Natur)"이라는 것이다. 나는 이러한 뵈메의 주장에 동의하는 편이다. 특히 예술의 관점에서 순수한 자연을 재현하기란 불가능한 일이다. 예술로 재현되는 순간, 그 자연은 이미 문화화된 것이기 때문이다. 물론 이를 두고 자연을 무조건적으로 문화로 환원해야 한다는 주장으로 오해해서는 곤란하다. 뵈메도 강조하고 있듯이, 문화의 발전이 가속화될수록 자연을 더욱 돌아보아야 할 이유는 많아지기 때문이다. 이런 점을 생각한다면, 《바다미술제》는 미술문화를 통해 자연이 우리 인간에게 주는 의미를 돌아볼 수 있는 기회를 제공하는 장이다.

바다라는 자연은 특별하다. 바다는 생명의 원천이자 그 모습을 온전히 드러내지 않은 미지의 공간이다. 바다는 장엄하고 공포스러우며 격렬하면서도 평온하다. 시간의 흐름에 따라 바다는 가늠할 수 없는 인간의 감정에 상응하는 변용의 장소이기도 하다. 이 글을 쓰고 있는 필자는 어린 시절 그리고 중, 고등학교 시절에 많은 시간을 바닷가에서 보냈다. 돌이켜 보면, 그때 바다는 나에게 상상력의 놀이터였다. 부산 다대포해수욕장 일대에서 9월 19일에서 10월 18일까지 개최되는 《2015바다미술제》 또한 미술로 재현된 상상력의 놀이터라는 생각이 든다.

이번 바다미술제는 일반적인 자연환경 미술제와 공유되는 성격을 갖고 있으면서도, 특히 다음과 같은 점에서 주목할 만한 특징을 보여주고 있다. 첫째, 자연미술과 공공미술을 통합적으로 보여주는 환경미학을 제시하고 있다. 둘째, 현대미술의 실험성과 대중과의 소통 문제를 '긴장의 미학(aesthetics of tension)'으로 재현하고 있다. 셋째, 조각이나 설치미술뿐만 아니라 미디어아트, 퍼포먼스 등을 적극적으로 채택해 바다와 미술의 조형적 결합을 다양한 층위의 문화적 내러티브로 재구성하고 있다. 나는 이 짧은 글에서 참여 작가, 작품 그리고 전시 구성에 대해 구체적으로 언급하지는 않을 것이다. 전시감독의 서문에서 상세하고도 명료한 설명이 충분히 소개되어 있기 때문이다. 하여, 앞서 언급한 세 가지 특징에 중점을 두고 《2015바다미술제》를 미학적 관점에서 간략하게 고찰해 보려고 한다.

1. 바다미술제와 환경미학

현대미술, 특히 1960년대 이후의 현대미술에서 환경은 중요한 주제이다. 여기서 환경은 단지 물리적인 자연환경만을 의미하는 것이 아니라 인간의 삶을 구성하는 사회적, 문화적 환경을 포괄하는 개념이다. 환경미학(environmental aesthetics)은 이러한 환경 개념에 바탕을 두고 환경의 다양한 문제를 미학적으로 논의하는 학문이다. 즉, 자연, 인간 그리고 문화 사이의 복합적이고 다층적인 관계만을 미학적 관점에서 통합적으로 연구한다. 환경미학은 현대미술과 관련하여 구체적으로는 대지미술, 자연미술, 생태미술, 공공미술, 새로운 장르의 공공 미술 등의 영역과 접목하여 논의될 수 있을 것이다.

환경미학을 굳이 여기서 언급하는 이유는 있다. 이번 《2015바다미술제》가 특히 환경미학의 특징을 징후적으로 제시하고 있기 때문이다. 물론 환경미학을 표방한 전시가 없었던 것은 아니다. 그럼에도 이론적으로나 실천적으로 환경미학의 통합적 성격을 제대로 반영한 전시를 찾아보기란 어렵다. 환경미학의 미술적 적용은 자연환경과 문화환경의 상호작용을 내재적으로 진지하게 검토한 이후에 비로소 가능하다. 그러나 많은 경우 어느 한 쪽에 치우쳐 환경미학의 본래적 의미를 살리지 못하고 있다. 또한 기존의 전시기획이나 예술비평의 영역을 넘어 총체적인 미학적 고찰에 따른 새로운 문제의식이 제기되어야 하는데 그렇지 못한 경우도 적지 않다. 이에 반해 《2015바다미술제》는 자연미술과 공공미술을 결합한 환경미학의 통합적 성격을 잘 드러낸 전시이다.

환경미학은 환경의 특수성과 보편성을 동시에 이끌어내야 하는 어려운 과제를 갖고 있다. 예컨대 부산 다대포해수욕장의 환경적 특수성만이 강조된다면 아무래도 미술을 통해 보편적으로 열어갈 수 있는 문화적 추동력이 현저히 약화될 수밖에 없다. 그렇다고 해서 그 지역 환경의 특수성을 고려하지 않고 보편적 담론을 억지로 개입시킨다면, 미술로 촉발될 수 있는 고유한 생동감은 사라지고 말 것이다. 《바다미술제》와 같은 큰 규모의 자연환경 미술제가 안고 있는 딜레마도 여기에 있다고 하겠다. 문제는 이러한 딜레마를 단순히 회피할 수도 없고 번잡하게 다 드러낼 수도 없다는 데 있다. 이어지는 글에서 확인할 수 있듯이, 이번 《2015바다미술제》는 이와 같은 특수성과 보편성 사이의 예술적 아포리아(aporia)를 환경미학의 관점에서 합목적적으로 해결하고자 시도하고 있다.

2. 실험과 소통 – 긴장의 미학

《2015바다미술제》와 같은 형식의 전시에서 항상 논란이 되는 사항 중의 하나가 바로 대중과의 소통 문제이다. 미술의 사회적, 문화적 역할이 다른 전시보다 강조될 수밖에 없기 때문이다. 그러기에 대중에게 친숙하고 일반적으로 이해하기 쉬운 형식의 작품이 주를 이루어야 한다는 주장을 흔히 접할 수 있다. 그렇지만 이러한 일반론이 과연 적절한 지의 여부는 좀 더 많은 숙고를 요한다. 나는 미술, 특히 현대미술에서 소통은 작품의 실험성이나 난해성과는 별 상관이 없다고 생각한다. 실험적이고 난해한 형식의 작품에서도 얼마든지 대중과의 소통이 가능하기 때문이다. 오히려 친숙하고 이해하기 쉬운 작품이 역설적으로 소통을 방해할 수도 있다. 실상 대중의 눈높이에 맞춘다는 발상은 어떻게 보면 엘리트적인 시각문화의 산물이다. 대중과의 소통을 고려한다는 명분으로 억지스럽게 대중친화적인 형식의 작품을 위주로 전시한다면, 이는 대중의 예술적 감성을 인위적으로 규정하는 것이고, 예술을 통해 이루어질 수 있는 또 다른 문화적 소통의 가능성을 차단하는 것일 수도 있다.

미술과 소통의 문제는 특히 공공재원으로 운영되는 대규모의 전시를 기획하는 입장에서 보면 곤욕스러운 것이기도 하다. 현대미술에 대한 가장 일반적인 비판 중의 하나가 작품이 난해하고 이로 인해 대중이 현대미술에서 멀어지고 소통이 이루어지지 않는다는 것이다. 이번 바다미술제를 총괄하는 김성호 감독 또한 이러한 비판을 누구보다 잘 인식하고, 이 문제를 어떻게 풀어가야 할지를 전시 준비에서 최종 단계에 이르기까지 고려한 것으로 보인다. 결론적으로 전시감독은 실험적인 작품이 바다미술제의 고유한 성격을 약화시키거나 대중과의 소통을 어렵게 하는 것만은 아니라는 확신을 가졌던 것 같다. 나는 이러한 전시감독의 확신이 《2015바다미술제》에서 대중성을 견인하면서도 미술의 전문성을 보여주는 성과를 거둔 밑바탕이 되었다고 생각한다.

실험적인 형식과 대중의 감상에 따른 소통의 문제를 어떻게 해결할 것인가? 실험과 소통 사이의 '긴장의 미학(asethetics of tension)'을 보여줄 때 이러한 문제가 어느 정도 해결될 수 있을 것이다. 직관적으로 이해할 수 있는 친숙한 형식의 작품에서 실험적이고 난해한 형식의 작품에 이르는 전시의 스펙트럼이 전개된 《2015바다미술제》는 이러한 긴장의 미학을 다양한 방식으로 보여 주고 있다. 이런 점에서 이번 전시는 앞으로 바다미술제의 향방을 가늠하고, 이와 관련된 후속적이고 생산적인 담론을 촉발할 수 있는 계기가 될 것이다.

3. 바다와 미술 – 문화적 내러티브

《2015바다미술제》는 바다와 미술의 향연을 문화적 내러티브로 재구성하고 있는 전시이다. 이는 전시의 주제를 보더라도 뚜렷이 감지된다. '보다 – 바다와 씨앗'이라는 주제는 얼핏 생각하면 이해하기 어렵다. 바다에서 펼쳐지는 미술제이니 만큼 바다가 중점이 되어야 할 터인데 '보다'가 앞서 강조되고, 바다와 씨앗이 부연되어 있다. 왜일까? 전시 서문에서 그 이유에 대해 상세한 설명이 소개되어 있긴 하지만, 내가 생각하기에 결국 바다와 미술의 만남을 문화학적인 관점에서 내러티브해 보겠다는 시도이다.

'보다(see)'는 단순히 시각적 차원이 아니라 인식적이고 문화적인 함의를 지시하는 말이다. 존 버거(John Berger)가 적절하게 언급하고 있듯이, '보다'는 그 자체의 고유한 시각적 특성을 지닌 말이지만, 동시에 '아는 것'과 밀접히 연관된 것이다. '보다'의 중의성은 바다와 씨앗에서 다양한 방식으로 드러난다. 실상 바다와 씨앗은 외연적으로 그리 잘 어울리는 말이 아니다. 씨앗이라 하면 으레 땅을 연상하기 마련이다. 그런데 함축적으로 생각하면, 양자는 의외로 밀접한 내적 연관성을 갖는다. 씨앗이라는 기호로 생명의 근원인 바다를 지시하고 있기 때문이다.

《2015바다미술제》의 소주제인 산포, 발아, 성장 등은 바다의 문화적 가능성과 현실성을 씨앗이라는 기호를 통해 제시하고 있다. 이런 점에서 이번 전시는 단지 바다라는 자연환경을 조형적 관점에서 표현하는데 그치는 것이 아니라 일종의 문화학적 지형도를 그려 내고자 한다. 바다의 조형성을 역사적 맥락에서 흥미로운 방식으로 이끌어 내고, 이벤트와 축제의 분위기를 형성하는 것 또한 이러한 문화학적 지형도를 입체적으로 드러내는데 한 몫을 하고 있다. 조각이나 설치작품뿐만 아니라 일반적인 자연환경 예술제에서 구현하기 쉽지 않은 미디어아트, 미디어파사드 등을 전시의 구성에 포함한 이유도 이러한 문화학적 지형도를 충분히 의식했기 때문일 것이다.

바다와 미술의 만남을 문화적 내러티브로 풀어내는 작업은 그리 간단하지 않다. 자칫 잘못하면 '왜 이것이 미술로 표현되어야 하는가'라는 근본적인 물음에 제대로 된 답을 내놓지 못한 채 문화적 이벤트나 행사 위주의 전시로 끝나는 경우가 많다. 이런 점에서 이번 《2015바다미술제》는 높이 평가할 만하다. 바다와 미술의 결합에서 나올 수 있는 다양한 층위의 문화적 내러티브를 다대포해수욕장을 방문하는 관람객들이 자연스럽게 감지할 수 있는 예술문화의 공간을 창출하고 있기 때문이다.

나가면서

내가 이 글을 쓰면서 특히 주목한 것은 《2015바다미술제》에 나타난 환경미학, 실험과 소통, 문화적 내러티브 등의 요소이다. 이번 바다미술제가 이러한 요소를 합목적인 조형성으로 재현하고 있다는 점에서 다양한 측면에서 의미 있는 평가를 받을 수 있을 것이다. 물론 아쉬운 점도 있는데, 한 예로 스토리텔링이 지나치게 강조된 것이나 너무 많은 이야기를 전달하려고 한 것을 들 수 있을 것이다. 그러나 이런 아쉬운 점은 이번 전시를 통해 이루어진 미학적 성과를 떠올리기만 해도 간단히 뒤로 밀려 나간다.

An Aesthetic Study on the Sea Art Festival 2015

Seong-Hoon LIM(Aesthetics, Art Critic)

Prologue

Nature does not exist in itself. From time immemorial nature has been echoed in human lives in diverse ways. It is a place of imagination as well as a source of art and is thus not in confrontation with culture. Gernot Böhme, a German philosopher and aesthetician, asserts that nature is not an isolated "other" but is a "cultural product" (ein kulturelles produkt). That is, nature is a "socially constituted nature" (sozial konstituierte natur). By and large, I agree with his assertion. It is impossible to represent pure nature especially in terms of art because at the moment nature is represented with art, that nature becomes enculturated. This does not mean that nature has to be unconditionally reduced to culture. As Böhme underlines, the more cultural development accelerates, the more reasons we have to take care of nature. Taking this into account, the Sea Art Festival acts as a forum that offers an opportunity to look back on what nature gives us through art and culture.

The sea, a part of nature, is very special. It is a source of life and an unknown space whose nature has not yet been completely revealed. The sea is majestic yet horrible, violent yet peaceful. The sea is also a place of metamorphosis reacting to unfathomable human emotions with time. I spent many hours at the seashore during my childhood, especially in my middle and high school years. In retrospect, the sea was a playground for my imagination. I also think the Sea Art Festival 2015 to be held from September 19 to October 18 will be a playground of imagination represented with art.

While this year's Sea Art Festival shares traits with other nature-themed art festivals, it does have some notable features. First, the festival demonstrates how environmental aesthetics integrates nature art into public art. Second, the festival sheds light on contemporary art's experimental nature and communication with the general public through 'aesthetics of tension.' Third, the festival conveys cultural narratives of great diversity through a combination of art featuring modelling elements of the sea, aggressively adopting not only sculptures and installation works but also media art and performances. As the essay the artistic director wrote gives a detailed and clear account of the participating artists and their works and includes a site plan, I will not mention them in this brief writing. I will succinctly consider the festival from an aesthetic point of view, highlighting the three features mentioned above.

1. The Sea Art Festival and Environmental Aesthetics

The environment is an overarching theme in contemporary art, particularly contemporary art after the 1960s. 'Environment' here does not merely refer to the physical, natural environment but rather a concept inclusive of social and cultural surroundings that form human lives. Environmental aesthetics discusses aesthetically diverse issues on the environment based on this concept. This study makes an integrated approach to complex, multilayered relations between nature, man, and culture from an aesthetic perspective. Environmental aesthetics can be discussed in association with contemporary art, more specifically land art, nature art, ecological art, and public art.

The reason why I mention environmental art here is because the Sea Art Festival 2015 includes traces of it. Of course, there have been a few exhibitions advocating environmental aesthetics in the past yet those reflecting the integrative property of environmental aesthetics in both a theoretical and practical way are rare. An artistic application of environmental aesthetics is not possible until an interaction between natural and cultural environments is seriously reviewed. In many cases however, any artistic attempt cannot animate its original meaning as it leans toward just one side. A new critical awareness must be raised through comprehensive aesthetic considerations, going beyond the territory of exhibit planning and art criticism, but only a few cases are capable of doing so. On the contrary, the Sea Art Festival 2015 well represents the integrative property of environmental aesthetics that combines nature art and public art.

Environmental aesthetics has been given the extremely difficult task of simultaneously eliciting an environment's specificity and universality. For instance, if Dadaepo Beach's environmental specificity is the only thing emphasized, the cultural impetus universally triggered by art cannot help but become greatly weakened. Alternatively, if environmental specificity is involved to a certain degree, the intrinsic vividness stirred by art will die out. Gargantuan-scale environmental art festivals like the Sea Art Festival face such a dilemma. The problem is we cannot avoid or reveal such a dilemma. As confirmed in the writing below, the Sea Art Festival 2015 makes a foray into settling an artistic aporia between specificity and universality from the perspective of environmental aesthetics.

2. Experimentation and Communication – Aesthetics of Tension

One of the controversial issues in exhibitions like the Sea Art Festival is the matter of communicating with the public since it cannot help but underline art's social and cultural role more than any other art show. Many say that the exhibition should focus on displaying a type of art that is both familiar to the general public and easy to understand. However, whether this assertion is proper or not demands further consideration. I for one think that contemporary art's experimental, abstruse qualities do not really matter in communication as experimental, hard-to-understand works are still able to communicate with the public. Familiar, accessible artworks may paradoxically obstruct communication. The concept of bringing contemporary art down to the public's level is in a sense a product of an elitist visual culture. Obstinately displaying works familiar to the general public mainly in consideration of how to reach out to them may result in artificially defining their artistic sensibilities or may eliminate another possibility of cultural communication that can be achieved through art.

The matter of art and communication is one of the perplexities curators of large-scale exhibitions run with the public funds face. One of the most general critical viewpoints is that contemporary artworks are abstruse and are thus unable to communicate with the public. Artistic Director Sung-Ho Kim who is in charge of all the processes of the festival from its planning to its completion seems to be more aware of this fact than anyone else and has considered how to solve this problem. Consequently, he seems to have confidence that experimental artworks will not undermine the art festival's intrinsic property and will not make it difficult to communicate with the public. I think this conviction has been the foundation of its accomplishments: displaying specialty without losing popularity.

How can we address the issue of communication with the public's sensibility while depending on experimental form? This problem can be solved to some extent by applying 'aesthetics of tension' to experimentation and

communication. The Sea Art Festival 2015, encompassing intuitively comprehensible and familiar works alongside experimental, abstruse works, demonstrates the aesthetics of tension in diverse ways. This exhibition will serve as the momentum to gauge its future direction and trigger a productive follow-up discourse.

3. The Sea and Art – Cultural Narratives

The Sea Art Festival 2015 reconstructs a feast of the sea and art with a cultural narrative, something palpable only in its theme. The exhibit theme, See – Sea & Seed, is hard to understand at first. As the festival is held at the seashore, it has to focus on the sea, but 'see' comes first followed by 'sea' and 'seed.' Why? Kim expounds the reason in his essay, but in my opinion it seems to be an attempt to portray an encounter of the sea with art from a cultural perspective.

'Seeing' has a perceptual, cultural connotation rather than simply denoting some visual dimension. As John Berger pointed out, while 'seeing' has its own intrinsic trait, it is also closely associated with 'knowing.' The ambiguity of 'see' is diversely represented through 'sea' and 'seed.' 'Sea' does not seem to be a word that goes with 'seed' as seeds usually remind us of the land. The two elements actually have a close inner correlation as the symbol of a 'seed' may also refer to the sea as the source of life.

The sub-themes of the festival - scattering, germinating, and growing - present cultural possibilities and the reality of the sea alongside the symbolism of a seed. In this respect, this exhibition is not a mere representation of the natural environment of the sea but is a depiction of a cultural topographical map. In an intriguing way it manages to draw out the sea's modeling quality in a historical context and brings about a festive atmosphere which helps to reveal this cultural topographical map three-dimensionally. Included in the exhibition are not only sculptures and installation works but also media art and media façade that are hard to incarnate in an art festival with natural settings. This is because the director has been fully conscious of such cultural topography.

It is not easy to express an encounter of the sea with art through cultural narratives. If things go wrong, such attempts often end as a cultural event or an ostensibly showy exhibition without giving a definite answer to the underlying question "Why should it be expressed in art?" In this respect we can hold this festival in high regard for creating a space of art and culture where visitors of Dadaepo Beach may naturally sense cultural narratives in diverse layers that derive from a fusion of the sea and art.

Epilogue

What I have paid particular attention to in this article are elements such as environmental aesthetics, communication, and cultural narrative found in the Sea Art Festival 2015. This exhibition may garner meaningful reviews for representing such elements in a purposeful way. While this art event places too much emphasis on conveying too many narratives the aesthetic achievements made through this exhibition make up for this shortcoming.

2015바다미술제 소개

1. 개요

행사명	2015바다미술제
주제	보다 — 바다와 씨앗(See — Sea & Seed)
기간	2015. 9. 19~10. 18(30일간)
장소	다대포해수욕장(부산)
전시감독	김성호(독립큐레이터, 미술평론가, 미학예술학 박사)
출품 작품	16개국 34명(팀) 34점(국내 19, 해외 15)
행사 구성	전시 및 축제 행사
주최	부산광역시, (사)부산비엔날레조직위원회
후원	문화체육관광부, 부산일보사, 국제신문, 부산문화방송, KBS부산방송총국, ㈜KNN, 부산교통공사
협찬	㈜쏘카, ㈜아모레퍼시픽 리리코스, 조광페인트㈜, 두성종이㈜, ㈜하이플랜, ㈜동아연필, 부산광역시 상수도사업본부
미디어 후원	AROUND, 프레임 코리아

2. 주요 특징

–전문 기획자 선정 및 전체 초대작가로 구성
–스토리텔링을 기반으로 한 전시 주제와 공간 연출
–경계를 넘나드는 콜라보레이션 작품들
–야외 미술제에서 보기 힘든 미디어아트, 미디어파사드의 출현
–관객 참여형 예술과 퍼포먼스
–역사를 토대로 한 팩션(faction)으로서의 '상상발굴프로젝트'
–실험미술 + 대중 지향
–다양한 연령층과 신진작가 발굴
–축제 행사 및, 강연, 관객 참여 프로그램

3. 전시 구성

구분	번호	섹션명	출품작
본전시	섹션1	산포하는 씨앗	미디어파사드, 조각, 설치, 퍼포먼스
	섹션2	발아하는 씨앗_상상발굴프로젝트	발굴프로젝트(컨테이너), 미디어아트, 조각, 설치, 퍼포먼스
	섹션3	자라는 씨앗	조각, 설치, 퍼포먼스
	섹션4	자라는 바다	키네틱아트, 조각, 설치, 퍼포먼스
특별전	–	나는 바다	대형 언 설치 피포먼스 이벤트

Introduction of the Sea Art Festival 2015

1. Summary

Event	Sea Art Festival 2015
Theme	See — Sea & Seed
Period	2015. 9. 19 ~ 10. 18 (30days)
Venue	Dadaepo Beach (Busan)
Artistic Director	Sung-Ho KIM (Independent Curator, Art Critic, Ph.D of Aesthetics and Science of Arts)
Artists Artworks	34 artworks of 34 artists(teams) from 16 countries
Program	Exhibition and Festival Events
Host	Busan Metropolitan City, Busan Biennale Organizing Committee
Support	Ministry of Culture, Sports and Tourism, Netherlands Embassy in Seoul, South Korea, Embassy of Canada to Korea, BUSAN TOURISM ASSOCIATION, The Busan Ilbo, The Kookje Daily News, Busan Munhwa Broadcasting Corp., KBS Busan, KNN, Busan Transportation Corporation
Sponsor	AmorePacific Lirikos Co.,Ltd., Doosung Paper Co.,Ltd., ChoKwang paint Co.,Ltd., Hi-plan Co.,Ltd., Dongapen Co.,Ltd.
Media Partner	AROUND, Frame Korea

2. The Key Features

- Selection of Artistic Director and invitation of works by the Artistic Director
- Exhibition theme and space organization based on storytelling
- Works produced in collaboration with other genres
- Display of Media Art and Media Facades rarely found at other outdoor art festivals
- Viewer participatory art and performance
- Imaginary Excavation Project as "faction" based on the history
- Experimental art + orientation to the general public
- A variety of age groups and discovery of rising artists
- Festival events, lectures, and viewer participatory programs

3. Exhibition Contents Organization

Classification	No.	Section Name	Artworks
Main Exhibition	Section 1	Scattering seeds	Media Facade, Scupture Installation, Performance
	Section 2	Germinating Seed- Imaginary Excavation Project	Excavation Project(Container), Media Art, Sculpture, Installation, Performance
	Section 3	Growing Seed	Sculpture, Installation, Performance
	Section 4	Growing Sea	Kinetic Art, Sculpture, Installation, Performance
Special Exhibition	—	Flying Sea	Giant Kites Installation Performance

출품 작가

본전시

섹션	순번	작가	국가
섹션1 산포하는 씨앗	1	마티아 루리니(1985~)	이탈리아
	2	이경호(1967~)	한국
	3	앤디 드완토로(1973~)	인도네시아
	4	신원재(1971~)	한국
	5	오태원(1973~) & 고은(1933~)	한국
	6	김원근(1971~)	한국
	7	노주환(1960~)	한국
	8	이이남(1969~)	한국
섹션2 발아하는씨앗_ 상상발굴 프로젝트	9	도릿 크로시어(1944~)	독일
	10	조덕현(1957~)	한국
	11	**그룹 아키스트** 김등용(1983~), 김나륜(1993~), 유규영(1987~), 이찬민(1981~), 백근영(1985~), 김효영(1991~) 이가윤(1993~), 박성진(1987~), 지영배(1984~), 정철(1991~)	한국
	12	**그룹 세라에너지** 강미라(1987~), 김혜라(1989~), 박종환(1959~), 심희정(1990~), 임혜지(1991~), 정혜주(1983~), 조승연(1991~)	한국
	13	사라웃 추티옹페티(1970~)	태국
	14	최선(1973~)	한국
	15	스테펜 올랜도(1983~)	캐나다
	16	친탄 우파드야이(1972~)	인도
	17	차기율(1961~)	한국
섹션3 자라는 씨앗	18	리그돌 텐징(1982~)	미국
	19	김정민(1982~)	한국
	20	전원길(1960~)	한국
	21	페르난도 알바레즈 페레즈(1975~)	스페인
	22	오노 요코(1933~)	미국
	23	이종균(1971~)	한국
	24	정찬호(1979~)	한국
	25	김영원(1947~)	한국
섹션4 자라는 바다	26	윤영화(1964~)	한국
	27	조셉 타스나디(1960~)	헝가리
	28	손현욱(1982~)	한국
	29	**그룹 VGABS** 앤드류 아나다 부겔(1983~)	미국
		플뢰리퐁텐(갈드릭 플뢰리(1985~) & 앙투안 퐁텐(1985~))	프랑스
		배성미(1971~)	한국
		마리아 사모르체바(1992~)	러시아
	30	코넬 알베르투스 오우웬스 (1958~)	네덜란드
	31	이명호(1975~)	한국
	32	조나단 폴 포어맨(1992~)	영국
	33	루드위카 그라지나 오고르젤렉(1953~)	폴란드

특별전

나는 바다	34	피터 린 카이트 Ltd (1973 설립)	뉴질랜드

Participating Artists

Main Exhibition

Section	No.	Artist	Nation
Section 1. Scattering Seeds	1	Mattia LULLINI(1985~)	Italy
	2	Kyung-Ho LEE(1967~)	Korea
	3	Andy DEWANTORO(1973~)	Indonesia
	4	Won-Jae SHIN(1971~)	Korea
	5	Tae-Won OH(1973) & Ko Un(1933~)	Korea
	6	Won-Geun KIM(1971~)	Korea
	7	Ju-Hwan NOH(1960~)	Korea
	8	Lee-Nam LEE(1969~)	Korea
Section 2. Germinating Seeds_ Imaginary Excavation Project	9	Dorit CROISSIER(1944~)	Germany
	10	Duck-Hyun CHO(1957~)	Korea
	11	**Group Archist** Deung-Yong KIM(1983~), Na-Ryun KIM(1993~), Gyoo-Young YOO(1987~), Chan-Min LEE(1981~), Keun-young BAEK(1985~), Hyo-Young KIM(1991~), Ga-Yun LEE(1993~), Seong-Jin PARK(1987~), Young-Bae JI(1984~), Cheol JEONG(1991~)	Korea
	12	**Group Cera-energy** Mi-Ra GANG(1987~), Hea-Ra KIM(1989~), Jong-Hwan PARK(1959~), Hee-Jung SIM(1990~), Hye-Ji LIM(1991~), Hye-Joo JUNG(1983~), Seung-Yeon JO(1991~)	Korea
	13	Sarawut CHUTIWONGPETI(1970~)	Thailand
	14	Sun CHOI(1973~)	Korea
	15	Stephen ORLANDO(1983~)	Canada
	16	Chintan UPADHYAY(1972~)	India
	17	Ki-Youl CHA(1961~)	Korea
Section 3. Growing Seeds	18	Rigdol TENZING(1982~)	USA
	19	Jung-Min KIM(1982~)	Korea
	20	Won-Gil JEON(1960~)	Korea
	21	Fernando ALVAREZ PEREZ(1975~)	Spain
	22	Yoko ONO(1933~)	USA
	23	Jong-Kyun LEE(1971~)	Korea
	24	Chan-Ho JEONG(1979~)	Korea
	25	Young-Won KIM (1947~)	Korea
Section 4. Growing Sea	26	Young-Hwa YOON(1964~)	Korea
	27	Joseph TASNADI(1960~)	Hungary
	28	Hyun-Wook SON(1982~)	Korea
	29	**Group VGABS** Andrew Ananda VOOGEL(1983~) Feuryfontaine (Galdric FLEURY(1985~)& (Antoine FONTAINE(1985~) Sung-Mi BAE(1971~) Maria SAMORTSEVA(1992~)	USA France Korea Russia
	30	Cornelis Albertus OUWENS(1958~)	Netherlands
	31	Myoung-Ho LEE(1975~)	Korea
	32	Jonathan Paul FOREMAN(1992~)	U.K
	33	Ludwika Grazyna OGORZELEC(1953~)	Poland

Special Exhibition

Flying Sea	34	Peter LYNN Kites Ltd (Since 1973)	New zealand

작품 배치도

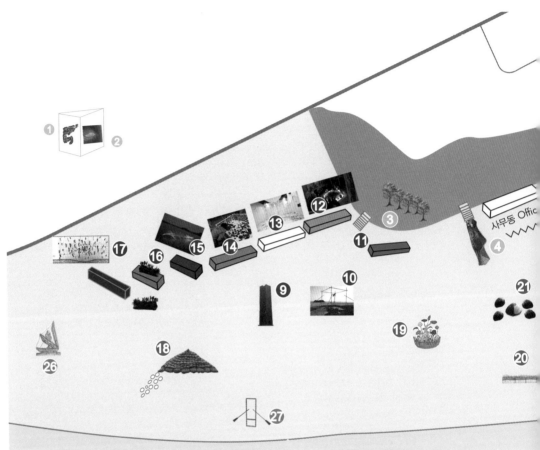

Map of the Artworks Site

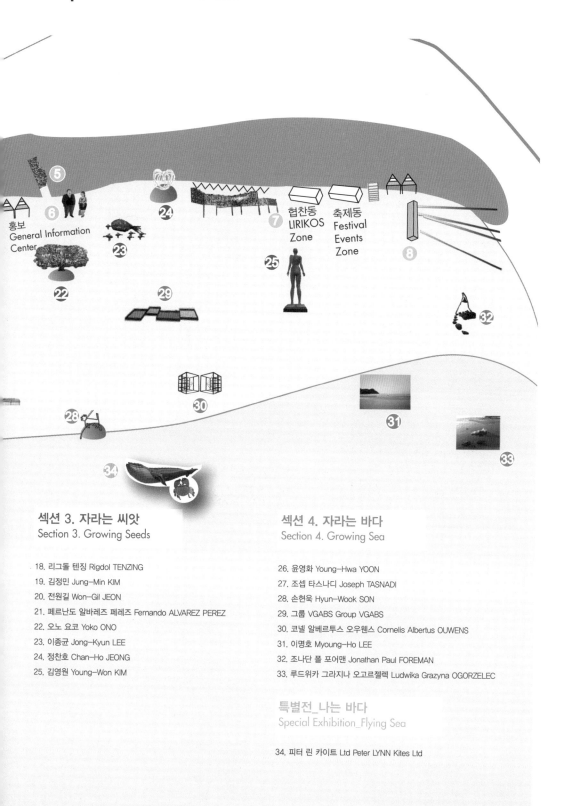

홍보
General Information
Center

협찬동
LIRIKOS
Zone

축제동
Festival
Events
Zone

섹션 3. 자라는 씨앗
Section 3. Growing Seeds

18. 리그돌 텐징 Rigdol TENZING
19. 김정민 Jung–Min KIM
20. 전원길 Won–Gil JEON
21. 페르난도 알바레즈 페레즈 Fernando ALVAREZ PEREZ
22. 오노 요코 Yoko ONO
23. 이종균 Jong–Kyun LEE
24. 정찬호 Chan–Ho JEONG
25. 김영원 Young–Won KIM

섹션 4. 자라는 바다
Section 4. Growing Sea

26. 윤영화 Young–Hwa YOON
27. 조셉 타스나디 Joseph TASNADI
28. 손현욱 Hyun–Wook SON
29. 그룹 VGABS Group VGABS
30. 코넬 알베르투스 오우웬스 Cornelis Albertus OUWENS
31. 이명호 Myoung–Ho LEE
32. 조나단 폴 포어맨 Jonathan Paul FOREMAN
33. 루드위카 그라지나 오고르젤렉 Ludwika Grazyna OGORZELEC

특별전_나는 바다
Special Exhibition_Flying Sea

34. 피터 린 카이트 Ltd Peter LYNN Kites Ltd

본전시 개요

주제: 보다 — 바다와 씨앗
구성: 4섹션
작가: 16개국 33인(팀) —국내 19, 해외 14
일정: 2015. 9. 19~10. 18
장소: 다대포해수욕장

본전시는 전시감독으로부터 초대된 국내 · 외 33인의 참여 작가들이 만드는 작품들로 구성된다.
본전시는 공간에서 펼쳐지는 하나의 스토리텔링을 따라 전개된다. 어디선가 씨앗들이 날아와 자리를 잡고 발아하여 식물로
자라는 일련의 '자연 성장'의 내러티브가 그것이다.
아래의 도표에서 보듯이 '1)산포하는 씨앗 → 2)발아하는 씨앗 → 3)자라는 씨앗 → 4)자라는 바다'는 이러한 '자연 성장'의
내러티브를 가시화한다.

섹션 번호	섹션명	출품작 유형
1	산포하는 씨앗	미디어 파사드, 조각, 설치, 퍼포먼스
2	발아하는 씨앗_ 상상발굴프로젝트	발굴프로젝트(컨테이너), 미디어아트, 조각, 설치, 퍼포먼스
3	자라는 씨앗	조각, 설치, 퍼포먼스
4	자라는 바다	키네틱아트, 조각, 설치, 퍼포먼스

Main Exhibition outline

Theme: See — Sea & Seed
Composition : 4 sections
Artist: 16 countries 33 artists (team) - Korean 19, Overseas 14
When: 19th Sept. ~ 18th Oct. 2015
Where: Dadaepo Beach

The Main exhibition consists of the works of the 33 international artists invited by Artistic Director.
This main exhibition spread out in accordance with a narrative. The narrative is about "natural growth"
: seeds flew from somewhere to settle, germinate, and grow into plants.
As seen in the table below, the sections of the exhibition are 1) Scattering Seeds, 2) Germinating Seeds,
3) Growing Seeds, and 4) Growing Sea. These Sections Visualize the narrative of 'natural growth'

No	Section name	Artwork
1	Scattering Seeds	Media facade, Sculpture, Installation, Performance
2	Germinating Seeds_ Imaginary Excavation Project	Excavation Project (Container), Media Art, Sculpture, Installation, Performance
3	Growing Seeds	Sculpture, Installation, Performance
4	Growing Sea	Kinetic Art, Sculpture, Installation, Performance

Section 1

산포하는 씨앗
Scattering Seeds

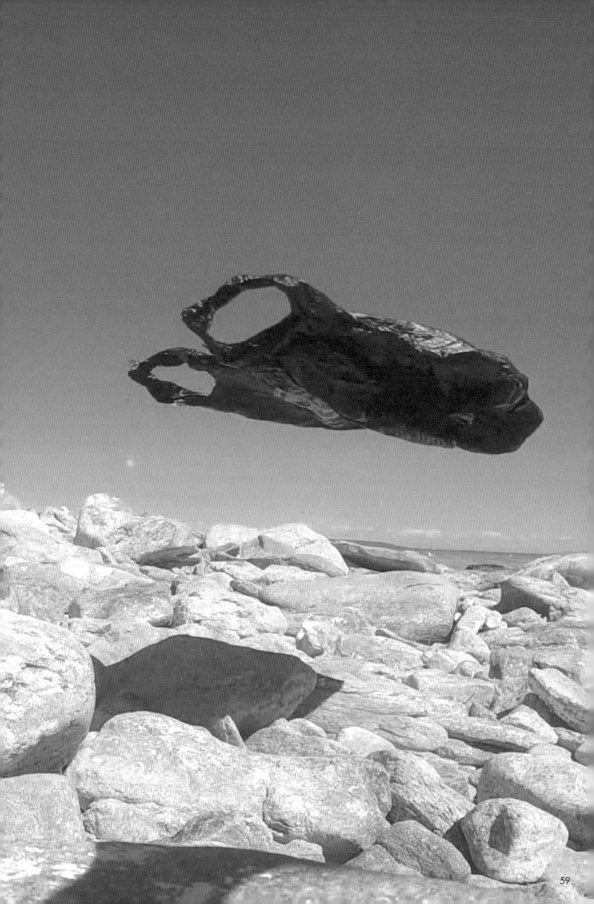

마티아 루리니 Mattia LULLINI
이탈리아 Italy

1985년 이탈리아, 볼로냐 출생. 현, 스웨덴 예테보리 거주 및 활동
Born in 1985, Bologna, Italy. Lives in and works in Gothenburg, Sweden

파도
Surf

바다로 둘러싸인 곳에 있을 때는 많은 것들을 볼 수 없다. 지극히 제한적인 것들만이 뚜렷하게 시야에 들어올 뿐이다. 볼 수 있는 몇 가지 이미지들 조차도 한 때 변하지 않는 것으로 여겨졌지만, 색채와 형태가 흐려지며 서로 간에 요동치듯 스며든다. 바다와 연관된 감정이 본질적으로 독특하며 지속적이듯 바다는 그 자체로 하나의 세계이다. 그러나 우리가 바다 한 가운데 있을 때 놀랍게도 보다 심오하고 다양한 본질을 느낄 수 있다. 무언가 오묘한 느낌이 우리의 감정을 지배하며, 우리는 오직 육체를 통해 이것을 느낄 뿐이다. 마티아 룰리니의 작품 〈파도〉는 바로 이러한 순간을 주제로 다루고 있다.

'파도'는 형이상학적인 영역으로서의 물의 세계를 시각적으로 재현해 낸다. 파도와 사유에 의해 감정을 일으키는 마음 속 중성적이고 추상적인 공간에서는 꿈의 형상을 얻게 된다. 바다에 존재하는 것은 궁극적으로 느낌 그 자체로서 올 수 있는 것이며, 파도는 유동적인 사유를 나르는 바다의 언어로서 마치 바닷속 깊은 곳으로부터 온 씨앗인 것처럼 바다를 만들어 나간다. 다채로운 물의 세계는 다른 언어로 우리의 내면에 말을 건다. 수면 아래에는 깊은 물들이 살아 움직이며 수면 위에는 오로지 파도만이 넘실거리고 있다.

When surrounded by water one can't see very much. Very few things clearly appear, the shape and forms around fluidly melt into each other shading the colors and the forms once reckoned as immutable. The sea is already a world of its own as the feelings we connect to it have a unique nature and consistence, but, when its waters are the element surrounding us, an even more deep and diverse nature can surprise us. An ethereal sensation can take control and make impossible to keep one's feelings to pass from the physical to the spiritual and that very moment is the subject of Mattia Lullini's artwork.

'Surf' is, in fact, a visual representation of the aquatic world as a metaphysical realm. A neutral and abstract space of mind where feelings are driven by currents and thoughts gain the shape of dreams. Being in the sea could be seen eventually as a feeling itself and the waves as its words carrying the fluid thoughts it generates as seeds from its depths. A colorful and liquid world which speaks another language to our inner-selves where the deep waters underneath are alive and above there is only surf.

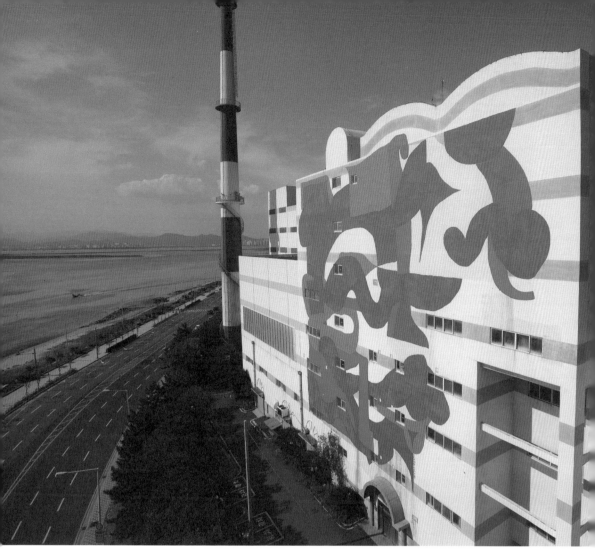

〈파도〉, 2015, 벽화, 34.1×26.5 m,
'Surf', 2015, Mural Painting, 34.1×26.5 m

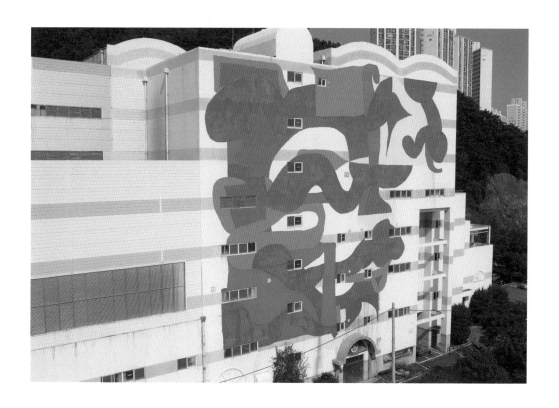

이경호 Kyung-Ho LEE
한국 Korea

1967년 한국 김천 출생. 현, 한국 서울 거주 및 활동
Born in 1967, Gimcheon, Korea. Lives in and works in Seoul, Korea

'생명의 씨앗' 어떻게 하실래요? 미래를 향한 일기…
Seeds of life: How would you like? A diary for the future...

청정… 물과 생명, 욕심의 과잉, 화석 연료, 100년, 방사능… 불안… 기후 변화, 식량 부족, 해수면 상승, 인구 증가, 난민, 바닷가… 씨앗의 미래, 우리 아이들의 미래를 바다를 통해 보여 주기! 발아하는 씨앗과 산포하는 모든 것들, 날아다니는 모든 것. 불, 물, 분출하는 화산… 먼지… 산성비… 20세기와 21세기의 이미지 과잉(인터넷 음란물 폭력물)의 산포. 산포하고 발아하고 자라고… 책임지는 미래, 불, 물, 흙, 바람, 바다, 생물, 냄새… 변이… 지켜 줘야 할 것들… 꼭 있어야 할 것들… 당연한 시간. 바다를 보는 것은 과거를 안은 미래를 보는 것이다.
"좋은 씨앗을 뿌리는 자는 사람의 아들이니라." (마태)

The purity; water and life; the plethora of desire, fossil fuel, one hundred years; anxiety; climate change, food shortages, rising sea levels, population growth, refugees, the seashore; the future of seeds; showing the future of our children through the sea! Sprouting seeds, all dispersed, all flying; fire, water, erupting volcanoes; dust; acid rain; superfluous images (obscene material and violent things) in the 20th and 21st century.
Dispersing, germinating, and growing; the future for which we take responsibility; fire, water, earth, wind, sea, organisms; smell; modification; things we have to keep; must-have things; due time. Seeing the sea is seeing the future embracing the past.
"The one who sowed the good seed is the Son of Man." (Matthew)

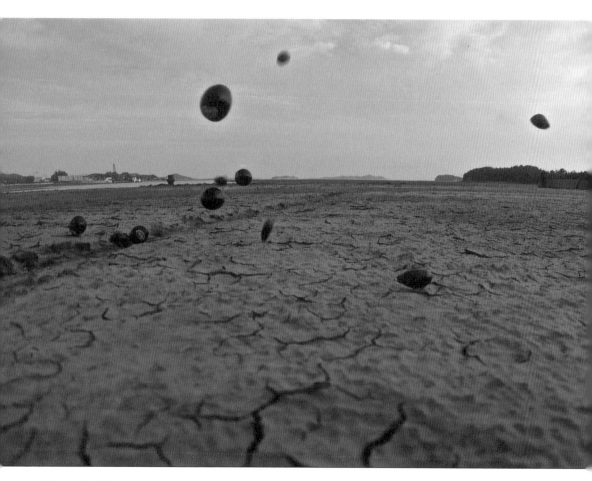

⟨'생명의 씨앗' 어떻게 하실래요? 미래를 향한 일기…⟩, 2015, 미디어 파사드, 싱글 채널 비디오, 가변 크기
"Seeds of Life" How would you like? A Diary for the Future…, 2015, Media Façade, Single Channel Video, Variable Dimension

비디오 스틸
〈'생명의 씨앗' 어떻게 하실래요? 미래를 향한 일기…〉, 2015, 미디어 파사드, 싱글 채널 비디오, 가변 크기
Video Stills
"Seeds of Life" How would you like? A Diary for the Future…, 2015, Media Façade, Single Channel Video, Variable Dimension

앤디 드완토로 Andy DEWANTORO

인도네시아 Indonesia

1973년 인도네시아 탄중 카랑 출생. 현, 인도네시아 거주 및 활동
Born in 1973, Tanjung Karang, Indonesia. Lives in and works in Indonesia

100명의 사람들
One Hundred Peolple

자연, 혹은 자연적 상황에서 나무는 인간의 삶에 매우 중요한 요소이다. 나무는 우리의 생명을 보호하듯 우리의 대지를 지켜줄 것이다. 근래에 우리 주변에서 많은 자연재해가 일어나고 있는데 이는 대부분 자연 파괴에 기인한 것이다. 자연은 오직 이윤에만 관심이 있는 무책임한 사람들에 의해 파괴되고 있는데 이들은 자연 파괴가 자신들의 생명뿐만 아니라 자신의 자녀들의 생명까지도 위험에 빠뜨릴 수 있음을 간과하고 있다. 나는 이 설치 작품을 통해 나무들이 우리의 대지를 안전하게 지켜 주듯, 나무를 보존하는 것이 곧 우리의 생명을 지키는 길임을 상기시키고자 한다.

Nature, or in this case Trees is very important for human's life. They will protect our earth as it will protect our lives. As we can see these days, there are a lot of nature disasters happening around us that are mostly caused by the destruction of the nature. These destructions are done by irresponsible people who only care about profit without realizing that it could endanger not only their children's life but also their lives, too. So, this installation aimed to remind people that if we protect the trees then it means we also protect human's life, as those trees could safe our mother earth from harm.

〈100명의 사람들〉, 2015, 혼합 재료, 가변 크기, 관객 참여형 작품
'One Hundred People', 2015, Mixed Media, Variable Dimension, Viewer Participation

〈100명의 사람들〉, 2015, 혼합 재료, 가변 크기, 관객 참여형 작품
'One Hundred People', 2015, Mixed Media, Variable Dimension, Viewer Participation

신원재 Won-Jae SHIN
한국 Korea

1971년 한국 서울 출생. 현, 한국 경기도 거주 및 활동
Born in 1971, Seoul, Korea. Lives in and works in Gyeonggi-do, Korea

환상
Illusion

일정한 형태를 반복 혹은 왜곡함으로써 바다의 물결을 표현한 작품이다. 조형적인 덩어리와 빛이 어우러진 채 바다를 향해 꿈틀대는 형상성을 표현한 작품이다. 터널 구조의 작품에서 관람객들이 작품의 내,외부를 느낄 수 있도록 한, 관객과의 호흡을 중시한 작품이다.

This work is a representation of waves in the sea as seen through the repetition or distortion of certain forms. A mass inside one form mingles with light while wriggling toward the sea. This work stresses an interaction with viewers both inside and outside its tunnel structure.

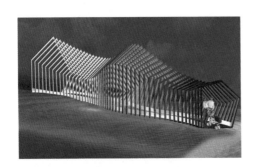

〈환상〉, 2015, 1톤 철, 나무, 혼합재료, 3.2×7.5×3.2m
'Illusion', 2015, 1ton Steel, Wood, Mixed Media, 3.2×7.5×3.2m

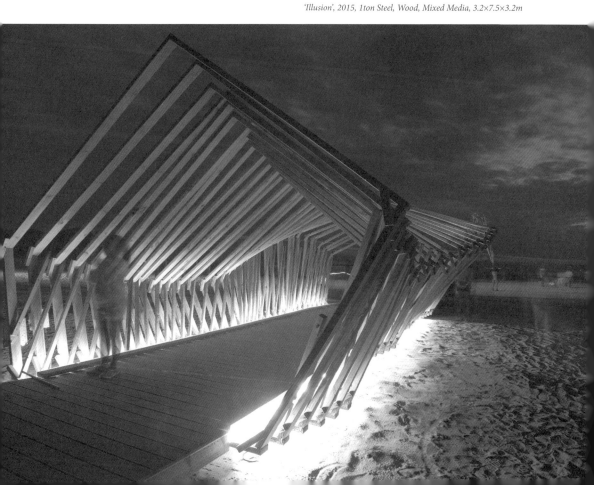

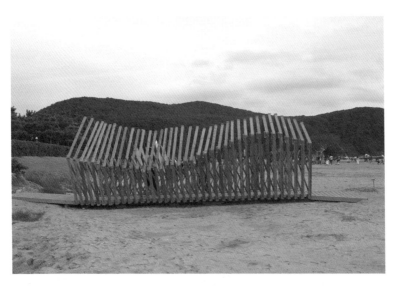

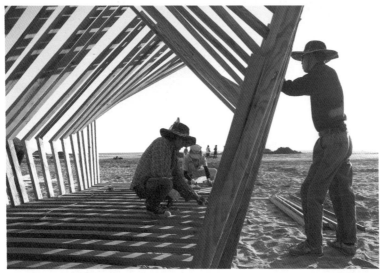

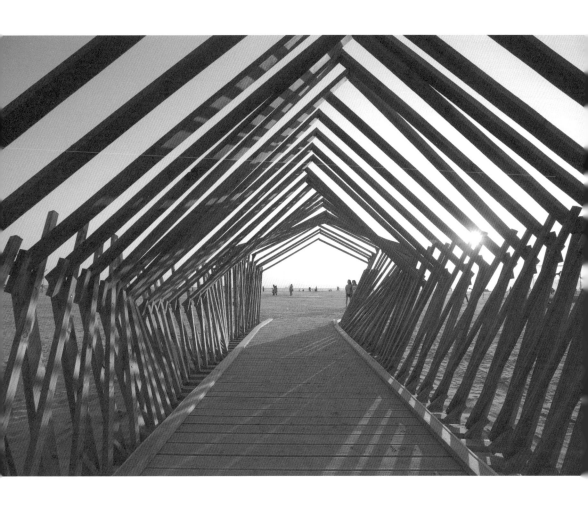

오태원 Tae-Won OH

한국 Korea

1973년 한국 여수 출생, 현, 한국 서울 거주 및 활동
Born in 1973, Yeosu, Korea
Lives in and works in Seoul, Korea

고은 Ko Un

한국 Korea

1933년 한국 군산 출생, 현, 한국 수원 거주 및 활동
Born in 1933, Gunsan, Korea.
Lives in and works in Suwon, Korea

천 개의 빛, 천 개의 물방울
A Thousands Light, Thousands of Water Droplets

〈천 개의 빛, 천 개의 물방울〉은 물과 빛이 하나가 되는 순간, 낮과 밤이 공존하는 일시적인 찰나를 표현한다. 18m에 이르는 터널 입구로 들어가면 은은한 별빛 같은 무수한 물방울이 머리 위로 쏟아져 내리는 듯한 공간을 만날 수 있다.

이 공간을 위해서, 나는 이집트 화이트사막 여행 중, 어둠이 내리는 밤하늘을 바라보고 누웠을 때, 눈앞까지 쏟아지는 듯한 별빛들을 보고 느꼈던 그 감성을 재현해 보고자 했다. 이집트 신화에서 하늘의 여신 누트의 몸에는 별들이 아로새겨져 있는데, 매일 저녁 태양을 삼켰다가 새벽에 다시 토해 내기 때문에 낮과 밤이 생긴다고 상상했다. 이집트 화이트사막이 그러한 낮과 밤이 공존하는 시공간일 것이라는 생각을 했던 순간이었다.

빛은 자연과 인간을 함께 공존할 수 있게 해 주는 중요한 요소이다. 낮과 밤이 공존하는 이 공간에서 우리는 낮에는 자연광을 통해 별을 은유하는 물방울을 볼 수 있으며, 밤에는 LED조명으로 어두운 배경에서 군데군데 빛나는 빛들을 머금은 물방울들을 더욱 선명하게 볼 수 있다. 이 곳은 낮과 밤이 공존하는 공간이다. 18m의 긴 터널을 지나가는 동안, 천 개의 물방울과 다양한 빛의 조화로 탄생된 몽환적인 공간 속에서 다채로운 신비로움을 경험하게 된다. 이 작품은 2015바다미술제의 서막을 열어 주는 통로이며, 시인 고은 선생님의 현시대를 사유하는 문학적 단상의 동사형 시어 100개를 물방울 조명 아래 아크릴 거울에서 찾아볼 수 있다.

'A Thousand Lights, A Thousand Droplets' alludes to the moment when water and light become one and day and night coexist. Stepping into a tunnel measuring eighteen meters long, one comes across a space where a myriad of water droplets seem likely to pour down like the subtle lights of stars.

This space is a representation of the fantastic feelings I had at the White Desert in Egyptas I was gazing at the starlight that seemed likely to pour down before me. I felt overpowered with these emotions during my road trip to the desert as I was laying down one evening, looking up at the night sky. In Egyptian mythology Nut was the goddess of the sky whose body was covered with stars. Ancient Egyptians believed that day and night resulted from the goddess's act of devouring the sun every night and spewing it up at dawn. During my travels I thought that the White Desert was a space-time where day and night coexisted.

Light is an overarching factor that enables humans to coexist with nature. In this space during the day, one can see dropletssymbolizing stars in the natural light. At night, however, they seem to reflect bright lights here and there, appearing more vivid against the gloomy backdrop thanks to the use of LED lights. This place is a space where day coexists with night. While passing through a 18-meter long tunnel, one can experience various wonders in this hypnotic space where harmony has been created between a thousand water drops and a multitude of lights. This work is a prelude to the Sea Art Festival 2015. 100 verbal type poetries representing poet Ko Un's literary thoughts on the present age can be found in the acrylic mirror under the water drop lighting.

〈천 개의 빛, 천 개의 물방울〉, 2015, 조명등, 1EA (20×20×30cm)
: 1,000EA, LED, 폴리에틸렌, 혼합 재료, 300×400×1800cm
'Thousands of Light, Thousands of Water Droplets', 2015, Lighting, 1EA (20×20×30cm)
: 1,000EA, LED, polyethylene, Mixed Media, 300×400×1800cm

오태원 작가와 고은 시인의 콜라보 작업에 소개된 동사형 시어

꽃 피어나리라 / 너훌너훌 춤추어라 / 함부로 누구를 사랑하지 말아라 / 네 뜻이 세상 뜻이라 / 진리를 깨달을 지어다 /

가슴 앓고 가슴으로 사랑하여라 / 네 탓이라 하지 말라 / 바다여 사랑하지 말라 / 내가 아닌 무한이어라 / 새로운 니르바냐야 /

4대강이 웃는 것 보고 싶어라 / 철없는 자율이로다 / 예술도 미래도 무엇 아니다 / 우주를 우러르라 /

빈 수평선은 거짓이다 / 아침 이슬을 믿는다 / 언어란 침묵의 쓰레기인가 / 함부로 기쁘지 않으리라 / 꿈에 참여하라 /

달빛의 처음을 띄워 주리라 / 정상의 절정을 꿈꾸지 말라 / 그러므로 불가사의여라 / 이제 그대 눈감아라 /

숨차지 마라 / 마음껏 장엄하여라 / 너희들의 백년을 살아라 / 나를 모르리라 / 김소월의 청춘을 믿어라 /

바람에 자비를 청하지 마라 / 너희들의 미래이거라 / 기다리는 모습을 두고 온 네 모습이러라 / 뉘우치듯 깨닫는 것이다 /

순간의 은유는 순간이다 / 내면을 버려라 / 낮추고 낮추어라 / 그런 사랑하고 싶어라 / 두근대는 가슴까지 빠져들어라 /

망상하고 놀다 일어나거라 / 태어나서 죽는 것 감사하리라 / 내 운명을 믿어라 / 가슴속에 잔물결 미소를 담자 /

어서 속히 일어나라 / 네가 오직 드높아라 / 너는 네 사랑하는 모습이어라 / 너는 네 진리여라 / 비로소 웃자 /

아름다움 네 일이어라 / 모든 것 읊어 시름하여라 / 어리수굿 살아가거라 / 입다물고 멈춰 서 있어라 / 슬픔 하나 없이 지리라 /

내일이라는 이름이 떠나간다 / 꽃의 날이라 / 기다리는 사람의 눈에 별 있어라 / 좀 더 가벼워야 하리 /

마치 잔칫날처럼 / 울어야 할 때가 오리라 / 기죽지 말아라 / 고요가 그러하리라 / 세상마다 떠나니거라 / 눈물 나리라 /

짙푸르게 울어라 / 메아리를 들어 보아라 / 죽어서 밤이 되리라 / 어제의 노래는 어제가 아니다 / 내 현재를 확장하라 /

화합하라. / 진리는 살아 머무르리라 / 진리를 꾸미는 자 그것을 알리라 / 해탈을 얻으리라 /

삶이 있으면 죽음이 있노라 / 니르바나에 들 때이니라 / 모든 것은 흐르노라 / 나는 돌아오리라 /

별을 비춰 주는 이 있으리라 / 넓고 의연하여라 / 새 세상이 되게 하리라 /

비를 이루어 비 내리는 밤이리라 / 문득 성숙하리라 / 너 하고자 하는 바를 하라 / 스스로 노래이리라 / 그리운 것을 그리워하라 /

지붕을 낮추어라 / 훤히훤히 밝히리라 / 흰 구름으로 떠다니어라 / 흰나비야 뒤따르라 /

눈 감은 다음 보아라 / 서투른 사랑이어라 / 한층 더 넓어지리라 / 왔다 돌아가리라 / 진실로 말하리라 /

바닷바람 불러 보아라 / 파도 소리로 말하리라 / 흙을 이루리라 / 깊은 샘 푸르러라 /

진리는 살아 머무르리라 / 그런 하늘이 있듯 사랑이 있어야한다 /

평화로 덮여 가노라 / 여기서부터 희망이다 / 가로되 사랑이더라 / 미완이다 /

솜구름 널린 하늘이더라 / 한 방울의 물이 꿈꾼다 / 바람 불더라 /

위의 시어는 아래의 시집에서 발췌되었습니다.

1. 고은 전집

제 2권 ~ 7권 (시1~시6)

제 8권 ~ 10권 (시7~시9, 백두산1~7)

제 11권 ~ 15권 (시10~시14, 만인보1~9)

제 20권 (산문5)

제 23권 (자전1)

고은 지음, 김영사, 2002

(고은 전집 총 38권 중에서)

2. 고은 단편시집

마치 잔칫날처럼	창작과 비평사, 2012	오늘도 걷는다	신원문화사, 2009
허공	창작과 비평사, 2008	산천을 닮은 사람들	효형출판, 1998
두고 온 시	창작과 비평사, 2002	네 눈동자	창작과 비평사, 1988
무제 시편(109)	창작과 비평사, 2013	그냥 놔두라	화남출판사, 2008
머나먼 길	문학사상사, 1999	나의 파도소리	답게, 2007
새벽길	창작과 비평사, 1978	나는 격류였다	서울대학교출판문화원, 2010
전원 시편	믿음사, 2007	바다 꽃이 피었습니다	고은, 하세기와 류세이 지음, 한성례 옮김, 해성출판, 2013
내 변방은 어디 갔나	창작과 비평사, 2011		
상화 시편	창작과 비평사, 2011	부끄러움 가득	시학, 2006
내일의 노래	창작과 비평사, 2014	시이 황홀	고은, 김형수 (엮음)지음, 알에이치코리아, 2014
개념의 숲	신원문화사, 2009		
어느 바람	창작과 비평사, 2002		

김원근 Won-Geun KIM
한국 Korea

1971년 한국 보은 출생. 현, 한국 양평 거주 및 활동
Born in 1971, Boeun, Korea. Lives in and works in Yangpyeong, Korea

손님
Guest

작품 속 주인공은 어느 여름날 우리 집으로 찾아온 낯선 손님이다. 손님이 다녀간 후 부모님은 다투셨다. 어린 시절 부모님의 다툼의 이유보다 손님이 가져온 선물 꾸러미가 더욱 궁금했다. 나는 누구나 경험했던 유년 시절의 어떤 날을 드라마 속 한 장면처럼 관람객들에게 제시한다. 부모님의 다투신 이유를 관람객 각자의 경험에서 찾아보길 기대하면서 상상으로 웃어 보고자 한다.

The main character in my work is a guest who called of my home on a summer day. My parents quarreled after his visit. I wondered more about what the guest had bought as a gift than why my parents were in conflict. I present one day of my childhood to viewers as a dramatic scene. I'd like to reflect why my parents quarreled through each viewer's experience and reaction and represent it in an imaginary manner.

〈손님〉 2015, 철, 특수 시멘트, 외부 수성 페인트, 3.5×1.5×1.5m(남자), 3.5×1.5×1.5×m (여자)
'Guest' 2015, Iron, special cement, water-based paint outside, 3.5×1.5×1.5m(Man), 3.5×1.5×1.5m(Woman)

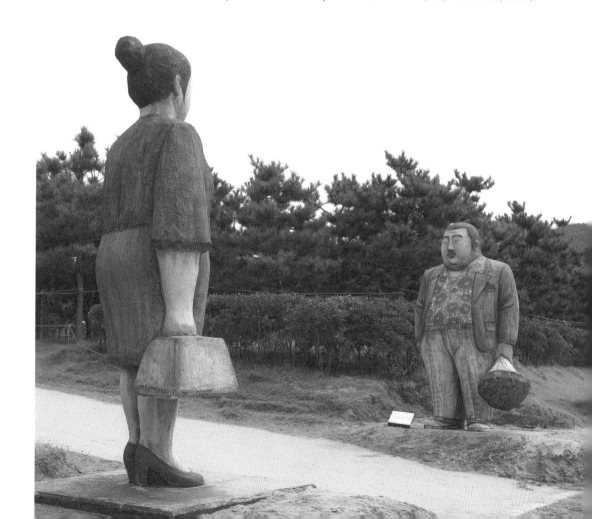

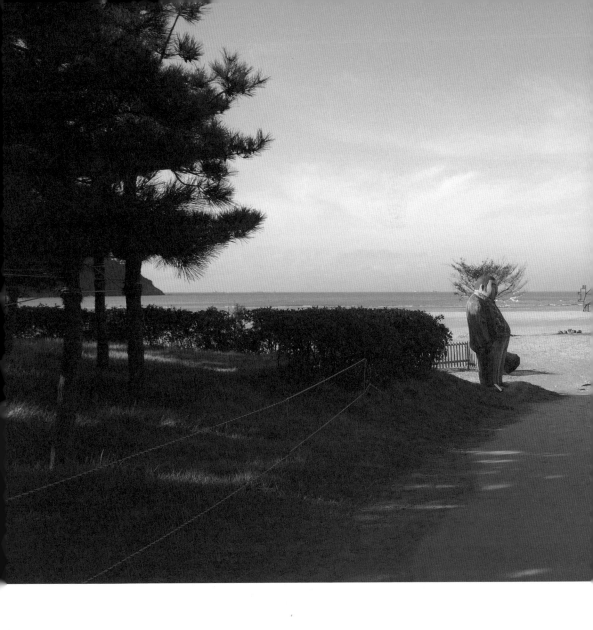

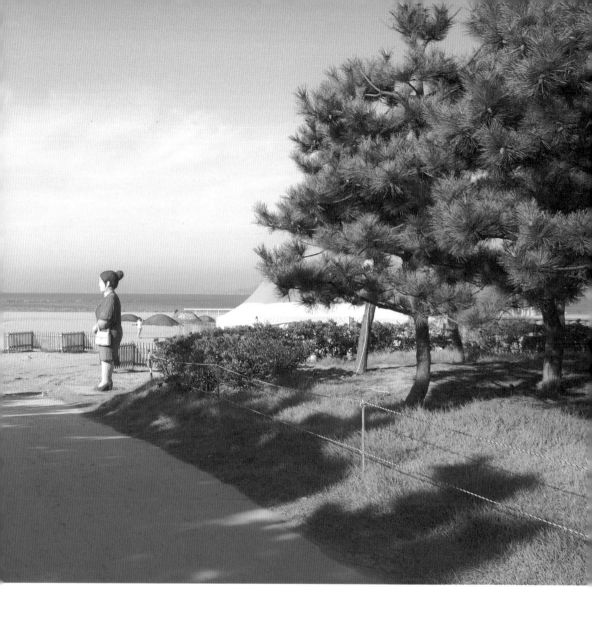

노주환 Ju-Hwan NOH
한국 Korea

1960년 한국 나주 출생. 현, 한국 서울 거주 및 활동
Born in 1960, Naju, Korea. Lives in and works in Seoul, Korea

사랑해요_천 개의 꿈
Love_1000 Dreams

어린이들이 자신의 꿈과 소원을 적어서 만든 천 개의 바람개비들을 모아서 부산의 다대포해변에 갈매기 형상의 바람벽 구조물을 만들고 그 위에 하나씩 부착하여 바람에 자유롭게 돌아가며 서로의 아름다운 꿈들을 바람에 실어 보내도록 표현하였다. 바람벽 한 켠에 '사랑해요'라는 글씨를 LED조명의 밝은 빛으로 형상화하고 여기저기서 LED조명이 점멸하여 반짝이게 하여 행복한 어린이들의 미래를 비추어 주고, 그들이 적은 꿈과 소원들을 LED전광판에 글자로 디스플레이를 하여 어른들에게 이야기할 수 있도록 만들었다. 부모님과 어른들이 어린이들에게 해 주어야 하는 최고의 배려와 보살핌을 '사랑해요'라는 말로 비추어 주고 어린이들이 만든 천 개의 바람개비들로 그들이 바라는 꿈과 소원들이 이루어질 수 있도록 자유롭게 반짝이면서 움직이는 갈매기의 바람벽으로 표현하였으며 그 바람개비 날개 아래로 걸어 다니며 즐길 수 있도록 설치하였다.

On the Daedaepo beach in Busan I set up a seagull-shaped wind-wall structure made of 1,000 pinwheels on which children wrote down their dreams and wishes. The pinwheels, each added to the structure one by one, spin in the wind, dispersing their beautiful dreams in the breeze. The words "사랑해요" (I love you) are displayed on a corner of the wall using bright LED lights, reflecting the future of happy children as they flicker on and off. The dreams and wishes they wrote are displayed to adults via an LED electronic display board. This work represents adults' care and regard for children through the reflection of the words "사랑해요" (I love you). A freely flying wind wall that children can enjoy as they pass underneath was made to express the achievement of their dreams and wishes.

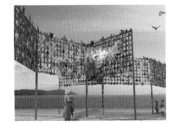
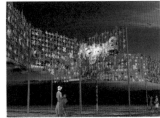

〈사랑해요_천 개의 꿈〉, 2015, LED, 철, 나무, 혼합 재료, 30×10×3.5m
'Love_1000 Dreams', 2015, LED, Iron, Wood, Mixed Media, 30×10×3.5m

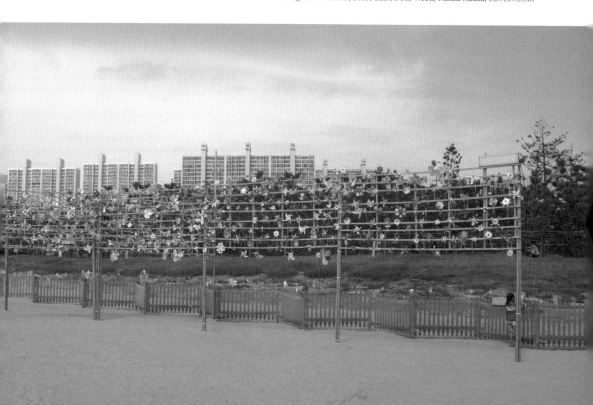

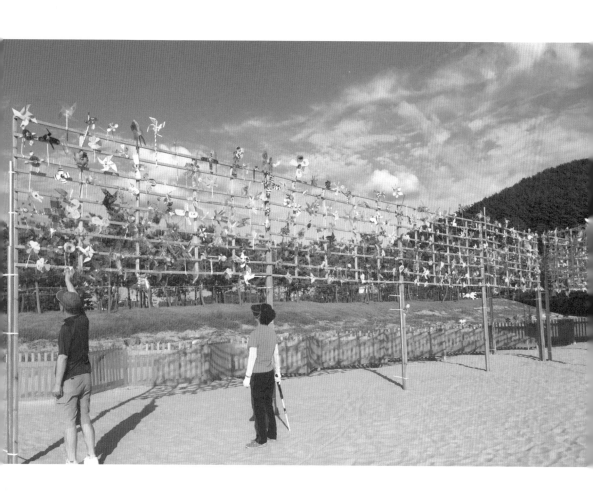

이이남 Lee-Nam LEE

한국 Korea

1969년 한국 담양 출생. 현. 한국 광주 거주 및 활동
Born in 1969, Damyang, Korea. Lives in and works in Gwangju, Korea

빛의 움직임으로
With the Movement of Light

빛의 움직임을 통해 깊은 어둠 속에 잠긴 밤을 깨운다. 레이저를 통해 표출되는 다양한 기하학적 문양과 패턴들로 몽환적인 이미지를 연출한다. 바다와 씨앗을 주제로 하는 이번 전시에 모래사장과 숲에 투영되는 레이저 빛을 통해 시공간을 초월한 새로운 형태의 아트 쇼를 선보이려 한다. 기하학적 무늬는 씨앗이 되어 바다 건너 숲에 흩뿌려지듯 구현될 것이다. 어두운 밤, 2015바다미술제를 찾는 관람객에게 반짝거리는 빛의 향연을 선물할 것이다.

A night submerged in darkness is awoken by the movement of lights. A rich variety of geometric designs and patterns depicted with lasers create a dreamlike atmosphere. At this art festival I'd like to showcase an art show in a new way using lasers that are reflected onto the sandy beach and the forest around the themes of the sea and seeds. The geometric patterns turn into seeds and scatter over the forest across the sea. This work will offer a festival of lights to visitors of the Sea Art Festival 2015.

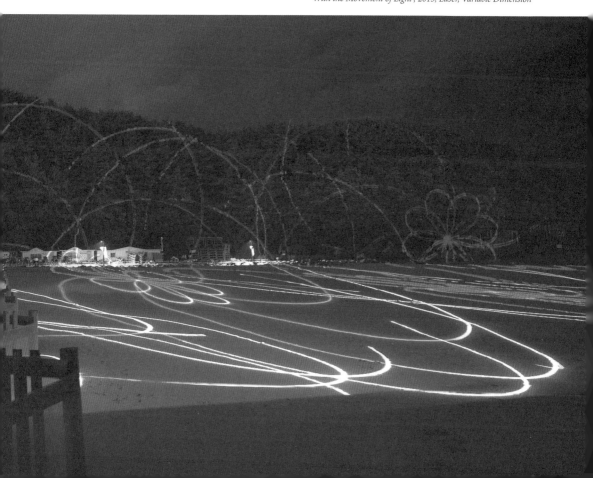

〈빛의 움직임으로〉, 2015, 레이저, 가변 크기
'With the Movement of Light', 2015, Laser, Variable Dimension

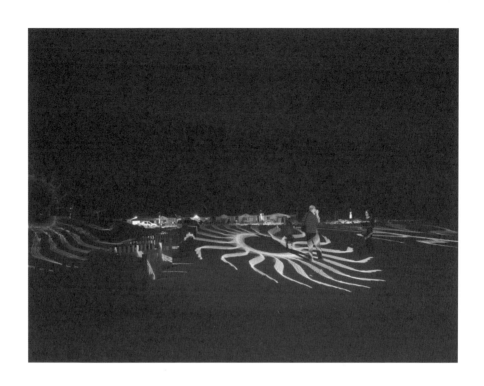

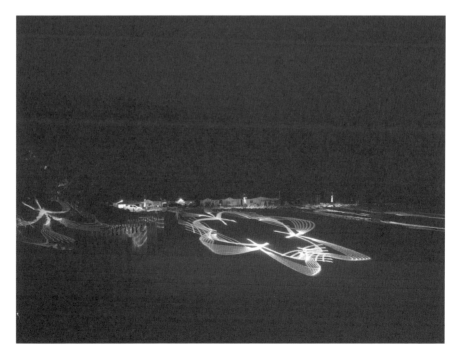

Section 2

발아하는 씨앗_상상발굴프로젝트
Germinating Seeds_Imaginary Excavation Project

도릿 크로시어 Dorit CROISSIER

독일 Germany

1944년 벨치히, 브란덴부라크 출생. 현, 독일 거주 및 활동
Born in 1944, Belzig, Brandenburg, Germany. Lives in and works in Germany

대지의 탑
Earth Tower

벽돌 공장 인근에서 작업함으로써 조형 작업을 위한 새로운 도전의 기회를 얻을 수 있었다고 생각한다. 벽돌의 특수한 물질성이나 건축적 구조 등 벽돌의 생산과 관련해 무엇을 배울 수 있었는가? 처음 작업을 시작했을 때부터 특별한 종류의 '산업적인 시'에 매력을 느꼈다. 산업적인 시는 무엇인가? 획일적인 시를 의미하는가? 혹은 연속적으로 생산되는 작품의 미학을 의미하는가? 작품을 시작하며 순환적인 작업의 모든 과정을 알게 되었다. 그리고 또한 기계에서 발생하는 소음을 어떻게 조절해야 하는지도 알게 되었다. 작업 도중 이러한 일은 부서지기 쉽지만 안정성이 높은 품질의 벽돌을 생산하는 과정과 동시에 일어났다. 벽돌은 생태학적 관점에서 생각해 보면 지속 가능하다고 할 수 있다. 벽돌의 재료가 되는 점토는 지구 상 모든 곳에서 구할 수 있다. 점토나 벽돌을 통해 우리는 자연의 상태, 고고학적인 증거, 고대 역사, 인구의 특성 등을 파악할 수 있다. 흙은 많은 정보를 담고 있으며 여전히 우리는 이것으로부터 많은 것을 배울 수 있다. 벽돌 공장에서의 경험을 통해 보다 많은 작업을 할 수 있었다. 그리고 벽돌을 재료로 이용하기도 했다. 위에서 말했듯 이는 왜 내가 흙으로 탑을 쌓았는지 설명해 준다.

Working in a nearby Brick Yard I assumed would bring a new challenge concerning my sculptural work. What could I learn about production of bricks, their special materiality and architectural structure? Right from the start my artistic view got attracted by this particular kind of industrial poetry. Industrial poetry? What's that? Poetry of uniformity? The aesthetics of series? I started this project and got acquainted to all steps of the process cycle. And also the noises of the machines I had to adjust to. While working they synchronize the process of the production of these fragile but stabile and high quality bricks. The products are sustainable in the thinking of ecological terms. Clay as a material can be found everywhere on our planet. It tells us about nature, archaeology, ancient history and the history of population; a huge amount of information and still a lot to learn about. Since I made this experience in the Brickyard my own work increased: I got used to it. This – the writing above – is the explanation for building and constructing the Earth Tower.

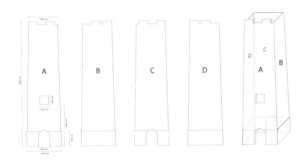

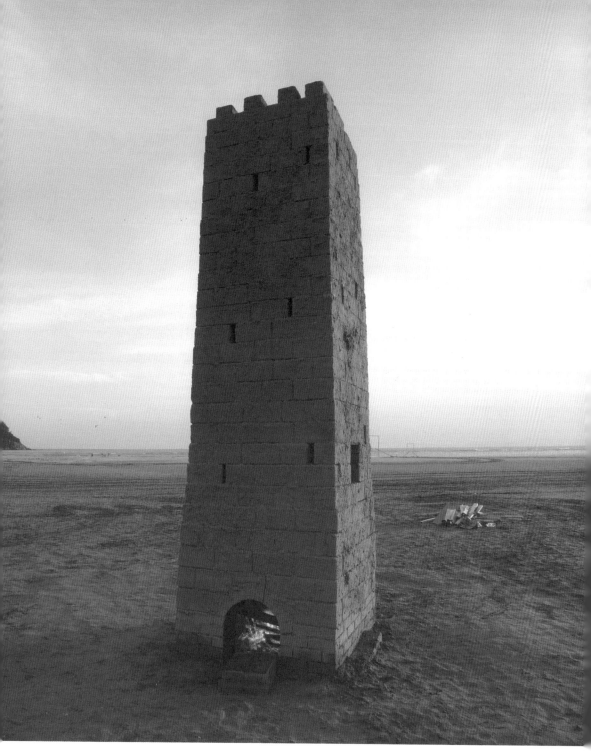

〈대지의 탑〉, 2015, 벽돌, 철 막대, 1.2×1.2×4.2 m
'Earth Tower', 2015, Unfired and Fired Bricks, Cement, Iron Rods, 1.2×1.2×4.2m

101

조덕현 Duck-Hyun CHO
한국 Korea

1957년 한국 강원도 횡성 출생. 현, 한국 서울 거주 및 활동
Born in 1957, Hoeng-seong, Gangwondo. Lives in and works in Seoul, Korea

시(示)
Visible Invisibility

'시'는 이번 바다미술제의 타이틀 '씨–'의 음가(音價)를 살짝 한번 비틀어 연장하는 작업이다. 이는 발굴의 의미를 강조하며 다대포와 주변의 역사를 심층적으로 거슬러 올라간다. 다대포는 낙동강의 하류 말단에 위치하며 상류로부터 지속적으로 토사가 유입, 퇴적되었다. 이에 착안하여 낙동강 주변의 역사성을 짚는다. 멀게는 청동기 시대의 부족 국가로부터 제국을 이룬 신라의 역사. 가야의 역사. 그리고 면면히 흐른 영남 지역의 역사. 거대 서사로서 낙동강의 흐름을 보고 그 흐름 속에 숱한 삶의 부침을 본다. 켜켜이 쌓인 삶의 서사. 그 중에서도 가장 극적인 전쟁의 역사를 언급한다. 그리하여 상징적인 오브제를 유물로써 제시한다. 개, 방어와 보호의 주술.

작가에겐 이미 이서국프로젝트(2002. 경주 선재미술관 / 경상북도 청도군 화양면)가 있었다. 경상북도 청도에 존재하던 청동기 시대의 왕국인 이서국은 신라의 부상에 맞물려 역사의 뒤안길로 사라졌다. 그 기억을 오늘에 되살린 프로젝트에 상징물로 쓰인 오브제가 개 조각상이었다. 이번 발굴은 해변 모래 속에서 상류로부터 떠내려 온 듯한 십 수기의 개 조각상을 찾아내는 일이다. 터를 조성하고, 특정한 구조물을 설치하고, 여러 장정들이 실제로 발굴하는 행위를 한다. 그들은 개막일 전부터 주기적으로 그러한 퍼포먼스를 하게 된다. 보일 시(示) 자는 한자의 변으로 쓰이며 숱한 글자를 생성해 낸다. 그런데 그 한자들은 모두가 발굴의 내용과 직간접적인 관련이 있다. 어쩌면 그렇듯 하나의 글자가 파생해 내는 모든 의미들을 곱씹는 것이 이 작업의 의미와 직결될 지도 모른다.

The title of my work is an extension of "씨(si)," one of the Korean syllables of "씨앗" (seed) from the title of the Sea Art Festival 2015, but slightly twisted. This work puts emphasis on excavation or the mechanism of excavation. As Dadaepo is located at the lower course of the Nakdong River, earth and sand have constantly flowed into and been deposited in this river. It explores the history of Dadaepo and its surrounding area. I bring the history of Silla that had started as a tribal nation but achieved a unified country, the history of Gaya, and the history of the Yeongnam region to my excavation project. I see the flow of the Nakdong River as a grand narrative and find the rise and fall of numerous lives in its stream. I think the history of wars is most dramatic. I employ "dog" artifacts as objects symbolic of this. My work is to excavate from the sand a dozen of dog statues that seem to have floated down from the upper region of the river.

 The artist already conducted the Yiseoguk Project (2002, Art Sonje, Geyongju / Hwayang-myeon, Cheongdo-gu, Gyeongsangbuk-do). Yiseoguk was a kingdom in the Bronze Age located at Cheongdo, Gyeongsangbuk-do but perished with the rise of Silla. I employ "dog" artifacts as objects symbolic of this. My work is to excavate from the sand a dozen of dog statues that seem to have floated down from the upper region of the river. Several man actually carry out an excavation after installing a specific structure at the site. They will perform periodically several days from a day before the opening and the opening day. My work title which is the Chinese character 示 that shapes innumerable characters when used as part of them. These characters are all directly and indirectly associated with the content of the excavation. In this way, the meaning of my work is perhaps to brood over all connotations stemming from this character.

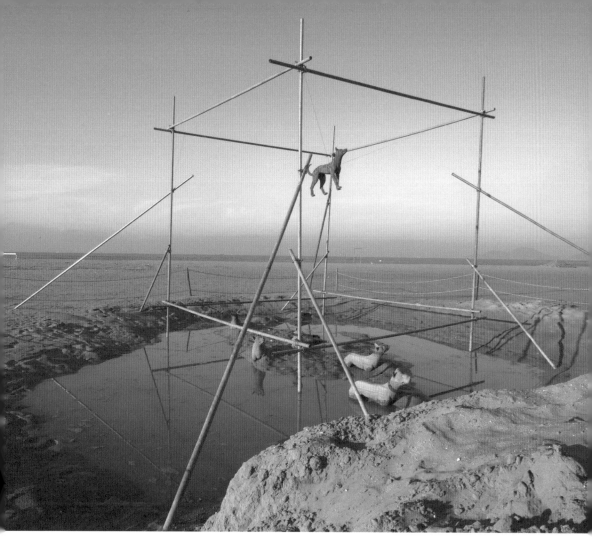

시(示), 2002~2015, F.R.P 소조상에 철분, 현장 설치 작업, 가변 크기
'Visible Invisibility', 2002~2015, Iron Powder on F.R.P Sculpture, Site-specific Installation, Variable Dimension

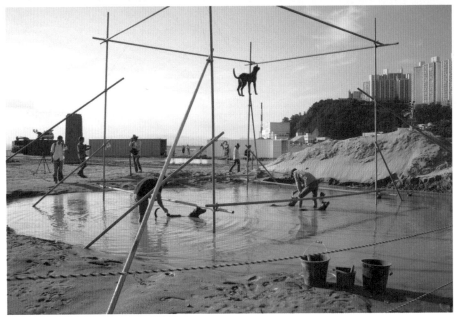

발굴퍼포먼스

시(示), 2002~2015, F.R.P 소조상에 철분, 현장 설치 작업,

Excavation project

'Visible Invisibility', 2002~2015, Iron Powder on F.R.P Sculpture, Site-specific Installation, Variable Dimension

ARCHIST

그룹 아키스트 Group Archist (Artist + Archaeology)

한국 김등용(1983~), 김나륜(1993~), 유규영(1987~), 이찬민(1981~), 백근영(1985~),
 김효영(1991~) 이가윤(1993~), 박성진(1987~), 지영배(1984~), 정철(1991~)

Korea Deung-Yong KIM(1983~), Na-Ryun KIM(1993~), Gyoo-Young YOO(1987~),
 Chan-Min LEE(1981~), Keun-young BAEK(1985~), Hyo-Young KIM(1991~),
 Ga-Yun LEE(1993~), Seong-Jin PARK(1987~), Young-Bae JI(1984~),
 Cheol JEONG(1991~)

던지다, 혹은 버리다	공존 공간
Throw away	**Coexistence Space**

아키스트(ARCHIST)는 미술과 고고학의 프로젝트를 포괄한 합성 용어로 2015바다미술제에 참가한다.
우리의 프로젝트는 땅속에 묻힌 유물이 현대미술로 전환될 수 있는 질문임과 동시에, 작품의 존재 방식이 다양한 동시대 미술에서 지역성의 미적 가치를 되묻는 것이다. 해양도시로 알려진 부산. 동삼동 패총에서 발굴된 장신구인 조개 팔찌, 주술적인 조개 가면, 화패 개념으로 사용한 조개 화패 등이 지역의 특성을 지시하는 것인 반면에 발굴된 유물을 현대적으로 번역하여 설치와 참여 미술이 가능해졌다.
아키스트(Archist=미술가와 고고학의 합성어)는 새로움을 추구하는 현대미술이 아니라 초시간과 공간성(지역성)의 융합이 지니는 가치에 대한 질문이자 공동 프로젝트에 있어 새로운 대안이다.

We participate in Sea Art Festival 2015 as an 'ARCHIST'. It means 'ART' and 'ARCHAEOLOGY'.
This project can change buried underground artifacts for modern art. In a contemporary art, we do ask again an aesthetic value of regionality. Shell-bracelet, shell-mask, shell-money are excavated at Dongsamdong sites in Busan which is known as marine city. They represent regional characteristics. We can interpret them modernly by using these artifacts and use as an installation art and participatory art.
ARCHIST(Artist +Archaeology) is not modern art. It is a question about value of a confluence of time (eternal things) and space(regionality).

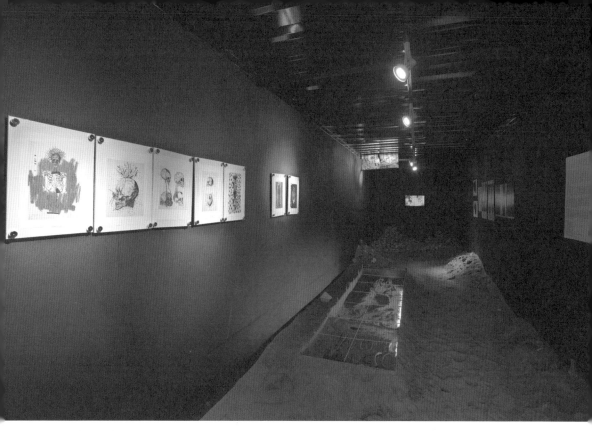

〈 공존공간(共存空間)〉, 2015, 혼합재료, 모래, 4×1.3×3m
'Coexistence space', 2015, Mixture, Sand, 4×1.3×3m

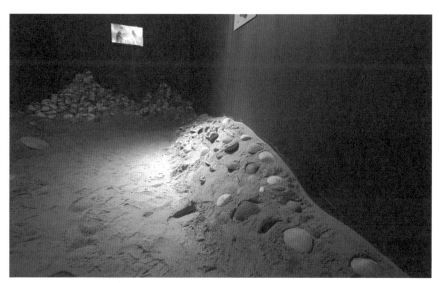

〈던지다 혹은 버리다〉, 2015, 조개껍질, 채색, 3×1.3×1.8m
'Throw away', 2015, Seashell, colored, 3×1.3×1.8m

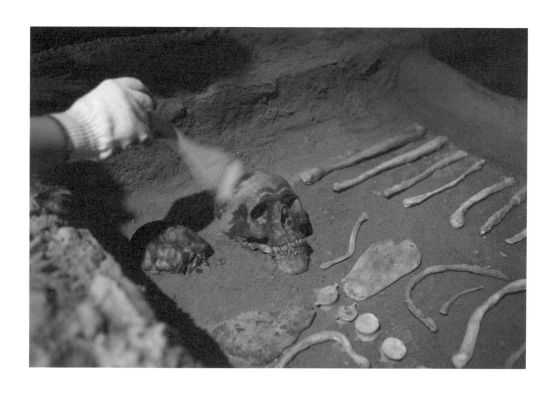

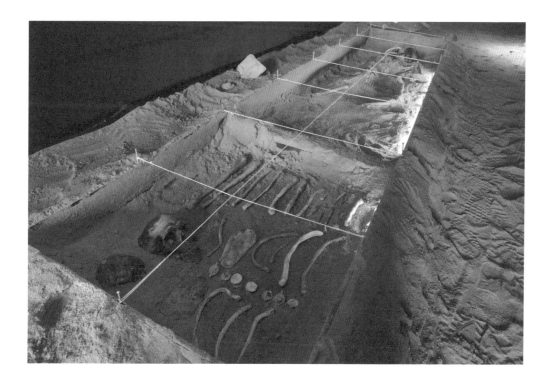

그룹 세라에너지 Group Cera-energy

한국 강미래(1987~), 김혜라(1989~), 박종환(1959~), 심희정(1990~), 임혜지(1991~),
　　정혜주(1983~), 조승연(1991~)

Korea Mi-Ra GANG(1987~), Hea-Ra KIM(1989~), Jong-Hwan PARK(1959~),
　　Hee-Jung SIM(1990~), Hye-Ji LIM(1991~), Hye-Joo JUNG)(1983~),
　　Seung-Yeon JO(1991~)

우주–'지(地)·수(水)·화(火)·풍(風)'
Cosmos – Ji(Earth) · Su(Water) · Hwa(Fire) · Poong(Wind)

〈'우주–지(地)·수(水)·화(火)·풍(風)'〉은 역사적 자료를 바탕으로 한반도 고대 토기의 독창성에 주목하고 현대적으로 재해석한 도예 설치 작품이다. 흙이 가지고 있는 자연스러운 질감과 작가의 생각과 행위의 흔적으로 완성되는 도자기는 어떠한 의미에서 형태를 만드는 것이 아니라 그 속에 비어 있음을 만드는 일이다. 단순한 기능의 범위를 벗어나 형태가 이루고 있는 빈 공간과 그것을 감싸고 있는 외부의 공간의 만남은 우리에게 생경함과 동시에 공명을 느끼게 해준다. 그것은 마치 우리의 능력 너머에 존재하는 우주의 섭리와 거대한 힘의 작용일지도 모른다. 고대인들이 우주의 4대 원소라고 생각했던 지(地), 수(水), 화(火), 풍(風)의 과정으로 완성되는 도자기는 일정한 노동 속에서 창조의 질서를 거스르지 않고 에너지로 가득 차게 된다.
이번 프로젝트의 목적은 설치 작품을 통해 도자기가 가지고 있는 우주적인 힘, 그리고 에너지의 전달이다. 그러한 의미에서 현대적으로 재해석한 원시 토기의 감상은 고고학적 자료가 아닌 현대미술의 입장에서 기능을 배제한 추상성과 회화성에 있다.

The Cosmos is a ceramic installation work created through a modern reinterpretation of ancient Korean earthenware's originality, based on historical data.Ceramics can be completed with clay's natural texture and signs of a potter's ideas and actions. In a sense, ceramic work is not a process of creating form but fashioning emptiness insidethe form. An encounter of the empty internal space of a form with the internal space surroundingit makes us simultaneously feel some discord and resonance. This might have resulted from a provision of nature or enormous power, going beyond our capability. Ceramics are completed with the actions of earth, water, fire, and wind, the four elements ancient people regarded as the four cosmic elements. Ceramics are filled with the energy of labor without opposing the order of creation.

 This project aims to convey the cosmic force and infinite energy engendered in an installation space. In this sense its abstractness and pictorial quality can be appreciated as a work of contemporary art, not as an archeological material to the exclusion of its function

〈우주-'지(地)·수(水)·화(火)·풍(風)'〉, 2015, 토기, 물레, 벽돌, 모래, 가변 크기
'Cosmos–Ji(Earth) · Su(Water) · Hwa(Fire) · Poong(Wind)', 2015, Ceramic, Wheel, Mixed Media, Variable Dimension.

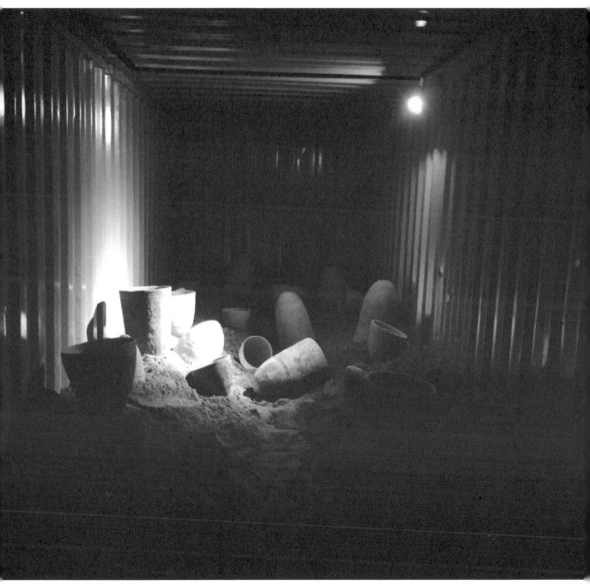

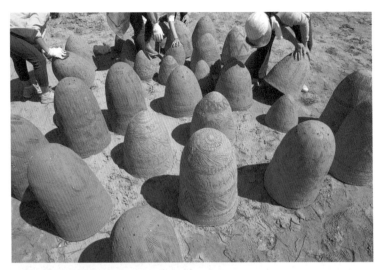

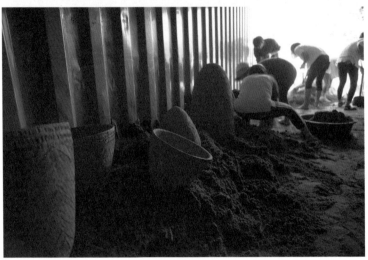

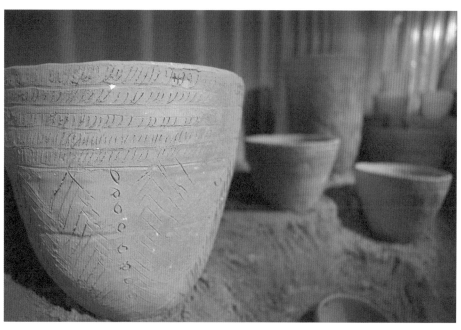

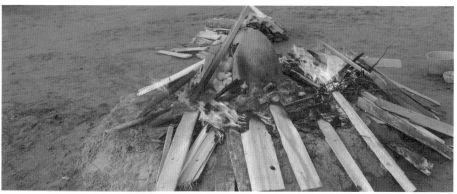

사라웃 추티옹페티 Sarawut Chutiwongpeti
태국 Thailand

1970년 태국 방콕 출생, 현, 스위스 거주 및 활동
Born in 1970, Bangkok, Thailand. Lives in and works in Switzerland

소망, 거짓말 그리고 꿈, 아름다운 신세계
'Wishes, Lies and Dreams, -Beautiful New World...'

이 설치 연작(소망, 거짓말, 그리고 꿈—아름다운 신세계)은 매력적이며 동시에 목가적이나 기이하며 비루한 세계의 삭막한 아름다움으로 관람객을 초대한다. 싸구려 보석, 진주, 다이아몬드가 얼어붙은 야생 동물들과 함께 흩어져 있다. 친근하거나 기이해 보이는 이러한 꿈결 같은 풍경 속에 자연적이며 인공적인 대상들이 공존하고 있다. 이러한 반짝이는 세계는 인식과 꿈의 기제, 환상과 무의식의 사적인 세계, 그리고 마음과 정신이 작동하는 체계를 이루는 조건들을 주로 다룬다.

The installation series of "Wishes, Lies and Dreams, -Beautiful New World..." invites you to step into an enchanted natural, simultaneously idyllic yet bizarrely repellent in its stark beauty. Riches of baubles, pearls and diamonds are strewn alongside the frozen wildlife in this universe. The natural and the artificial are thrown into coexistence in this dreamscape that is both familiar and uncanny. This atmospheric glittering world focuses on the mechanisms of perception and dreams, the private world of the world of fantasy and unconscious, and the conditions underlying the system by which the human mind and spirit operates.

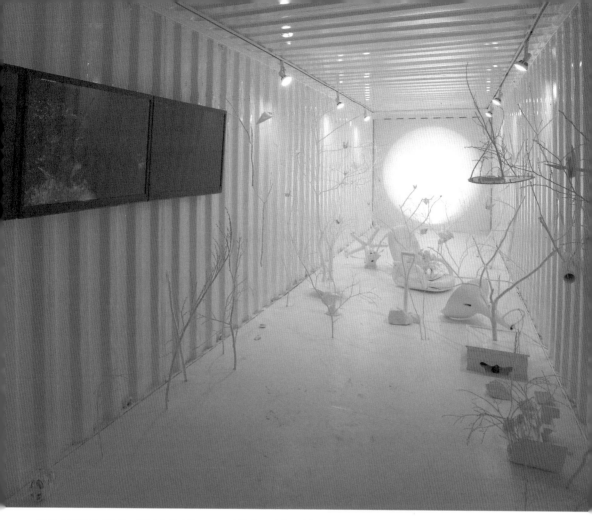

〈소망, 거짓말 그리고 꿈, 아름다운 신세계〉, 2015, 혼합재료, 다대포 해변가의 발견한 오브제, 글리터, 조화, 조명과 비디오 설치, 가변 크기

'Wishes, Lies and Dreams, - Beautiful New World…', 2015, Mixed Media, Found Objects from Dadaepo Beach, Glitter, Artificial Flowers, Lighting and Video Installation, Variable Dimension

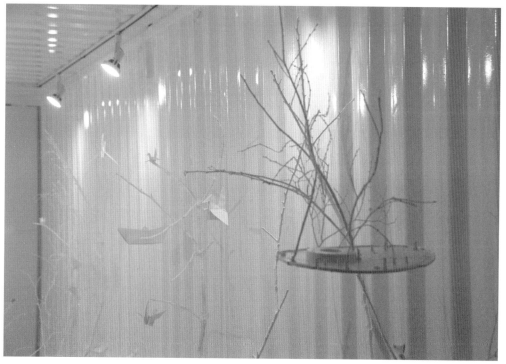

최선 Sun CHOI
한국 Korea

1973년 한국 서울 출생. 현, 한국 서울 거주 및 활동
Born in 1973, Seoul, Korea. Lives in and works in Seoul, Korea

나비
Butterflies

회화는 질료가 빚어낸 환영(幻影)의 한계를 넘어서 우리의 실제를 담을 수는 없는 것일까? 2014년 이스라엘은 무자비한 침공으로 50일 동안 팔레스타인인 2천 2백 명을 사살하고 만여 명의 부상자들과 10만여 명의 피난민들을 만들어 냈다. 최근 몇 년 동안 세계에는 서로를 향해 끝을 모를 증오와 공포가 계속해서 커져 갔고, 이성을 잃은 집단의 광기는 다른 인간의 목숨을 하찮게 거두고 있다. 모든 사람들은 숨을 쉬고 내뱉는다. 한국어에는 서로에게 인사를 건네는 뜻으로 '소식', 즉 서로의 숨을 주고받는다는 말이 있는데. 증오와 공포를 넘어서 서로의 비슷한 듯 다른 숨결을 담고 싶었다. 나는 길 위의 손 없는 화가가 되어 여러 인종과 나이와 성별의 사람들 숨을 받아서 그림을 그렸다. 색깔도 형태도 없기에 얼마나 아름다운지 떠올리기가 쉽지 않은 반성 위에서 서로의 숨이 우리의 눈앞에 아주 선명한 것으로 다시 드러나길 바라는 마음이다.

Can painting contain our reality beyond the limit of an illusion brought up by material? A cruel invasion launched by Israel in 2014 resulted in the deaths of over 2,200 Palestinian people, about 10,000 wounded, and 100,000 refugees over the course of roughly 50 days. Hatred and horror has in recent years increased in the world. Some regard the life of others as insignificant due to a collective madness. Everyone breathes in and out. The Korean word sosik (소식, 消息) refers to an exchange of greetings but originally meant to exchange breath. I'd like to depict the breath of everyone that is similar and different from one another. I paint with the breath of those of different race, age, and sex as an artist with no hands on the street. I hope each breath appears vivid before our eyes, although I am not sure how beautiful it will be as there is no color or form.

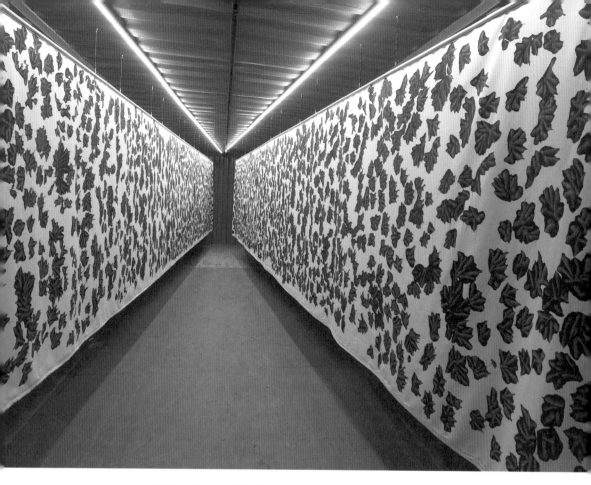

〈나비〉, 2015, 여러 사람의 숨을 이용한 캔버스 위의 잉크, 9.16×1.60m
'Butterflies', 2015, Ink on Canvas by Human Breathing, 9.16×1.60m

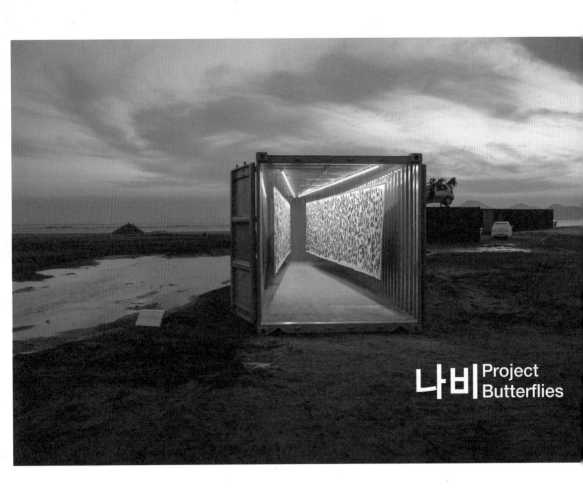

나비 Project Butterflies

나비 Butterflies, 캔버스 위에 잉크 blue ink on canvas, 914cm x 160cm, 2014~

최선 Sun Choi
umber303@gmail.com | http://ssunya.net

2008 홍익대학교 미술대학 회화과 졸업

주요 개인전
2015 〈메아리〉, 송은아트스페이스, 서울, 한국
2015 〈자홍색회화〉, 봉산문화예술회관, 대구, 한국
2013 〈두 세상〉, 뱀부커튼 스튜디오, 타이베이, 대만
2013 〈매와 허공 晨::晁〉, 뱅크아트 Studio NYK, 요코하마, 일본 등

주요 기획전
2015 〈The Meeting Points〉, 워싱턴DC한국문화원, 워싱턴DC, 미국
2015 〈2015비다이술제〉, 다대포 해수욕장, 부산, 한국
2015 〈Think It Over, Think It Slow〉, 뉴욕한국문화원, 뉴욕, 미국
2014 〈팔로우미 난지미술창작스튜디오 8기 리뷰전〉, 서울시립 북서울미술관, 서울
2014 〈아시아 예술축전〉, 안산 만남의 광장, 안산
2014 〈동아시아의 꿈(東アジアの夢)〉, 2014 요코하마 트리엔날레 특별 연계전시, 뱅크아트 Studio NYK, 요코하마, 일본
2013 〈텔레비(tele-Be)〉, 갤러리현대, 서울, 한국
2013 〈후쿠타케 하우스 아시아 아트 플랫폼(Fukudake House Asia Art Platform)〉, 2013 세토우치 트리엔날레, 쇼도시마, 일본
2012 〈12회 송은미술대상전〉, 송은아트스페이스, 서울, 한국
2006 〈예술의 표면과 이면, 그리고 리얼리티〉, 인사갤러리, 서울, 한국
2004 〈삼순이 미술관〉, 삼성 미술관 대안 웹 프로젝트 등

수상
2014 해외레지던스프로그램 지원기금 (한국문화예술위원회, 한국)
2013 Creative talent Artist (뱀부커튼 스튜디오, 타이베이, 대만)
2013 세토우치 트리엔날레 참여작가 선발 (금천예술공장, 서울문화재단, 한국)
2012 제12회 송은미술대전 대상 (송은문화재단, 한국)
2012 레지던스 작가 기금(문화예술 해외방신거점형성사업), (일본 문부성, 일본) 등

2000 Bachelor of Fine Arts in Painting, Hong-Ik University, Seoul, Korea

Selected Solo Exhibitions
2015 Meari, SongEun Art Space, Seoul, Korea
2015 Magenta Painting, BongSan Culture Center, Taegu, Korea
2015 Two Worlds, Bamboo Curtain Studio, Taipei, Taiwan
2013 Falcon and Firmament, BankART Studio NYK, Yokohama, Japan

Selected Group Exhibitions
2015 〈The Meeting Points〉, Korean Cultural Service, Washington D.C., U.S.A.
2015 〈2015 Sea Art Festival of Busan Biennale〉, Dadaepo Beach, Busan, Korea
2015 〈Think It Over, Think It Slow〉, Korean Cultural Service, New York, U.S.A.
2014 〈Follow Me : SeMA Nanji 8th Review〉, Buk Seoul Museum of Art, Seoul, Korea
2014 〈Asian Art Festival〉, Ansan, Korea
2014 〈Dream of East Asia〉, 2014 Yokohama Triennale, BankART Studio NYK, Yokohama, Japan
2013 〈tele-Be〉, Gallery HYUNDAI, Seoul, Korea
2013 〈Fukudake House Asian Art Platform〉, 2013 Setouchi Triennale, Shodoshima, Japan
2004 〈Samsumi Museum〉, an alternative web museum to Samsung Museum

Selected Awards and Grants
2014 Grant for Foreign Residency (Arts Council of Korea, Korea)
2013 Grant for Creative Talent Artist (Bamboo Curtain Studio, Taipei, Taiwan)
2013 Setouchi Triennale competition(Geum-Cheon Art Factory, Seoul Foundation for Arts & Culture, Korea)
2012 Grand Prize of the 12th SongEun Art Award(SongEun Art Foundation, Korea)
2012 Grant for visiting artist(Japan Foundation, Japan)

나는 최근 몇 년 동안 사회 속 개인의 존재를 너무 허무하고 무의미하게 만드는 소식을 자주 접하게 되면서 한명한명의 보이지 않는 숨길을 드러내는 작업을 구상하게 되었다. 나비 프로젝트는 2014년 안산의 길거리에서 마주친 외국인 노동자들과 처음 시작하였으며, 참여자들이 다르면서도 엇비슷한 인간의 숨길을 직접 눈으로 목격하게 했다. 참여자들은 관념적으로만 인식하기 쉬운 자신의 숨을 시각적으로 확인하는 강렬한 경험을 할 수 있다. 이 프로젝트는 한국뿐 아니라 뉴욕에서도 이루어졌으며, 앞으로도 종교와 국경, 성별과 장애에 대한 경계없이 계속 진행될 예정이다.

이질적인 개인들이 동일한 숨을 가지고 만들어내는 이 작품을 통해 현대사회에서 작가는 누구이고 또 예술작품은 무엇인가라는 근본적인 질문을 던지고 미술의 사회적 가치에 대한 하나의 담론을 만들어 나갈 수 있기를 바란다.

This is a painting completed by the act of blowing paints of many people on a large canvas. I conceived the painting in that breathing is a natural and common thing for human being, but the traces that every breath makes on canvas could be different and beautiful. Although blowing breath is very easy, but the audience who participate in the painting experience strong visual impact of their action and this sometimes attracts passersby in the street, especially when I tried this in 2014 in Ansan, a Korean city where many foreign workers live and work.

Through this project we can ask the meaning of being artist or being audience of the artworks, and our attitude to them, namely, the meaning of throwing artworks into our contemporary society.

스테펜 올랜도 Stephen ORLANDO
캐나다 Canada

1983년 캐나다 출생. 현. 캐나다 온타리오 거주 및 활동
Born in 1983, Canada. Lives in and works in Ontario, Canada

〈파란색, 자주색, 하얀색 카약〉, 〈석양의 카약〉
Blue, Purple, White Kayak, Sunset Kayak

스테판 올랜도는 카약의 노에 부착한 프로그래밍이 가능한 엘이디 조명이나 노의 움직임이 만들어 내는 궤적을 긴 노출로 촬영한 사진을 작품에 이용한다. 카메라 앞에서 카야커가 노를 젓는 모습을 20초 동안의 노출로 촬영한다. 〈파란색, 자주색, 하얀색 카약〉과 같은 작품은 캐나다 오타리주헌츠빌에 위치한 페어리 호수에서 카약의 노가 만들어내는 궤적을 포착하고 있다. 작품 〈석양의 카약 I〉(Sunset Kayak)도 마찬가지로 캐나다 온타리오주니피싱 호 위에서 두 카약의 노가 만들어 내는 궤적을 보여 준다. 이러한 빛의 자취들은 후속 작업을 통해 인위적으로 만들어지거나 합성된 것이 아니다.

Stephen Orlando uses programmable LED lights attached to kayak paddles and long exposure photography to reveal the path of the kayak paddles in front of the camera. As the kayaker paddles in front of the camera, a long exposure photograph lasting approximately 20 seconds is taken. In <Blue Purple White Kayak> we see the path of a kayaker's paddle on Fairy Lake in Huntsville, Ontario, Canada. In <Sunset Kayaks> I we see the paths of two kayaker's paddles at sunset on Lake Nipissing in North Bay, Ontario, Canada. These light trails have not been artificially created in post-production and the photos are not composite images.

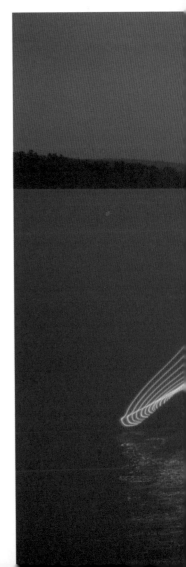

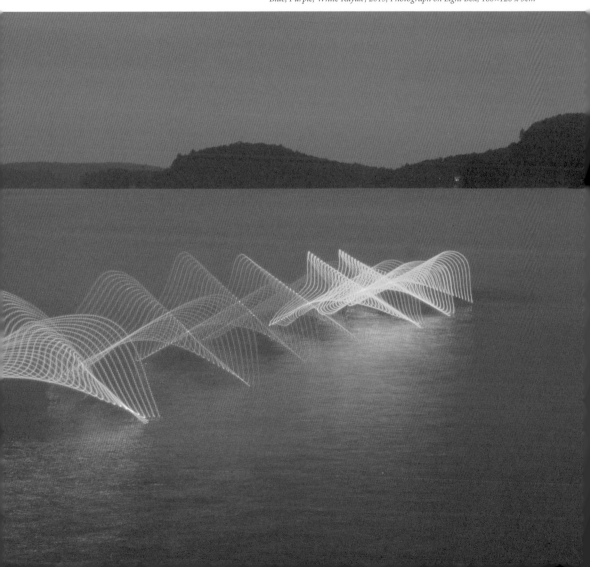

〈파란색, 자주색, 하얀색 카약〉, 2015, 라이트 박스에 사진, 180×120x5cm
'Blue, Purple, White Kayak', 2015, Photograph on Light Box, 180×120 x 5cm

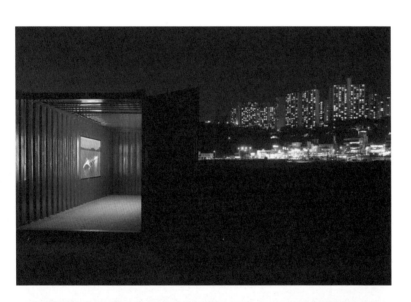

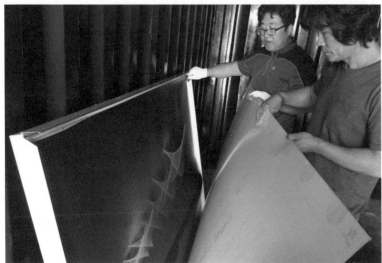

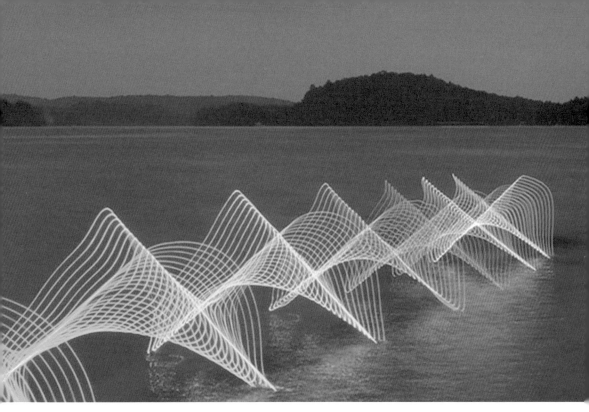

〈석양의 카약〉 2015, 라이트 박스에 사진, 180×120x5cm
'Sunset Kayak', 2015, Photograph on Light Box, 180×120 x 5cm

친탄 우파드야이 Chintan Upadhyay
인도 India

1972년 인도 라자스탄 출생. 현, 인도 뉴델리 거주 및 활동
Born in 1972, Rajasthan, India. Lives in and works in New Delhi, India

생성시키다
Engender

예술적인 대상을 통해 관념의 씨앗을 뿌린다는 개념은 예술가/예술 공동체, 지역 공동체, 그리고 국가 구성원들이 특정 예술과 관념을 위한 관용을 기르고 발전시키며 확산시키기 위해 함께 모여 행동한다는 의미이다. 씨 뿌리기는 대중들이 생각해보거나 서서히 수용할 수 있도록 공공의 영역에 관념이나 개념을 심는 과정이다. 자동차는 현재 우리 삶의 일부분이 된 매우 흔한 기계이다. 이 작품은 폐차를 이용해 이동이나 움직임과 같은 개념을 다룬다. 이러한 개념은 환경이나 인간의 삶에 영향을 미친다. 나는 이러한 개념을 씨앗을 통해 해석하는데 관심이 있다. 하나의 씨앗은 내부에 미래의 나무를 담고 있으며 자연적인 요소들을 통해 한 장소에서 다른 장소로 이동한다. 예술 또한 동일한 역할을 하며 이러한 개념을 통해 미적인 대상이나 이를 공유할 방법을 창조한다. 이 작품에서 화분은 희망, 애정, 집단적인 노력, 협력, 관용, 대자연을 향한 사랑의 상징이다. 이는 일종의 공동체 내에서의 심기이다. 이는 일종의 예술적 형태로 단순한 대상이아니라 여러 기억의 결과물이다.

The concept behind the seeding ideas through art objects is about an action by the artist/art community, local community and members of the public come together to cultivate, produce, and spread tolerance for the arts and ideas. Seeding is a process of planting an idea or a concept in the public domain where the public can be thinking about it and slowly accept it so when we bring it again it is already accepted. The car is a very common machine, which is now part of human life as another body. It deals with the idea of transport, and movement. It has its own effect on the environment, and human life. I am interested in taking it as a seed. A seed can carry a tree of the future in it and natural resources transport it from one end to another. Art also plays the same role and ideas empower art to create an aesthetic object or way to share. These planters are asymbol of hope, love affection collective efforts, collaboration, tolerance and love for Mother Nature. It is a kind of community planting. It is form of art, which is not just an object, but a result of many memories coming together.

〈생성시키다〉, 2015, 자동차 설치, 식물, 씨앗, 흙, 물, 금속, 컨테이너
'Engender', 2015, Installation made of cars, Plants, Seeds, Soil, Water, Metal, Container

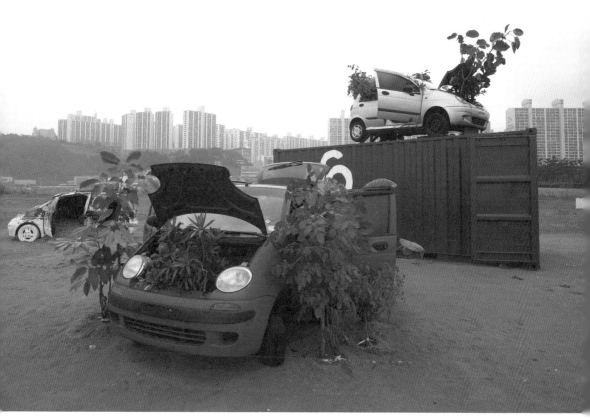

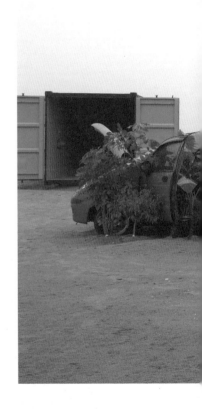

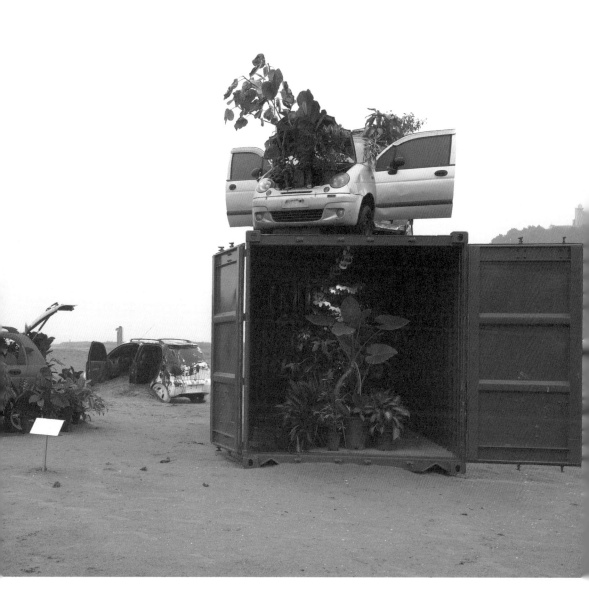

차기율 Ki-Youl CHA

한국 Korea

1961년 한국 화성 출생. 현, 한국 인천 거주 및 활동
Born in 1961, Hwaseong, Korea. Lives in and works in Incheon, Korea

성지—큐브의 비극
Holy Land-Tragedy of the Cube

다대포에서 이루어지는 이번 프로젝트는 가상의 발굴 프로젝트이다. 지층을 발굴하거나 인간 흔적을 발굴하는 여타 발굴형식과는 다른 인류의 여정을 반추하고 그들의 마음속 깊은 곳에 존재하는 신성에 대해 다시 한번 성찰하고 되돌아보는 프로젝트이다. 역사 이래 인류는 숭배의 대상을 찾기 위해 방황하였고 이러한 지점은 샤먼의 노래로, 종교의 경전으로, 이데올로기의 대상으로 나타났으며 때론 깊은 갈등의 기제로 작용하였다. 신성한 숲 앞에 서있는 자들이었던 이들은 생경하고 낯선 풍경 속 일원이 되었으며 추락한 천사의 모습으로 현상한다. 컨테이너 박스 속에 설치된 장치들은 땅 위를 부유하며 떠도는 인류의 역사를 상징한다. 박제화가 된 뼈로, 날것의 살덩이로, 탄화된 단백질과 탄소로 새롭게 발굴되고 시각화된다. 이 프로젝트는 인류의 가슴 깊은 곳에 존재하는 신성을 환기하고 되돌아보고자 하는 시공간을 발굴하는 행위이며 고백이다.

This work on Dadaepo Beach is an imaginary excavation project. Unlike other projects that excavate a site to look for human traces, this project was meant to trace the journey of humanity and investigate the divinity hidden behind our minds. Since the beginning of history mankind has wandered about seeking an object of worship and the results of people's actions have appeared as shamanic songs, religious scriptures, and ideological objects at times causing severe conflicts. Those standing before a sacred forest become part of an unfamiliar scene, incarnated as fallen angels. Devices in a shipping container symbolize the history of mankind which has floated and wandered around the earth, excavated and visualized with stuffed bones, chunks of raw flesh, and carbonized protein. This project is both an act and a confession to reflect on the divine nature that remains deeply imbedded in our hearts

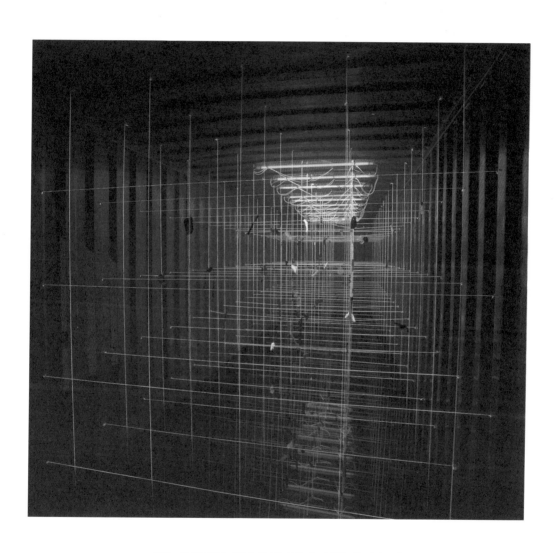

〈성지-큐브의 비극〉, 2015, 물, 먹, 동물 뼈, 자연목, 철, 가변 크기
'Holy Land- Tragedy of the Cube', 2015, Water, Chinese ink, Bones, Wood, Steel, variables Dimension

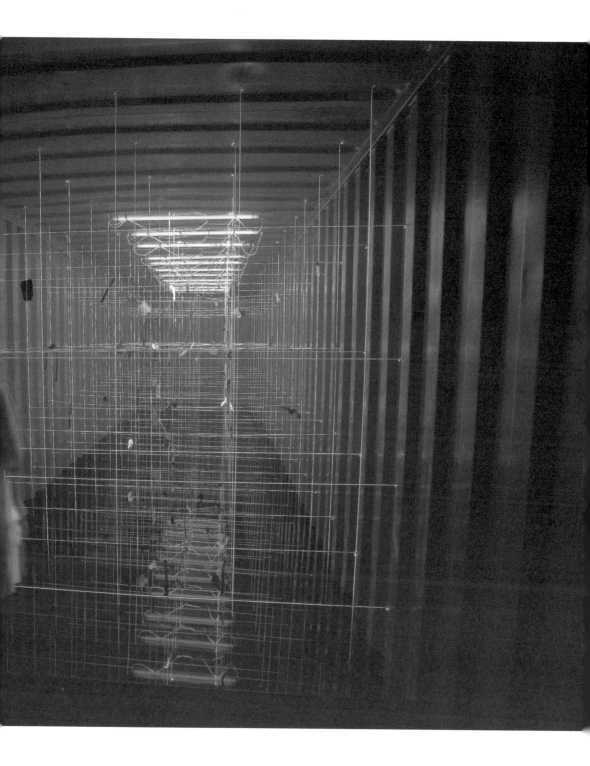

Section 3

자라는 씨앗
Growing Seeds

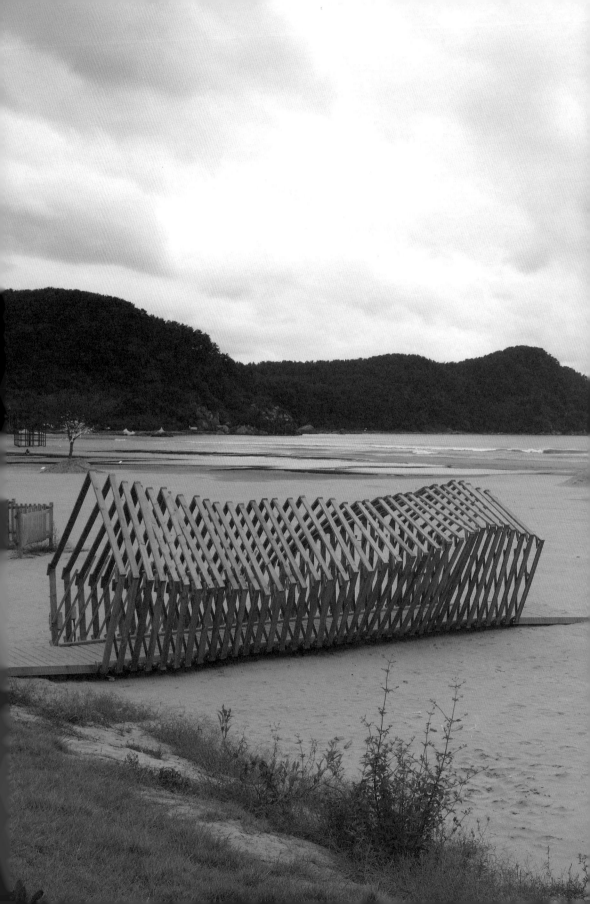

리그돌 텐징 Rigdol TENZING

미국 USA

1982년 네팔 출생. 현. 미국 뉴욕 거주 및 활동
Born in 1982, Nepal. Lives in and works in New York, USA

따뜻한 소망으로 가득한 보따리
Bags full of warm wishes

나에게 흙은 스스로 지구와 사적인 연결을 의미한다. 그것은 나에게 우리가 얼마나 집 혹은 자연과 교감하는 것으로부터 멀리 여정을 해왔는지를 상기시킨다. 그래서 예술 작품은 어떤 점에서 참여하는 부분인 것인데, 관람자는 작품을 그저 바라보거나 그 또는 그녀가 신체적으로 흙 한 줌을 집어 그들 마음에 꿈을 담아 바다로 흘러 보내면서 직접 그 부분이 되는 선택을 갖는다. 즉, 이 설치 작품은 매우 단순한 것이다. 나는 200개의 흙주머니를 쌓고 그를 따라 추가로 20개의 흙주머니로 긴 꼬리를 만들어 바다로 향하게 할 것이다.

To me soil symbolizes the personal connection of oneself to the earth. It reminds me of how far we have journeyed away from the touch of home or nature. So the artwork will be a participatory piece wherein, the visitors have the choice to either just look at the work or he or she could physically be part of it by taking some soil in their hands and release it in the ocean with a wish in their mind. The installation of the work will be a very simple one. I will have a pile of soil bags (total 200 bags) with a long tail made out of about additional 20 soil bags that run towards the ocean.

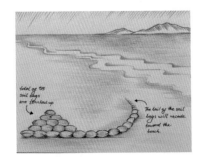

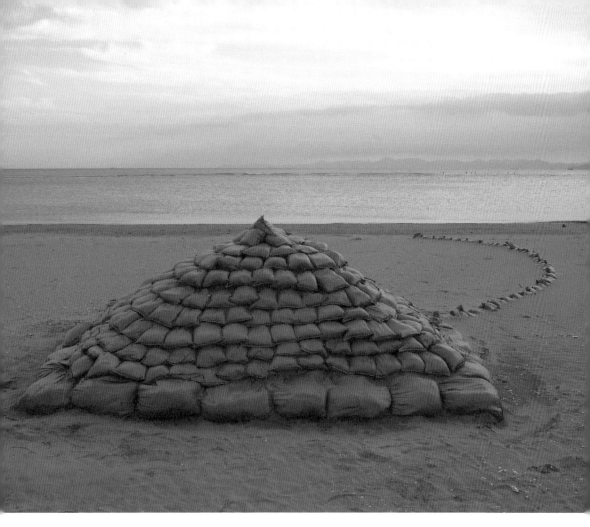

〈따뜻한 소망으로 가득한 보따리〉, 2015, 흙주머니들, 유목 프로젝트, 182×182×2370cm
'Bags Full of Warm', 2015, Soil bags, Nomadic Project, 182×182×2370cm

노마딕프로젝트 일정 (2박 3일)
Time Schedule of Nomadic Project (2nights 3days)

도착일	도착시	순서	도착지	도착지 세부	의미	흙 포대	마중/배웅자	동행자
8일(화)	08:00	1	인천 Incheon	인천국제공항	서해, 인천항으로부터		이탈(작가)	운전1 영상 기록1 어시스턴트1
	10:00	2	인천 Incheon	인천아트플랫폼	서해, 예술계	20개	허은광(인천아트플랫폼 관장)	상동
	13:00	3	강화도 Gangwhado	이탈 아틀리에	이북과 맞닿은 땅	20개	이탈(작가)	상동
1박	16:00	4	파주 Paju	메이크샵스페이스+출판단지+임진각+오두산통일전망대	이북과 맞닿은 땅	20개	김동섭(메이크샵스페이스 실장)	상동
9일(수)	09:00	5	양평 Yangpyeong	김영헌 아틀리에	내륙, 예술계	20개	김영헌(작가)	상동
	14:00	6	고성/속초 Goseong/Sokcho	봉포플랫폼	동해, 속초항으로부터	20개	이기범(봉포플랫폼 대표)	상동
2박	16:00	7	강릉/정동진 Gangneung/Jeongdongjin	하스라아트월드	동해, 예술계	20개	최옥영(작가, 하스라아트월드 대표)	상동
10일(목)	09:00	8	포항 Pohang	포항시립미술관 영일대해수욕장	동해, 예술계	20개	장정렬(포항시립미술관 학예실장)	상동
	11:00	9	울산 Ulsan	울산북구예술창고	동해, 예술계	20개	김수진(울산북구예술창작소 매니저)	상동
	14:00	10	부산 Busan	오픈스페이스배	남해, 부산항으로부터	20개	서상호(오픈스페이스배)	상동
	18:00	11	부산 Busan	다대포해수욕장	남해, 목표지	20개	김성호(전시감독)	상동

* 인천부터 다대포해수욕장에 이르는 구간을 거치면서 200개의 흙더미를 모아 최종적으로 다대포에 설치하는 노마딕 프로젝트.

** 이 프로젝트에는 위의 도표의 마중/배웅자 외에 김병권(영상), 신언일(차량) 박상옥(작가 어시스턴트)씨가 수고해 주었다.

노마딕프로젝트 과정　　　Process of Nomadic Project

흙포대, Soil bags

인천 , Incheon

강화도, Gangwhado

강화도, Gangwhado

파주, Paju

오두산 통일전망대, Odu Mountain Unification Observatory

양평, Yangpyeong

고성/속초, Goseong/Sokcho

강릉/정동진, Gangneung/Jeongdongjin

포항, Pohang

울산, Ulsan

부산, Busan

김정민 **Jung-Min KIM**

한국 Korea

1982년 한국 부산 출생. 현, 한국 부산 거주 및 활동
Born in 1982, Busan, Korea. Lives in and works in Busan, Korea

자라는 씨앗
Growing Seeds

다대포해변에 실제로 자라고 있는 여러 꽃들과 식물들을 단순한 형태로 조형화시켰다 꽃과 식물들을 배라는 매개체로 군집시켜 한 단위의 집합체로 묶어 우리 사회의 작은 커뮤니티를 연상케 한다. 출렁이는 배 위에 서로를 의지하며 자라는 씨물들은 부산 시민을 상징하며 형형색색 아름다운 자태를 가지고 자라는 식물들은 다가올 수확에 대한 희망을 상징한다.

I have given simple forms to many of the flowers and plants that can be found at Dadaepo Beach. The flowers and plants loaded in a boat are collected in a cluster, redolent of a small community in our society. The seeds that sprout and rely on one another on the rocky boat represent the citizens of Busan whereas the plants boasting beautiful forms symbolize hope for the upcoming harvest.

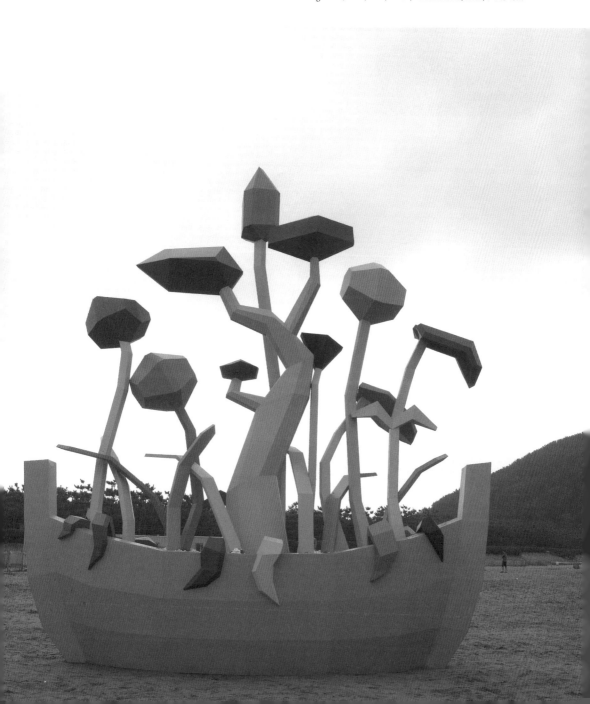

〈자라는 씨앗〉, 2015, 철, 나무, 혼합재료, F.R.P, 5×2.5×5m
'Growing Seeds', 2015, Steel, Wood, Mixed Media, F.R.P, 5×2.5×5m

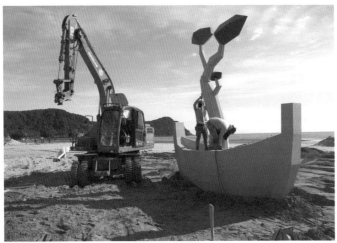

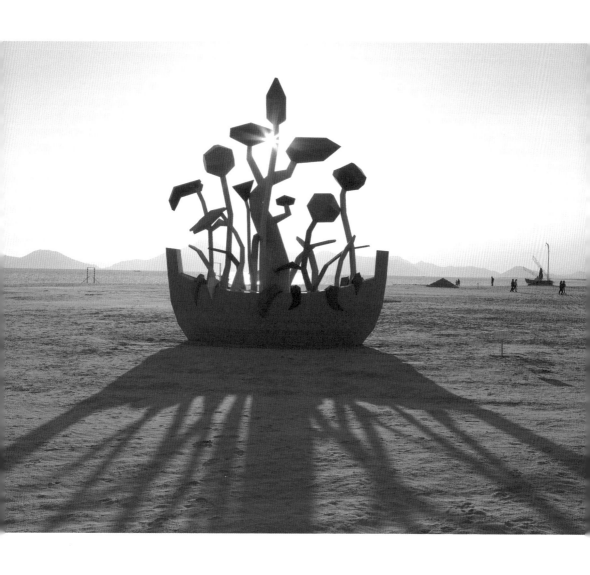

전원길 Won-Gil JEON
한국 Korea

1960년 한국 경기도 출생. 현, 한국 안성 거주 및 활동
Born in 1960, Gyeonggi-do, Korea. Lives in and works in Anseong, Korea

녹색 수평선
A Green Horizon

식물은 흙 속에서 끌어 올린 수분과 공기 중의 이산화탄소를 흡수하여 광합성을 통해 자라고 결실할 뿐만 아니라 공기 중에 산소와 수분을 발산함으로써 자연 생태 순환의 중요한 매개 역할을 한다. 나는 자연의 순환 과정에 미술이라는 이름으로 개입을 시도한다. '녹색 수평선'은 식물의 생태적 성장 과정을 작품 속에 반영한 작품이다. 박스 형태로 제작된 틀 속에서 보리 싹이 자란다. 나는 바닷가 어디서도 보이지만 사실 그 선을 찾을 수는 없는 수평선과 보리의 뜬금없는 만남을 주선한다.
수평선을 따라 설치된 구조물에 심겨진 보리는 멀리 보이는 수평선을 향하여 자라 오르고 마침내 수평선과 나란하게 키를 맞추게 된다. 언제나 수평을 유지하는 수평선과 수직으로 자라 오르는 보리의 만남이다. 나는 앉아서 멀리 보이는 수평선에 초록으로 자라 오르는 보리가 만드는 선과의 눈 맞춤을 시도한다. 수평선. 보리 그리고 나는 하나로 연결된다.

Plants grow and bear fruit through photosynthesis, a process by which they synthesize carbon dioxide secured from the air and water drawn from earth. These plants assume an important intermediary role in the ecosystem by giving off oxygen and moisture into the air. I make an attempt to intervene in the cycles of nature in the name of art. *A Green Horizon* displays the process of the ecological growth of plants. Barley sprouts are grown in box-shaped frames. I set up an unexpected meeting between barley and the horizon that can be seen from anywhere on the beach.
I plant barley in the structure and set it along the horizon, watching as it grew toward it, its height at last becoming level with the horizon. This is a chance meeting between the horizon that always remains horizontal and the vertically-growing barely. I make a foray into harmonizing the horizon that can be seen from far away with the line that is formed as barely grows. The horizon, barley and I are connected as one.

〈녹색 수평선〉, 2015, 스틸, 흙, 씨앗, 85×30×2100 cm
'A Green Horizon', 2015, Steel, Soil, Seeds, , 85×30×2100 cm

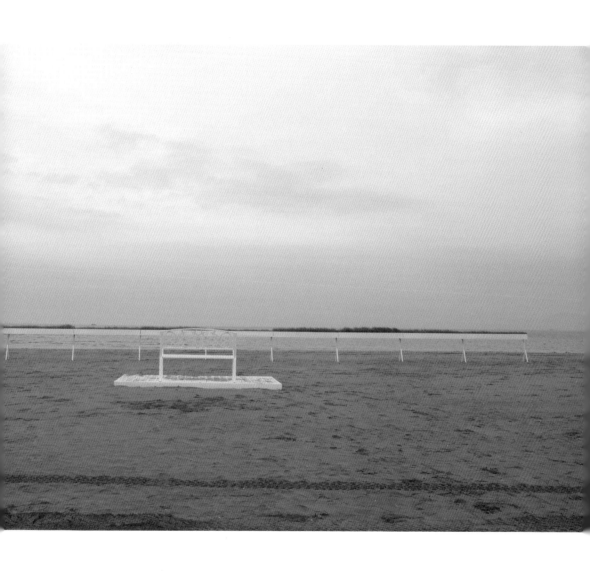

페르난도 알바레즈 페레즈 Fernando ALVAREZ PEREZ

스페인 Spain

1975년 스페인 출생. 현, 스페인 거주 및 활동
Born in 1975, Spain. Lives in and works in Spain

씨앗들
Seeds

이 작품은 자연에서 얻은 재료로 표면을 덮은 다섯 개의 거대한 흙이나 모래 반구들로 구성되어 있다. 모든 자연에의 개입이 그렇듯 작품의 크기는 작품이 설치될 장소나 사용될 재료에 따라 결정된다. 자연에서 얻은 재료를 기하학적인 형태나 선과 대비시키고자 하므로 반구들은 가능한 완벽하게 구현되어야 한다. 각각의 반구는 두 가지 재료를 혼합해 만들어졌으며 직선과 각도의 조합이나 융합을 보여 준다. 그리고 각 반구의 표면은 적어도 세 가지 이상의 재료를 이용해 조성하며 이는 색채와 질감 사이의 대조를 보여 준다. 가능하다면 이들 중 하나는 살아 있는 재료(풀, 꽃, 혹은 다른 식물), 다른 하나는 무생물 재료(돌 혹은 자갈), 그리고 또 다른 하나는 과거 생명체의 일부였던 재료(나뭇가지, 조개 껍질, 혹은 짚)를 이용하고자 한다. 이 작품을 통해 인간의 합리성과 자연의 우연성 사이의 균형이 가져다 주는 아름다움을 반영하고자 한다.

The project is a composition of five big hemispheres of ground or sand covered with natural materials taken from the Nature. Like every intervention in the nature, the exact size depends of the place where will be installed and the materials that could be used. The hemispheres are realized as perfect as possible, because I search the contrast between the natural materials and the geometric forms and lines. Each hemisphere will mix two different materials, combinated in a composition of straight lines and angles. In the surface of the forms at least three different materials will becombinated, making contrasts between the colours and textures. If possible, I would like to choose one material alive (grass, little flowers, plants...), other material that must be inert (stones or gravel...) and a third material that must be something that one day was alive (branches, shells, straw...). I want to reflect the beauty of the right balance between the rationality of the human kind and the spontaneity of the Nature.

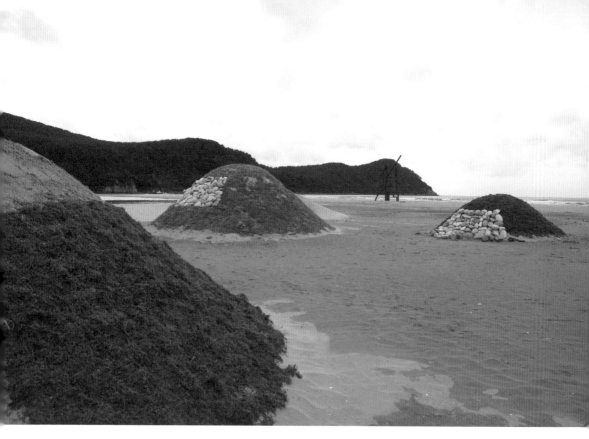

〈씨앗들〉, 2015, 모래, 자연물들, 가변 크기
'Seeds', 2015, Sand and Natural Materials, Variable Dimension

오노 요코 Yoko ONO
미국 USA

1933년 일본 출생. 현, 미국 뉴욕 거주 및 활동
Born in 1933, Japan. Lives in and works in New York, USA

소망나무
Wish Tree

무언가를 소망하라.
그 소망을 쪽지에 적어라.
쪽지를 접어 소망의 나뭇가지에 매달아라.
친구들에게도 그렇게 하라고 권하라.
나뭇가지가 온통 소망으로 뒤덮일때까지 소망하기를 멈추지 말라.
y.o. '96

Make a wish.
Write it down on a piece of paper.
Fold it and tie it around a branch of Wish Tree.
Ask your friends to do the same.
Keep wishing
Until the branches are covered with wishes.
y.o. '96

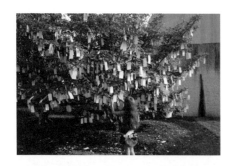

〈소망나무〉, 1996~2015, 나무, 종이, 끈, 안내문, 필기구, 가변 크기 © Yoko Ono
'Wish Tree', 1996~2015, Living tree, paper, string, instructions on paper, writing tools, Variable Dimension © Yoko Ono

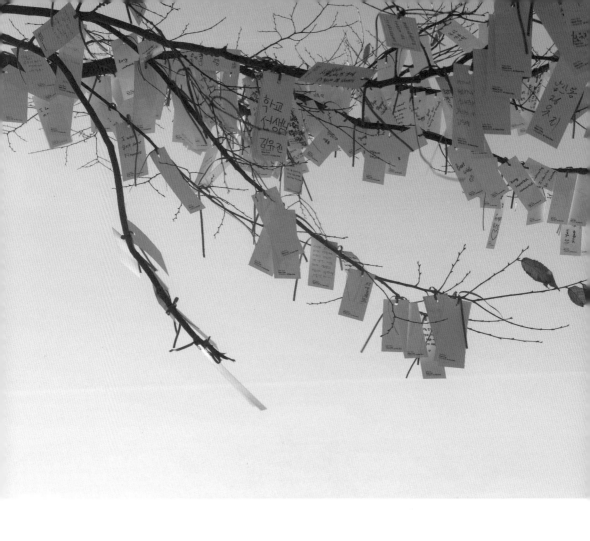

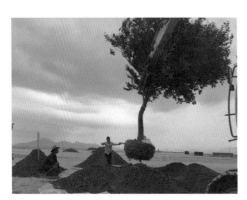

158

© Yoko Ono

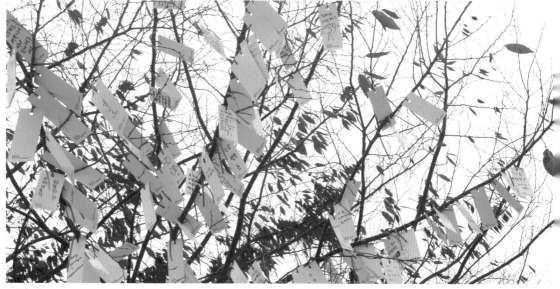

© Yoko Ono

이종균 Jong-Kyun LEE

한국 Korea

1971년 한국 서울 출생. 현, 경기도 거주 및 활동
Born in 1971, Seoul, Korea. Lives in and works in Gyeonggi-do, Korea

물고기-쓰레기 탐색자
Fish-A Trash Investigator

나는 최근까지 수행적 의미로서 신체적 드로잉을 해왔다. 목적지까지 안전하고 수월하게 도달할 수 있는 기존의 길보다 새로이 길을 만들어 가는 작업으로 노동과 삶의 가치에서 예술적 의미를 찾고자 하였다. 또한 나로부터 출발한 작업이 외부의 다른 요소(장소)와 충돌하면서 예상치 못했던 의미가 발생하고, 그것이 작품의 의미를 재구성함으로써 결과마저도 과정으로 치환된다. 나의 작업(일)과 그 장소의 역사적, 사회적, 환경적인 특징들이 연결되고 교차되면서 의미가 발생하는 지점을 나는 작품의 완성으로 본다. '물고기-쓰레기 탐색자'는 예술가의 삶을 유지하기 위해 고물과 폐지를 주워 생활했던 경험과 현재 바다가 주변 나의 작업실에서 흔히 보이는 해양 쓰레기가 동기가 되어 예술과 환경이라는 내용으로 작업을 하게 되었다. 예술가는 무엇으로 먹고 사는가와 사회로부터 예술은 어떤 역할을 해야 하는가에 대한 물음을 생태적 관점에서 해답을 찾고자 하였다. 생태학에서 말하는 분해란 생산자나 소비자로부터 이용되지 못한 것들, 이용하고 남은 것들을 분자 단위까지 해체하여 새로운 순환이 이뤄질 수 있도록 하는 것을 말하는데, 세상의 물질과 에너지의 흐름을 만드는데 결정적 역할을 하고 있다. 예술은 생산과 소비가 아닌 분해에 있다고 보았고, 분해자로서 예술가의 행위를 넝마주이로 표현하였는데, 사회로부터 버려진 부산물과 그로 인해 망가지는 자연을 때로는 날 선 비판의 눈으로 세상을 바라보기도 하고, 때로는 따뜻한 연민의 시선으로 사회를 품으려고 하는 치유의 의미를 갖는다.

Until recently I have worked on physical drawings as a way to practice asceticism or seek truth. I have tried to discover artistic significance and authenticity in the value of labor and life, opening up a new road as opposed to taking some preexisting path that is safe and easy to traverse. An unexpected meaning arises when my work clashes with other factors. This meaning helps to reconstruct my work, even managing to change any final result through its process. I see the point where my work intersects with the historical, social, and environmental features of such places and how a meaning arises upon completion of my work. Fish - A Trash Investigator is a reflection on my experience of collecting junk and waste paper to earn a living as an artist. My work which addresses the content of art and the environment has been inspired by the ocean litter often found around my studio adjacent to the sea. What do artists do to make a living? What part does art play in society? I try to find the answers to these questions from an ecological perspective. Decomposition refers to an ecological process in which things unused by both a producer and consumer and things left after use are broken down into molecular units and create a new cycle. This process plays a decisive role in creating the flow of matter and energy in the world. . I see art as an act of decomposition, not production or consumption, and define an artist as a decomposer or a ragpicker. I cast a critical eye upon byproducts that have been abandoned by society and nature that has been damaged by them, doing my best to see and embrace society with a warm heart.

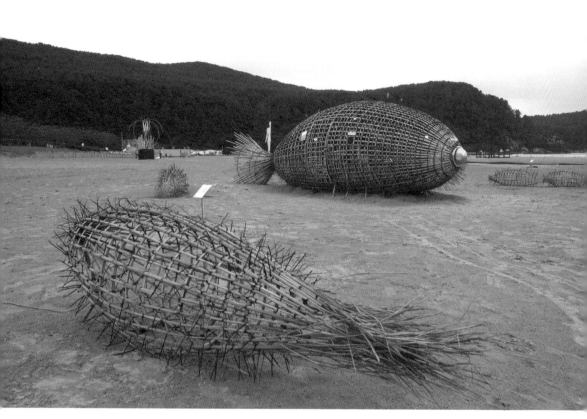

〈물고기−쓰레기 탐색자〉, 2015, 철, 대나무, 전선 타이, 2×10×2(1개), 0.6×2×0.6m (10개)
'Fish-A Trash Investigator', 2015, Steel, Bamboo, Cable Tie, Big size 2×10×2m (one), Small 0.6×2 ×0.6m (Ten)

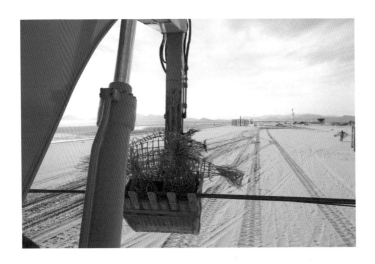

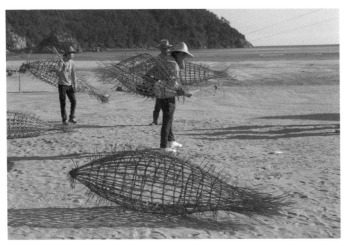

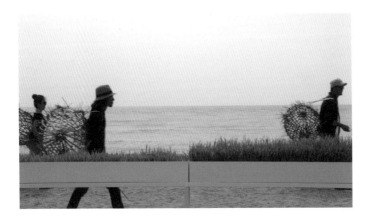

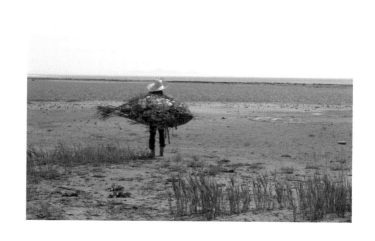

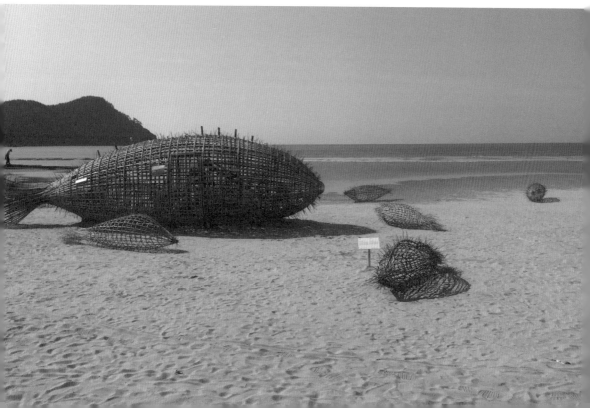

정찬호 Chan-Ho JEONG
한국 Korea

1979년 한국 부산 출생. 현, 한국 부산 거주 및 활동
Born in 1979, Busan, Korea. Lives in and works in Busan, Korea

하트 스파클라
Heart Sparkler

매년 이맘때면 전국 해수욕장의 개장일로 시작해 많은 인파가 여름을 나기 위해 바닷가를 찾는다. 해수욕장의 개장과 더불어 휴양객들을 위한 다양한 먹거리와 즐길거리를 제공하는 부대시설과 이벤트가 진행된다. 친구, 가족, 연인 등 휴가 기간과 주말을 활용하여 더운 날씨, 일상에서 벗어나 지친 마음과 몸을 재정비하고 기억에 남는 좋은 추억을 만들고자 밤낮으로 북적거리는 모습을 엿볼 수 있다. 그 중의 하나로 야간의 해변가에서 인기 있는 것이 불꽃놀이인데 로켓, 분수, 폭죽 등 그 규모와 종류도 다양하다. 스파클라(sparkler)는 폭죽놀이의 한 종류로 야간에 빛의 잔상에 의해 생겨나는 형태를 카메라의 노출 기능을 활용하여 기록한 이미지다. 그 모양도 각양각색으로 기호와 문자, 자유곡선 등 그들만의 시간과 감정을 기록하기 위한 소재로 활용된다. 하트 스파클라(Heart sparkler) 작업은 개개인이 가지고 있는 경험적 추억을 회상하고 현재를 기록하기 위한 염원적 작업이라 할 수 있다.

Around this time of year a multitude of people throng to the beaches throughout the nation. Many facilities on the beaches provide vacationers with food, spectacles, and events. During the vacation season and weekends the beaches are crowded day and night with friends, families, and lovers who come to replenish their fatigued minds and bodies and make unforgettable memories. Fireworks are popular among them: the fireworks vary in scale and kind from sky rocket fireworks to girandoles and sparklers. A sparkler is a type of firework that burns slowly while emitting coloredsparks that leave afterimages in thedark. The images vary: signs, letters, free-flowing curves, and more.Sparklers can be utilized as a material to chronicle one's own time and emotions. Heart Sparkler is awork that recalls each individual's memories of experiences and documents their present and wishes.

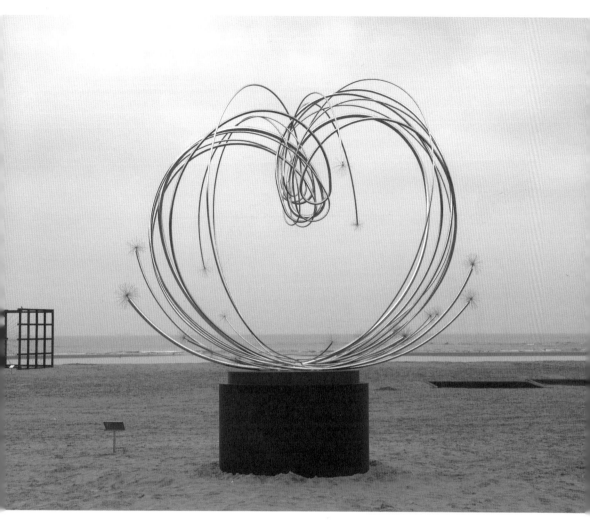

〈하트 스파클라〉, 2015, 스테인리스 스틸, 3×3.5×3m
'Heart Sparkler', 2015, Stainless steel, 3×3.5×3m

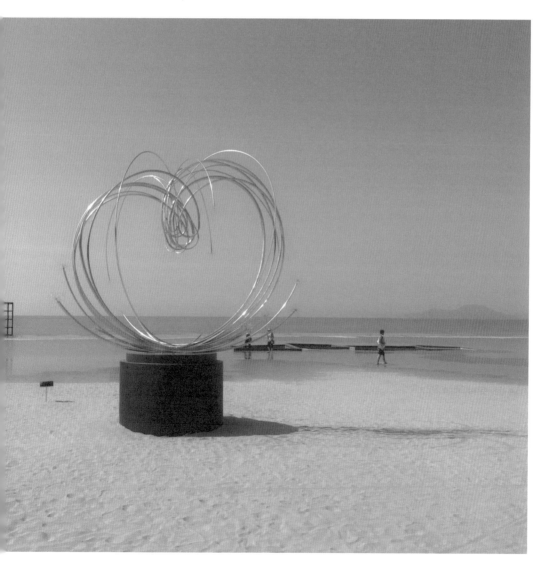

김영원 Young-Won KIM

한국 Korea

1947년 한국 창원 출생. 현, 한국 경기도 거주 및 활동
Born in 1947, Changwon, Korea. Lives in and works in Gyeonggi-do, Korea

그림자의 그림자 (홀로 서다)
Shadow of Shadow (Alone)

부조를 그 이미지만 절취하여 입체 공간에 세우면, 낯선 공간의 이미지를 얻을 수 있다. 마치 사진을 오려 입체 공간에 세워 놓는 것처럼 말이다. 특히, 부조 이면은 존재감만 있고 시간과 공간이 멈춘 듯, 물질화된 빈 공간만 남는다. 이 물질화된 인체 이미지를 멋대로 절단하고 자유롭게 조립해서 새로운 이미지를 만든다. 음(陰)과 양(陽)이 공존하고, 유(有)와 무(無)가 뒤얽히고 체(體)와 용(用)을 한 덩어리로 새로운 인체 이미지를 얻을 수가 있었다. 물결, 바람, 꽃, 사랑 등 추상적인 개념이나 어떠한 이미지도 평면과 입체의 뒤섞임 속에 자연스럽게 표현이 가능해졌다. 이러한 방법으로 IT 시대에 있어서 실재와 부재의 경계가 모호한 현실과 가상의 극점에서 위태롭게 유희하는 현대 인간에 대한, 무한한 연민과 비판적인 시각의 은유적 담론을 엮어 가고자 한다.
이 작품은 4면이 모두가 정면이다.이쪽저쪽 관람객이 바라보는 면이 정면이고 뒷면은 아예 없다. 각각 면들을 살펴보면 한 면은 뒤를 향해 먼 곳을 바라보는 것처럼, 다른 한 면은 평면의 인간과 입체적 사실적인 인간 두 사람이 겹쳐 함께 서 있는 듯, 또 한 면은 사람이 공간 속으로 사라지기도 나타나기도, 또 다른 면은 추상적이고 평면인 인간의 실루엣만 보이 게끔 각 면마다 별개의 개념과 이미지로 되어 있다. 이러한 제 각각의 이미지를 통합하여 한 작품 안에 녹여 넣어 조화를 꾀하는 것이 특징이다. 조각이 갖는 정태적인 공간에서 적극적으로 동태적인 공간이 되도록 했다. 작품 앞에 서면 반대 면이 궁금해 한 바퀴 돌며 작품을 볼 수밖에 없게 만들어져 있는 것 역시 특징이라 할 수 있다.

When a relief is cut out and its image is set up in a three-dimensional space, an unfamiliar spatial image can be obtained as if a photo has been set in a three-dimensional space. The back of a relief has only a sense of existence but it is actually a materialized empty space as time and space seem to stand still. I create new images by freely cutting and combining these materialized body images as I please. Yin and yang coexist and nothing and something get entangled in this work. I can get new body images from these contrasting elements. I become able to naturally depict any abstract concept such as the wind, a flower, and love as well as any image in a mix of two-dimensional and three-dimensional objects. In this way I intend to raise a critical view and metaphorical discourse on contemporary humans who are in a precarious state at the opposite points of reality and imagination where the boundaries between presence and absence remain blurred.

All four sides of this work are the front. That is, each side a viewer looks at is the front: there is no back. A man with his back facing the viewer seems to look away on one side; a two-dimensional man appears to either overlap or stand alongside a three-dimensional realistic man on another side; a man appears or disappears on another; and a two-dimensional abstract man emerges only by his silhouette. As such, each face of this work is made up of different concepts and images. This work is characterized by an attempt to integrate and harmonize such diverse images. I have aggressively brought a shift from a static space in sculpture to a dynamic space. One cannot help but walk around my work as standing in front of itmakes viewers curious about its back, something which is also one of its hallmarks.

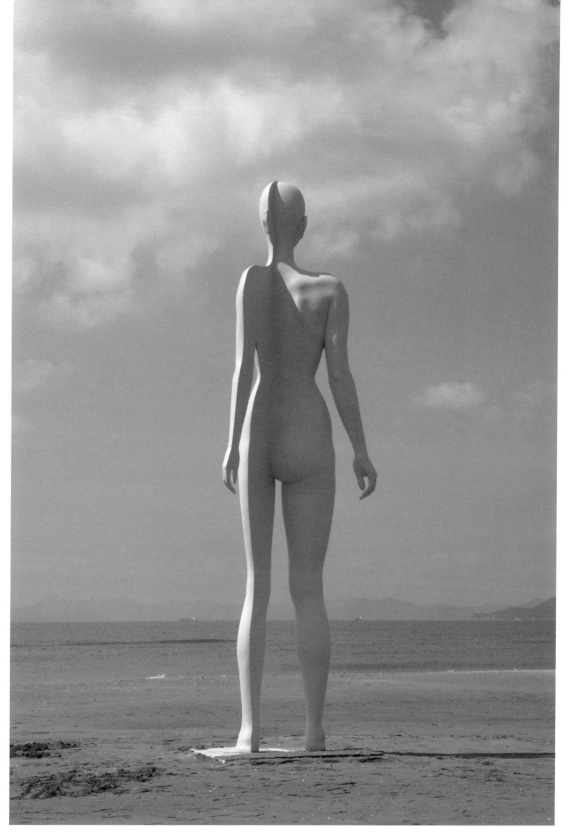

〈그림자의 그림자 (홀로 서다)〉, 2010, 브론즈, 800×230×216cm
'Shadow of Shadow (Alone)', 2010, Bronze, 800×230×216cm

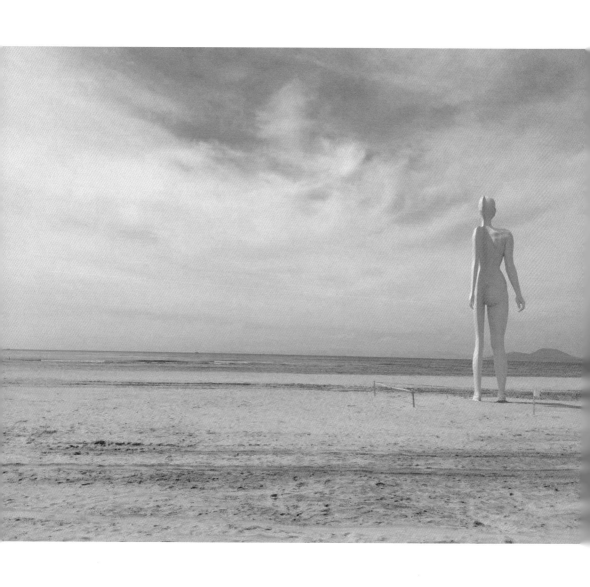

Section 4

자라는 바다
Growing Sea

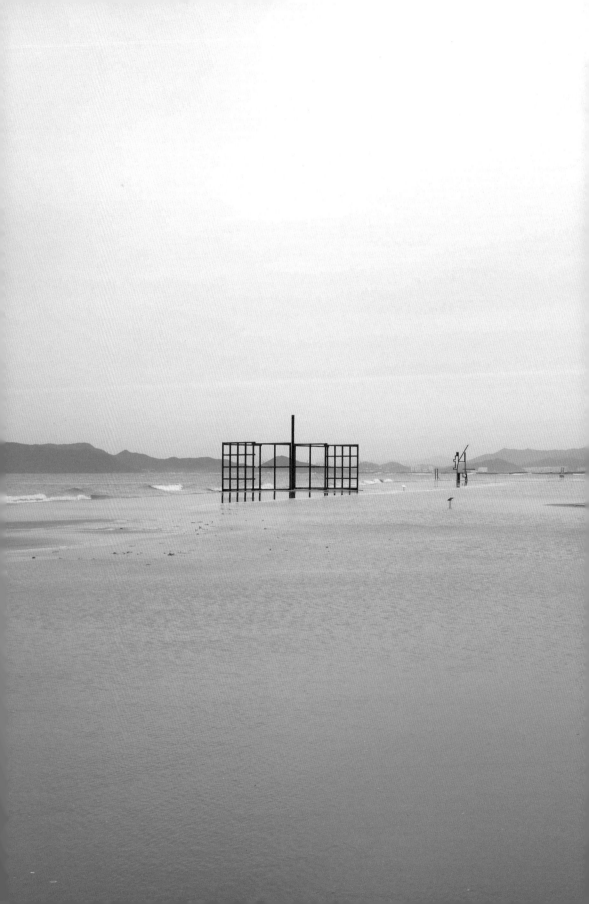

윤영화 Young-Hwa YOON
한국 Korea

1964년 한국 대구 출생 . 현. 한국 부산 거주 및 활동
Born in 1964, Daegu, Korea. Lives in and works in Busan, Korea

유산–항해
Heritage-Voyage

배–폐선으로 상징되는 인간 존재와 사회 현실. 그리고 인류 역사의 아픈 유산을 딛고서. 자연 속에 내재한 생명력–씨앗이
발아되어 나무 한 그루가 폐선 내부 중앙에서 심겨 곧게 뻗어간다. 다시금 성장–비상하는 존재의 변모하는 양상은, 목재
및 철 구조물의 두 대의 배에 설치된 빛(LED)을 통해 생장하여 미래를 향해 항해를 떠날 채비로 용트림을 하고 있다.

2008년도에 나는 폐선을 가지고 퍼포먼스('하늘바다로 노 저어가다')를 한 적이 있다. 그때 나는 불의의 사고로 3일간 의
식 불명을 겪은 뒤, 인간 존재의 무한히 유약함과 삶의 무상을 절감하게 되었는데 이런 경험은 나에게 훨씬 그 이전부터
천착해온 '초월'이라는 주제를 더욱 직접적으로 대면하도록 충동질하였고, 이것은 또 자연스레 다매체, 복합매체라는 형식
적 특징을 지니고서 빛과 영상 설치 조형 작업으로의 작업 양상의 변화를 초래했다.

나는 최근까지 바다, 배, 소금 등의 소재로 '유산'이라는 주제의 사진과 빛–영상 설치 작업을 선보여 왔다. 사실 이는 바
로 우리가 살아온 터전으로서의 세계와, 그 세계 내 우리 존재의 지난한 몸부림을 표상함에 다름 아니었다. 시원(始原)의
자연을 상기시키기에 부족함 없는 드넓은 백사장에, 우리의 슬픈 자화상처럼 떡 하니 버티어 지키고 있는 배–폐선 한 대
에는 모진 파도와 해풍을 무릅쓰고 새 생명의 잉태와 발아를 통하여 자라고 있는 한 그루의 나무. 이 나무를 중심에서 감
싸고 폐선 위에 있는 두 대의 배 조형물이, 빛과 움직임으로써 차원이 다른 변모를 위한 용트림. 즉 우리 모든 존재들의 긴
항해–'삶의 여정'을 은유하고 있다.

In my work a ship or an abandoned ship stands for human existence and social reality. Overcoming the painful
heritage of human history, a tree grown from a seed grows straight through the middle of the ship, symbolizing
a life force innate in nature. The altering aspects of a growing or soaring being are expressed with LED lights
set on two boats made of woodand steel. The boats are busy getting ready for their voyage toward the future.
In 2008 I conducted a performance using an abandoned ship. After I had lapsed into unconsciousness for three
days due to an unexpected accident, I was able to keenly feel the vulnerability of human existence and the
transience of life. This experience encouraged me to more immediately confront the subject of "transcendence"
that I had addressed long before. It also caused a change in my light and video installation work characterized
by multimedia and complex media.

In recent years I have dealt with the theme of "heritage" in photography, light, and video installation, working
with subject matter involving the sea, ships, and salt. This was actually a manifestation of the world as a site
we inhabit and our struggles within it. A sandy beach that recalls the beginning of nature, an abandoned ship
symbolic of our sad-looking portraits, a tree growing through the conception and germination of new life despite
harsh waves and winds, and two boat-shaped sculptures on the abandoned ship represent the long voyage all of
us take known as the "journey of life" as we seek change in a new dimension through the movement of light.

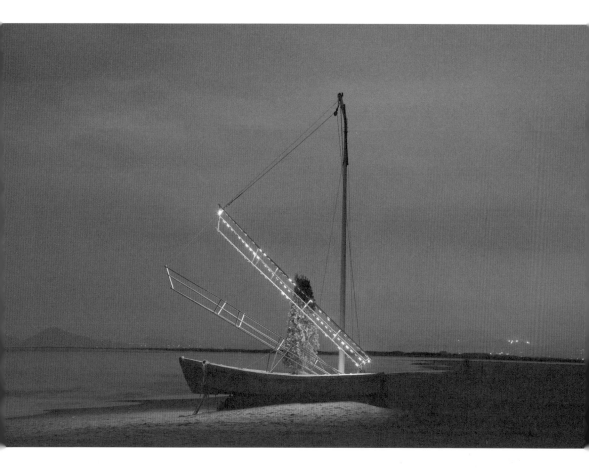

〈유산-항해〉, 2015, 철, 나무, 폐목선, LED모듈, 묘목, 도르래, 동력 장치 등, 6×2×7m
'Heritage-Voyage', 2015, Steel, Wood, Obsolete Vessel, LED module, Tree, A System of Ropes and Pulleys, Power Plant Unit etc., 6×2×7m

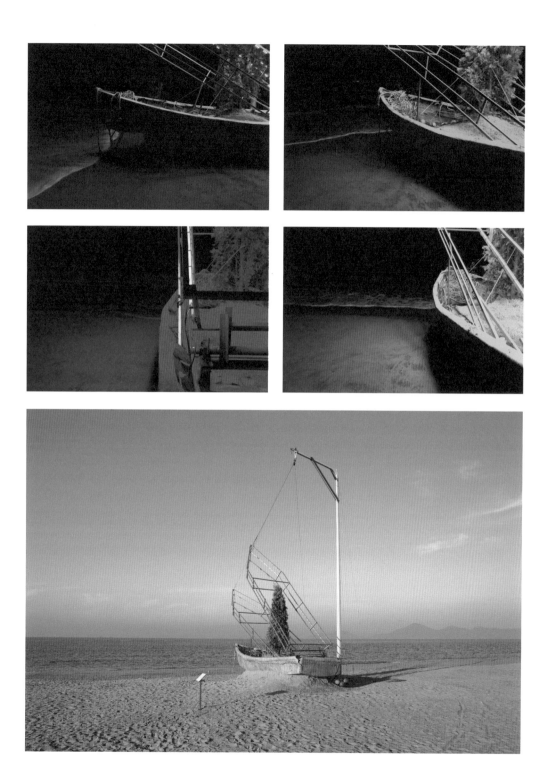

조셉 타스나디 Joseph TASNADI

헝가리 Hungary

1960년 루마니아 비소아라 출생. 현, 헝가리 부다페스트 거주 및 활동
Born in 1960, Viisoara, Romania. Lives in and works in Budapest, Hungary
http://www.josephtasnadi.hu

기억의 지속
The Persistence of Memory

무언가를 생각하기 위해 발걸음을 멈췄을 때 실제가 단편적이긴 하지만 하나의 이미지로 다가왔다. 이 이미지는 실재의 한 조각이다. 이 조각은 순간적인 분위기를 전달하거나 중개하지 못한다. 설령 이 이미지가 분위기를 환기시킬 수 있을지라도 실재를 보여 주진 못한다. 순간적인 분위기를 시각적으로 기록하기 위해 무수한 이미지들이 필요하다. 물론 이는 불가능하다. 이 작품은 기억이 순간을 사실적으로 재현할 수 있음을 보여 주고자 한다. 어떤 면에서 혹은 어느 정도는 이 설명은 사실일 수 있다. 그러나 기억은 변화를 겪으며 분위기를 주체적으로 환기시킨다. 내 목표는 실재의 중심들 중 하나가 되는 것이다. 한가운데이므로 변두리는 너무 멀리 떨어져 보이지 않는다. 나는 심각한 근시이다. 근시의 영향을 지속적으로 받고 있다. 이 때문에 나는 때로 고립되어 있지만 이로 인해 세계와 관계를 맺기도 한다. 나는 멀리 나아가거나 뒤로 되돌아오기도 한다. 이는 나의 이동 수단이다. 〈기억의 지속〉은 설치와 대지미술의 개념을 혼합하고자 한 작품이다. 이를 위해 해변 풍경 속에 상징적인 물체들을 설치한다. 이 작품은 자연과의 정적이며 동적인 상호 작용을 필요로 하는 모순 개념을 바탕으로 정지와 운동의 동시적인 발생을 다룬다. 이러한 상호 작용은 결국 우리의 기억을 환기시킨다.

When I make a stop to contemplate, reality offers itself to me largely as an image, even though the image is only one dimension of reality. The image is but a fragment of reality. A fragment is able neither to carry, nor to mediate the atmosphere of a moment. The image never shows reality – still, as if it invoked the atmosphere of it. In order to record the atmosphere of the moment visually I would need an endless number of images. This, of course, is impossible. It might be reassuring to think that memory is able to reproduce a moment realistically. It is – in a certain sense and to a certain degree. But memory is an altered, subjective invocation of the atmosphere. A certain atmosphere-fragment. My fate is to be one of the centers of reality, a reality whose margins are too remote for me to see. I am near-sighted. My near-sightedness is persistent and stubborn. It determines and orientates me; it isolates me but also connects me to the world. It carries me away and brings me back. It is simply my carrier. 'The Persistence of Memory' intends to be a mixture between installation and land-art. I'd like to install a set of symbolic objects in the seaside landscape. The artwork is dealing with the idea of being simultaneously standstill and in motion, with the concept of contradiction between the need of being both static and dynamic in our interaction with nature, which interaction - after all feeds our memories.

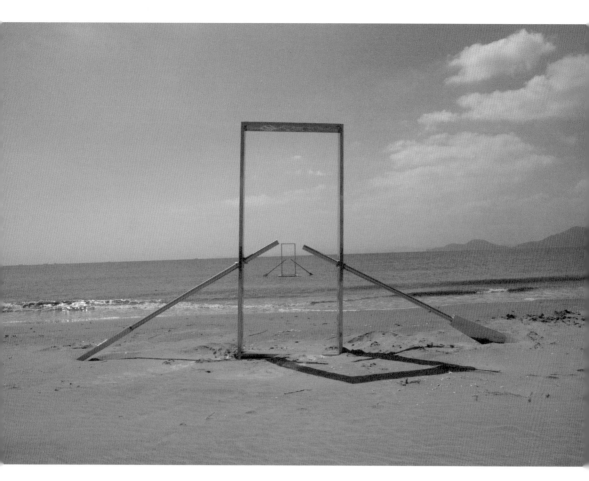

〈기억의 지속〉, 2015, 이중 스테인리스, 플라스틱, 3×3×4 m
'The Persistence of Memory', 2015, Duplex stainless steel, plastic, 3×3×4 m

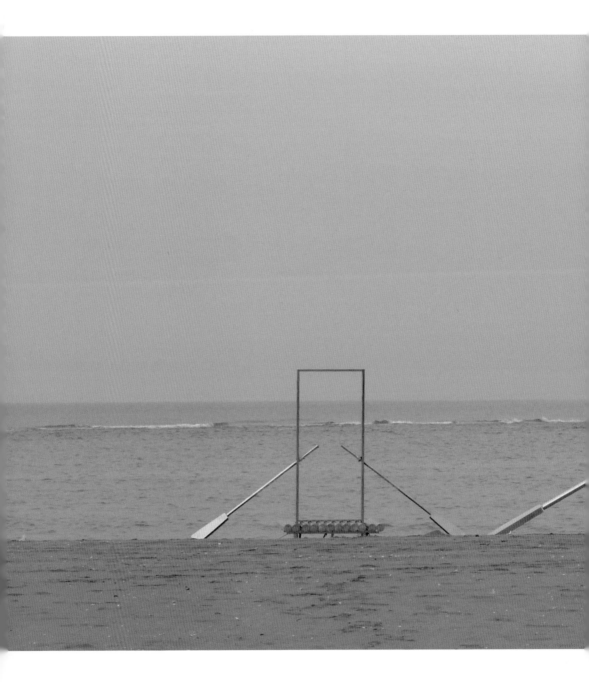

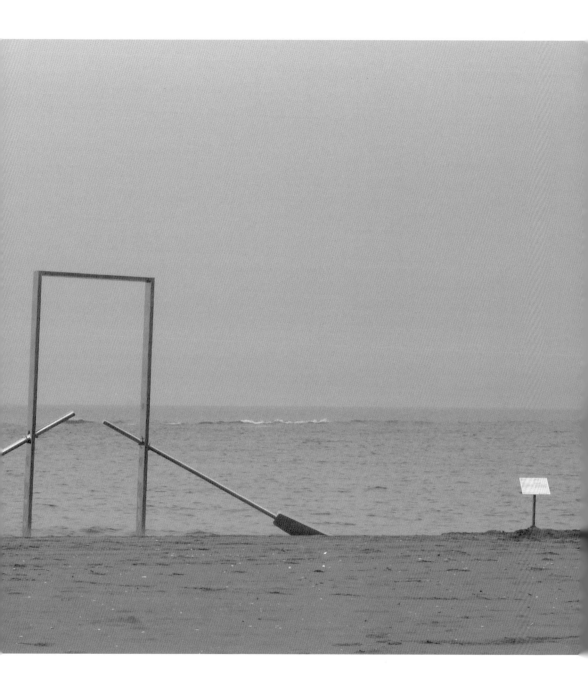

손현욱 Hyun-Wook SON
한국 Korea

1982년 한국 부산 출생. 현. 한국 부산 거주 및 활동
Born in 1982, Busan, Korea. Lives in and works in Busan, Korea

배변의 기술
Pissing Contest

작가는 〈배변의 기술〉을 통해 수컷들이 가지고 있는 허황된 허위의식을 통렬하게 비판한다. 그러나 비단 수컷들뿐인가? 허황된 가치를 좇는 것은 어쩌면 인간이라면 공통으로 가지고 있는 숙명이다. 그래서 〈배변의 기술 – Pissing Contest〉이라는 제목은 심하게 가슴에 와 닿는다.
동물들의 배설을 지켜보는 인간의 심리 상태는 처음에는 우습지만 결국 자연스럽게 자신의 모습이 투사된다. 손현욱의 작품을 보면 쉽게 공감하면서도 인간의 심리적 폐부를 찌르는 통찰과 촌철살인의 유머가 스며 있다. 이러한 유머는 통속적인 삶에 대한 관찰과 성찰의 사유 없이는 닿을 수 없다. 작가의 작품이 가지는 형태의 단순함 못지않게 작가는 이야기를 압축하는 탁월한 자질을 가지고 있다.

The artist severely criticizes males' absurd bluff. Yet, who can confidently say "I am free of charge!"? Maybe it is a kind of fate that every human being pursues false values. That's why the title of <pissing Contest> really touches our heart.
When people appreciate <pissing Contest> series, similar sentiments would emerge, at first, it is ridiculous for individuals to watch animal's defecation, but soon they find themselves in the scene. Son HyunOok's works surprisingly arouse sympathy, perception(giving a deep thrust) and humor. Such sense of humor cannot come naturally without observation and consideration to the ordinary life. People would agree that his works are particularly predominant in that his pieces imply stories while remaining unsophisticated in shape.

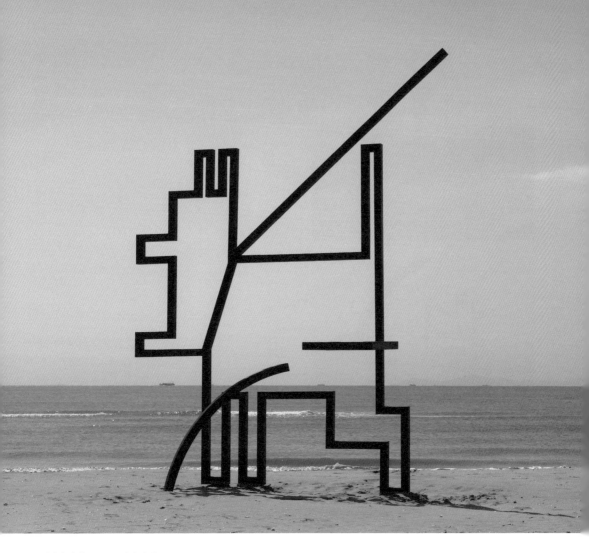

〈배변의 기술〉, 2015, 철에 채색, 4×3×6m
'Pissing Contest', 2015, Painted on steel, 4×3×6m

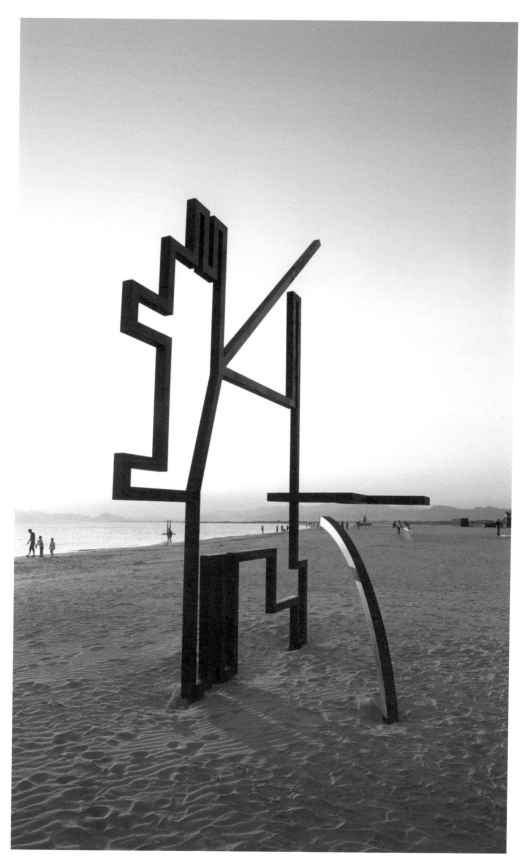

그룹 VGABS Group VGABS

앤듀르 아나다 부겔 Andrew Ananda VOOGEL

미국 USA

1983년 미국 로스앤젤레스 출생. 현, 한국 부산 거주 및 활동
Born in 1983, Los Angeles, USA. Lives in and works in Busan, Korea

플뢰리퐁텐 Fleuryfontaine

프랑스 France

갈드릭 플뢰리 & 앙투안 퐁텐
Galdric FLEURY & Antoine FONTAINE

1985년 프랑스 출생. 현, 한국 거주 및 활동
Born in 1983, France, Lives in and works in Korea

배성미 Sung-Mi BAE

한국 Korea

1971년 한국 서울 출생. 현, 한국 서울 거주 및 활동
Born in 1971, Seoul, Korea. Lives in and works in Seoul, Korea

마리아 사모르체바 Maria SAMORTSEVA

러시아 Russia

1992년 러시아 출생. 현, 한국 거주 및 활동
Born in 1992, Russia. Lives in and works in Korea

상상 염전
Imaginary Salt Pond

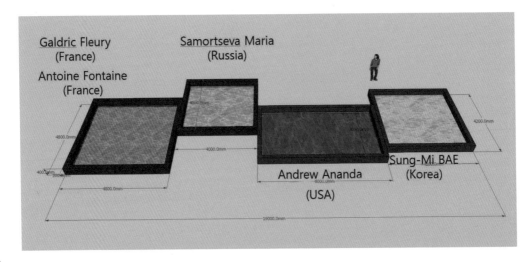

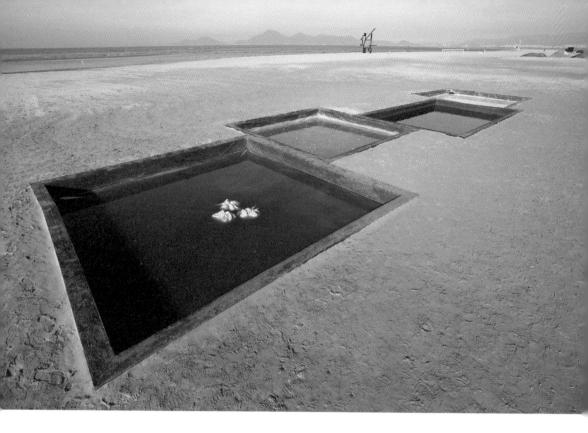

〈상상 염전〉, 2015, 나무, 소금, 바닷물, 목탄, 빨간무, 송화가루, 녹차잎, 가변 크기
'Imaginary Salt Pond', 2015, Wood, Salt, Sea Water, Charcoal, Red Beet, Pine Flower Powder, Green Tea Leaves, Variable Dimension

앤듀르 아나다 부겔 Andrew Ananda Voogel

흑수 The Blackwater

19세기 초 대영제국은 수많은 인도인들을 대양을 건너 카리브해로 강제로 이동시켰다. 인도인들은 영국과 고용 계약을 맺고 바다 너머 카리브해 연안과 남아메리카의 영국 식민지의 사탕수수 농장에서 오랜 기간 동안 일했다. 당시 바다를 건너가는 이 항해는 직역할 경우 "흑수"(black water)를 의미하는 "칼란파니"(Kalanpani)라 불렸다. 인도인들에게 흑수는 바다의 신비를 의미했으며 인도를 떠났던 많은 사람들에게 그 대양을 건너는 것은 자신들이 역사와 문화를 잃는 것을 의미했다. 고용된 노동자로서 바다를 횡단해야만 했던 수많은 인도인들에게 그들의 여정은 공허, 어둠, 미지의 세계로 향하는 것이었다. 그들은 카리브해 연안의 사탕수수 농장에서 영국인들을 위해 장시간 노동하며 하인이나 노예로서 멀리 떨어져 있는 해안을 바라보았다. 흑수의 개념은 그들이 항해했던 중간 항로의 역사를 의미한다. 역사에서 이러한 이야기는 잊혀졌지만 수많은 인도인들이 여전히 식민지 시대에 카리브해 연안에 형성된 농장에서 장시간 노동하고 있다. 단 그들은 더 이상 영국의 노예는 아니다. 이 염전은 그들이 흑수를 건너며 자신들의 역사가 지워졌을 때 그들이 경험했던 알려지지 않은 빈 공간을 은유한다.

In the early 19th Century, the British Empire forced many thousands of Indians to cross the ocean from India to the Caribbean. They were signed up as indentured servants to the British and brought across the ocean to work long hours in the sugar cane fields and plantations through out the British Colonies in the Caribbean and South America. At the time, the journey across the sea was referred to as the "Kalapani," directly translated as "Blackwater." The Blackwater for Indians represented the mystery of the sea, and for many to leave India and to cross the sea meant to lose one's history and culture. For those thousands of Indians that were forced across the sea as indentured servants, they took a journey into the void, the darkness and the unknown. They ended up on distant shores as servants and slaves, working long hours in the sugar-cane fields of the Caribbean for the British. The concept of Blackwater is the history of their Middle-Passage. It is one the stories that history has forgot, but thousands of Indians still occupy the many shores of the Caribbean, no longer slaves to the British, but still working long hours in the plantations and fields established under colonial rule. This salt-pond represents the metaphor of the unknown void that those individuals passed through when their history was erased as they crossed over the Blackwater

플뢰리퐁텐 Fleuryfontaine

백화제방 Let a Hundred Flowers Blossom

〈백화제방〉(百花齊放)은 마오쩌둥의 구호로부터 차용한 제목이다. 이 설치 작품은 레드 비트를 모아 염전 가운데 작은 섬을 형상화한 것이다. 그리고 연못의 물은 점차 빨간색으로 물든다.
이 구호는 1957년 여름 중국 공산당이 정치 제도를 개선하기 위해 지식인들로 하여금 이를 비판하도록 허용하는데 이용했다. 그러나 대부분의 사람들은 이것이 중국 정부가 반체제 인사를 식별해 내고 후일 숙청하기 위해 파놓은 함정일 것이라 추정한다.

"Let a hundred flowers blossom" is a common quotation of Chairman Mao Zedong's. This installation is made of hibiscus flowers gathered as a small isle in the center of a salt pond, coloring little by little the water in the pool in red.
This slogan was used during the summer of 1957 when the Chinese intelligentsia was invited to criticize the political system and consequently improve it. It's commonly supposed that this proposition of the China's government was a sort of trap for the Chinese dissidence in order to identify it and purge it afterwards.

배성미 Sung Mi BAE

바람에게 바람 Wish on the Wind

바닷물이 햇빛과 바람을 만나 땅에서 느리게 익어가는 소금. 시간이 흐르면서 마침내 눈부시게 빛나는 결정체가 된다. 과거에 사람보다 소금이 더 소중했던 염부들은 너나없이 소금이 '온다'라고 했다고 한다. 그만큼 소금은 귀한 것이었고 기다림이 준 대자연의 선물이었다. 나는 이번 작품을 통해 햇빛, 바람, 바닷물이 대지에서 느리게 잘 익어갈 수 있도록 하며 자연과 더불어 현재의 삶이 조화롭게 순화되기를 희망한다.

〈바람에게 바람〉은 미생물과 세포에 의해 색이 변한 캘리포니아 남부 만을 모티브로 소금이 자라는 염전을 재현하며, 바람에 날려온 노란색 송화가루를 통해 자연이 준 시공간에 대해 생각해 볼 수 있도록 하고 있다. 자연에게 무엇인가를 바라는 마음은 오래 전부터 인간이 취하던 주술적 행위이다. 나는 이곳에 부는 바람에게, 시간이 내어 준 소금에게 현재의 빠른 속도와 시간이 조금은 느리게 가기를 바란다.

Salt develops when sea water meets sunlight and wind. As time slips by, it at last turns into a dazzling crystal. In the past when salt was considered more precious than people, workers at seawater evaporation ponds often said "salt turns up." Salt was something precious that was considered a gift from nature and a product of waiting. In this work I hope that sunlight, wind, and seawater come together on the land and our present lives are in harmony with nature.

A 'Wish to the Wind' shows a representation of the salt ponds of a southern Californian bay whose color was changed by microorganisms, allowing viewers to think about space and time offered by nature with yellow pine flower powder. Our longing for nature is based on the shamanistic actions we humans have carried out for a long time. I wish that the present would flow slowly here as the salt time allows us to harvest.

마리아 사모르체바 Maria SAMORTSEVA

초록 마음 Green Mind

초록은 식물, 자연 그리고 성장의 색이다. 살아 있음을 증명하는 외피의 색이자 동시에 내면의 색이기도 하다. 나는 녹차잎을 통해서 내 마음의 작은 염전을 가꾸기로 한다.

Green is the color of plants, nature and growth. This is the color of the outside and inside at the same time to prove it to be still alive. I will make and cultivate my little salt pond in my mind through the tea leaves.

〈백화제방〉, 2015, 물, 소금, 레드 비트, 480×480cm
'Let a hundred flowers blossom', 2015, Water, salt, Red Beet, 180×180cm

〈초록 마음〉, 2015, 소금, 바닷물, 녹차잎, 400×400cm
'Green mind', 2015, Salt, Sea Water, Tea Leaves, 400×400cm

〈흑수〉, 2015, 소금물, 활성탄, 600×360cm
'The Blackwater', 2015, Salt Water, Activated Charcoal, 600×360cm

〈바람에게 바람〉, 2015, 소금, 바닷물, 송화가루, 420×420cm
'Wish on the Wind', 2015, Salt, Sea Water, Pine Flower Powder, 420×420cm

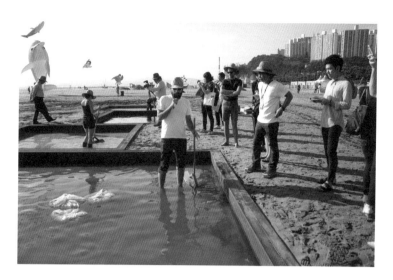

코넬 알베르투스 오우웬스 Cornelis Albertus OUWENS

네덜란드 Netherlands

1958년 네덜란드 출생. 현, 네덜란드 거주 및 활동
Born in 1958, Netherlands. Lives in and works in Netherlands

바다의 메아리
'Echoes of the Sea'

이 조형물은 세 개의 입방체 형태를 표현한 것으로 실제로는 두 개의 입방체만 드러나 보인다. 두 개의 실제 구조물은 철재 빔을 용접해 제작한다. 반면 가상의 입방체는 두 구조물들 사이의 중앙에 수직으로 강철봉을 세워 표현한다. 두 입방체는 각각 25가닥의 철선으로 세워진다. 입방체의 한 쪽 면의 여러 지점과 반대쪽 면의 한 점을 25가닥의 철선으로 단단하게 고정시키며, 이는 다시 중앙에 수직으로 세운 강철봉에 연결된다. 이 강철봉은 모래 위에 땅을 파서 세우고 여러 높이에 드릴로 구멍을 낸다. 이 구멍을 통해 소리가 발생한다. 이 두 입방체는 바다와 해변 주변의 환경을 틀 속에 집어 넣으며 작은 부분을 통해 보이는 이들 풍경은 시시각각 다르게 보인다. 철선은 세 곳. 즉 두 입방체 두 곳과 중앙의 강철봉 한 곳의 힘이 모이는 중심점에 모종의 움직임을 일으킨다. 또한, 이러한 철선들은 바람에 의해 움직이며 해가 질 무렵 햇빛을 반사한다. 이 설치물의 또 다른 중요한 점은 모래사장 위로 흥미있는 그림자를 드리우며 철골 위에 드릴로 낸 구멍과 바람이 불 때 하프처럼 움직이는 철선을 통해 소리를 발생시킨다는 점이다. 나는 자연과 인간이 조화를 이루는 쌍방향적 설치 작품을 제작하고자 했다.

Sculptural Installation representing 3 cubic forms of which 2 are actually visible made out of hollow steel beams which are welded together and 1 imaginary cubic form which is created in the center space between the 2 steel cubes in which a vertical steel rod is placed. The 2 steel cubes have each 25 steel wires which are fastened to one side of the cube and tied together in one center spot on the opposite side of the cube which is again connected with steel wires fastened to the vertical steel rod in the center space of the installation. The steel rod is also dug into the sand and has at various heights drilled holes in the steel which produces sounds. The cubes are framing the surrounding environment of the beach and the sea into small parts which views differ during the day. The steel wires are creating a certain "movement" into the cubes and 3 center points of "Energy" , 2 in each steel cube and 1 into the center space of the vertical positioned steel rod. Also these wires will be "moved" by the wind and will reflect the sun ray's, especially when the sun sets in the evening. This installation other main point is the producing of interesting shadows casted on the sand and the producing of sound through the drilled holes into the steel rod and maybe through the steel wires which will move like a harp when the wind blows strong enough. This Sculpture intention is to be an interactive installation in which nature and man harmonize.

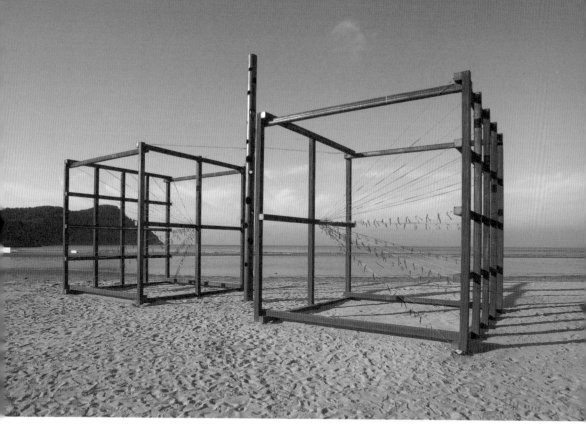

⟨바다의 메아리⟩, 2015, 할로우 스틸 빔, 철 와이어, 철 막대, 360×360×1080 cm
'Echoes of the Sea', 2015, Hollow Steel Beams, Steel Wires and a Steel Rod, 360×360×1080 cm

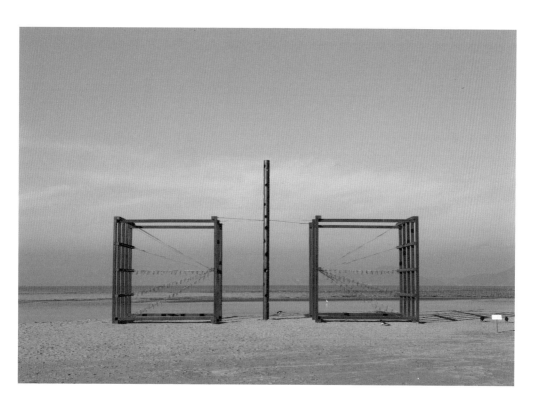

이명호 Myoung-Ho LEE

한국 Korea

1975년 한국 대전 출생. 현. 한국 서울 거주 및 활동
Born in 1975, Daejeon, Korea. Lives in and works in Seoul, Korea

다대포 돌
Dadaipo Stone

그간 이어 온 본인 작업의 연장선 상에서 다대포의 특성을 결합한 개념의 새로운 작업을 선보이고자 한다. 다대포의 돌에 캔버스를 설치한다. 다대포의 특성상 간만의 차가 크기 때문에 돌은 만조 때 완전히 바다에 잠기고 간조 때 완전히 바닥을 드러낸다. 간조와 만조 때 각 돌의 위치 별로 바다의 수위를 파악하여 적절한 높이의 각 캔버스를 만들되 만조 때에도 완전히 바다에 잠기지 않고 시각적으로 개념적으로 알맞은 높이가 되도록 설치한다. 따라서 만조 시에는 바다 위에 캔버스만 보이고 간조로 넘어가면서 서서히 돌과 바닥까지 온전히 드러나게 된다. 캔버스와 돌은 간만의 차에 따라 서서히 드러나고 사라지면서 캔버스에 돌의 모습을 그렸다 지웠다 한다. 캔버스에 자연이 그림을 그리는 개념이다. 나의 '사진–행위 프로젝트'를 다대포의 환경 특성에 맞게 활용한 작업이다. 기존 작업에서 나는 '예술 행위의 본질을 작업화' 하면서 '가치의 환기'에 주목하고 있는데 이번 작업에서는 그 맥락의 연장선 상에서 발전적으로 환경 특성에 따라 응용한 경우라고 하겠다.

I intend to present a new installation that reflects the traits of Dadaepo Beach as an extension of my previous works. I set up a canvas on a rock on the beach. As there is a large tidal range, the canvas and rock are completely submerged underwater at high tide and completely visible at low tide. I set the canvas at a proper height after examining the water levels of the sea at high and low tide: the canvas is visually and conceptually set at an appropriate height so as not to be completely submerged underwater. Accordingly, only the canvas is visible at high tide while the rock and ground are gradually revealed at low tide. The canvas and rock slowly appear and disappear due to the difference between the rise and fall of the tide that draws and erases the rock on the canvas. This work draws on the concept that nature paints a picture on canvas and applies my "photography-action project" to the environmental feature of the beach. While I paid attention to an "arousing value" in my previous works, representing the "nature of artistic practice," this work is applied to the environmental element of the beach as an extension of this context.

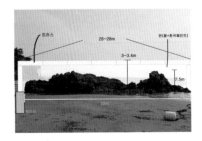
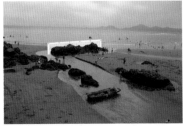

〈다대포 돌〉, 2015, 돌, 쇠, 가변 크기
'Dadaepo Stone', 2015, Stone, Steel, Variable Dimension

조나단 폴 포어맨 Jonathan Paul FOREMAN
영국 U.K

1992년 영국 웨스트 서식스 출생. 영국 펨브룩셔 거주 및 활동
Born in 1992, West Sussex, U.K. Lives in and works in Pembrokeshire, U.K

무제
Untitled

펨브로크셔 해변 주변에는 모래. 돌, 나무 등 대지미술에 영감을 불러 일으키는 소재들이 무궁무진하다. 바다에 비말을 일으키는 바람의 느낌과 맛, 조형물과 관람객들에게 미치는 비와 태양의 효과, 부드럽거나 거칠며, 차갑거나 따뜻한 촉감, 나무나 돌 등 자연에서 발견되는 소재를 설치 작업 현장에서 발견해 창조성을 발휘해 자연의 미를 표현할 수 있다. 이러한 모든 것들을 통해 우리는 원래의 장소에서 조형물을 감상하는 경험의 수준을 크게 향상시킬 수 있다. 물 위에 떠돌아 다니는 나무 조각도 한 때는 살아 있는 나무의 일부였으므로 이를 다시 심을 경우 새로운 나무가 될 수 있으나 이는 다른 방식으로 나무의 과거로 회귀하는 것이다.

옛 나무가 다시 심을 수 있는 유목(流木)이 되듯 과거의 작업은 새로운 작업으로 인도된다. 모래 위의 발자국이 순간적으로 사라지듯 모든 것은 영원하지 않으며, 이러한 창조물은 불과 수일 동안만 존재한다. 무언가를 받아들이는 것이 세상에서 가장 어려운 일일 수 있다. 그러나 우리는 이러한 실험을 진행하며 모든 것을 자유롭게 하는 방법을 배워야 한다. 무언가를 창조할 때 가정 생활이나 기법은 대부분 잊혀진다. 이것이 해방의 한 형태. 균형을 유지하기 위한 평온함의 한 형태이다. 창조는 또 다른 창조를 낳는다. 돌이나 나뭇가지가 끊임없이 변화하듯 이는 지속적인 연속과 같다. 변화는 생명체에 필수적인 것이다.

There is much inspiration for Land Art/Sculpture among the sand, stone and wood around the coast of Pembrokeshire. The beauty of nature with human creativity using materials found at the sight of the installation.
The feel and taste of wind swept sea spray, the effect of rain and Sun both on the sculpture and the viewer, the touch of Smooth, rough, cold or warm, wood or stone. All this and much more can greatly enhance the experience of viewing a sculpture in its original location.
As a piece of driftwood was once a growing tree it may be re-planted to become something new but returning to its past in a different way. Although at times the hands lead the way, past work guides new work as the past tree becomes driftwood to re-plant. Almost nothing lasts forever but these creations last less than days; as ephemeral as the footprints made in sand. Acceptance can be the hardest thing in the world, but in doing these experiments you learn of letting go. When creating, home life and technology are for the most part forgotten; this is a good form of release, a form of serene tranquillity to keep the balance. A creation leads to another creation; it is like a constant sequence none the same as no stone or branch is exactly the same constantly bring in the new and different, change is essential to life.

〈무제〉, 2015, 모래사장 위 드로잉, 가변 크기
'Untitled', 2015, Drawing on the Sand Beach, Variable Dimension

〈무제〉, 2015, 혼합재료, 다대포 해변가 주변에서 찾은 물체들, 가변 크기
'Untitled', 2015, Mixed Media, Found Objects from Dadaepo Beach, Variable Dimension

루드위카 그라지나 오고르젤렉 Ludwika Grazyna OGORZELEC
폴란드 Poland

1953년 폴란드 출생. 현, 프랑스 파리 거주 및 활동
Born in 1953, Poland. Lives in and works in Paris, France

공간 결정화 순환이 야기한 바다의 숨결
'The Breath of the Sea' from 'Space Crystalliztion' Cycle

연작 〈공간의 결정화〉의 일부인 부산의 다대포에 설치될 〈공간 결정화 순환이 야기한 바다의 숨결〉은 장소특정적인 조형 작품으로 24년 전인 1990년 최초로 프로빈스타운에서 제작되었으며 현재까지 세계 곳곳에서 발전된 형태를 선보이고 있다. 주어진 공간에서의 선(line)의 개입은 이러한 개입으로 초래된 다양한 변화로부터 비롯된 경험과 발전을 상기시킨다. 그리고 나아가 이러한 과정은 우리의 정신에 영향을 미친다. 나는 이것을 "공간이 여러 개체/결정으로 분리되는 것을 의미하는 "공간의 결정화"라 정의한다. 이 연작에 착수할 당시 처음에는 대단히 연관성이 높은 조각적 재료로 자갈을 사용하기로 결정했다. 보이거나 만질 수 있는 선은 공간을 분리하거나 전체로부터 분리된 공간의 윤곽선을 구성한다. 1991년 글에서 나는 다음과 같이 적었다. "공간은 새로운 심리적, 미적 수준을 성취하고자 하는 목적으로 물리적 혹은 의도적으로 개입된 선에 의해 결정된다. 공간은 내면을 보여줄 뿐만 아니라 감성으로 강화된 개인을 반영한다. 움직이는 선에 의해 창조된 그림을 추종하는 사람들은 춤의 일종이라 할 수 있는 신체의 움직임(구부리기, 굽히기, 주변을 걷기)에 기인한 공간적 상황에 조응할 필요를 경험하며 동시에 일상의 고정 관념, 행동 규범, 습성의 경계가 흐려지는 상태를 경험한다. 나는 나의 조각 작품이 생물학, 기계, 그리고 도구의 세계에서 비롯된 일시적인 현상과 같은 것이 되길 원한다. 우리는 조각 작품을 견고하고 무거우며 외부로부터 감상되고 오래 지속되는 재료로 만들어지는 것으로 이해한다. 나는 선에 의한 표현을 조각적 재료나 공간의 속성을 갖는 것으로 이해한다." (1991년 작업 노트))

'The breath of the sea' from 'Space Crystallization' Cycle at Dadaepo Beach, Busan city, South Korea - it will be site specific sculpture next one from 24 years old cycle- is also therefore a type of artistic action that I began in Provincetown in 1990 and am developing through today in a variety of spaces and places in the world. Speaking of the intervention of line in a given space brings to mind the experiences and developments resulting from the various transformations of this intervention and furthermore, the impact of these procedures on the human psyche. I named it – it meaning the division of space into individual pieces/crystals – "Space Crystallization" somewhat after the fact. I decided in the program written at the time that the cobblestones of space / were entrusted with my first, most relevant sculptural material. Line – seeable and touchable – is the only contour dividing such and such fragments of space from the previously undivided whole."…Space is determined physically and purposefully by the interference of lines with the purpose of obtaining new psychological and aesthetic qualities."Spaces" show not only the inside but carry it to the person, the reflection of whom are intensified with emotion…."…A person following the picture created by the moving line experience the necessity of adjusting to the spatial situation producing motions of the body (bending, ducking or stepping around) which is a form of dance, simultaneously experiencesstates that go beyond the boundaries of quotidian stereotypes, behavioural codes and habits(…) want my sculpture to be like a passing phenomenon springing out of the world of biology, machines and instruments. From an understanding of sculpture as solid and heavy, viewed from the outside and made from lasting materials. I have left myself line expressing itself with the properties of its material and the space…" (From my art statement written 1991)

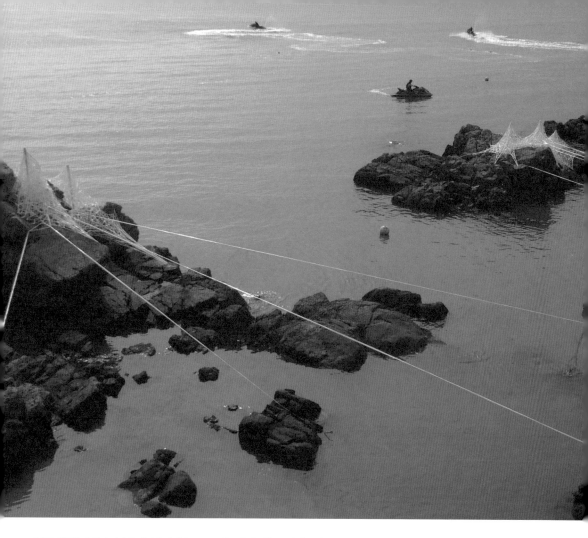

〈공간 결정화 순환이 야기한 바다의 숨결 〉, 2015, 셀로판 줄, 철 끈, 가변 크기
'The Breath of the Sea' from 'Space Crystallization' Cycle, 2015, Cellophane line, Steel lines, Variable Dimension

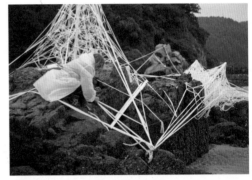

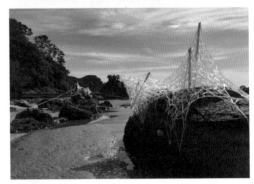

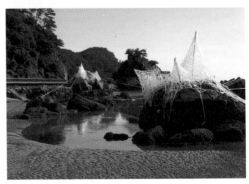

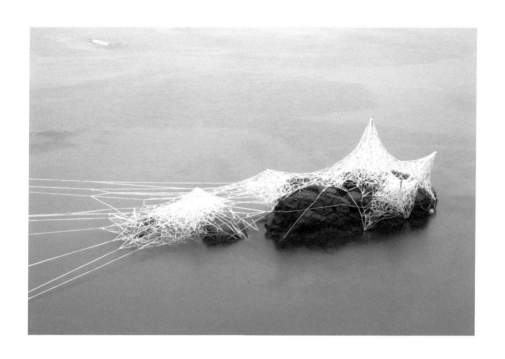

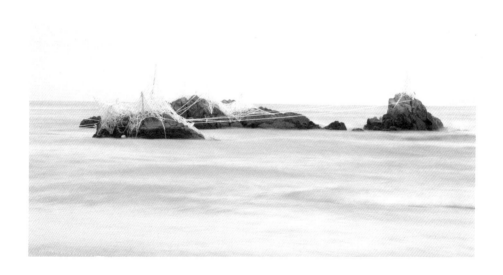

특별전 개요

주제	보다 — 바다와 씨앗
구성	섹션_나는 바다
작가	피터 린 카이트 Ltd (뉴질랜드)
대표	피터 린
쇼디렉터	크랙 한센
일정	2015. 9. 18~9. 24
장소	다대포해수욕장

피터 린 카이트(Peter Lynn Kites Ltd, 뉴질랜드)라는 기업을 초대하여 일주일 동안 선보이는 《특별전_나는 바다(Flying Sea)》는 '대형 연 설치 퍼포먼스 이벤트'로 꾸며진다. 25m에 이르는 흰수염고래(Blue Whale)과 가오리(Stingray) 그리고 8미터가 넘는 게(Crab) 등 3종의 대형 연이 참여한다.

구분	섹션명	출품작 유형
특별전	나는 바다	대형 연 설치 퍼포먼스 이벤트

Special Exhibition outline

Theme	See — Sea & Seed
Composition	Section_Flying Sea
Who	Peter Lynn Kites Ltd
CEO	Peter LYNN
Show Director	Craig HANSEN
When	18th Sept. ~ 24th Sept. 2015
Where	Dadaepo Beach

The Special Exhibition_Flying Sea is a one-week special exhibition presented by Peter Lynn Kites Ltd. On show at this large-scale kite installation performance event are three kites. They are Blue Whale which is twenty five meters long, Stingray, and Crab which is over eight meters long.

Part	Section name	Artwork
Special Exhibition	Flying Sea	Giant kites Installation Performance Event

1973년 이래, 뉴질랜드를 중심으로 활동
Since 1973, Based in New Zealand
www.peterlynnkites.com

대기의 대양
Oceans of Air

매일 아침 해변에 나와 바람의 방향과 세기를 살펴본다. 작품의 설치는 전적으로 이러한 요소들에 의존한다. 매일 바람을 고려해 적당한 장소에 지지대를 설치하는데 한 시간이 걸리며 하루의 전시를 마친 후 장비들을 정리하고 모래주머니의 모래를 제자리로 되돌려 놓는데 또 한 시간이 소요된다. 하루의 일정은 연(kites)이 잘 날 수 있도록 바람의 방향과 세기에 따라 이를 조정해 어떤 조건에서도 잘 보이도록 하는 것이다.

Every Day that I arrive to the beach the setup will depend on the wind direction and strength, but in principal it will take one hour each day to setup the anchor in the correct place for the wind and at the end of the day one hor to pack up and make good the beach by removing the sand from the bag and placing it back on the ground. The day will consist of keeping the kites flying and adjusting for wind strength and direction, to make the best display in all conditions.

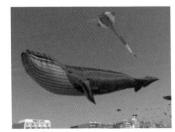 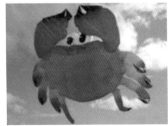

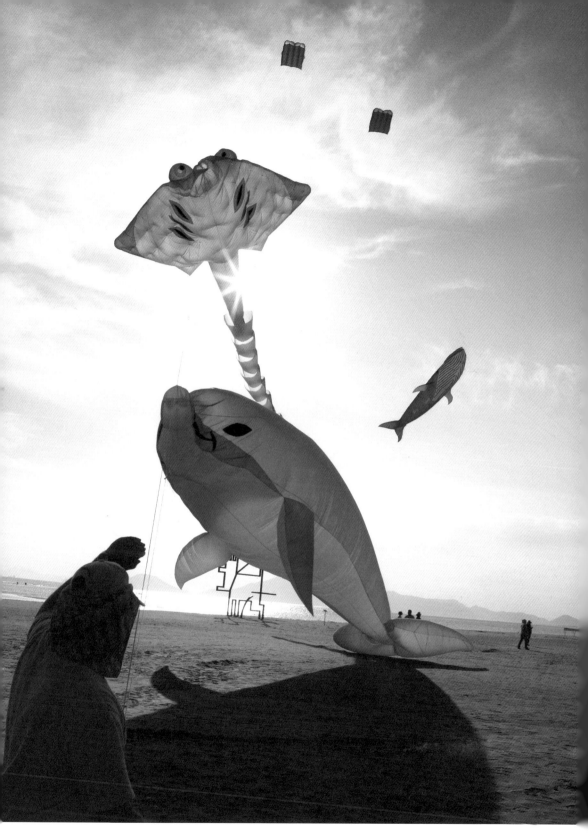

〈대기의 대양〉, 2015, 립 스톱 나일론, 스펙트라 선, 모래, 돌고래(15m), 가오리(30m), 게(8.2m)
'Oceans of Air', 2015, Rip stop Nylon, Spectra Lines, Sand, Blue Whale (15m), Stingray (30m), Crab (8.2m)

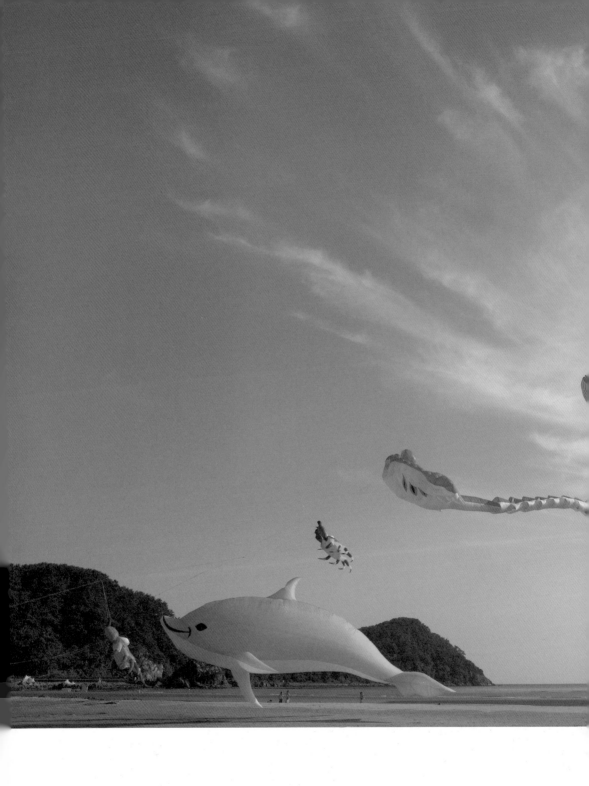

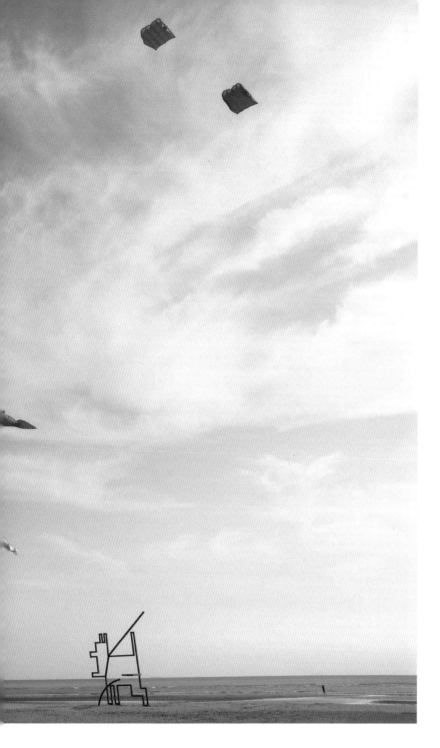

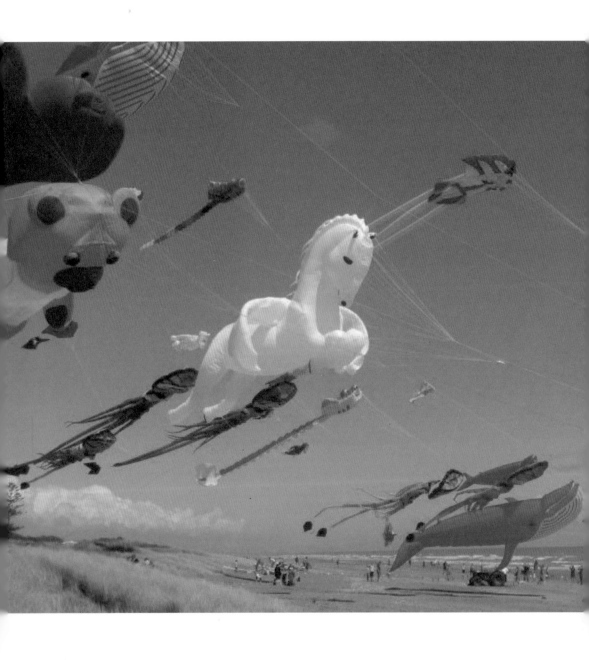

대표: 피터 린 CEO: Peter LYNN
뉴질랜드 New Zealand

쇼감독: 크랙 한센 Show Director: Craig HANSEN
뉴질랜드 New Zealand

피터 린 카이트 Ltd
<u>Peter Lynn Kites Ltd</u>

피터 린 카이트 Ltd는 1973년 이래 연들을 만들고 날려 왔다. 이 회사는 세계를 선도하는 대형 연(쇼 카이트) 제조회사로서 설립되었다. 피터 기업의 스펙터클하고 변화무쌍한 연 연출은, 평균적으로 2주에 한 번씩 초대를 받을 만큼, 세계 각지의 연 축제로부터 가장 많은 초청을 받고 있는 중이다.

Peter Lynn Kites has been making and flying kites since 1973. We have established ourselves as the worlds leading manufacturer of large show kites.
Peter's spectacular and ever changing kite display is one of the most invited to kite festivals the world over, on average one every two weeks.

〈피터 린 카이트의 대형 연 날리기〉 중에서
'Peter Lynn Kites's the giant kites-flying show

퍼포먼스

연번	작가명	기간		시간	횟수	내용	섹션
1	이종균	9. 19~9. 23		1시–3시	5회	관객이 참여하여 물고기 형태의 망태기에 쓰레기를 채워가며 이동하면서 작품을 완성하는 예술 체험 퍼포먼스	섹션 3
		10. 8~10. 10			3회		
2	조덕현	9. 18 / 9. 26 10. 3 / 10. 10 / 10. 17		11시~17시 (12시~13시 제외)	5회	상상의 발굴퍼포먼스	섹션 2
3	그룹 세라에너지	9. 19		16시~18시	1회	노천 소성을 통한 토기 제작 퍼포먼스	섹션 2
4	최선	1차 사전 워크숍(서울) 8. 25~9. 5		10시~18시	상시 진행	컨테이너 앞 책상 위 펼쳐진 캔버스 위에 작가가 떨구어 놓은 아크릴 물감을 관객들이 숨을 불어넣어 무수한 숨길을 만들어 가면서 작품을 완성해 가는 예술 체험 퍼포먼스	섹션 2
		2차 본전시 워크숍(부산) 9. 17~9. 21					
5	도릿 크로시어 Dorit CROISSIER	9. 18~9. 19		16시~18시	2회	한국의 봉화를 재현하여 흙탑에 불을 피우는 퍼포먼스	섹션 2
6	친탄 우파드야이 Chintan UPADHYAY	9. 20~9. 21		16시~18시	2회	–1단계: 폐차 흰색 페인트칠 하기 –2단계: 폐차 부수기 –3단계: 시민들과 폐차에 꽃과 식물을 심고 구성하기	섹션 2
7	조나단 폴 포어만 Jonathan Paul FOREMAN	9. 17~9. 23		10시~18시	상시진행	다대포해수욕장의 자연물을 수집하여 즉흥적으로 작품 제작, 백사장에 드로잉 퍼포먼스	섹션 4
8	앤디 드완토로 Andy DEWANTORO	9. 18~10. 18		10시~18시	상시진행	관객이 촬영한 얼굴 사진을 매일 10인씩 선정하여 100명이 되었을 때 완성	섹션 1
9	오노 요코 Yoko ONO	9. 18~10. 18		10시~18시	상시진행	관객이 자신의 소원을 기원하는 소망 쪽지를 작가의 소망나무에 매다는 관객 참여형 퍼포먼스	섹션 3

Performance

No.	Artist	Period	Time	Number of Times	Contents	Section
1	Jong-Kyun LEE	Sept. 19~23	13h-15h	5	Moving art performance with visitor participation filling fish shaped string bags with trash	Section 3
		Oct. 8~10		3		
2	Duck-Hyun CHO	Sept. 18, 26 Oct. 3, 10, 17	11h~17h (except 12h~13h)	5	Imaginary excavation project	Section 2
3	Group Cera-energy	Sept. 19	16h~18h	1	Ceramic making performance baking pottery in the open air	Section 2
4	Sun-CHOI	1st Pre-Workshop (Seoul) : Aug. 25~Sept. 5	10h~18h	All day long	Visitor participation performance which accomplished art work through the visitors' invisible breath on the canvas beside the container	Section 2
		2nd Main-Exhibition Workshop (Busan) : Sept. 17~21				
5	Dorit CROISSIER	Sept. 18~19	16h~18h	2	Fire performance inside the brick tower, which reproduced a Korean traditional beacon	Section 2
6	Chintan UPADHYAY	Sept. 20~21	16h~18h	2	-step 1: Painting a damaged car white -step 2: Breaking the damaged car -step 3: Installation of the plants and the flowers-	Section 2
7	Jonathan Paul FOREMAN	Sept. 17~23	10h~18h	All day long	Spontaneous Installation performance after collecting natural objects from Dadaepo beach. Drawing performance on the sand	Section 4
8	Andy DEWANTORO	Sept. 18~Oct. 18	10h~18h	All day long	Visitor participation performance selecting ten portrait photos daily until reaching one hundred people	Section 1
9	Yoko ONO	Sept. 18~Oct. 18	10h~18h	All day long	Visitor participation performance allowing visitors to tie a piece of paper around a branch of a wish tree	Section 3

이벤트

2015바다미술제 서포터즈

전시 현장을 일반 관람객의 입장에서 보다 가까이에서 취재하고 컨텐츠를 기획하는 2015바다미술제 서포터즈를 기획하고 운영하였다. 지난 8월 17일부터 26일까지 10일간 부산, 경남에 거주하는 일반 시민들을 대상으로 모집하였으며 총 6명의 서포터즈가 선발되어 전시장 곳곳을 누볐다. 본격적인 전시 준비에 들어간 9월부터 2015바다미술제가 막을 내릴 때까지 온, 오프라인으로 활동하였고, 전문 미술인이 아닌, 시민의 눈으로 2015바다미술제 작품과 현장, 그리고 다양한 축제 행사 프로그램, 참여 프로그램들을 소개하며 2015바다미술제와 관람객 간의 소통을 도모하였다.
서포터즈
김수진, 남가희, 심유정, 안혜진, 이지윤, 조초희

Sea Art Festival 2015 Supporters

The Sea Art Festival 2015 Supporters, who plan contents and cover the exhibit with the eyes of general visitors, were planned and operated. For ten days from August 17 to 26, they were selected from the public living in Busan and Gyeongnam, and a total of six supporters were selected who examined every corner of the exhibit. From September when full-fledged preparation for the exhibit began until the end of the Sea Art Festival 2015, they were active both on and offline. They introduced artworks, site, various festival event programs and participation programs of the Sea Art Festival 2015 as citizens rather than art experts in order to provide communication between the Sea Art Festival 2015 and the visitors.

2015바다미술제 아트메이트

2015바다미술제 작품 설치 기간 동안 2015바다미술제 아트메이트를 진행하였다. 아트메이트는 2015바다미술제 전시 준비 과정, 작품 제작 과정을 함께 경험하며 미술, 전시 현장의 제작 과정을 몸소 체험하고 작가와 소통하는 프로그램으로 이번 2015바다미술제에서 처음 진행되었다. 오태원, 노주환, 사라웃 추티웅페티, 페르난도 알바레즈 페레즈 작가의 작품을 함께 만들어 갈 아트메이트를 지난 9월 4일부터 10일까지 7일간 모집하였으며 신청서 접수 및 선별 과정을 통해 총 6명의 아트메이트가 프로그램에 참여했다. 9월 12일 노주환 작가의 〈사랑해요_천 개의 꿈〉 작품을 시작으로 9월 15일엔 오태원작가의 〈천 개의 빛, 천 개의 물방울〉, 9월 16일엔 사라웃 추티웅페티 작가의 〈소망, 거짓말 그리고 꿈, 아름다운 신세계〉, 9월 23일엔 페르난도 알바레즈 페레즈 작가의 〈씨앗들〉이란 작품에 아트메이트가 활동했으며 아트메이트는 작가, 작품에 대한 간단한 소개를 들은 후 설치가 진행 중인 현장으로 이동하여 3시간~4시간 정도 작가와 함께 작품 제작을 진행하고 대화하며 소통하는 시간을 가졌다.
아트메이트에는 어린이 교육 기관 관계자, 대안학교 학생, 외국인 등 다양한 사람들이 참여했으며 미술 분야에 종사하는 사람은 아니지만 전시 준비 및 작품 제작이라는 짧은 활동을 통하여 미술과 전시를 좀 더 이해하는 시간을 가졌다. 작가의 영감이 작품으로 탄생하는 순간을 함께 하며 관람객으로서 느꼈던 감동과는 또 다른 새로운 추억을 선사했다.
아트메이트
Agatha Christiana, 권수진, 안다솜, 유정희, 한연주

Event

Sea Art Festival 2015 Art Mate

While the artworks were on display at the Sea Art Festival 2015, the Sea Art Festival 2015 Art Mate was also carried out. The Art Mate is a program to experience the Sea Art Festival 2015 exhibit preparation process and the art production process, while experiencing the production process of arts and exhibits and communicating with artists. It was first introduced in the Sea Art Festival 2015. Art Mates who would make artworks together with artists such as Tae-Won OH, Ju-Hwan NOH, Sarawut CHUTIWONGPETI, and Fernando ALVAREZ PEREZ were recruited for seven days from September 4 to 10, and a total of six Art Mates were selected to participate in the program. Starting on September 12 with Ju-Hwan NOH's *Love_1000 Dreams*, and Tae-Won OH's *A Thousand Lights, Thousands of Water Droplets* on September 15, Sarawut CHUTIWONGPETI's *Wishes, Lies and Dreams, Beautiful New World...* on September 16, and Fernando ALVAREZ PEREZ's *Seeds* on September 23, the Art Mates listened to brief introductions on the artists and artworks, and moved to the site where installations were being made, and helped produce the artworks with the artists for three to four hours, and talked and communicated with them.

Various people such as persons from children's education institutes, alternative school students, and foreigners participated as Art Mates, and though they do not work in the art field, they were able to have a deeper understanding of art and exhibitions through the short activities of preparing for the exhibit and working on the artworks. While experiencing the transformation of an artist's inspiration into an artwork, they gained new memories that are different from the impressions felt as simple audiences.

2015바다미술제 사진 공모

2015바다미술제의 도록에 들어갈 사진들을 위해 일반 관람객들을 대상으로 공모를 진행하였다. 전시 장소인 다대포해수욕장은 아름다운 경관으로 많은 사진 애호가들이 찾는 곳이기도 하다. 이에, 다대포의 아름다운 경관에 작품이 더해진 사진들을 공모를 통해 모집하였다. 인스타그램과 이메일을 통해 개막 첫 주 주말 동안 많은 이들이 접수하였고, 이 중에서 전시감독이 선정한 사진들이 최종적으로 도록에 실리게 되었다.

Sea Art Festival 2015 Photo Contest

Photos to be placed in the catalog of the Sea Art Festival 2015 were collected by holding a contest among visitors. Dadaepo Beach, which is where the exhibition was held, is also frequented by many amateur photographers for its beautiful scenery. Thus, photos that add the artwork on the beautiful sceneries of Dadaepo were collected through contests. Many people submitted their works via Instagram and e-mails in the first week, and photos selected by the artistic director were carried in the catalog.

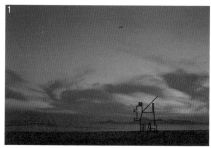

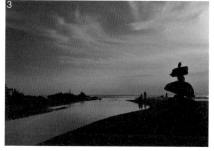

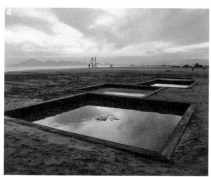

1, 2 장영옥, 부산시 연제구 거제동
3, 4, 5 김효숙, 부산시 동래구 안락동
6 강한나, 부산시 연제구 연산동
7 류화자, 부산시 수영구 남천동
8 박미향, 부산시 연제구 연제동

223

2015바다미술제 작품 음성 해설

매년 전시의 작품 음성 해설을 모바일 홈페이지를 통해 들을 수 있지만 이번 2015바다미술제의 작품 음성 해설엔 특별한 점이 있다. 바로 2015바다미술제 김성호 전시감독이 직접 설명하고 녹음한 해설을 들을 수가 있다는 것이다. 작가의 작가 노트가 아닌 기획자가 직접 전하는 작품 설명을 전시감독의 목소리를 통해 들을 수 있다는 점이 새롭다. 이번 작품 음성 해설은 부산영어방송국과의 협업과 지원을 통해 이루어졌으며 2015바다미술제 김성호 전시감독이 직접 전달하는 작품해설은 2015바다미술제 모바일 홈페이지를 통해 확인할 수 있다(www.busanbiennale.org/m)

Sea Art Festival 2015 Artwork Audio Commentary

Commentaries on artworks in the exhibits were available through the mobile homepage every year, but there is something special about the Sea Art Festival 2015 artwork audio commentaries. In the Sea Art Festival 2015, artistic director Sung-Ho KIM recorded commentaries himself. This is new in the fact that rather than using the work notes of artists, the director's descriptions on artworks are told through the voice of the artistic director. The audio commentaries were made with the cooperation and support of the Busan English Broadcasting and commentaries given by the Sea Art Festival 2015 artistic director Sung-Ho KIM are available in the Sea Art Festival 2015 mobile homepage (www.busanbiennale.org/m)

2015바다미술제 도시철도 테마칸 운영

다대포해수욕장은 부산의 주요 번화가로부터 멀리 떨어져 있다는 취약점을 가지고 있었다. 이러한 단점을 해소하고 일반 시민들에게 더 가까이 다가가기 위해 올해 최초로 도시철도 테마칸을 기획하고 운영하였다. 부산 도시철도 1호선의 내부를 2015바다미술제의 현장처럼 조성하여 2015바다미술제를 알리고 이용객들은 실제 전시장에 온 듯한 느낌을 가질 수 있도록 기획하였다. 도시철도의 바닥에는 백사장과 바닷물을 연출하고, 각 창문마다 2015바다미술제의 대표 작품들의 사진들을 랩핑하여 일반 대중들로 하여금 자칫 어렵게 보일 수도 있는 전시를 더 친근하게 이해할 수 있도록 하였다. 이번 '2015바다미술제 도시철도 테마칸'은 부산교통공사의 협의를 얻어 성사되었으며, 노포역과 신평역 사이를 운행하는 부산 지하철 1호선을 대상으로 1대에 1량씩, 총 2량에 조성되었다. 평일과 일요일, 공휴일에는 왕복 7회, 토요일에는 왕복 6회씩 운영되어 전시 폐막일인 10월 18일까지 운영되었다.

Sea Art Festival 2015 Metro Theme Car

A weakness of Dadaepo Beach is that it is far away from the geographical and cultural centers of Busan. In order to address this weakness, a metro theme car was planned and operated for the first time this year to help make it more accessible to people. The interior of the Busan Metro line 1 was designed to look like a scene from the Sea Art Festival 2015 to tell people about the Sea Art Festival 2015, and it was designed so that users could feel as if though they were at the exhibit. The floor of the subway was made to look like a sandy beach and the ocean, and each window was wrapped with photos of the main works of the Sea Art Festival 2015 to make the public feel a bit more at ease when viewing exhibits. The 'Sea Art Festival 2015 Metro Theme Car' was made through the consent of the Busan Transportation Corporation, and was made in a total of two cars, with one being in each train in the Busan Metro line 1 servicing between Nopo Station and Shinpyeong Station. It runs seven round trips on weekdays, Sundays and holidays, and six times on Saturdays until the last day of the exhibit on October 18.

노주환 작품 공모 수상작

대상

사하초등학교 6-6 김희준

최우수상

사하초등학교 1-2 최민성

사하초사하초 2-5 김진은

우수상

좌측부터
사하초등학교 6-2 임채윤
응봉초등학교 2-1 박인영
토성초등학교 3-2 이해인
토성초등학교 4-3 김희주
토성초등학교 4-4 안혜원
하남초등학교 1-3 전수원
하남초등학교 2-1 조현수

227

[장려상]

가남초등학교 4-1 송여주
구평초등학교 6-1 김준혁
나무칠드런아트 이준원
대평초등학교 6-3 박세원
사하초등학교 1-3이루리
사하초등학교 3-5 김시연
사하초등학교 6_2 박수빈
사하초등학교3-4 신화연
삼동어린이집 김재욱
샤샤의 미술(대연초등학교 1-2) 박강인
예그랑 열매반 김소향
응봉초등학교 1-2 이종원
응봉초등학교 3-1 김예원
응봉초등학교 4-1 이은영
토성초등학교 1-1 최수인
토성초등학교 1-3 김윤서
토성초등학교 2-4 이윤지
토성초등학교 4-3 김민정
펀아트미술학원 (신재초등학교) 김해민
학사초등학교 3-1 유승아

구평초등학교 4-1 장윤정
나무칠드런아트 김민서
대연초등학교 1-6 김준혁
사하초등학교 1-1 김지유
사하초등학교 2-3 김류민
사하초등학교 3-5 오서율
사하초등학교 6-2 박수인
삼덕초등학교 4-1 박한빈
샤샤의미술 (대연초등학교 3-1) 홍진효
연학초등학교 4-1 구경은
옥천초등학교 1-3 오준서
응봉초등학교 1-2 최운학
응봉초등학교 3-2 장다혜
응봉초등학교 5-1 박서연
토성초등학교 1-1임예담
토성초등학교 2-4 강동현
토성초등학교 3-2 고은진
펀아트미술학원 (송수초등학교 3학년) 박유람
펀아트미술학원 전지훈
행복나무미술학원 -이예린

아트 워킹, 아트 토킹, 아트 메이킹

감독 김정주

《2015바다미술제》는 '보다 — 바다와 씨앗(See — Sea & Seed)'을 주제로 16개국 34인(팀)의 작가들이 다대포해수욕장에서 미술 작품을 한 달 동안 선보인다.

이 기간 동안 진행되는 축제 행사는 2015바다미술제의 기획 의도와 연동하여, 일상에서 만나는, 그리고 자연에서 만나는 예술을 통해 사람과 바다, 예술과 지역, 미술가와 시민들이 관계를 형성하는 것을 목표로 두었다. 관람으로 그치는 미술제가 아닌 머물고 즐기며 참여하는 프로그램으로, 현대미술에 좀 더 친근하게 접근할 수 있도록 안내하는 프로그램으로, 환경을 생각하고 부산을 알아가는 체험 활동으로 축제 행사의 코너를 다음과 같이 구성하였다.

Art Walking 거닐다+만나다, 예술 산책 리사이클링 아트 쉼터, Artalk 콘서트	**Art Talking** 바다, 미술을 이야기하다. 아트큐브, 아트토크	**Art Making** 바다, 강, 해안의 재료로 만드는 미술 체험 활동 사랑海 체험존, 아트마켓

해변을 거닐다 만나는 예술 'Art Walking'은 바다미술제 작품을 감상하다 잠깐 쉴 수 있는 – 폐패트병, 폐비닐, 폐현수막 등으로 만들어진 – 스트리트 퍼니쳐를 준비하여 천천히 머물며 바다와 작품을 볼 수 있도록 하고, 축제 무대에서 진행되는 주제별 음악 공연인 'Artkalk 콘서트'로 구성하였다. 부산을 중심으로 활동하고 있는 다양한 장르의 뮤지션 총 18개 팀과 개인으로 각 회차별 '바다', '보다', '그리고', '씨앗'이라는 주제로 9회 공연이 구성되었다. 회차별 주제 또한 바다미술제의 기획 의도와 흐름에 맞추도록 했다.

바다에서 예술을 이야기하는 'Art Talking'는 축제 행사 안내소의 역할을 하며 도슨트의 작품 설명도 들을 수 있는 컨테이너 '아트큐브'가 마련되었고, 'Artkalk 콘서트'와 함께 진행되는 '아트 토크'는 2015바다미술제 참여 작가와의 만남, 전시감독과의 만남, 부산과 포구 이야기, 바다와 인문학, 일상의 문화 예술 등에 대한 이야기로 관객들과 소통한다.

'Art Making'은 핸드메이드 아트 상품으로 구성되는 아트마켓이 열리는데 행사 기간 총 40여 팀이 번갈아가며 참여하여 시민들과 만난다. 그리고 바다와 강에서 얻어지는 재료로 만드는 미술 체험 활동인 사랑海아트체험 프로그램이 진행된다. 예술 체험 강사와 묶고, 엮고, 자르고, 다듬고 그리는 조형의 기본 요소를 접하며 시민들 개개인의 미술적 감각을 발견하고 친환경 재료와 자원 순환의 리사이클링 아트 체험을 통해 환경을 생각해 보는 시간을 제공한다.

축제 행사가 열리는 장소의 공간 구성은 여백이 많고 광활한 다대포 해변과 잘 어우러질 수 있도록 나무 소재로 제작해 편안함과 친숙함을 느낄 수 있게 했다. 쉼터로도 쓸 수 있는 축제 무대와 'Artalk 콘서트' 관람석이면서도 전시 관람객들이 앉았다 갈 수 있는 벤치, 작은 공간이지만 바다의 풍경을 감상할 수 있는 '예술가의 집'이 그러하다.

특히 '예술가의 집'은 '시인의 방'과 '화가의 방'으로 구성하여 바다와 작품에서 얻은 다양한 감성을 글과 그림으로 풀어낼 수 있도록 하여 바다미술제의 연장선에 있는 체험이라고 할 수 있다.

자칫 가족 단위의 관람객 유치 도구이거나 부대행사로 전락될 수 있는 위험성을 없애기 위해 최대한 바다미술제의 기획 의도와 다대포라는 장소의 특성을 고려하고 좀 더 친숙하게 미술을 이해하고 접근할 수 있도록 프로그래밍을 하였고, 주최 측에서도 기획 단계부터 축제 행사 위치와 공간 구성, 내용이 바다미술제에 잘 녹아들 수 있도록 많은 배려를 했다.

격년제로 열리는 바다미술제가 부산 시민들에게 부산과 바다를 사랑하는 마음을 일깨우고 일상에서 자연스럽게 예술을 즐기는 문화 향유의 계기가 되길 바란다.

Art Walking, Art Talking, Art Making

Director, Jung-Ju KIM

The 36 artists and teams from 17 countries have been exhibiting their works for one month at Dadaepo Beach in 2015 Sea Art Festival under the theme See – Sea & Seed. Interworking with the purpose of the Sea Art Festival, the festival events taking place in this period have set up an objective to form relations between man and the sea, art and the region, and artists and citizens through art we come across everyday life and nature. The event consists of the following sections: a program where viewers join and enjoy rather than merely seeing, a program to help viewers become closer with contemporary art, and an experience activity to consider the environment and gain knowledge about Busan.

Art Walking Walk+Meet, Art Walking	Art Talking Sea, Talking with Art	Art Making Art Program with materials from sea, river, beach
Recycling Art Shelter Artalk Concert	Art Cube Art Talk	Love-Sea Art Program Zone Art Market

Art Walking, where viewers meet while walking along the beach, allows viewers to leisurely view the sea and artworks near the rest area filled with street furniture made of plastic bottles, vinyl waste, and waste banners and take a rest while appreciating the works on exhibit at the Sea Art Festival. This section includes the Artalk Concerts, music concerts which reflect each sub-theme. The 18 musicians and teams who are mainly active in Busan will perform nine concerts with the sub-themes 'sea,' 'see,' and 'seed.' Each concert is advised to reflect each sub-theme or the purpose and tendency of the Sea Art Festival.

Art Talking, a section in which we talk about art at the sea, plays the role of an information post where work explanations are offered by the docent at the Art Cube, a refurbished shipping container. The Art Talk to be conducted alongside the Artalk Concerts consists of talks with participating artists and talks with the artistic director to open up communication with viewers, addressing the subjects of Busan and ports, the sea and humanities, and quotidian culture and art.

Art Making consists of art markets in which 40 teams sell their handmade artistic products in turns and the Love Sea Art Experience Program, an art experience program in which participants produce artworks with materials secured from the sea and the river. While going through the elemental factors of creating form, such as binding, weaving, cutting, and honing, participants can discover their artistic sense and have an opportunity to consider the environment through their experience of art using eco-friendly materials and reclaimed materials.

The facilities for the events were made with wooden materials to allow viewers to feel comfortable and familiar and to be in harmony with the vastness of Dadaepo beach with its many empty spaces. They include the festival stage that can also be used as a rest place, benches that are seats for the Artalk Concerts for the viewers to rest on, and the Artist House, a small space where viewers can appreciate the seascape. The viewers are allowed to express their feelings toward the artworks in writing and pictures, especially at the Artist House composed of the poet's room and the painter's room.

The events have been designed to reflect the purpose of the Sea Art Festival and the spatial features of Dadaepo as much as possible, hoping to not be seen as a subsidiary event and a mere tool for inducing family viewers, but rather something to enable viewers to understand and feel more familiar with contemporary art. The organizer offered considerations from its initial stage for the events to be in accordance with the Sea Art Festival in terms of its venues, site plan, and content.

The Sea Art Festival, a biannual art occasion, is expected to awaken Busan citizens to their love of the region and the sea and serve as a momentum to enjoy culture and art in a natural atmosphere.

축제 행사　　　Festival Events

○ 개요

　　기간 : 2015. 9. 19～10. 18

　　장소 : 다대포해수욕장 일대

　　내용

> ### Art Walking
> 거닐다+만나다, 예술 산책
>
> 리사이클링 아트 쉼터,
> Artalk 콘서트

> ### Art Talking
> 바다, 미술을 이야기하다.
>
> 아트큐브, 아트토크

> ### Art Making
> 바다, 강, 해안의 재료로
> 만드는 미술 체험 활동
>
> 사랑海 체험존, 아트마켓

○ 세부 내용 및 실행 계획

Art Walking: 거닐다+만나다, 예술 산책

리사이클링 아트 쉼터 (12:00～18:00, 상설 운영, 축제 행사장 일대)

모래사장에서 바다미술제 작품과 바다를 보며 감상과 휴식을 위한 공간

폐파레트, 폐페트병, 폐현수막, 페비닐 등을 이용한 리사이클링 스트리트 아트 퍼니쳐

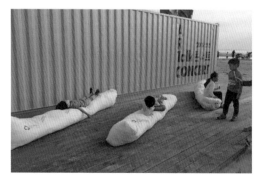

리싸이클링 아트쉼터

Artalk 콘서트 (공연+아트토크 / 16:00~18:00, 총 9회, 축제 행사장 무대)

회차	주제	날짜	이름(팀명)	장르, 내용
1	바다	9/20(일)	오페라컴퍼니	오페라 퍼포먼스
2		9/27(일) *추석연휴	리에또트리오	클래식&뉴에이지
			하지림재즈트리오	재즈 연주
3		9/28(월) *추석연휴	김일두	어쿠스틱 포크락(싱어송라이터)
			자이	소울 재즈(싱어송라이터)
			곡두	어쿠스틱 포크락(싱어송라이터)
4	보다	10/3(토)	아이씨밴드	어쿠스틱 포크락
			라루체	팝페라
5		10/4(일)	밴드 곱창카레	어쿠스틱 포크락
			현미밴드	포크락
6	그리고	10/9(금)	조연희	어쿠스틱 포크락(싱어송라이터)
			하쿠승호	어쿠스틱 포크락(싱어송라이터)
			김일두	어쿠스틱 포크락(싱어송라이터)
7		10/10(토)	허밍버드밴드	어쿠스틱 포크락
			올포원	아카펠라+콰이어
8		10/11(일)	셀피쉬	어쿠스틱 팝밴드
			소정밴드	어쿠스틱 팝밴드
9	씨앗	10/17(토)	킬라몽키즈	비보이 스트릿댄스
			프리즈몰릭	힙합

오페라컴퍼니

리에또트리오

하지림재즈트리오

김일두

곡두

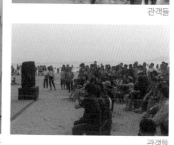

관객들

자이

관객들

Art Talking: 바다, 미술을 이야기하다.

아트큐브 (12:00~18:00, 상설 운영, 축제 행사장 일대)
축제 행사 안내, 도슨트 안내

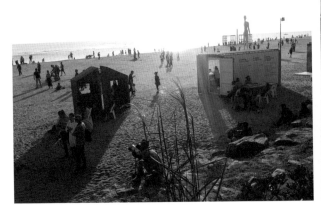

아트토크 (16:00~18:00, 총 9회, 축제행사장 무대)
Artkalk콘서트와 함께 진행되는 짧은 토크로 작품과 예술, 2015바다미술제 주제에 대한 이야기로 진행

회차	주제	날짜	사회자/ 초대손님	장르, 내용
1	바다	9/20(일)	이민아 / 남송우	바다와 예술
2		9/27(일) *추석 연휴	이민아 / 김상화	노는 사람
3		9/28(월) *추석 연휴	박수지 / 김정민, 정찬호 작가	작가와의 대화
4	보다	10/3(토)	이민아 / 다대포 주민	2015바다미술제를 보다1
5		10/4(일)	이민아 / 김성호 바다미술제 감독	2015바다미술제를 보다2
6	그리고	10/9(금)	방호정 / 뮤지션	음악 그리고 바다 그리다 (토크 콘서트 형식)
7		10/10(토)	김효영 / 이종균	작가와의 대화 '버려진 것들 &'
8		10/11(일)	이민아 / 김한근	부산, 그리고 바다
9	씨앗	10/17(토)	차재근 / 청소년 단체 비상	일상 예술의 씨앗

아트토크

Art Making: 바다, 강, 해안이 주는 재료로 만드는 미술 체험 활동

사랑海 체험존 (12:00~18:00, 예술강사 프로그램 시간 14:00~17:00, 축제행사장 내 일대)

주제	내용	구분	체험 장소
미안海	쓰레기로 인한 해양 동물들의 피해 미안해	소개	몽골텐트
그만海	해양 쓰레기 투기 그만해	소개	
사랑海	바다를 알고 부산을 사랑해	소개	
기억海	동물 발자국 찍기	상설 체험	모래사장
시작海	예술가의 방	상설 체험	예술가의 방
심심海	리사이클링 아트1 〈내 친구를 소개 합니다〉	상설 체험	몽골텐트, 모래사장
	리사이클링 아트2 〈나를 그리기 위하여〉	특별 체험	
좋아海	바다 담은 브로치 만들기	특별 체험	몽골텐트, 모래사장

동물 발자국 찍기

동물 발자국 찍기

나를 그리기 위하여

예술가의 방

내 친구를 소개합니다

내 친구를 소개합니다

나를 그리기 위하여

예술가의 방

바다 담은 브로치 만들기

바다 담은 브로치 만들기

아트마켓 (14:00∼17:00, 총 9회, 축제행사장 내 데크 일대)
수공예품과 리사이클링 작품들을 중심으로 구성되는 아트마켓과 제작 워크숍

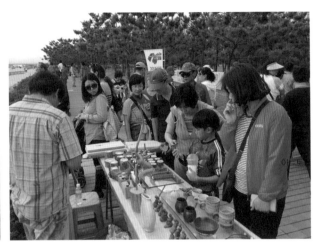

○ **종합일정**

상설 운영 12:00∼18:00	스케줄 운영	사랑海 체험존 (예술강사) 14:00∼17:00	아트마켓 14:00∼17:00	Artalk 콘서트 (아트토크+공연) 16:00∼18:00
리사이클링 아트 쉼터 아트큐브 사랑海 체험존	9/19(토)	O	O	X
	9/20(일)	O	O	O
	9/27(일)	X	X	O
	9/28(월)	O	O	O
	10/3(토)	O	O	O
	10/4(일)	O	O	O
	10/9(금)	O	O	O
	10/10(토)	O	O	O
	10/11(일)	O	O	O
	10/17(토)	O	O	O

Festival Events

○ **Summary**

Period : 2015. 9. 19~10. 18

Venue : Dadaepo Beach

Contents

Art Walking
Walk+Meet, Art Walking

Recycling Art Shelter
Artalk Concert

Art Talking
Sea, Talking with Art

Art Cube
Art Talk

Art Making
**Art Program with materials
from sea, river, beach**

Love-Sea Art Program Zone
Art Market

○ **Detailed Contents**

<u>Art Walking: Walk+Meet, Art Walking</u>

Recycling Art Shelter (12:00~18:00, Daily Operation during Exhibition , Dadaepo Beach Festival Zone)
A place with Recycling Street Art Furniture made of recycled pallets, recycled plastic bottles, recycled banners, and recycled plastic bags, etc to take a rest to enjoy the artworks on the sand.

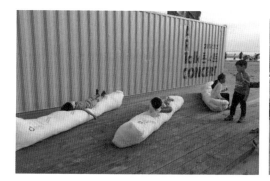

Recycling Art Shelter

239

Artalk Concert (Concert + Art Talk / 16:00-18:00, 9 times, Festival Stage)

No.	Theme	Date	Name	Genre, Content
1	Sea	Sept. 20(Sun)	Opera Company	Opera
		Sept. 27(Sun)	Lieto Trio	Classic&New age
2			Ha Jeerim Jazz Trio	Jazz
		Sept. 28(Mon)	Il-Du KIM	Folk Rock
3			Jai	Soul Jazz
			Gokdoo	Folk Rock
4	See	Oct. 3(Sat)	I See Band	Folk Rock
			La Luce	Popera
5		Oct. 4(Sun)	Gobchang Kare	Folk Rock
			Rough Rice	Folk Rock
6	And	1Oct. 9(Fri)	Yeon-Hee JO	Folk Rock
			haku sungho	Folk Rock
			Il-Du KIM	Folk Rock
7		Oct. 10(Sat)	Humming Bird	Folk Rock
			All For One	Acapella+Choir
8		Oct. 11(Sun)	Selfish	Acoustic Pop
			SOJUNG	Acoustic Pop
9	Seed	Oct. 17(Sun)	KILLA MONKEEZ	Street Dance
			PRIZMOLIQ	Hip-hop

Opera Company

Lieto Trio

Ha Jeerim Jazz Trio

Il-Do KIM

Audiences

Jai

Gokdoo

Audiences

Art Talking: Sea, Talking with Art

Art Cube (12:00-18:00, Daily Operation during Exhibition Period , Festival Zone)
Festival Events Guide, Docent Program

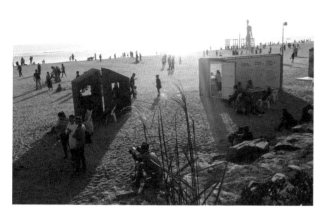

Art Cube

Art Talk (16:00-18:00, 9 times, Festival Stage)
A short talk with the Artalk concert including a talk on art and the theme of the Sea Art Festival 2015

No	Theme	Date	MC / Guest	Genre, Content
1	Sea	Sept. 20(Sun)	Min-A LEE / Song-Woo NAM	Sea and Art
2		Sept. 27(Sun)	Min-A LEE / Sang-Hwa KIM	Playing People
3		Sept. 28(Mon)	Su-Ji PARK / Jung-Min KIM, Chan-Ho Joeng	Talking with Artist 1
4	See	Oct. 3(Sat)	Min-A LEE / Resident In Da-De	About 'Sea Art Festival 2015-1
5		Oct. 4(Sun)	Min-A LEE / Sung-Ho KIM	About 'Sea Art Festival 2015-2
6	And	Oct. 9(Fri)	Ho-Jung BANG / Musicians	Music and Sea
7		Oct. 10(Sat)	Hyo-Young KIM / Jong-Kyun LEE	Talking with Artist 2
8		Oct. 11(Sun)	Min-A LEE / Han-Keun KIM	Busan and Sea
9	Seed	Oct. 17(Sat)	Jae-Keun CHA	Seed of Art

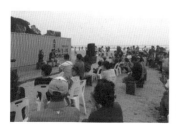

Art Talk

Art Making: Art Program with materials from Sea, River and Beach

Love-Sea Art Program Zone (12:00~18:00, Art Instructor Program 14:00~17:00, Festival Zone)

Theme	Contents	Category	Venue
Be Sorry	Be sorry for making marine litter to the marine animal	Introduction	Art Cube
Stop	Stop dumping in the sea	Introduction	Art Cube
Love	Know the sea & Love Busan	Introduction	Art Cube
Remember	Stamping the animal's footmark	Daily Experience	Sandy Beach
Start	Artist's Room <Drawing Zone>, <Writing Zone>	Daily Experience	Artist's Room
Be Bored	Recycling Art Program 1 <I intruduce my friend>	Daily Experience	Tent, Sandy Beach
	Recycling Art Program 2 <For drawing myself>	Special Experience	
Like	Making the Sea Broach	Special Experience	Tent, Sandy Beach

Stamping the animal's footmark

Stamping the animal's footmark

For drawing myself

Artist's Room

I intruduce my friend

For drawing myself

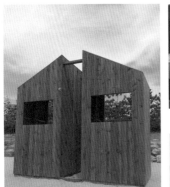
Artist's Room

I intruduce my friend

Making the Sea Broach

Making the Sea Broach

Art Market (14:00~17:00, 9 times, Festival Zone)
Art Market with handicraft and recycling artworks + Manufacturing Workshop

○ **Schedule**

Time	Date	Love-Sea Art Program Zone (Art Instructor Program) 14:00-17:00	Art Market 14:00-17:00	Artalk Concert (Concert+Art Talk) 16:00-18:00
Recycling Art Shelter Art Cube Love-Sea Art Program Zone	Sep. 19(Sat)	O	O	X
	Sep. 20(Sun)	O	O	O
	Sep. 27(Sun)	X	X	O
	Sep. 28(Mon)	O	O	O
	Oct. 3(Sat)	O	O	O
	Oct. 4(Sun)	O	O	O
	Oct. 9(Fri)	O	O	O
	Oct. 10(Sat)	O	O	O
	Oct. 11(Sun)	O	O	O
	Oct. 17(Sat)	O	O	O

출품 작가 약력

Artist's CV

Fernando ALVAREZ PEREZ / Spain
페르난도 알바레즈 페레즈 / 스페인

Born in 1975, Spain
Lives in and works in Spain
1975년 스페인 출생
현, 스페인 거주 및 활동

Selected Group Exhibitions
last: 65 International Sculpture Urban Exhibitions and
Symposiums in 21 different countries,
2015 6thBeijingArtBiennale, China.
2015 Taichung International Sculpture Symposium. Taiwan.
2015 Bursa Int. Sculpture Symposium, Turkey.
2015 Fuzhou Int. Sculpture Exhibition, Fujian, China. (Excellent
 Award)
2015 Nordart, Kunstler Carlshutte, Germany.

Sarawut Chutiwongpeti / Thailand
사라웃 추티옹페티 / 태국

Born in 1970, Bangkok, Thailand
Lives in and works in Switzerland
1970년 태국 방콕 출생
현, 스위스 거주 및 활동

Selected Solo Exhibitions
2014 The installation series of Untitled 'Wishes, Lies and
 Dreams, Once Upon a Time...',
 Gallery A5/Soulangh Culture Park, Taiwan
2013 The installation series of Untitled 'Wishes, Lies and
 Dreams, the Last Century...', Kunstverein GRAZ, German
2013 The installation series of Untitled 'Wishes, Lies and
 Dreams , I Wish It Would Rainbow Now...',
 Galleri Rostrum, Sweden
2011 The Installation series of Untitled 'Wishes, Lies and
 Dreams , Tomorrow Is Another Day...',
 Organhaus Art Space, China
2010 The Installation series of Untitled 'Wishes, Lies and
 Dreams', London Art Fair

Selected Group Exhibitions
2015 World Watercolor Triennale 2015, Hangaram Art
 Museum and Seoul Museum of Art, Korea
2015 Time is Love.8 , Touring Exhibitions : Expressive Arts
 Institute (USA), Zeta Art Center & Gallery(Australia),
 Kulter Gallery(Netherlands), Sala Rekalde Museum and
 Galeria Kalao Panafrican Creations(Spain) and National
 Institute of Fine Arts(Morocco)
2014 Contemporary Art at Tell - Edition 2/2014, University of
 St. Gallen, Switzerland
2014 3rd Mediterranean Biennale of Contemporary Art of
 Oran, La Médiathe que Municipale d'Oran, Algeria

Dorit Marianne CROISSIER / Germany
도릿 크로시어 / 독일

Born in 1944, Belzig, Brandenburg, Germany
Lives in and works in Germany
1944년 벨치히, 브란덴부라크, 독일 출생
현, 독일 거주 및 활동
http://www. Droit-croissier.de

Selected Solo Exhibitions
2014 Installation & Objects , Salzwedel, Germany
2013 Orangerie Ostenwalde, Melle, Germany
 kunst findet stadt, Brakel, Germany
2012 Objekte & Installationen, Städtische Galerie, Halle,
 Germany
2011 Übersetzungen, Kloster Corvey, Höxter, Germany
2009 Standpunkte, Kunstverein Schwalenberg, Germany

Selected Group Exhibitions
2012 EarthCharta, Höxter, Germany
2011 ARTd, Bad Driburg, Germany
2010 ART Association KVAK, Kröte, Wendland, Germany
 EarthCharta, Warburg, Germany
2009 KG WinterhART, German Federal Environmental Agency,
 Dessau, Berlin, Germany
2008 International HanseART, Salzwedel, Germany
 5th InternationalNatureArtBiennale,Gongju,Korea

Andy DEWANTORO / Indonesia
앤디 드완토로 / 인도네시아

Born in 1973, Tanjung Karang, Indonesia
Lives in and works in Indonesia
1973년 인도네시아 탄중 카랑 출생
현, 인도네시아 거주 및 활동

Selected Solo Exhibitions
2012 'We Wanted To Be The Sky', D Gallery, Jakarta,
 Indonesia
2011 'Half Full Half Empty', Valentine Willie Fine Art, Kuala
 Lumpur
2010 'empty – space – landscapes', Gallery Semarang,
 Semarang, Indonesia
2008 'Silent World', Ark Gallery, Jakarta, Indonesia

Selected Group Exhibitions
2014 'Symbol, Spirit, Culture', To Communicate in The Art
 Making Today, Edwin's Gallery, Jakarta, Indonesia
2014 ART STAGE SINGAPORE 2014, Semarang
 Contemporary Art Gallery, Marina Bay Sands,
 Singapore
2013 'Lost and Found', Ark Gallery, Space K, Gwacheon,
 Seoul, South Korea
2013 Art Basel 2013, Hong Kong Convention and Exhibition
 Center, Hong Kong
2011 The Indonesian Eye Contemporary Art Exhibition, Saatchi
 Gallery, London, England

Jonathan Paul FOREMAN / U.K
조나단 폴 포어맨 / 영국

Born in 1992, West Sussex, U.K
Lives in and works in Pembrokeshire, U.K
1992년 영국 웨스트서식스 출생
현, 영국 펨브룩셔 거주 및 활동

Selected Group Exhibitions
2014 BA Design - Final Exhibition, Coleg Sir Gar, Carmarthen,
 Carmarthenshire, Wales, UK
2013 BA Design - Personal Project Exhibition, Pembrokeshire
 College, Haverfordwest, Pembrokeshire, Wales, UK
2012 BA Design - Love Project Exhibition, Pembrokeshire
 College, Haverfordwest, Pembrokeshire, Wales, UK
2012 BA Design - Patterning Project Exhibition, Pembrokeshire
 College, Haverfordwest, Pembrokeshire, Wales, UK
2011 Pre BA Foundation - End of Year Exhibition,
 Pembrokeshire College, Haverfordwest, Pembrokeshire,
 Wales, UK

Mattia LULLINI / Italy
마티아 루리니 / 이탈리아

Born in 1985, Bologna, Italy
Lives in and works in Gothenburg, Sweden
1985년 이탈리아, 볼로냐 출생
현, 스웨덴 예테보리 거주 및 활동

Selected Solo Exhibitions
2015 Close Your Eyes And Let It Begin With, Freedom Men Art
 Gallery, Taichung City, Taiwan
2014 The Weird Rainbow, Galleria Portanova12, Bologna,
 Italy
2013 Yuletide, Rubik, Bologna Italy
2012 Kalaa Kaari, Square 23 Gallery, Turin, Italy
2011 Animals I, Elastico Gallery, Bologna, Italy

Selected Group Exhibitions
2015 Hall Of Fame, Ringön Konsthallen, Gothenburg, Sweden
2014 Balance, Urban Outfitters Gallery, Copenhagen,
 Denmark
2014 This Is Not Street Art, Social, New Delhi, India
2012 Extension Khirkee, Khirkee, New Delhi, India
2011 Sub Urb Art, Fabbrica, Turin, Italy

Yoko Ono in her installation En Trance at the opening of her exhibition, Half-A-Wind Show, Louisiana Museum of Modern Art, Humlebaek, Denmark, June 1 - September 15, 2013.
Photograph by Louisiana Museum, courtesy of the artist.

Ludwika Grazyna OGORZELEC / Poland
루드위카 그라지나 오고르젤렉 / 폴란드

Born in 1953, Poland
Lives in and works in Paris, France
1953년 폴란드 출생
현. 프랑스 파리 거주 및 활동

Selected Solo Exhibitions

2015 The transition, from Space Crystallisation "cycle, large
sitespecyfic public sculpture
at centre of Wroclaw town- Sukiennice- Wroclaw, Poland
2012 Dancing with the line" from "Space crystallization" cycle
at Sunshin Museum of Contemporary Art, Coachangdi
Art District in Beijing,China
2007 Toronto Sculpture Garden, 6 month solo show in public
space, Toronto ,ON Canada
2005 Nancy Margolis Gallery, Chelsea, New York, USA
2003 National Museum in Sofia, Bulgaria
2000 Pardo Gallery in New York, USA

Selected Group Exhibitions

2011 "Breathing Claud" from "Space Crystallisation" cycle at
the Exeter Castle, UK
2008 "Earth Art" curated by John Grande at Royal Botanical
Garden in Hamilton, Canada
1999 "Weaving the World"Yokohama Museum of Art Japan
1997 "Postawy" Royal Kastell in Dresden, Germany
1984 "Dyplom 83" best diploma's show in the country, Krakau,
Poland

Yoko Ono / USA
오노 요코 / 미국

Born in 1933, Japan
Lives in and works in New York, USA
1933년 일본 출생
현. 미국 뉴욕 거주 및 활동

Selected Art Activities

Dec 1960 to June 1961: La Monte Young series of concerts at Yoko
Ono's Chambers Street loft
(Concerts by Terry Jennings, Toshi Ichiyanagi, Henry Flynt, J. Byrd, Mac
Low, Maxfield, L Young, S Forti, R Morris Dennis Lindberg,)
July 17–30, 1961: Show of Ono's ("Instruction") paintings at AG Gallery
May 1962: First Concert Exhibition at Tokyo's Sōgetsu Art Center.
Her show was based on a series of instructions for "paintings to be
constructed in your head"
October 1962: Ichiyanagi arranged through Sogetsu Art Center
for Cage and Tudor to visit Japan and perform several concerts.
Ono participated in those programs appearing in Cage's premiere
performances of Music Walk and Arias for Solo Piano with Fontana Mix.
Around this time, she checked into a sanatorium.
1964 – Ono compiled her instructions, scores and poems for the
publication of Grapefruit.
1969 – Yoko and John perform Bed–In for Peace and record their single
Give Peace a Chance.

Awards

2003 The Museum of Contemporary Art (MOCA) honoured
artist Yoko Ono, at the fifth MOCA Award to Distinguished
Women in the Arts.
2005 Yoko Ono received a Lifetime Achievement Award at
IMAJINE 2005, the Japan Society Arts & Culture Gala Benefit.
2006 Yoko Ono was awarded the International Prize for Visual
Arts 2006 of the Cristobal Gabarron Foundation, Spain.
2008 Yoko One was awarded the Distinguished Body of Work
Award 2008 by College Art Association and Americans
for the Arts National Arts Award.
2009 Yoko Ono will be awarded Venice Biennale Golden Lion
for Lifetime Achievement in June 2009.

Stephen ORLANDO / Canada
스테펜 올란도 / 캐나다

Born in 1983, Canada
Lives in and works in Ontario, Canada
1983년 캐나다 출생
현, 캐나다 온타리오 거주 및 활동

Selected Solo Exhibitions
2015 Motion Exposure, Odeon Gallery, Waterloo, Ontario,
 Canada
2015 Canoe Light Painting, Tom Thomson Gallery (Chi-
 Cheemaun), Owen Sound, Ontario, Canada

Cornells Albertus OUWENS / Netherlands
코넬 알베르투스 오우웬스 / 네덜란드

Born in 1958, Netherlands
Lives in and works in Netherlands
1958년 네덜란드 출생
현, 네덜란드 거주 및 활동

Selected Solo Exhibitions
2013 Sculptfusion , Michigan, Idaho, USA
2012 Geumgang Nature Art Biennale, Gongju, Korea
2011 Festival Arte de la Tierra, Volcan Paricutin,Michoacan,
 Mexico
2010 Ehime Prefectural Museum of Art, Matsuyama, Japan
2009 Echigo Tsumari Art Triennial, Niigata, Japan

Selected Group Exhibitions
2013 Art in Public Spaces, International Airport, Knoxville,
 Tennessee, USA
2012 Jardin de Esculturas, Xalapa, Veracruz, Mexico
2011 Art on the River, Dubuque, Iowa, USA
2009 Frostic School of Art, Kalamazoo, Michigan, USA
2008 Sculpture Key-West, Florida, USA

Joseph TASNADI / Hungary
조셉 타스나디 / 헝가리

Born in 1960, Viisoara, Romania
Lives in and works in Budapest, Hungary
1960년 루마니아 비소아라 출생
현, 헝가리 부다페스트 거주 및 활동
www.josephtasnadi.hu

Selected Solo Exhibitions
2015 The Woodcutter's Hobby , Óbudai Társaskör Gallery, Budapest, Hungary
2015 I guess I'm a Pink Haze Goupie… , Jurányi Incubator House, Budapest, Hungary
2014 Waiting is a Way of Life , Platan Gallery, Polish Institute, Budapest, Hungary
2014 Holiday in the Pyrenees , Liget Gallery, Budapest, Hungary
2013 Desert Inn , New Hungarian Gallery, King Saint Stephen Museum, Székesfehérvár, Hungary

Selected Group Exhibitions
2014 Kinetika, A fusion of art | design | engineering, New Plymouth, Taranaki, New Zealand
2012 Drift, Kunstbroedplaats/Art Breeding Place, Dutch Rerun Productions Foundation, Waterloopbos, Marknesse, Netherlands
2011 Nature, Human Being & Sound, 2011-2012 Geumgang Nature Art Pre-Biennale, Gongju, South Korea
2011 Ruas / Segment, Campus Gallery, Yogyakarta, Indonesia
2011 Hybrid Art Projects , El Zonte Beach, El Salvador

Rigdol TENZING / Tibetan American
리그돌 텐징 / 티벳계 미국

Born in 1982, Nepal
Lives in and works in New York, USA
1982년 네팔 출생
현, 미국 뉴욕 거주 및 활동

Selected Solo Exhibitions
2013 Darkness into Beauty, Rossi & Rossi, London, UK*
2012 Tenzing Rigdol, Art Stage Singapore, Rossi & Rossi, Singapore
2011 Our Land Our People, in collaboration with Rossi & Rossi, site-specific installation, TCV Dharamshala, India
2009 Tenzing Rigdol, Experiment with Forms, Rossi & Rossi, London, UK*

Selected Solo Exhibitions
2014
Korea: A Meditation on Pilgrimage, Queens Museum, New York, USA
Parallel Realities, ARNDT, Berlin, Germany in conjunction with Rossi & Rossi, London, UK
A Time for Dreams, the IV Moscow International Biennale for Young Art, Moscow, Russia Impermanence, Rossi & Rossi, Hong Kong
Tibet and India: Buddhist Traditions and Transformations, the Metropolitan Museum of Art, New York, USA
Our Clouded Hills, Art14, London, UK Anonymous, The Fleming Museum at the University of Vermont, Burlington, Vermont, USA and the Queens Museum of Art, New York, USA
2013
SAME : DIFFERENCE, Rossi & Rossi, London UK In-Between: 21st Century Tibetan Artists Respond to 12th - 15th Century Tibetan Manuscript Covers, Rossi & Rossi, London, UK Anonymous, Dorsky Museum at the State University of New York, New Paltz, New York, USA
2012
Victory! 'Triumph' in Classical and Contemporary Asian Art, Rossi & Rossi, London, UK*

Chintan UPADHYAY / India
친탄 우파드야이 / 인도

Born in 1972, Rajasthan, India
Lives in and works in New Delhi, India
1972년 인도 라자스탄 출생
현, 인도 뉴델리 거주 및 활동

Selected Solo Exhibitions
2015 Between Time and Culture. Zorlu Performance Centre by
BEYAZ Art. Istanbul. Turkey.
2014 Jaane Bhi Do Yaaron Redux, Gallery Espace. New
Delhi. India.
2010 Nature God, Sakshi Gallery, Taipei. Taiwan
2009 Mistake, Inda Gallery, Budapest, Hungary
2008 2008, New Indians, Gallery Seroussi Natalie, Paris,
France

Selected Group Exhibitions
2013 "children library" a sculptural installation part of 16th
International Sculpture Symposium In Icheon. S.Korea.
2013 "Silent Protest" a collaborative performance with farmers
of Hatholiapada village, Rajasthan. India.
2011 ROUNDABOUT City Gallery Wellington. New Zealand
and Tel Aviv Museum of Art Israel.
2011 "Roots in the Air, Branches Below". San Jose Museum of
Art. USA
2010 "mix match" a performance produced in performance
festival. EX TERESA , Mexico

Ki-Youl CHA / Korea
차기율 / 한국

Born in 1961, Hwaseong-si, Korea
Lives in and works in Incheon, Korea
1961년 한국 화성 출생
현, 한국 인천 거주 및 활동

Selected Solo Exhibitions
2013 OCI Museum Of Art, Seoul
2011 LA ARTCORE, LA, CA, USA
2009 Space Gallery, Seoul
2007 Gallery Kunst Doc, Seoul
2006 Kwanhoon Gallery, Seoul

Selected Group Exhibitions
2015 Beyond The Borders (Culture Station Seoul 284, Seoul)
2014 Stone encountered Steel (Jeongok Prehistory Museum,
Jeongok)
2013 Sea of Peace (Baengnyeong Island, Incheon Art Platform)
2010 Busan Biennale 'Living in Evolution' (Busan Museum of
Art, Busan)
2009 Nomadic Project-Time & Space (Ulaanbaatar,
Omnogobi)

Duck-Hyun CHO / Korea
조덕현 / 한국

Born in 1957, Hoeng-seong, Gangwondo, Korea
Lives in and works in Seoul, Korea
1957년 한국 강원도 횡성 출생
현. 한국 거주 및 활동

Selected Solo Exhibitions
2015 "Dream", Ilmin Museum, Seoul
2014 "The Garden of Sounds", Artclub1564, Seoul
2009-2010 "Flashback", TUAD Museum, Yamagata, traveling to
　　　　　　KUAD Museum, Kyoto, Japan
2008 "re-collection", Kukje Gallery, Seoul
had more than 29 solo shows inside and outside of Korea.

Selected Group Exhibitions
2012 "Korean eye", Saatchi Gallery, London
2011 "Korean Rhapsody", Leeum Museum, Seoul
2010 "Herstory Museum", Seoul Media Biennale, Seoul
2005 "The Elegance of Silence", Mori Museum, Tokyo
participated more than 400 group shows inside and outside of
Korea

Sun CHOI / Korea
최선 / 한국

Born in 1973, Seoul, Korea
Lives in and works in Seoul, Korea
1973년 한국 서울 출생
현. 한국 서울 거주 및 활동

Selected Solo Exhibitions
2015 Meari, SongEun Art Space, Seoul, Korea
2015 Magenta Painting, BongSan Culture Center, Taegu,
　　　Korea
2013 Two Worlds, Bamboo Curtain Studio, Taipei, Taiwan
2013 Falcon and Firmament, BankART Studio NYK, Yokohama,
　　　Japan
2011 Breath in an Instant, Cake Gallery, Seoul, Korea

Selected Group Exhibitions
2015 Think It Over, Think It Slow, Korean Cultural Service, New
　　　York, U.S.A.
2014 Follow Me : SeMA Nanji 8th Review, Buk Seoul Museum
　　　of Art, Seoul, Korea
2014 Asian Art Festival, Ansan, Korea
2014 Dream of East Asia, 2014 Yokohama Triennale, BankART
　　　Studio NYK, Yokohama, Japan
2013 Fukudake House Asian Art Platform, 2013 Setouchi
　　　Triennale, Shodoshima, Japan

Won–Gil JEON / Korea
전원길 / 한국

Born in 1960, Gyeonggi–do, Korea
Lives in and works in Anseong, Korea
1960년 한국 경기도 출생
현, 한국 안성 거주 및 활동

Selected Solo Exhibitions
2014 'Rainbow APT' ,Alternative Art Space Sonahmoo,
 Anseong , Korea
2014 'The Sign of Typhoon' ,Cross Gallery, Taipei Taiwan
2014 'Sky Enters Indoor' Dongtan Art Space, Hawsung, Korea
2012 'Summer Blue' Kepco Art Center Gallery, Seoul, Korea
2012 'White Fragrance' Darmstadt, Germnay

Selected Group Exhibitions
2013 'Land Art Biennale' , Plettenberg Bay South Africa
2012 'Creative Attitude of the Distance' ,Seoul Art Space_
 GEUMCHEON, Seoul, Korea
2012 'Reality & Romanticism' (Darmstadt, Germany)
2012 'Nomadic Report -Wind from Persian-' ,ARKO Museum,
 Seoul, Korea
2010 '7thGeumgangNatureArtBiennale',Gongju,Korea

Chan–Ho JEONG / Korea
정찬호 / 한국

Born in 1979, Busan, Korea
Lives in and works in Busan, Korea
1979년 한국 부산 출생
현, 한국 부산 거주 및 활동

Selected Solo Exhibitions
2014 Poverty guy, Art Space Alliance Française de Busan,
 Busan, Korea
2012 Life is sports, Centum Art space Centum Hotel, Busan,
 Korea

Selected Group Exhibitions
2015 Double exhibition(Kim, Jong Sun+Jeong, Chan Ho), Lee,
 Yeon Ju gallery, Busan, Korea
 Interspace, Kim's Art Field museum, Busan, Korea
2014 Busan Biennale special exhibition asian curatorial,
 Kiswire factory, Busan, Korea
 Gongsaenggongyou, Hongti art center, Busan, Korea
2013 Art exchange project TOUCH, New zero art space,
 Yangon, Myanmar

Jung-Min KIM / Korea
김정민 / 한국

Born in 1982, Busan, Korea
Lives in and works in Busan, Korea
1982년 한국 부산 출생
현. 한국 부산 거주 및 활동

Selected Solo Exhibitions

2015 montage, Leeyeonju Gallery, Busan, Korea
2014 Remember delivered, MIBOO art center, Busan, Korea
2010 An image of memory or a sculpture in search of lost time,
 Gallery A1, Seoul, Korea

Selected Group Exhibitions

2015 Art Busan, Bexco, Busan, Korea
2014 Equivalent table, Art zone -P, Busan, Korea
2014 Busan Citizen's Park Factory Art Festival-
 Gongwongongrak(公園共樂), Civic Park, Busan, Korea
2014 Today and Tomorrow of modern sculpture - MacGyver,
 Gallery 2yeonju, Busan, Korea
2014 Korea Contemporary Sculpture Invitational Exhibition,
 Chuncheon mbc, Chuncheon, Korea

Won-Geun KIM / Korea
김원근 / 한국

Born in 1971, Boeun, Korea
Lives in and works in Yangpyeong, Korea
1971년 한국 보은 출생
현. 한국 양평 거주 및 활동

Selected Solo Exhibitions

2001 1st Solo Exhibition Hall of the Cheongju Arts Korea
2006 2nd exhibition space Xhosa. Insa-dong South Korea
2013 3rd solo exhibition galleries child. Insa-dong South Korea

Selected Group Exhibitions

2015 Korea Taiwan Singapore International Sculpture Exhibition
 Japan Miyazaki Airport International Sculpture Exhibition
 Japan sapporo six Exhibition Sinajina Gallery
 Seongnam Arts Center Seongnam face sculpture Exhibition
 Ulsan Culture and Arts Center sculpture Exhibition
 Busan International Art Fair Art Gallery. Samsung COEX,
 Seoul Art Fair.
2014 Almería, Spain International Marble Sculpture Symposium
 International bronze sculpture symposium in Istanbul,
 Turkey
2013 International stone sculpture symposium in Turkey

Young—Won KIM / Korea
김영원 / 한국

Born in 1947, Changwon, Korea
Lives in and works in Gyeonggi—do, Korea
1947년 한국 창원 출생
현, 한국 경기도 거주 및 활동

Selected Solo Exhibitions
2014 shadow of shadow, pyo callery, Seoul, Korea
2013 kim young-won-Novello Finotti Exhibition, palazzo
 Zuckermann, Musei civici agli Eremitani, piazza
 Municipio-liston,
 Galleria la teca, nella citta di padova, Padova, Italy
2012 Kim young-won Exhibition, Hongik Art museum, Seoul,
 Korea
2011 Kim young-won Exhibition, Gyeong nam artmuseum,
 Changwon, Korea
2009 Kim young-won Exhibition, Moonsin museum,
 Changwon, Korea

Selected Group Exhibitions
2014 Korea-China Sculpture Exhibition, China sculpture Institute
 Hall, Firenze, Italy
2012 Korea Sculpture Festival-pietrasanta, Pietrasanta, Italy
2011 Wuhu International sculpture, Wuhu sculpture park, ,
 Wuhu, China
2011 100 people sculpture for the 100th at university of
 founding of Qing-hua university, Qing-hua university,
 Beijing, China
1994 The 22nd San Paulo Biennale, San Paulo, Brazil

Jong—Kyun LEE / Korea
이종균 / 한국

Born in 1971, Seoul, Korea
Lives in and works in Gyeonggi—do, Korea
1971년 한국 서울 출생
현, 경기도 거주 및 활동

Selected Solo Exhibitions
2010 '320m, The movement of 320 blockes'(Cultural Salon
 Gong, Uijeongbu)
2009 'Story about Village' (Village center of Dongmun-ri,
 Beobwon-ub)
2007 'Reconciliation' (Kwanhoon Gallery)
2000 木 - 生 . 性 Wood-Life, Sex (Jongro Gallery, Mokam
 Museum)

Selected Group Exhibitions
2015 'The new boundary fence' (Seoul National Grand Park)
2014 'Island Play'(Jeju Island)
 'Peace Art Festival at Meahyang-ri' (Meahyang-ri)
2013 'Garden of Nomad' (Suncheon Garden Festival)
 'Sustainable Project of Children's Art Furniture'(Borim
 publisher)

Kyung-Ho LEE / Korea
이경호 / 한국

Born in 1967, Gimcheon, Korea
Lives in and works in Seoul, Korea
1967년 한국 김천 출생
현, 한국 서울 거주 및 활동
www.leekyungho.com

Selected Solo Exhibitions
2007 Exhibition of "No-Signal" (Gallery sejul, Seoul, Korea)
2006 Exhibition of "Treveler" (Gallery Sejul, Seoul, Korea)
2002 Exhibition, Gallery Sejul, Seoul Korea

Selected Group Exhibitions
2014 "K-P.O.P.—Korean Contemporary Art" Taipei MOCA
 "Digital Triangle" Korea Japan China , Alternative space
 LOOP
 "Qingdao Biennale" (China, Qingdao)
 "Bomb" Alternative space Noon Korea
 "curator Won-Il Lee's Creative Paradox" Exhibition KunstDoc
 Space Korea
 "Scars became Stars" Hankuk Art Museum Korea
 "Slow Slow Quick Quick!" summer, 7 Days' Nanjang
 Performance Festival KunstDoc Space
2010 "The Flower of May" A Special Exhibition Commemorating
 the 30thAnniversaryofGwangjuUprising
 (Gwangju City Museum Korea)
2008 Sevilla biennale (Spain)
2007 Exhibition of "Thermocline of Art-New Asian Waves"
 (Museum of Contemporary Art, ZKM, Germany)
 Exhibition at CITY ART MUSEUM LJUBLJANA, Ljubljana,
 Slovenia
2006 Exhibition of "2006 Shanghai Biennale" (China, Shanghai)

Lee-Nam LEE(Korea)
이이남(한국)

Born in 1969, Damyang, Korea
Lives in and works in Gwangju, Korea
1969년 한국 담양 출생
현, 한국 광주 거주 및 활동

Selected Solo Exhibitions
2015 'Language of light', Gallery GMA, Seoul, Korea
2014 'Light, Gana Art Cente'r, Seoul, Korea
2013 'Nature & Gogh', Leeahn Gallery, Seoul, Korea
2012 'Good night Analog', Good morning Digital, Soul art
 space, Pusan, Korea
2011 'Les Peintures Vivantes', Art Center Nabi, Seoul, Korea

Selected Group Exhibitions
2015 Personal Structures, 'Crossing Borders', Palazzo Mora,
 Venice, Italy
2014 'Simultaneous Echoes', Fortabat Art Collection, Buenos
 Aires, Argentina
2013 'A Soldier's Tale: 60 Years of Memories, 130 Years of
 Friendship', Asia House, London, UK
2012 Korean Eye: Energy and Matter, New York Design
 Center, New York; Fairmont Bab Al Bahr, Abu Dhabi
2011 Qingdao Biennale, Qingdao, China

Myoung—Ho LEE / Korea
이명호 / 한국

Born in 1975, Daejeon, Korea
Lives in and works in Seoul, Korea
1975년 한국 대전 출생
현, 한국 서울 거주 및 활동

Selected Solo Exhibitions
2014 798 Photo Gallery, Beijing, China
2013 Gallery Hyundai, Seoul, Korea
2012 Gallery Jungmiso, Seoul, Korea
2010 Sungkok Art Museum, Seoul, Korea
2009 Yossi Milo Gallery, New York, USA

Selected Group Exhibitions
2015 Wooyang Museum of Contemporary Art, Gyeongju,
 Korea
2015 Taewha River Eco Art Festival, Ulsan, Korea
2015 Gallery of Classic Photography, Moscow, Russia
2015 Toronto Photography Festival, Toronto, Canada
2015 Centro Cultural Coreano en America Latina, Bueno Aires,
 Argentina

Ju—Hwan NOH / Korea
노주환 / 한국

Born in 1960, Naju, Korea
Lives in and works in Seoul, Korea
1960년 한국 나주 출생
현, 한국 서울 거주 및 활동

Selected Solo Exhibitions
2015 'The Room of wisdom', Baum Art Gallery, Seoul, Korea
2014 'I Love You', Gallery SeoRim, Seoul, Korea
2011 'First Do', Gallery Artpark, Seoul, Korea
2008 'Noh's Works', tng Gallery, Baijing, China
2006 'Noh's Works', Gallery Kunstdoc, Seoul, Korea

Selected Group Exhibitions
2015 'King Sejong Opens the Age of HanGeul Culture',
 National Hangeul Museum, Seoul, Korea
2014 'Unexpected Sceme's, Culture Factory Osan, Osan,
 Korea
2013 'Heain Art Projec't, Temple of Heain, HapCheon, Korea
2013 ChangWon Asia Art Festival, Sungsan Art Hall,
 ChangWon, Korea
2011 Korea-China Sculpture, Korea Cultural Center, Beijing,
 China

Won-Jae SHIN / Korea
신원재 / 한국

Born in 1971,Seoul, Korea
Lives in and works in Gyeonggi-do, Korea
1971년 한국 서울 출생
현, 한국 경기도 거주 및 활동

Selected Solo Exhibitions
2009 'Mr. gomtaengyi' Exhibition, Cosa Gallery, Seoul, Korea
2008 'stereotypical thinking', Eye Gallery in Suwon, South
 Korea
2005 'fantastic imagination the wall', Suwon Art Gallery,
 Suwon, South Korea
 'Fantastic imagination' passage, Kwanhoon Museum of
 Art, Seoul, Korea
2004 'Mazinger dream', Suwon Art Gallery, Suwon, South
 Korea
2000 1st Solo Exhibition 'transplantation plant, Kwan-Hoon
 Gallery, Seoul, Korea

Selected Group Exhibitions
2015 Sculpture Festival, Seoul Arts Center, Seoul, Korea
 Good Son,
2013 'Black Devil', Kunstdoc Museum of Art, Seoul, Korea
 'Modern Art Show', Seoul Arts Center, Seoul
2012 'Korea, China Exhibition', Fine Art Museum, Zhuhai City,
 China
 The flow of Contemporary Art Exhibition, Museum
 Suwon, Suwon, South Korea
 Outdoor Sculpture Exhibition, Chang'an yard, Suwon,
 South Korea

Hyun-Wook SON / Korea
손현욱 / 한국

Born in 1982, Busan, Korea
Lives in and works in Busan, Korea
1982년 한국 부산 출생
현, 한국 부산 거주 및 활동

Selected Solo Exhibitions
2015 Sonhyunook Solo exhibition, herald gallery, Seoul, Korea
2015 Sonhyunook Solo exhibition, MIBU art center,
 Busan,Korea
2013 Sonhyunook Solo exhibition, Merciel bis gallery,
 Busan, Korea
2013 Sonhyunook Solo exhibition, Gallery viva,
 Hongcheon, Korea
2013 Sonhyunook Solo exhibition, Gallery S+, Busan, Korea

Selected Group Exhibitions
2015 QUARTET, Yang gallery, Peiching, China
2014 Come from BUSAN, Cite des arts, Paris, France
2013 PoHang Steel art festival, Pohang canal, Pohang, Korea
2012 Seokdang museum of arts opening show, Seokdang
 museum of arts, Busan, Korea
2011 The ground of conquer, Busan Museum of arts,
 Busan, Korea

Young-Hwa YOON / Korea
윤영화 / 한국

Born in 1964, Daegu, Korea
Lives in and works in Busan, Korea
1964년 한국 대구 출생
현, 한국 부산 거주 및 활동

Selected Solo Exhibitions
2012 Heritage, Kepco Art Center Gallery, Seoul, Korea
2012 Heritage, Memory Workshop, Bongsan Cultural Center,
Daegu, Korea
2008 A boat in a storm, Gallery Sejul, Seoul, Korea
2006 Photo-drawing & Photo-painting, Gallery SUN
Contemporary, Seoul, Korea
1996 Bateau Lavoir Space, Paris, France

Selected Group Exhibitions
2014 Busan Biennale-main exhibition: Inhabiting the World,
Busan Museum of Art, Busan, Korea
2014 the 6th Geumgang Nature Art Biennale: Horizontally
Growing Trees-Secret Garden, Geumgang Int'l Nature
Art Center, Gonju, Korea
2014 the 8th Taehwa River Eco Art Festival: Bridge to the
Future, Ulsan Bridge taehwa river area, Ulsan, Korea
2013 The 55th Venice Biennale: Benetton collection <Imago
Mundi> (Foundazione Querini Stampalia, Venice, Italy
2012 2011 Network Project: The Secret, Arko Museum,
Seoul / Gwangju-Busan Museum of Art, Korea

Tae-Won OH / Korea
오태원 / 한국

Born in 1973, Yeosu, Korea
Lives in and works in Seoul, Korea
1973년 한국 여수 출생
현, 한국 거주 및 활동

Selected Solo Exhibitions
2014 'Natural intensity', Gallery IANG, Seoul, Korea
2013 'Mystique Watery', Gallery Space Sun+, Seoul, Korea
2011 'The Stream of Memory',Gallery IANG, Seoul, Korea
2010 'Eye touch the visualization', Gallery Woosuk, Seoul,
 Korea
2009 'Tears of Fontainebleau forest story', Gallery SO, Seoul,
 Korea

Selected Group Exhibitions
2015 'Open National Assembly Art Festival 2015', National
 Assembly grass Garden, Seoul, Korea
2014 'Body-Sense of Recovery', Zaha Museum, Seoul, Korea
2014 'Art flowing the Green Way', Open Sculpture, Gangdong
 ArtCenter, Seoul, Korea
2014 'Changwon Asia Contemporary Art Festival2014',
 Sungsan ArtHall, Changwon, Korea
2014 'île de France', KimBoSung ArtCenter, Seoul, Korea

Ko Un / Korea
고은 / 한국

Born in 1933, Gunsan, Korea
Lives in and works in Suwon, Korea
1933년 한국 군산 출생
현, 한국 수원 거주 및 활동

Ko Un (born in 1933) started his literary career in 1958 through
Hyundai Munkak (Contemporary Literature), one of the leading
magazines in the literary field. Ko has published more than 155 books,
including poems, novels, and critical essays since he published his first
collection of poems, Sensibility in the Land of Enlightenment (피안감
성) in 1960. He published Baekdu Mountain Vol. 1–7, the collection
of epic poems between 1987 and 1994. After 25 years of writing
he completed in 2010 his 30–volume epic poems Ten Thousand Lives
(Maninbo) highly acclaimed as a monumental work not only in Korean
literature history but also in world literature history. Also included in his
books published are Ko Un Anthology of Poetry (1984), Some Winds
(어떤 바람)(2002), The Complete Works of Ko Un (2002), and Like
a Gala Day (마치 잔칫날처럼)(2012). The collections of his poems
recently published are Poems Dedicated to Sang–hwa (상화시편)(2011),
Where Has My Frontier Gone (내 변방은 어디 갔나)(2011) and
Untitled Poems (2013). He is presently gaining a worldwide reputation
as one of the key poets with the world of his poems enriched by high
artistic tension and boundless imagination and aspiration. His 60 books
have been translated into more than 25 languages including English,
German, Chinse, French, and Spanish. He served as a research
professor at the Harvard–Yenching Institute, a guest professor at UC
Berkeley, and a visiting scholar at Seoul National University ad he was
awarded many prestigious literary prizes at home and abroad. He
has been the president of the Joint Board of South and North Korea for
Compilation of Gyeoremal–Keunsajeon, a chair professor of Dankook
University, and a Goodwill Ambassador for Peace by the Korean
National Commission for UNESCO. He has been active in writing and
invited by numerous poetry festivals throughout the world.

그룹 VGABS　Group VGABS

Andrew Ananda VOOGEL / USA
앤드류 아나다 부겔 / 미국

Born in 1983, Los Angeles, USA
Lives in and works in Busan, Korea
1983년 미국 로스앤젤레스 출생
현, 한국 부산 거주 및 활동

Fleuryfontaine / France
플뢰리퐁텐 / 프랑스

Galdric FLEURY & Antoine FONTAINE
Born in 1983, France, Lives in and works in Korea
갈드릭 플뢰리 & 앙투안 퐁텐
1985년 프랑스 출생. 현, 한국 거주 및 활동

Sung-Mi BAE / Korea
배성미 / 한국

Born in 1971, Seoul, Korea
Lives in and works in Seoul, Korea
1971년 한국 서울 출생
현, 한국 서울 거주 및 활동

Maria SAMORTSEVA / Russia
마리아 사모르체바 / 러시아

Born in 1992, Russia
Lives in and works in Korea
1992년 러시아 출생
현, 한국 거주 및 활동

Group Archist (Artist+Archaeology) / Korea
아키스트 / 한국

Deung-Yong KIM(1983~), Na-Ryun KIM(1993~),
Gyoo-Young YOO(1987~), Chan-Min LEE(1981~),
Keun-Young BAEK(1985~), Hyo-Young KIM(1991~),
Ga-Yun LEE(1993~), Seong-Jin PARK(1987~),
Young-Bae JI(1984~), Cheol-JEONG(1991~)
김등용(1983~), 김나륜(1993~), 유규영(1987~),
이찬민(1981~), 백근영(1985~), 김효영(1991~)
이가윤(1993~), 박성진(1987~), 지영배(1984~),
정철(1991~)

Selected Solo Exhibitions

2015 Chan-Min Lee, Solo exhibition, 'incompleteness >
　　completeness', cheon Cerapia, Gyeonggi-do
2014 'Our skin, Cockroach became Flower', MIBOO Art center,
　　Busan
2014 'Crossed World', Gallery FINE, Busan, Korea

Selected Group Exhibitions

2015 'Gyeonggi international CeraMIX Biennale', Icheon
　　Cerapia, Gyeonggi-do
2015 '2015 SUMMER City and image', ARA Art Center, Seoul
2014 'Art Connection', ART in NATURE, Busan, Korea
2014 'The Korea Archaeology & Art History Research Institute',
　　Busan Gadeokdo Site
Busan Museum, 2009, Bumbang Site

Group Cera-energy / Korea
세라에너지 / 한국

Mi-Ra GANG(1987~), Hea-Ra KIM(1989~),
Jong-Hwan PARK(1959~), Hee-Jung SIM(1990~),
Hye-Ji LIM(1991~), Hye-Joo JUNG)(1983~),
Seung-Yeon JO(1991~)
강미라(1987~), 김혜라(1989~), 박종환(1959~),
심희정(1990~), 임혜지(1991~), 정혜주(1983~),
조승연(1991~)

Selected Group Exhibitions

2015 Far East Asia Handicraft Exhibition, Daebu-do Glass
　　Island Macart Gallery, Ansan, Korea
2015 The 17th Kyungsung Ceramic Art Group Exhibition, Jung
　　Jun-ho gallery, Busan, Korea
2014 Far East Asia Handicraft Exhibition, Okinawa Prefectural
　　University of Arts gallery, Japan
2014 Project Group Exhibition 'Thank you, December', Merci
　　gallery, Busan, Korea
2014 The 16th Kyungsung Ceramic Art Group Exhibition,
　　Haeundae Cultural Center, Busan, Korea

부록
Appendix

사진
Photos

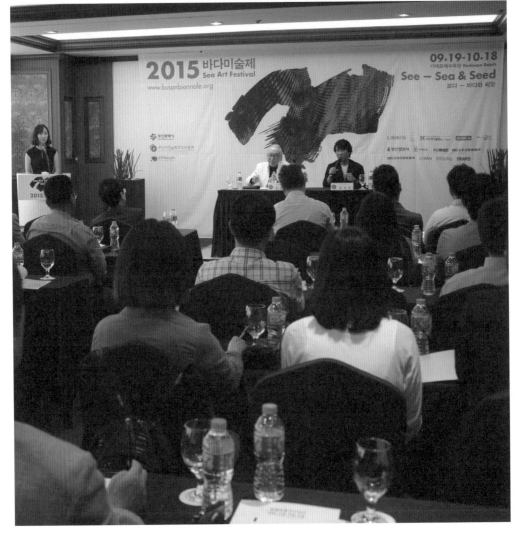

해운대그랜드호텔, 부산, 2015. 8. 19
Haeundae Grand Hotel in Busan, Aug. 19. 2015

웨스틴조선호텔, 서울, 2015. 8. 20
Westin Chosun Hotel in Seoul, Aug. 20. 2015

설치 현장　　Installation Scene

2015. 9. 9 ~ 2015. 9. 17
Sept. 9 ~ Sept. 17, 2015

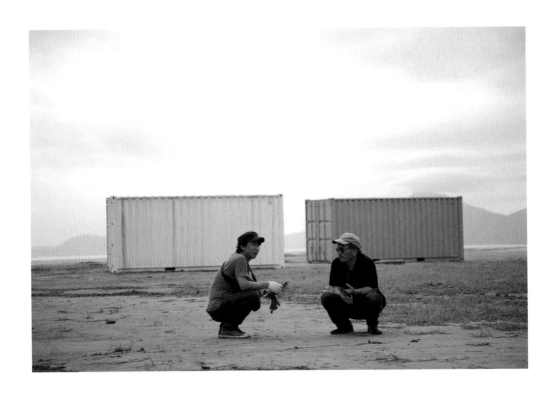

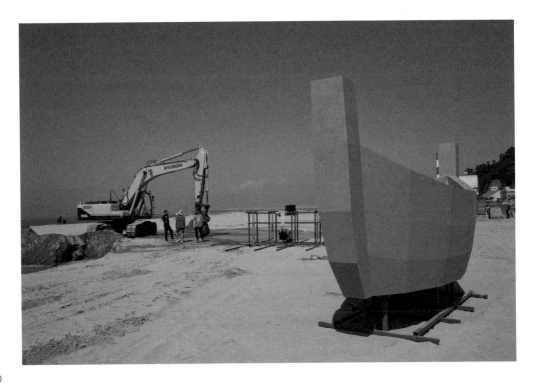

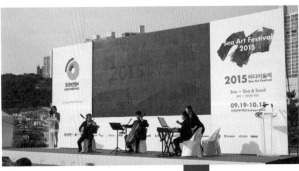

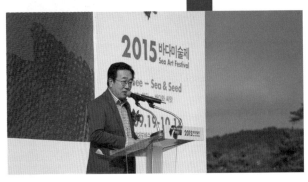

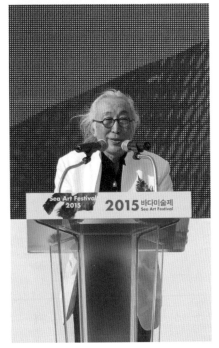

바다미술제 역사

제1회 바다미술제(1987)

88서울올림픽의 프레올림픽(Pre Olympic) 문화 행사의 일환으로 처음 개최되었고 대중 친화적이고 환경 지향적인 야외 전시의 전형으로 부산의 지정학적 여건을 반영함과 동시에 부산 미술의 독자적이고 특성화된 행사로 발전시키고자 하는 취지에서 출범하였다.

기간 : 1987. 9. 15~9. 24(10일간)
장소 : 해운대해수욕장
출품작품 : 32명(팀) 32점
주최 : 한국미술협회 부산지부(지부장 김대륜)
주관 : 제1회 바다미술제 운영위원회
운영위원 : 김대륜(위원장), 김해성, 김정명, 김홍석, 박종선, 조무광, 허황
출품작가
권오순, 김귀호, 김남진, 김민군(전희주), 김원백, 김형균, 남순추, 류무수, 박명란(김혜경, 김일래), 박미화, 박원희, 박인관, 유명균, 위정숙, 이성재, 이정형, 전광수, 정광화, 정명해(이인선), 정세창, 정철교, 조순옥, 조현부, 조현성, 최석운, 최영희(이숙향), 최현수, 황인철, 허종하, 방효성, 이두한, 이창섭

제2회 바다미술제(1988)

세계 평화와 전 인류의 우애를 다짐하는 88서울올림픽과 함께 개최되었으며, 처음으로 바다미술제 전시 도록이 1, 2회 통합본으로 출판되었다. 또한 해외 작가(일본)가 처음 참여하기도 하였다.

기간 : 1988. 9. 15~9. 25(11일간)
장소 : 해운대해수욕장
출품작품 : 2개국 28명(팀) 28점
주최 : 한국미술협회 부산지부
주관 : 제2회 바다미술제 운영위원
운영위원 : 김홍석(위원장), 권달술, 박춘재, 주정이, 허황
출품작가
강은엽, 김귀호(김미숙), 김남진, 김명수, 김석중, 김원백, 김현수(박정선), 김형균, 제3작업실(박영수외 17명), 박시영, 박명란, 박윤성, 박은수, 위정숙, 윤명국, 이강소, 이순선, 이성재, 이안희(양인진, 문효정, 조현순), 조현순, 정수옥, 황 희(정연주), 정희욱, 조종두, 허위영, 허종하, 히구마 하루오, 하마다 고지

제3회 바다미술제(1989)

전체적으로 표현 기법이나 내용면에서 과년도에 비해 크게 향상되어 바다미술제가 해양 도시 부산의 개성을 드러낼 수 있는 국내의 유일한 미술 행사로 자리를 잡게 되었다. 무엇보다 회화적이고 공작적인 수준에서 탈피하여 압축되고 완결된 형태의 작품들이 많이 출품되었으며 광안리해수욕장으로 전시 장소를 옮겨 보다 적극적이고 실험적인 전시 의도를 보여 주었다.

기간 : 1989. 9. 25~10. 3(9일간)
장소 : 광안리해수욕장

출품작품 : 2개국 26명(팀) 26점
주최 : 부산미술협회(이사장 김홍석)
주관 : 제3회 바다미술제 운영위원회
운영위원 : 허황(위원장), 김정명, 김광우, 김응기
후원 : 부산직할시, 부산일보사, KBS부산방송, 부산MBC
출품작가
김광우, 김귀호, 김명희, 김종구, 김현근, 문성권, 송영길, 우대경, 이승택, 정민영, 정연주, 조현부, 차경대, 최남배, 부산여대 지그잭 그룹(김덕진, 김문희, 김양희, 노현정, 박정진, 변미숙, 이민하, 이정희, 이종희, 정애경, 주승미, 허윤희, 허점순, 김경미), 소리회원(김미숙, 박정선, 송종래, 김명희, 이경남, 조현순), 동아대 조소과(도태근, 박은생, 송민규, 신무경, 조정민), 김형균 (박해원, 신중록, 박임수, 정창수), 변신희(박경화, 손성목), 박민준(박영희), 오경택(이대희), 정세창(허영미), 정희욱(문수영), 안치인(이석호), 심홍재, 히구마 하루오

제4회 바다미술제(1990)

처음으로 그랑프리제(시상제)를 도입하여 수상자별 상금을 시상함으로써 창작 의욕을 고취시킴과 동시에 사전 평가를 위한 모형전시회를 개최하였다.

기간 : 1990. 9. 24~10. 5(12일간)
장소 : 광안리해수욕장
출품작품 : 2개국 29명(팀) 29점
주최 : 부산미술협회(이사장 김홍석)
주관 : 제4회 바다미술제 운영위원회
운영위원 : 김광우(위원장), 이시우, 허황, 정철교, 김응기, 박종선
후원 : 부산직할시
출품작가
김언지, 곽순곤, 고승현, 서윤희, 서혜영, 서현화, 이영구, 이응우, 이상진, 이진용, 윤여관, 차경대,. 조현순(이동춘), 서진우(이정위), 석대성(김오경, 원선희), 오소영(이상수), 최진식(도경희), 정흥록(한진섭, 손동기, 이태홍, 이관형), 진경미(차안자, 차현림, 하숙영, 이소영), "끼"그룹(강승용, 임창송, 박동호, 전은숙, 정유미, 김병준, 이근창, 황성욱, 정갑진, 정수룡). 나섬(박계원, 박은일, 양리애, 서경렬, 최남배, 심이성), 동아조각회(하석원, 박경희, 김무범, 오금구), LINE-UP(김명희, 이경희, 여순진, 채승희), 유도화(조현재, 선미순, 김은하, 김향애), 황정오, 세지 시모다, 부산여대미술과 서양화전공 2, 3학년(지도교수 임봉규), 이성원, 히구마 하루오

제5회 바다미술제(1991)

환경 미술에 대한 관심이 높아지고 있는 문화 흐름에 따라 바다미술제는 더욱 중요한 의미와 사회적 책임을 가지게 되면서 시민들과 보다 자연스럽게 교감할 수 있는 이러한 환경 미술제는 미술 문화의 대중화에 크게 기여할 수 있다 "올해 설치 작품들이 환경 오염의 문제와 인간성 회복이란 주제를 주로 다루고 있다는 점이 매우 주목되는 현상이다(1991. 10. 4. 부산일보 인터뷰 박인관)"

기간 : 1991. 9. 26~10. 6(11일간)
장소 : 광안리해수욕장
출품작품 : 27명(팀) 27점
주최 : 부산미술협회(이사장 김홍석)
주관 : 제5회 바다미술제 운영위원회
운영위원 : 권달술(위원장), 김홍석, 허종화, 정철교, 박인관
후원 : 부산직할시
출품작가
김계현, 김창원, 김 현, 양재용, 위창완, 이재석, 이청남, 김영소(노선옥, 이선미, 강소라), 황무현(이규선, 하춘근), 박선옥(강선미), 김종구(손우수), 정영진(강정희, 김경수, 안재연), 김미경(이수진, 문경아), 이숙현(김송필, 윤정희), 김민정(이은주), 정혜영(차종례, 신명희, 이헌진), 장은철(장 민, 고명희, 오민순), 나 · 솜(최남배, 황정오, 심이성, 김말자, 정종효, 박은일, 양리애, 박계원, 서경렬, 이창훈, 박범석), 얼룩(배영훈, 송부경, 이세련, 이혜영, 정미향, 이승희, 주귀란, 송혜선, 강무정, 우 징, 정여손, 이은주, 하미화, 배수철, 황인홍가), 김영목(이재용, 이상헌, 조영진, 이성원, 임원일, 이호근), 문정규(김희동, 권혁중, 박성용, 박성진, 신상훈, 이인희), 고승현, 김광우, 김영섭, 류무수, 안치인, 조현재.

제6회 바다미술제(1992)
지역이나 장르별 '커미셔너'를 채택하여 작가 발굴에 있어 논리적이고 객관성을 확보하려는 시도가 있었고 작가와 작품 또는 환경의 상호 연관 관계와 그 의미를 지역 정서에 밀착시키려는 비전을 제시하고 있다는 점에서 변화를 보이고 있다. 전시 구성의 면에서는 실험작 위주의 공모전에서 벗어나 기성 작가만이 출품하는 초대전으로서 설치 미술을 비롯한 입체, 영상 미술과 각종 실내 전시 미술, 그리고 무용과 초청 강연 등 행사의 스펙트럼의 다양성을 기했다.

기간 : 1992. 10. 5~10. 14(10 일간)
장소 : 광안리해수욕장, 아트타운
출품작품 : 4개국 71명(팀) 71점
주최 : 부산미술협회(이사장 장상만)
주관 : 제6회 바다미술제 운영위원회
운영위원 : 임동락(위원장), 김종기, 임봉규, 문장철, 조정애, 주명우
후원 : 부산직할시, 한국문화예술진흥원, 대전EXPO조직위원회, KBS부산방송본부, MBC부산, 부산일보, 국제신문, 부산매일신문
출품작가
김광우, 최병춘, 길레스 토우야드, 하석원, 주명우, 전준호, 강영모, 김학제, 김종구, 김성식, 김외칠, 곽순곤, 이동훈, 이진용, 이홍수, 이일호, 이기문, 이상일, 이영주, 임동락, 임형준, 엄혁용, 문성원, 서송, 신범상, 신동효, 심이성, 송근배, 송필용, 류 인, 이승택, 아사달청년회, 부산여대 지구잭(홍은정, 김덕진, 강영미, 차애경, 김정선, 윤은옥, 전미경, 김정진, 박희정, 정효정, 이덕희, 황미숙, 황경선, 황정원, 정춘희, 정은정, 장유리), 채민정, 창원대, 천년토탈미술협회(김범무, 노상완, 박봉기, 오금구, 이상호, 조난주), 동아대 아배(백성근, 홍자현, 도평원, 이왕희, 김구태, 김성주, 서봉균, 김진수, 정

성호, 이회장, 윤석빈, 윤경원, 권수경, 이승환, 차은정, 문병탁, 최정선, 김현정, 최정영, 신경하), 여덟 아홉, 효성여대(정란연, 허현순, 구영선, 서정화, 손여옥), 전북대 지.지.지, 정하응, 강희준, 강홍석, 김정희, 고승현, 경남대, 경성대 아솜(진성훈, 이은영, 신만수, 김현근, 임성호, 강안임, 정수룡, 김춘기, 채귀한), 이강일, 이상진, 임동식, 미셀 모페, 필리페 페린, 페트릭 레이나우드, 신남철, 손을수, 임재광, 영남대, 시아오 시아, 이건용, 가와지, 안치인, 임봉규 외 부산여대 40여명, 문정규, 요이치로, 장창익, 김현옥, 김종기, 쿠미오 쿠시야마, 김 윤, 이성원, 박은국

제7회 바다미술제(1993)
기간 : 1993. 10. 1~10. 14(15 일간)
장소 : 해운대해수욕장, 동백아트센터
출품작품 : 2개국 62명(팀) 62점
주최 : 부산미술협회(이사장 장상만)
주관 : 제7회 바다미술제 운영위원회
운영위원 : 이동순(위원장), 송근배, 여상진, 정철교, 이상식, 주명우, 장준호
후원 : 부산직할시, 한국문화예술진흥원, KBS부산방송본부, 부산문화방송, 부산일보, 국제신문, 부산매일신문
출품작가
김진석, 류 훈, 서동화, 이상진, 모토 우타, 방준호, 김구태, 김봉경(윤진원, 조연희), 김질편(김창원), 김춘기(박향숙), 김형균, 박영택(이현기), 심이성, 이상근명(천영훈), 이상기(임상규), 이일노, 이종현, 그룹 고리(강천석, 임동기, 천원식, 이정호, 박주백, 강현주, 김미옥, 이행남), 동아대 아배(백성근, 홍자현, 도평원, 이왕희, 김구태, 김성주, 서봉균, 김진수, 정성호, 이회장, 운석빈, 윤경원, 권수경, 이승환, 차은정, 문병탁, 최정선, 김현정, 최정영, 신경하), 조예창, 부산여대 여덟·아홉(김윤정, 김지현, 김경란, 박정옥, 손명주, 한해순, 김경화, 강현주, 박명희, 이혜정, 정선영, 유연정, 박은정, 유현경, 전영아, 강혜종), 남순추, 미츠타카 이시이, 방병욱(김수연), 윤명국, 김우한, 김윤성, 김태호, 배동환, 손기덕, 박종선, 송주섭, 이강소, 이동순, 이상식, 이석주, 예슨근, 이태호, 임철순, 전준자, 정진윤, 지석철, 최병기, 최아자, 허 황, 김광우, 김영욱, 김정명, 김학제, 류무수, 류 인, 박부찬, 박충흠, 이갑열, 이종희, 임동락, 임형준, 조기수, 주명우, 정철교, 최석호, 홍승남

제8회 바다미술제(1995)
기간 : 1995. 9. 22~10. 1(10일간)
장소 : 해운대해수욕장, 부산문화회관, 파라다이스호텔 공연장
출품작품 : 12개국 50명(팀) 50점
주최 : 부산미술협회(이사장 조일상)
주관 : 제8회 바다미술제 운영위원회
운영위원 : 권달술(위원장), 강숙자, 김염훈, 김이선, 김종구, 남순추, 이상진, 구본호
후원 : 부산직할시

출품작가

강이수, 거리에서 만날 수 있는 사람들(이상훈, 고문수, 양경이, 양천우), 고보현(문영실, 박경화, 김양희), 고승현, 김해민, 나 솜, 니시나 게루, 다니엘 로스, 도래샘, 정연민, 미야게야스오, 박재현, 문병탁(박경미, 박상호, 정형중, 제드 알라귀(필리핀), 터(8명─전인숙, 조인숙, 강숙경, 김동기, 김학일, 황무현, 신충민, 정종호), 박광우·이남규, 이상문, 박종혁, 박현곤, 백성근, 스탄 엔더슨, 심이성, 아 배, 안대희, 원과점(신종식 외 3명), 유명균, 이소미, 이카와 세이로, 젊은 여자들, 징 후, 김석환, 나경자, 남순추, 문정규, 리 웬, 리챠드 마텔, 바르톨룸 페르난도, 박병욱, 반연희, 와디스와브 카지미르쟈크, 심홍재, 요하즈 요셉, 유도화, 윤명국, 이상진, 이우진, 이혁발, 카쥬 미쯔시마, 쿄오코 남바, 페러 에스터, 홍오봉

2000PICAF 국제바다미술제

2000PICAF 국제바다미술제는 설치와 행위예술을 통한 환경미술 작품들이 바다가 지니는 자연의 원초적 의미를 통하여 다시 되살아남으로써 도시 환경에서 초래하는 메마른 삶의 정서를 순화시켰을 뿐만 아니라 인간과 자연이 "함께 하는 삶"이 조형화된 독자적 언어로 표현되어 지역미술의 위상을 한층 높이는 계기가 되었다. 2000PICAF 국제바다미술제는 작품제작을 위한 모형전시와 더불어 실제 현장에서의 설치 및 행위예술에 이르기까지 해운대해수욕장을 찾는 국내·외 관람객들에게 작품제작과 전시의 전 과정을 보여줌으로써 부산이 가지고 있는 해양문화의 독자적 에너지를 표출하는 인상적인 바다연계 이벤트로 자리 잡았다.

전시주제 : 바다·조형·인간
기간 : 2000. 10. 2~10. 16(15일간)
장소 : 해운대해수욕장
출품작품 : 5개국 37점
분과위원장 : 김광우
분과위원 : 김영원, 김정명, 안예효, 김영욱, 주영도, 신현중. 곽순곤, 이정형
출품작가

로저 리고흐, 우오타 모토, 프랭크 우도 티엘만, 구본주, 김종호, 문병탁, 이경섭, 석대성, 표인숙, 설경철, 이상봉, 흙사람, 김성호, 강효명, 박상호, 윤여일, 양재선, 류승현, 이효문, 문정준, 노금식, 그룹 1.5.9.5, 그룹 여덟, 아홉, 김태균, 박형필, 아베, 박종현, 김용섭, 주민선, 강신영, 정윤선, 볼프 가브리엘레, 방영자, 도지호, 이상진, 시모다 세이지, 성능경, 홍오봉, 황민수, 줄리안 브렌느, 조성철

2002부산비엔날레 바다미술제

문화와 문화가 만나 수직적인 관계가 아닌 수평적인 관계 설정으로 대륙문화와 해양문화가 서로 맞닿아 있는 지역적 특성과 위상에 부합되는 새로운 문화생산의 역할을 담당하기를 기대했다. 2002부산비엔날레 바다미술제는 국제공모와 초대로 구분되어 작가를 선정하였으며, 단순히 조형물을 바다라는 공간에 전시하는 차원을 넘어 해양환경에 걸맞은 설치미술양식의 새로운 가능성을 제시하였다.

바다라는 특수한 상황(파도, 강한 해풍, 수많은 인파)이 종합적으로 고려되었을 뿐만 아니라 이러한 요건들이 작품에 흡수되어 자연과 주변환경을 포함한 작품으로 승화되었으며, 작품의 대형화를 통해 개방공간에서의 전시효과를 극대화한 전시였다.

전시주제 : 문화에서 문화로
기간 : 2002. 9. 30~10. 27(28일간)
장소 : 해운대해수욕장
출품작품 : 10개국 80명 39점
전시감독 : 김광우
출품작가

아사타니 히로시, 카를로스 블랑코, 차율, 최평곤, 팀 커티스, 도호선, 도태근, 트루디 엔트위슬, 에이월트 힐게만, 임승오, 그렉 린, 박상호, 박태원, 미켈리 사이, 신무경, 다카다 사토루, 아텔리에 반 리샤우트, 황수로, 증성강, 아베, 레오나르도 아귀날도, 차주만, 정혜령, 흙사람, 전홍식, 강효명, 김귀호(김미숙), 김명범, 김태인(이동주, 김성민, 임태현), 성태관, 김태균, 고이즈미 사야(투루타 하루코, 요시가와 사토코, 요시다 가노코), 이새나, 남수진(이수연), 박동섭, 박종현(강동현, 김민호), 박성찬, 박순우, 서상호, 신호윤

2004부산비엔날레 바다미술제

한국 제2의 도시이자 해양수도인 부산이라는 도시의 해양적 특성을 부각시키는 한편, 도시의 문화적 가능성을 탐구하는 기회가 되었다. 또한 서로 다른 문화의 흐름은 새로운 삶의 양식을 낳게 되며 이를 통해 문화는 더욱 풍부해진다는 설정 아래 대륙문화와 해양문화가 맞닿아 있는 지역적 특성과 국제도시라는 부산의 위상에 부합하는 새로운 문화생산의 역할을 충실히 하기를 기대한 전시였다. 2004부산비엔날레 바다미술제 출품작품은 한 장소에 반영구적으로 설치되는 조형물과는 달리 특정장소에 특정기간 동안만 설치되었다가 전시종료와 함께 옮겨지거나 소멸되는 특성을 살려 장소특정적인 작품으로 기획되었으며, 시각뿐만 아니라 촉각 청각 등 여러 감각을 통한 '끌림'을 의도하였다. 특히 2004부산비엔날레 바다미술제에서는 해운대해수욕장을 중심으로 백사장과 해수면 뿐만 아니라 인근 시설물과 해운대 도심 한가운데까지 진출하여 퍼포먼스를 비롯한 영상매체, 소리를 이용한 조각 등 신개념과 신소재를 수용하여 보다 확장된 영역의 전시로 진행되었다.

전시주제 : 틈─건너가기
기간 : 2004. 10. 9~10. 31(23일간)
장소 : 해운대해수욕장
출품작품 : 11개국 45명 34점
전시감독 : 김광우
출품작가 : 첸 지안 홍, 정현, 마르코 데사르도 하석원, 김인태, 김영준, 크레이그 크래프트 박종현, 선 루, 춤풍 아피숙, 부이 콩 콴, 김춘기, 리 웬, 보리스 니슬로니, 츄바키하라 아키요, 조성진, 윌리엄 베리 3세, 칼 빌링슬리, 알저다스 보사스, 최휘복, 최지연, 이경휴, 최수환, 윤성준, 신제충, 전인식, 조는새, 하야카와 마유, 장준서, 전동명, 미주호 카지, 김희영, 김경아, 아제쉬 쿠마스, 이현걸, 권칠건, 권민규, 마르크 슈미츠, 양혜정

2006부산비엔날레 바다미술제

전시공간이 공공영역이자 일상생활이 영위되는 공간이라는 점에서
전시의 주제는 '생활 속의 아트(Art in Life)'로 선정하였으며, 퍼블릭
퍼니처(public furniture)와 리빙 퍼니처(living furniture)라는 두 개의
파트로 나뉘어 기획되었다. 퍼블릭 퍼니처는 기존 스트리트 퍼니처
곳곳에 예술을 개입시켜 도시환경의 변화를 꾀하고 관객의 출품과
사용을 통해 기능하는 관객을 중심으로 하는 미술을 구현코자 기획
되었으며, 리빙 퍼니처는 집안에서 흔히 볼 수 있는 가구 등에 예술
적 상상력을 조화시켜 인간 생활의 주요 무대인 주거공간과 일상
속에서 예술을 체험할 수 있는 독특한 경험을 선사토록 기획되었
다. 특히 2006부산비엔날레 바다미술제는 전체 행사의 주제였던 '
어디서나(Everywhere)'와 그 맥을 같이하여 현대미술을 대중들에게
어떻게 다가가게 할 것인지를 고민한 전시였으며, 나아가 우리가
일상생활을 영위하는 공간과 예술의 결합을 통해 예술이 우리의 삶
과 무관하지 않으며, 생활에 근접해 있음을 알리는 전시가 되었다.

전시주제 : 아트 인 라이프
기간 : 2006. 9. 16~11. 25(71일간)
장소 : 해운대해수욕장, 부산비엔날레 파빌롱 등
출품작품 : 14개국 115명(팀) 99점
전시감독 : 류병학
출품작가

올리버 크루제, 니시카와 가츠히토, 윤 희, 기욤 바일, 클라우스 포
비쩌, 안나 포어만 & 구나르 프릴, 하이모 조베르닉, 헹크 피쉬, 피
오트르 자모이스키, 김미진, 이미경, 이수경, 오순환, 정윤선, 하석
홍, 한젬마, 수보드 케르카, 알리나&제프 블리우미스, 야마후지 히
토시, 자킨 가스고니아 팔렌시아, 아트패밀리, 한주용, 양문기, 김선
주, 쏨생이별─박민영 외 5명, 유코 시라이시, 감민경, 강애란, 강홍
석, 국종훈, 권기수, 김경덕, 김경호, 김기라, 김기철, 김문수, 김미
진, 김병권, 김유선, 김인배, 김준, 김준용, 김태중, 김해민, 김혜란,
남춘모, 노병렬, 문경원, 문형민, 민병헌, 밀리미터밀리그람, 박명래,
박성선, 박소영, 박인진, 박지선/양선혜, 박진우, 방정아, 변대용, 변
지훈, 백진, 서영배, 서은애, 서해근, 손동현, 신경애, 신원재, 심정
아, 심영철, 심점환, 안성희, 안종연, 안진우, 양민하, 5.5 Designer,
오현아, 우주&임희영, 유대영, 유미연, 유재웅, 윤희선, 이교준, 이
동기, 이미지 놀이터, 이상봉, 이상호, 이수경, 이승리, 이은호, 이
완, 이원조, 이정화, 이재곤, 이주희, 이준익, 이중근, 이진이, 이찬
호, 임선이, 부산비엔날레 파빌롱 건설팀, 장민석, 장광효, 장영필,
장우석, 전기호, 전용일, 전혜원, 정지윤, 정연주(조재임, 진현옥), 정
한나, 조소희, 주상현, 주혜진, 최병훈, 최소영, 최용진, 최유경, 추
지연, 한계륜, 한수정, 한지영, 한윤주, 함여주, 함영이, 함영훈, 허
성하, 허한솔, 홍상식, 홍수경, 홍유영, 홍시야, 홍지윤, 황진, 데이비
드&히진 호지, 존 로저스, 호세 카를로스 카사도, 로리 해밀턴, 유코
시라이시, 아이 웨이 웨이, 안 지아오 통, 리우 지안후아, 루 하오,
선 리앙, 티안 웨이, 왕 마이, 왕 지아오 후이, 왕 찌후이안, 예 팡,
에이미 카오, 차 레이추, 와우 브라보(펑키 랩), 후이샨 양, 마 준푸,
린 준팅, 케네다 쇼이치, 하루코 쿠마쿠라, 신야 마츠야마(히사카즈
나베시마), 카오루 스카모토, 코타 네즈, 쿠미코 스에츠니(사야카 오
하나), 마코도 히라하라(신야 마츠야마), 마사키 야기사와, 미도리

미타무라, 쇼조 쿠제, 다카시 마에카와, 토모야 와타나베, 비하이클,
요코 이시이, 요스케 이가, 유이치 히가시오나

2008부산비엔날레 바다미술제

지난 전시를 통해 축적된 바다미술제의 양식을 벗어나 새로운 방
향을 제시하고자 하였다. 2008부산비엔날레 바다미술제는 이전의
어느 전시보다 바다미술제가 가지는 고정관념으로부터의 탈주라는
본래의 취지를 전시의 중심에 두었다고 할 수 있다. 해수면과 해수
변 등을 활용하던 전시 개념에서 벗어나 4개의 스페이스(Outdoor
Space, Indoor Space, Urban Space, Mobile Gallery)로 전시장을
구분하였으며 기존의 바다미술제 작품은 Outdoor Space로 회화,
영상 등의 작품은 Indoor Space로 그리고 문화센터와 지하철 등
도심 속 생활공간을 활용한 Urban Space와 항만과 물류의 도시 부
산을 상징하는 컨테이너 전시장인 Mobile Gallery 등으로 바다미술
제 전시의 폭을 확대하였다. 전시의 주제는 '비시간성의 항해'. 이
전시주제는 바다미술제가 처음 개최된 이후 20년의 세월이 흐른
시점에서 바다미술제는 무엇으로 새로운 것을 찾을 것인가에 대한
고민에서 시작되었다. 비미래는 불확실이 아닌 비결정을 전제로 하
는 불확정성을 특징으로 한다. 2008부산비엔날레 바다미술제에서
는 이런 불확정성의 항로 즉 결정되지 않은 미래를 위해 새로운 항
로를 개척하는 실천적 영역을 강조하여 새로운 예술가들이 시.공간
의 좌표, 그 사이와 사이를 미끄러져 들어가면서 만들어내는 예술
적 사건들을 의미한다.

전시주제 : 비시간성의 항해
기간 : 2008. 9. 6~11. 15(71일간)
장소 : 광안리해수욕장 일원, 금련산지하철역, 미월드
출품작품 : 26개국 77명(팀) 195점
전시감독 : 전승보
출품작가

안두진, 뱌체슬라브 아후노브(세르게이 트이치나), 리차드 애널리,
리차드 애널리(데니스 글레이저), 배인석, 배지민, 박선기, 부 후아,
최태훈, 최예희, 최연우, 소냐 릴리백 크리스텐슨, 홍현숙, 이레네 호
펜베르그, 테레사 허버드(알렉산더 버클러), 허숙영, 리사 지닌, 롭
요하네스마, 테레르보 칼라이넨(올리버 코차-칼라이넨), 강용면, 김
창겸, 김지영, 김해심, 김종구, 김계현, 김미애, 김석, 김선득, 김태준,
김태균, 디터 쿤즈, 필립 라루, 이배경, 이진경, 이종빈, 이준영, 이상
길, 이상우, 이수영, 임욱상, 롱마치 프로젝트(샤오 슝), 뮌, 미야나가
아이코, 티비 무어, 모리모토 겐, 나명규, 에코 누그로호, 오쿠무라
유키, 니판 오라니웨스나, 오를랑, 엄정순, 박미경, 게리-로스 파스
트라나, 핑 선, 레이첼 라케나(페즈 파나나, 브라이언 푸아타), 켈리
리차드슨, 나이젤 롤페, 록스리, 라리사 산소어, 사와 히라키, 사라
쉬나트, 카리나 스미글라-보빈스키, 손한샘, 손몽주, 쁘라팁 수타통
타이, 다나카 코키, 식스텐 테레칼드슨, 이것은 동화가 아니다: 동남
아시아의 속담임, 질 트래블러, 쯔 관유, 츠지 나오유키, 운 티엔 웨
이(림 콕분, 리 쩌친), 양주혜, 양태근, 유지훈, 유승재, 릴리언 줌케미

2010부산비엔날레

기존 3개 전시를 통합하여 1명의 전시기획자가 실내·외로 구분하여 구성함으로써 부산비엔날레 전시의 특성을 살리는 방향으로 기획되었다. 2010부산비엔날레의 전시주제는 '진화 속의 삶(Living in Evolution)'. 개인의 삶과 이것들의 집합인 인류의 진화라고 하는 두 개의 커다란 시간 축이 서로 교차하는 지점에 대한 이야기이다. 특히 바다를 중심으로 바다와 함께 발전해온 항구도시 부산이라는 지역성에 기반하여 타문화와의 소통을 촉진시킨 바다의 존재를 강하게 부각하고 바다가 상징하는 '생명감'과 '장대한 시간'을 중심으로 생물학적 의미의 진화뿐만 아니라 지적·문화적 측면에서의 인류 및 도시의 진화 그리고 진화 속에서의 '개인의 존재'에 대해 고찰한 전시였다. 2010부산비엔날레의 출품작품 중에서도 바다에 설치된 작품들이 주는 감동이 배가된 것은 전시 주제와의 강한 연관성 때문일 것이다. 2010부산비엔날레에 출품된 작품 중 광안리해수욕장을 전시장으로 설치된 작품은 총 5개국 13명 19점. 과년에 비해 작품수를 줄이되 작품의 규모와 완성도를 높여 많은 작품을 감상할 때 오는 예술적 피로를 최소화하고 바다라는 특정장소가 주는 예술적 감흥을 극대화하는 전시였다.

전시주제 : 진화 속의 삶
기간 : 2010. 9. 11~11. 20(71일간)
장소 : 부산시립미술관, 요트경기장, 광안리해수욕장, 부산문화회관 등
설치작품 : 23개국 252명 338점(광안리해수욕장 설치 : 5개국 13명 19점)
출품작가
강민규, 김정명, 류신정, 박발륜, 이송준, 원다연, 정승, 짜오 쩡우, 아마르사이항 남스래자브, 치우 안시옹, 아다치 키이치로, 타위싹 씨텅디, 코노이케 토모코

2011바다미술제

부산비엔날레와의 통합 10년 만에 다시 독자적으로 출범하였다. 역사적 의미와 근원을 알리고자 그동안 개최되어온 해운대와 광안리해수욕장을 벗어나 한국의 제1호 해수욕장인 송도해수욕장을 배경으로 열렸으며, 예술을 통해 송도와 원도심의 새로운 활력, 나아가 부산이라는 도시의 역동성에 주목하고자 전시주제를 '송도.(松道, SongDo)'라 정하였다. 송도의 아름다운 자연환경과 이를 적극적으로 해석한 작품이 한데 어우러진 열린 미술축제에서는 12개국 29점의 작품들이 초대 공모작품 구분없이 해수변, 백사장 등에 21일간 설치, 전시되었다. 출품작품은 송도해수욕장이라는 공간적 배경을 십분 활용하여 스토리텔링이 가미된 작품들과 자연의 위기와 이에 따른 경각심을 일깨워주는 작품들이 다수를 이루었으며 다양한 부대행사(작가와의 만남, 기록사진전, Sea Art Fun Zone)를 통하여 관람객의 참여를 유도하였다. 특히 2011바다미술제는 독자적으로 출범하는 의미를 되살려 초기 바다미술제의 특성인 청년성과 실험성을 실현한 전시였다.

전시주제 : 송도.(松道, SongDo)'
기간 : 2011. 10. 1 ~ 10. 21(21일간)
장소 : 송도해수욕장
출품작품 : 12개국 29점
주최 : 부산광역시, (사)부산비엔날레조직위원회
출품작가
강찬호, 노순천, 김도형, 김민찬, 김수진, 유은석, 니카 오블락, 프리모즈 노박, 루멘 디미트로프, 리프 자이니, 문병탁, 문재범, 정영환, 박건원, 박재하, 벌 떼, 베라 마테오, 베이야드 마오리스, 아나벨라 클라우디아 호프만, 와타르 하마사카, 요시노리 니와, 이용재, 이용희, 이준, 조금미, 이유진, 이재민, 이정윤, 이창진, 임상규, 정안용, 정혜진, 타냐 프리밍어, 티안 예, 피샤드 슈테판, 피터'비틀'콜린스

2013바다미술제

2013바다미술제는 2011바다미술제를 계기로 송도해수욕장에서 열렸다. 2013바다미술제는 독립개최된 이래 처음으로 전시감독제를 도입함으로써 전시 개념에 있어 일관성 있는 구성으로 더욱 결속력을 갖추게 되었다는 역사적 의미를 가진다. 송도해수욕장의 개장 백주년을 기념하는 중요 프로그램으로서, 바다미술제는 이 지역의 도시 맥락을 강조하면서 시민들의 예술 향유의 권리를 도모하고 지역문화의 균형 있는 발전에 기여했다. 특별히 'With 송도, 기억, 흔적, 사람'이라는 주제와 개념은 송도의 장소와 조화롭고도 유기적으로 연결되어, 기획자가 자신의 공간 연출의 능력을 드러내는데 기여했다. 미술제는 관객 참여와 장소특정적인 작품들로, 관람객과의 소통을 창출하면서 전형적인 야외미술제의 개념을 탈피했다. 2013미술제는 단지 전시뿐만이 아니라 출품작들과 연계된 퍼포먼스와 도슨트 프로그램 그리고 시민 참여를 통해서 예술작품의 이해를 향상시키려는 새로운 시도들로 돋보였다.

전시주제 : With 송도 : 기억·흔적·사람
기간 : 2013. 9. 14~10. 7
장소 : 송도해수욕장
행사구성 : 전시, 축제행사
주최 : 부산광역시, (사)부산비엔날레조직위원회
출품작가
후미히코 사노, 프란시스코 데 올라비에라 지레스니카, 탈루 L.N. 크레이그 코스텔로, 콘스탄틴 디모폴로스, 코린 켐스터, 줄리아 자로지크, 최문수, 조은필, 제임스 잭, 정만영, 임확준, 이일, 이수홍, 이성옥, 왕 하이위안, 왕 이, 예치섭, 김승현, 정세윤, 박상환, 심준섭, 송성진, 손몽주, 성동훈, 사니타스 스튜디오, 벌떼, 방준호, 박헌열, 박채연, 준킴, 마테오 베라, 마리아 레베카 발레스트라, 라첼라르네 아베트, 리우보촌, 대구청년작가회, 김재영, 김숙빈, 김성민, 서영호, 김상일

History of the Sea Art Festival

1st Sea Art Festival (1987)

The 1st Sea Art Festival(1987), which was held as part of the cultural program of the Pre-Olympic held to promote the 1988 Seoul Olympics, served as a paragon of an viewer-friendly and environment-oriented outdoor exhibition and was launched to reflect the geographical characteristics of Busan and to establish an independent and specialized art festival of the city

Period : Sept. 15~Sept. 24, 1987(10 days)
Venue : Haeundae beach
Artworks : 32 artists(group) 32 artworks
Host : Busan sub association of Korean Fine Art(branch manager : Dae-Ryun Kim)
Organizer : 1th Sea Art Festival Operating Committee
Member of Operating Committee : Dae-Ryun Kim(executive director), Hae-Sung Kim, Jung-Myung Kim, Hong-Suk Kim, Jong-Sun Park, Mu-Gwang Cho, Hur Hwang
Artists
Kwon O Soon, Kim Gui Ho, Kim Nam Jin, Kim Min Gun(Jeon Hee Ju), Kim Won Baek, Kim Hyung Kyun, Nam Soon Chu, Ryu Moo Soo, Park Myung Ran(Kim Hye Kyung, Kim Il Rae), Park Mi Hwa, Park Won Hee, Park In Kwan, Yoo Myung Kyun, Wi Jung Sook, Lee Sung Jae, Lee Jung Hyung, Jeon Kwang Soo, Jung Kwang Hwa, Jung Myung Hae(Lee In Sun), Jung Se Chang, Jung Chul Kyo, Cho Soon Ok, Cho Hyun Boo, Cho Hyun Young, Choi Seok Woon, Choi Young Hee(Lee Sook Hyang), Choi Hyun Soo, Hwang In Chul, Heo Jong Ha, Bang Hyo Sung, Lee Doo Han, Lee Chang Sub

2nd Sea Art Festival (1988)

The 2nd Sea Art Festival(1988) was held to coincide with the 1988 Seoul Olympics, which was aimed at promoting the world peace and friendship among all nations and peoples. The exhibition catalog was published for the first time, combining the 1st and 2nd Festivals. It also marked the first time that an artist from overseas (Japan) participated in the exhibition.

Period : Sept. 15~Sept. 25, 1988(11 days)
Venue : Haeundae beach
Artworks : 28 artists(group) 28 artworks from 2 countries
Host : Busan sub association of Korean Fine Art
Organizer : 2th Sea Art Festival Operating Committee
Member of Operating Committee : Hong-Suk Kim(executive director), Dal-sul Kwon, Chun-Jae Park, Jeong-i Joo, Hur Hwang

Artists
Kang Eun yup, Kim Gue Ho(Kim Mi Suk), Kim Nam Jin, Kim Myoung Soo, Kim Sok Joong, Kim Won Back, Kim Hyon Sun(Bak Jung Seon), Kim Hyoung Gyun, The third studio(Bak Young Soo and 17), Park Si Young, Park Myng Ran, Park Youn Seong, Park Eun Soo, We Joung Sook, Yun Myeong Kook, Lee Kang So, Lee Soon Sun, Lee Seung Jea, Lee Ahn He(Yung In Jen, Moon Hio Chung, Jho Hyun Soon), Jho Hyun Soon, Jeong Soo Ock, Hwang Hee(Jung Yun Joo), Jeong Hee Uk, Jo Jong Doo, Heo Wea Young, Heo Jong Hwa

3rd Sea Art Festival (1989)

The 3rd Sea Art Festival(1989) saw a great improvement in artistic skills and content over the previous two festivals and helped the Festival to establish itself as the nation's only art event featuring the characteristics of the marine city Busan. Departing from painting- or craft-like styles, most artworks on exhibition were compact and complete. Gwanganri Beach was chosen as a new exhibition venue, enabling the exhibition of a more active and experimental nature.

Period : Sept. 25~Oct. 3, 1989(9 days)
Venue : Gwangalli beach
Artworks : 26 artists(group) 26 artworks from 2 countries
Host : Busan Fine Art Association(Chairman : Hong-Suk Kim)
Organizer : 3th Sea Art Festival Operating Committee
Member of Operating Committee :Hur Hwang(executive director), Jung-Myung Kim, Kwang-Woo Kim, Eun-Gi Kim
Sponsors : Busan Metropolitan City, The Busan Ilbo, KBS broadcasting station, Busan MBC
Artists
Kim Kwang Woo, Kim Gue Ho, Kim Myung Hee, Kim Jong Gu, Kim Hyun Gun, Moon Seong Kwon, Song Young Kil, Woo Dae Kyung, Lee Seung Teak, Jeong Min Young, Jung Yeon Joo, Cho Hyun Doo, Cha Kung Dae, Choi Nam Bae, ZigZag Group(Kim Deuk Jin, Kim Moon Hee, Kim Yang Hee, Noh Hyun Jung, Park Jung Jin, Byun Mi Suk, Lee Min Ha, Lee Jung Hee, Lee Jong Hee, Jung Ai Kyung, Ju Seoung Mi, Heo Yun Hee, Heo Jum Soon, Kim kyung Mi), SoRi Member(Kim Mi Suk, Park Jung Seum, Song Jong Ae, Kim Myung Hee, Lee Kyung Nam, Cho Hyun Soon, Do Tae Keun, Park Eun Seaung, Song Min Gyu, Shin Moo Kyung, Cho Jang Min), Kim Hyung Gyun, Park Hai Won, Shin Jung Lock, Park Im Soo, Jeong Chang Soo, Byun Sin Hee, Park Kyung Hwa, Son Sung Mok, Park Min Jun, Park Young Hee, Oh Kyung Taeg, Lee Dai Hee, Jung Se Chang, Heu Young Mi, Jung Hee Uk, Moon Su Young, Ahn Chi In(Kim Hyun Ki, Lee Seok Ho), Shim Hong Jae

4th Sea Art Festival (1990)

The 4th Sea Art Festival(1990) introduced an awards system for the first time to inspire creativity by offering cash prizes and hosted a model exhibition presented for preliminary evaluation.

Period : Sept. 24~Oct. 5, 1990(12 days)
Venue : Gwangalli beach
Artworks : 29 artists(group) 29 artworks from 2 countries
Host : Busan Fine Art Association(Chairman : Hong-Suk Kim)
Organizer : 4th Sea Art Festival Operating Committee
Member of Operating Committee : Kwang-Woo Kim(executive director), Si-Woo Lee, Hur Hwang, Chul-Kyu Jung, Eun-Gi Kim, Jong-Sun Park
Sponsor : Busan Metropolitan City
Artists
Kim Eon Ji, Kwak Seung Kyun, Ko Seung Hyun, Seo Yun Hee, Suh Hai Young, Seo Hyun Wha, Lee Young Ko, Lee Eung Woo, Lee Sang Jin, Lee Jin Yong, Yoon Yea Kwan, Cha Kyung Dae, Cho Hyun Soon, Lee Dong Chun, Seo Jin Woo, Lee Jung Wi, Suk Dae sung, Kim Oh Kyum, Won Sun Hee, O So Young, Lee Sang Soo, Choi Jin Sik, Do Kyung Hee, Jung Hung Rock, Han Jin Sup, Son Dong Gi, Lee Tae Hong, Lee Kwen Hyung, Jin Kyung Mi, cha An Ja, Cha Hyun Lim, Ha Sook young, Lee So Young, KKI group(Kang Seang Yong, Lim Chang Song, Park Dong Ho, Jun Eun Sook, Jung Yoo Mi, Kim Byong Jun, Lee Gean Chang, Hwang Sung Wook, Jung Gap Jeen, Jung Soo Yoang), Na Som(Park Gea Won, Park Eun Il, Yang Lee Ae, Seo Kyung Yeal, Choi Nam Bae, Sim Lee Sung), DongA sculpture(Ha Seak Won, Park Kyung Hee, Kim Moo Bum, Oh Gum Goo), LINE-UP(Kim Young Hee, Lee Kyung Hee, Ye Soon Jin, Chae Seung Hee), Yu Do Hwha, Cho Hyun Jae, Sun Mi Soon, Kim En Ha, Kim Hang Ae, Hwang Jung Oh, Seiji Simoda, The Fine Art 2, 3 grade of Busan Women's College(professor : Im Bong kyu), Lee Sung Won, Higuma Haruo

5th Sea Art Festival (1991)

"With a cultural trend featuring a growing interest in environmental art, the Sea Art Festival has gained more significance and social responsibility. An environmental art festival like the Sea Art Festival, which facilitates spontaneous communication and interaction with citizens, can make a great contribution to the popularization of art culture. It is especially remarkable that installation works this year address the issue of environmental degradation and the recovery of humanity." (In-Gwan Park , October 4, 1991, interview with Busan Ilbo Daily News)

Period : Sept. 26~Oct. 6, 1991(11 days)
Venue : Gwangalli beach
Artworks : 27 artists(group) 27 artworks
Host : Busan Fine Art Association(Chairman : Hong-Suk Kim)
Organizer : 5th Sea Art Festival Operating Committee
Member of Operating Committee : Dal-Sul Kwon(executive director), Hong-Suk Kim, Jong-Hwa Hur, Chul-Kyu Jong, In-Gwan Park
Sponsor : Busan Metropolitan City
Artists
Kim Gae Hyon, Kim Chang Won, Kim Hyun, Yang Jae Yong, Wee Chang Wan, Lee Jae Seok, Lee Cheong Nam, Kim Young Soon, No Sun Ok, Lee Sun Mi, Kang So Ra, Hwang Mu Hyeon, Lee Kyoo Souk, Ha Choon Gun, Park Sun Ok, Kang Sun Mi, Kim Jong Gu, Son Eul Su, Jeng Young Jean, Kang Jeng Hee, Kim Kyung Su, An Jea Young, Kim Mi Kyoung, Lee Su Jin, Moon Kyung Ah, Lee Suk hyun, Kim Song Pil, Yun Jung Hi, Kim Min Jung, Lee Eun Ju, Jeung Hye Young, Cha Jong Rye, Shin Myung Hee, Lee Hyoun Jin, Chang Eun Cheol, Chang Min, Go Moung Hee, Oh Min Soon, Na Som(Choi Nam Bay, Hwang Jeong Oh, Sim Yi Seung, Kim Mal Ja, Cheong Jong Hyo, Park Eun Il, Yang Lee Ai, Park Gea Won, Seo Kyung Leul, Lee Chang Hun, Park Bum Suk, STAIN(Bae Yong Hoon, Song Bu Koung, Lee Se Loun, Lee Hye Young, Jeong Mi Hyang, Lee Seung Hee, Joo Gue Ran, Song Hye Sun, Kang Mu Jung, Woo jing, Jung Young Soon, Lee Eun Joo, Ha Mi Hwa, Bae Soo Chul, Hwang In hong ga, Kim Yong Mok, Lee Jai Yong, Lee Sang Heon, Cho Young Jin, Lee Sung Wan, Lim Won Il, Lee Ho Gun, Moon Jeong Kyoo, Kim Hee Dong, Kwon Hyouk Jung, Park Sung Yong, Park Sung Jin, Shin Sang Hoon, Lee In Hee, Ko Sueng Hyun, Kim Kwang Woo, Kim Young Sub, Ryy Moo Soo, An Chi In, Cho Hyun Jae

6th Sea Art Festival (1992)

The 6th Sea Art Festival(1992) made an attempt to raise objectivity in the process of selecting artists by introducing commissioners in charge of a certain region or a genre. The Festival set itself apart from the previous ones in that it provided a vision of promoting a correlation between artists, artworks and the environment and its significance among the public. It distinguished itself from the previous competition-based exhibitions composed of experimental works and was designed as an invitational for established artists. The spectrum of the Festival widened significantly with 3-dimensional artworks, including installations, video art, indoor exhibitions of various types, dance performances and lectures.

Period : Oct. 5~Oct. 14, 1992(10 days)
Venue : Gwangalli beach, Art Town
Artworks : 71 artists(group) 71 artworks from 4 countries
Host : Busan Fine Art Association(Chairman : Sang-Man Chang)
Organizer : 6th Sea Art Festival Operating Committee
Member of Operating Committee : Dong-Rak Lim(executive director), Jong-Ki Kim, Bong-Kyu Lim, Chang-Chul Moon, Jeong-Ae Cho, Myeong-Woo Joo
Sponsor : Busan Metropolitan City, Korea Arts & Culture Education Service, DaeJeon EXPO Committee, The Busan Ilbo, Kukje Newspaper, Busan Maeil Newspaper KBS broadcasting station, Busan MBC
Artists
Kim Kwang Woo, Choi Byong Chun, Gilles Touyard, Ha Suk Won, Joo Myung Woo, Jeon Jun Ho, Kang Young Mo, Kim Hak Jae, Kim Jong Gu, Kim Sung Sik, Kim Eui Chil, Kwak Soon Kon, Lee Dong Hoon, Lee jin Yong, Lee Hong Soo, Lee Il Ho, Lee Ki Moon, Lee Sang Il, Lee Young Ju, Lim Dong Rak, Lim Hyung Jun, Eum Heuk Yong, Moon Sung Won, Seo Song, Shin, Bum Sang, Shin Dong Hyo, Shim Yi Sung, Song Keun Bae, Song Pil Yong, Ryu Im, Lee Seng Tak, Asadal Youth Group, Busan Womans Univ.Jegejack(Hong Eun Jung, Kim Duk Jin, Kang Young Mi, Cha Ae Kyung, Kim Jung Sun, Yoon Eun Ok, Jeon Mi Kyung, Kim Jung Jin, Park Hee Jung, Jung Hyo Jung, Lee Duk Hee, Hwang Mi Sook, Hwang Kyung Sun, Hwang Jung Won, Jung Chun Hee, Jung Eun Jung, Jang Yu Ri), Chea Min Jeong, Chang Won Univ, Youth Total Art Association(Kim Bum Moo, No Sang Wan, Park Bong Ki, Oh Geum Gu, Lee Sang Ho, Cho Nan Ju), Dong-A Univ. A-Bae(Baek Sung Geun, Hong Ja Hyun, Do Pyung Won, Lee Wang Hee, Kim Gu Tae, Kim Sung Ju, Seo Bong Kyun, Kim Jin Soo, Jung Sung Ho, Lee Hoi Jang, Yoon Seok Bin, Yoon Kyung Won, Kwon Soo Kyung, Lee Seung Hwan, Cha Eun Jung, Moon Byung Tak, Choi Jung Sun, Kim Hyun Jung, Choi Jung Young, Shin Kyung Ha), Eight Nine, Hyo-Sung Univ(Jung Ran Yeon, Heo Hyun Soon, Gu Young Sun, Seo Jung Hwa, Son Yeon Ok), Jeon-Buk Univ.ZZZ, Jeong Ha Eung, Kang Hee Jun, Kang Hong Suk, Kim Jeong Hee, Ko Seung Hyun, Kyung-Nam Univ, Kyung-Sung Univ.A-Som(Jin Sung Hoon, Lee Eun Young, Shin Man Soo, Kim Hyun Geun, Im Sung Ho, Kang An Im, Jung Soo Ryong, Kim Chun Ki, Chae Gui Han), Lee Kang Il, Lee Sang Jin, Lim Dong Sik, MICHEL MOFFE, PHILIPPE PERRIN, PATRIC RAYNAUD, Shin Nam Chul, Son Eul Soo, Lim Jae Kwang, Young-Nam Univ, Xiao Xia, Lee Kyun Yong, KAWAJI, An Chi In, Lim Bong Kyu, Busan women's Univ 40 artists , Moon Jung Kyu, YOICHIRO, Jang Chang Ik, Kim Hyun Ok, Kim Jong Ki, KUMIKO KUSHIYAMA, Kim Yoon, Lee Sung Won, Park Eun Kuk

7th Sea Art Festival (1993)

Period : Oct. 1~Oct. 14, 1993(15 days)
Venue : Haeundae beach, Dong-baek Art Center
Artworks : 62 artists(group) 62 artworks from 2 countries
Host : Busan Fine Art Association(Chairman : Sang-Man Chang)
Organizer : 7th Sea Art Festival Operating Committee
Member of Operating Committee : Dong-Sun Lee(executive director), Geun-Bae Song, Snag-Jin Yeo, Chul-Kyu Jong, Sang-Sik Lee, Myung-Woo Joo, Jun-Ho Chang
Sponsor : Busan Metropolitan City, Korea Arts & Culture Education Service, The Busan Ilbo, Kukje Newspaper, Busan Maeil Newspaper, KBS broadcasting station, Busan MBC
Artists
Kim Jin Seok, Ryu Hoon, Seo Dong Wha, Lee sang Jin, MOTOO UOTA, Bang Jun Ho, Kim Gu Tae, Kim Bong Kyung, Yoon Jin Won, Cho Yeon Hee, Kim Jill Hyun, Kim Chang Won, Kim Chun Ki, Park Hyang Sook, Kim Hyoung Guyn, Park Young Tark, Lee Hyun Gi, Shim Yi Sung, Lee Sang Geun, Cheon Young Hoon, Lee Sang Guy, Im Sang kyu, Lee Il No, Lee Jong Hyun, Group GoRi(Kang Chun Seok, Im Dong Ki, Cheon Won Sik, Lee Jung Ho, Park Ju Baek, Kang Hyun Ju, Kim Mi Ok, Lee Haeng Nam, Dong-A Univ.A-Bae(Baek Sung Geun, Hong Ja Hyun, Do Pyung Won, Lee Wang Hee, Kim Gu Tae, Kim Sung Ju, Seo Bong Kyun, Kim Jin Soo, Jung Sung Ho, Lee Hoi Jang, Yoon Seok Bin, Yoon Kyung Won, Kwon Soo Kyung, Lee Seung Hwan, Cha Eun Jung, Moon Byung Tak, Choi Jung Sun, Kim Hyun Jung, Choi Jung Young, Shin Kyung Ha), Group : Cho Ye Chang, Busan women's Univ Eight Nine(Kim Yoon Jung, Kim Ji Hyun, Kim Kyung Ran, Park Jung Ok, Son Myung Ju, Han Hae Soon, Kim Kyung Hwa, Kang Hyun Ju, Park Myung Hee, Lee Hye jung, Jung Sun Young, Yoo Yeon Jung, Park Eun Jung, Yoo Hyun Kyung, Jeon Young A, Kang Hye Jong), Nam Soon Chu, Mitsutaka Ishii, Park Byoung Wook, Kim Su Yeun, Yoon, Myung Guk, Kim U Hank, Kim Yoon Seong, Kim Tae Ho, Bai Dong Hwan, Sohn Ki Duck, Park Jong Sun, Song Zoo Sub, Lee Kang So, Lee Dong Soon, Lee Snag Sik, Lee Suk Ju, Ye Yoo Geun, Lee Tae Ho, Lim Chul Soon, Jun Joon Ja, Cheong Jin Yun, Ji Seok Cheol, Choi Byung Ki, Choi A Ja, Heo Hwang, Kim Kwang Woo, Kim Young Wook, Kim Jung Myung, Kim Hak Jei, Ryu Moo Soo, Ryu In, Park Bou Chan, Park Choong Heum, Lee Kap Yeul, Lee Jong Hee, Lim Dong Lak, Lim Hyoung Jun, Cho Ki Soo, Joo Myeng Woo, Jeong Chul Kyo, Choi Suk Ho, Hong Seung Nam

8th Sea Art Festival (1995)

Period : Sept. 22~Oct. 1, 1995(10 days)

Venue : Haeundae beach, Busan Cultural Center, Paradise Hotel Theatre

Artworks : 50 artists(group) 50 artworks from 12 countries

Host : Busan Fine Art Association(Chairman : Il-Sang Cho)

Organizer : 8th Sea Art Festival Operating Committee

Member of Operating Committee : Dal-Sul Gwon(executive director), Suk-Ja Gang, Yeom-Hun Kim, I-Seon Kim, Jong-Gu Kim, Sun-Chu Nam, Sang-Jin Lee, Bon-Ho Gu

Sponsor : Busan Metropolitan City

Artists

Kang Yi Soo, People who could be meet in the street, Ko BoHyun, Moon Young Sil, Park Kyung Hwa, Ko Seung Hyun, Kim Hae Min, Na Som, Nishina Shigeru, Roth Daniel, Doraesem, Chong Yeun Min, Miyake Yasuo, Park Jae Hyun, Mun Byoung Tak.Park Kyung Mi.Park Sang Ho.Jung Hyoung Jung, Ged Alangui, Teo, Jeon In Suk, Kang Sook Young, Kim Dong Ki, Kim Hak Il, Hwang Mu Hyun, Shin Chung Min, Jeong Jong Hyo, Park Kwang Woo, Lee Nam Kuk, Lee Sang Moon, Park Jong Herk, Baek Sung Keun, Stan Anderson, Sim Yi Seoung, A-Bae, An Dae Hee, Circle and Point, You Maeung Gyun, Lee So Mi, Ikawa Seiryo, Young Women, Symptom, Kim Seuk Hwan, Na Kyoung Ja, Nam Soon Chu, Lee Wen, Richard Martel, Bartolome Ferrando, Park Byoung Uk, Pan Ueun Hi, Wladystaw Kazmierczark, Shim Hong Jae, Juhasz R. Jozsef, Yu Do Wha, Yun Myung Kuk, Lee Sang Jin, Lee Woo Jin, Lee Hyol Bal, Kazue Mizushima), Kyoko Namba, Ferrer Esther, Hong O Bong

The Sea Art Festival, 2000 Pusan International Contemporary Art Festival(PICAF)

Environmental artworks exhibited at the Sea Art Festival, 2000 PICAF including installations and performance art, served to highlight the meaning of the sea as a primeval place of nature and purify emotions affected by a cold-hearted and lonely life in cities. It also enhanced the status of the local art by depicting humans and nature 'living in harmony' through the unique works of formative arts. The 2000 Pusan International Art Festival(PICAF) put on exhibition the models created for the production of artworks and provided an opportunity for domestic and overseas visitors to Haeundae Beach to see the entire process of production from modeling to on-site installation to performance art in some cases, establishing itself as an impressive art event connecting art with the unique energy of Busan coming from the sea.

Theme : Sea·Human·Art

Period : Oct. 2~Oct. 16, 2000(15 days)

Venue : Haeundae beach

Artworks : 37 artists(group) 37 artworks from 5 countries

Chief of Managing Committee : Kwang-Woo Kim

Artists

Roger Rigoth, Uota Motoo, Frank-Udo Tielmann, Gu Bon-Ju, Kim Jong-ho, Moon Beung-Tak, Lee kyung-Sub, Suk Dae-Sung, Pyo In-Suk, Seol Kyung-Chul, Lee Sang-Bong, Soil human Group, Kim Sung-Ho, Kang hyo-Myung, Park Sang-Ho, Yun Yeo-Il, Yang Jea-sun, Ryu Seung-Hyun, Lee hyo-Moon, Moon Jung-Joon, No Kum-Sik, Group 1.5.9.5, Group Eight. Nine, Kim Tae-Kyun, Park hyung-Pil, A-Bae, Park Jong-Hyun, Kim Yong-Sub, Ju Min-Sun, Kang Sin-Young, Jung Yun-Sun, Gabriele Wulff, Bang young-Ga, Do Ji-Ho, Lee Sang-Jin, Seigi Shimoda, Sung Neung-Kyung, Hong O-Bong, Hwang Min Soo, Julien Blaine, Cho Sung chel

The Sea Art Festival, Busan Biennale 2002

The Sea Art Festival, Busan Biennale 2002 was designed to produce a new culture utilizing the geographical position of the city of Busan as a place where a continental culture and a marine culture come across each other, under the premise that different cultures establish an equal relationship, rather than a hierarchical one. Artists were chosen in two categories: one through an international competition and the other through an invitation. Going beyond the simple installation of artworks with the sea as the backdrop, the Sea Art Festival, Busan Biennale 2002 presented a new possibility for an installation art befitting a marine environment. The exhibition not just took into account the special elements of the sea, such as waves, sea wind and crowds, but also absorbed nature and the surroundings as part of artworks. It also went down in history as an exhibition which maximized the effect of exhibiting at an outdoor space by presenting large-scale artworks.

Theme : Culture meets Culture

Period : Sept. 30~Oct. 27, 2002(28 days)

Venue : Haeundae beach

Artworks : 80 artists(group) 39 artworks from 10 countries

Artistic Director : Kwang-Woo Kim

Artists

A-Bae, Aguinaldo Leonard, Asatani Hiroshi, Blanco Carlos, Cha Joo-Man, Cha You, Choi Pyung-Gon, Chung Hye-Ryung, Curtis Tim, Do Ho-Sun, Do Tae-Geun, Entwistle Trudi, Heulk Sa Ram, Hillgemann Ewerdt, Jeon Hong-Sik, Kang Hyo-Myung, Kim Gui-Ho(Kim Mi-Sook), Kim Myung-Beom, Kim Tae-In(Lee Dong-Ju, Kim Sung-Min, Im Tae, Hyun Sung), Tae-Kwan, Kim Iae-Kyun, Koizumi Saya(Turuta Haruko, Yoshikawa Satoko, Yoshida Kanoko), Lee Sae-Na, Lim Seung-O, Lynn Greg, Nam

Su-Jin(Lee Su-Yeon), Park Dong-Sub, Park Jong-Hyun Gang Dong-Hyun(Kim Min-Ho), Park Sang-Ho, Park Seong-Chan, Park Soon-Woo, Park Tae-Won, Saee Michele, Seo Sang-Ho, Shin Ho-Yoon, Shin Moo-Gyung, Takada Satoru, Van Lieshout Atelier, Whang Su-Roh, Zeng Cheng-Gang

The Sea Art Festival, Busan Biennale 2004

The Sea Art Festival, Busan Biennale 2004 provided an opportunity to highlight the marine features of Busan, which is Korea's 2nd largest city and its marine capital, and to explore the cultural potential of the city. Under the premise that mingling cultures produce a new mode of life, further enriching cultures, the exhibition was designed to serve as a producer of a new culture befitting the status of Busan as an international city and its geographical feature as a junction between a continental culture and a marine culture. Unlike installations put in place on a permanent basis, artworks at Sea Art Festivals were in place at a certain site for the period of the exhibition and got removed or disposed of upon the closure of the exhibition. This characteristic gave rise to the inception of site-specific artworks at the Sea Art Festival. In addition to visual effect, 'attraction' by different senses, such as senses of touch or hearing, was attempted. What set the Sea Art Festival, Busan Biennale 2004 apart was the expansion of exhibition venues from Haeundae Beach and the sea surface to nearby facilities and the downtown area of Haeundae. It also expanded its scope by including new concepts and materials, such as visual media and sculptures utilizing sound, in addition to performances.

Theme : Chasm-Crossing Over
Period : Oct. 9~Oct. 31, 2004(23 days)
Venue : Haeundae beach
Artworks : 45 artists(group) 34 artworks from 11 countries
Artistic Director : Kwang-Woo Kim
Artists
Chen Jian Hong, Chung Hyun, Marco Dessardo, Ha Suk Won, Kim In Tae, Kim Young Joon, Craig A. Kraft, Park Jong Hyun, Sun Lu, Chumpon Apisuk, Bui cong Khanh, Chun-Gee Kim, Wen Lee, Boris Nieslony, Akiyo Tsubakihara, Sung-Zin Zo, William Berry III, Carl Billingsley, Algirdas Bosas, Hwi-Bok Choi, Ji-Yeon Choi, Khyung-Hou Lee, Soo-Hwan Choi, Jae-Hong Shin, Sung-June Youn, In-Sik Chon, Sleeping Bird, Mayu Hayakawa, Jun-Seok Jang, Dong-Myung Jung, Mizuho Kaji, Hee-Young Kim, Kyoung-Ah Kim, Ajesh Kumar.s, Hyun-Geol Lee, Chil-Gun Kwon, Min-Gyu Kwon, Marc Schmitz, Hae-chung Yang

The Sea Art Festival, Busan Biennale 2006

The Sea Art Festival, Busan Biennale 2006 selected 'Art in Life' as its exhibition theme, considering the fact that the exhibition venue chosen served not only as a public space but also as a space of everyday life. The exhibition was divided into two categories: Public Furniture and Living Furniture. Public Furniture sought to make some changes to the city environment by incorporating art into existing street furniture and to create a viewer-oriented art by introducing artworks functioning through the operation of viewers. Living Furniture was designed to offer a unique experience of appreciating art as part of daily life in living space, that is, the main stage of human life, by harmonizing artistic imagination with the pieces of everyday furniture. In line with the theme of the Biennale 'Everywhere', the 2006 Sea Art Festival, Busan Biennale 2006 placed a particular focus on how to make contemporary art more approachable to the public. Furthermore, the exhibition served to promote the close relationship of art with our daily life by combining art with the space of everyday life.

Theme : Art in Life
Period : Sep. 16~Nov. 25, 2006(71 days)
Venue : Haeundae beach, Busan Biennale pavilion, etc
Artworks : 115 artists(group) 99 artworks from 14 countries
Artistic Director : Byoung-Hak Ryu
Artists
Oliver Kruse, Nishikawa Katsuhito, Yoon Hee, Guillaume Bijl, Klaus Pobitzer, Anja Vormann & Gunnar Friel, Heimo Zobernig, Henk Visch, Piotr Zamojski, Kim Mi Jin, Lee Mi Kyung, LeSoo Kyung, Oh Soon Hwan, Jung Yan Sun, Ha Suk Hong, Han Jemma, Subodh Kerka, Alina and Jeff Bliumis, Hitoshi Yamafuji, Joaquin Gasgonia Palencia, Art Family, Han Ju Yong, Yang Moon Gi, Kim Sun Ju, Pleiades cluster-Park Min Yeong with 5 artists, Yuko Shiraishi, Kam Minkyung, Kang Aae Ran, Kang Hong Suk, Kook Jonghoon, Kwon Kisoo, Kim Kyoung Duk, Kim Kyoungho, Kim Kira, Kim Kichul, kim Moonsoo, Kim Mi Jin, Kim Byoungkwon, Kim Yoo Sun, Kim In Bae, Kim Joon, Kim Joonyong, Kim Taejoong, Kim Haemin, Kim Hyeran, Lam Chunmo, Nho Byungyeol, Moon Kyoung Won, Moon Hyungmin, Min Byoung Hun, MILLIMETERMILLIGRAM, Park Byoung Rae, Park Sungsun, Park Soyoung, Park Injin, Park Jiseon/Yang Sunhye, Park Zinoo, Bang Jeongah, Byun Daeyong, Byun Jihoon, Baek Jin, Seo Youngbae, Seo Eun Aae, Seo Hae Guen, Son Dong Hyun, Shin Kyungae, Shin Won Jae, Shim Jung A, Shim Youngchul, Sim Jeamhwan, Ahn Sung Hee, Ahn Jong Yeon, Ahn Jin Uoo, Yang Minha, Oh Hyun A, U-joo&Lim Heeyoung, Yoo Deayoung, Yu Miyeon, Yu Jaejoong, Yune Hisun, Lee Kyojun, Lee Dongi, IMAGE PLAYGROUND, Lie Sangbong, Lee Sangho, Lee Sookyung, Lee Seung Lee, Lee Eunho, Lee Wan, Lee Won Joo, Lee Junghwa, Lee jaegon, Lee Ju Hee, Lee Junik, Lee Joong Guen, Lee Jiney, Lee Changho, Em Sun Eee, Jang Min Seung, Chang Kwanghyo, Jang Yeongpil, Jang Woosuk, Jun Kiho, Jeon Yongil, Jeon Hyewon, Jung Jiyoon, Jung Yeon Joo(Cho Jae Em, Jin Hyun Ok), Jung Han Na, Cho So Hee, Ju Sanghyun, Joo Haejin, Choi Byunghoon, Choi So Young, Choi Yongjin, Choi Yoo Kyoung, Chu Jiyoun, Han Kyeryoon, Han Soojung, Han Jiyoung, Han Younjoo, Ham

Yeon Joo, Ham Youngyi, Haam Younghoon, Heo Songha, Huh Hansol, Hong Sang Sik, Hong Sookyung, Hong Yoo Young, Hong Siya, Hong Jiyoon, Hwang Jin, David&Hi-jin Hodge, Jon Rogers, Jose Carlos Casado, Rory Hamilton, Yuko Shiraishi, Ai Weiwei, An Xiao Tong, Liu JianHua, Lu Hao, Sun Lian, Tian Wei, Wang Mai, Wang Xiao Hui, Wang Zhiyuan, Ye Fang, Amy Kao, Cha Raychu, Wow Bravo(Funky Rap), Hui-Shan Yang, Ma JunFu, Lin JunTing, Keneda Showichi, Haruko Kumakura, Shinya Matsuyama(Hisakazu Nabeshima), Kaoru Tsukamoto, Kota Nezu, Kumiko Suetsuna(Sayaka Ohata), Makoto hirahara(Shinya Matsuyama), Masaki Yagisawa, Midori Mitamura, Shozo Kuze, Takashi Maekawa, Tomoya Watanabe, Vehicle, Yoko Ishii, Yoske Iga, Yuichi Higashionna

The Sea Art Festival, Busan Biennale 2008

The Sea Art Festival, Busan Biennale 2008 sought to explore a new direction, departing from what had defined the Sea Art Festival in the previous exhibitions. Thus, the Festival placed a particular focus on the attempt to escape from the stereotypes of the Sea Art Festival. Departing from the concept of exhibiting works either on the beach or the sea surface, the exhibition venues were divided into 4 spaces: Outdoor Space, Indoor Space, Urban Space, and Mobile Gallery. The type of artworks which used to be exhibited at the Sea Art Festival went to the Outdoor Space, whereas paintings and video clips were deployed to the Indoor Space. The Urban Space utilized everyday space such as cultural centers and subway cars and the Mobile Gallery made use of containers, which symbolized the city of port facilities and logistics. The exhibition selected 'Voyage without Boundaries' as its theme with the objective to reflect upon possible ways of the Sea Art Festival continuing to reinvent itself two decades after its inauguration. Non-future is characterized by indeterminacy resulting from undecidedness, not from uncertainness. Underlining the practical aspect of exploring new routes for the undecided future, that is, the route of indeterminacy, the Sea Art Festival, Busan Biennale 2008 sought to bring together new artists to get them to produce artistic 'accidents' by experimenting with temporal and spatial coordinates.

Theme : 'Voyage Without Boundaries'
Period : Sept. 6 - Nov. 15, 2008(71 days)
Venue : 4 Sectors near Gwangalli Beach
- Outdoor Space : Gwangalli Beach area and nearby area
- Indoor Space : Minlakdong Me World
- Urban Space : Urban Spaces (Shops, Subway Station, Cultural Center)
- Mobile Gallery : Mobile Gallery (Container Boxes)
Artworks : 77 artists(group) 195 artworks from 26 countries
Artistic Director : Seung-Bo Jun
Artists
AHN, Doo Jin, Vyacheslav AKHUNOV(Sergey TICHINA), Richard ANNELY, Richard ANNELY(Denis GLASER), BAE, In

Seok, BAE, Ji Min, BAHK, Seon Ghi, BU Hua, CHOE, Tae Hun, CHOI, Yea Hee, CHOI, Yeun Woo, Sonja Lillebaek CHRISTENSEN, HONG, Hyun Sook, Irene HOPPENBERG, Teresa HUBBARD(Alexander BIRCHLER), HUH, Sook Young, Lisa JEANNIN, Rob JOHANNESMA, Tellervo KALLEINEN(Oliver KOCHTA- KALLEINEN), KANG, Yong Myeon, KIM, Chang Kyum, KIM, Gi Young, KIM, Hae Sim, KIM, Jong Ku, KIM, Kye Hyeon, KIM, Mia, KIM, Suk, KIM, Sun Deuk, KIM, Tae Jun, KIM, Tai Kyun, Dieter KUNZ, Philippe LALEU, LEE, Bei Kyoung, LEE, Jin Kyung, LEE, Jong Bin, LEE, Jun Young, LEE, Sang Gill, LEE, Sang Woo, LEE, Soo Young, LIM, Ok Sang, Long March Project and Xiao Xiong Mioon, MIYANAGA Aiko, TV MOORE, MORIMOTO Gen, NA, Myung Kyu, Eko NUGROHO, OKUMURA Yuki, Nipan ORANNIWESNA, ORANG, OUM, Jeong Soon, PARK, Mi Kyung, Gary-Ross PASTRANA, PING Sun, Rachael RAKENA/ Fez FA'ANANA(Brian FUATA), Kelly RICHARDSON, Nigel ROLFE, ROXLEE, Larissa SANSOUR, SAWA Hiraki, Sara SCHNADT, Karina SMIGLA-BOBINSKI, SON, Han Sam, SON, Mong Joo, Prateep SUTHATHONGTHAI, TANAKA Koki, Sixten THERKILDSEN, THIS IS NOT A FAIRYTALE : Whispered Messages from Southeast Asia-Ark Fongsmut, Jill TRAPPLER, TSUI Kuang-Yu, TSUJI Naoyuki, WOON, Tien Wei(LIM Kok Boon, LEE Sze-Chin), YANG, Ju Hae, YANG, Tae Geun, YOO, Ji Hun, YOO, Seung Jae, Liliane ZUMKEMI

Busan Biennale 2010

Integrating the three main exhibitions, the Busan Biennale 2010 had one exhibition planner dividing exhibition venues into indoor and outdoor spaces to highlight the hallmarks of exhibitions characterizing the Busan Biennale. The theme of the Busan Biennale 2010 was chosen as 'Living in Evolution'. It is a story about two large temporal axes, the life of individuals and the evolution of human beings, crossing with each other. Based upon the geographical feature of Busan as a port city, the Busan Biennale 2010 sought to place a strong focus on the meaning of the sea serving as a communicator with other cultures. The exhibitions focused on the symbolic meaning of the sea such as 'a sense of vitality' and 'time immemorial' and reflected not just upon the common concept of evolution in a biological sense but also the evolution of humans and cities from an intellectual and cultural perspective and the 'existence of individuals' in the process of evolution. Artworks installed on the sea surface left especially strong impression among viewers due to their close association with the exhibition theme. Of the artworks exhibited at the Busan Biennale 2010, 19 pieces created by 13 artists from a total of 5 countries chose Gwangalli Beach as their exhibition venue. The Busan Biennale 2010 sought to minimize artistic fatigue and to maximize artistic impression by decreasing the number of works over the previous exhibitions and selecting artworks larger in scale and more complete in the level of artistic quality.

Theme : Living in Evolution
Period : Sept. 11 - Nov. 20, 2010(71 days)
Venue : Busan Museum of Art, Busan Yachting Center, Gwangalli Beach, Busan Cultural Center, etc.
Artworks : 252 artists 338 artworks from 23 countries
(Gwangalli Beach : 13 artist 19 artworks from 5 counties)
Artistic Director : Azumaya Takashi

Artists

Min-Kyu KANG, Jung-Myung KIM, ShinJung RYU, Balloon PARK, Song Joon LEE, DaYeon WON, JUNG Seung, Zhengwu ZHAO, Amarsaikhan NAMSRAIJAV, Anxiong QIU, Kiichiro ADACHI, Thaweesak SRITHONGDEE, Tomoko KONOIKE

The Sea Art Festival 2011

Sea Art Festival 2011 embarked on its own journey following its incorporation into the Busan Biennale. In order to express its historical thrust and conceptual roots, the Sea Art Festival was held in Songdo—the first public beach in South korea—rather than at the previous sites of Haeundae and Gwanganri beach. Titled 'SongDo (송.도. 松道)' the exhibition promoted and highlighted contemporary art within Busan's urban dynamic and celebrated the energy and the originality of Songdo. In this Festive setting, in which 29 works from 21 countries were installed and exhibited on the beach for 21 days, Songdo's natural environment and work inspired by it came together beautifully and reflected each other. Many of the exhibited works examined environmental crises and explored regional traditions of story-telling in doing so. Additionally, various special events such as artist talks, a documentary photograph exhibition and the Sea Art Fun Zone encouraged the audience to actively participate in the festival as it was being launched as an independent event apart from the Busan Biennale.

Theme : 송.도. (松道, SongDo)
Period : Oct. 1 ~ Oct. 21, 2011(21days)
Venue: SongDo Beach
Program : Exhibition, Other Programs
Entries : 29 artworks from 12 countries
Host : Busan Metropolitan City, Busan Biennale Organizing Committee
Artists
Chang-Ho Kang & Soon-Cheon No, Do-Hyoung Kim, Min-Chan Kim, Su-Jin Kim, Eun-Suk Yoo, Nika Oblak & Primoz Novak, Rumen Dimitrov, Ryf Zaini, Byung-Tak Moon, Jae-Beom Moon, Young-Hwan Jung, Gun-Won Park, Jae-Ha Park, Bees, Berra Matteo, Bayard Morris, Annabella Claudia Hofmann, Wataru Hamasaka, Yoshinori Niwa, Young-Jae Lee, Young-Hee Rhee, Joon Lee, Keum-Mi Cho, You-Jin Lee, Jae-Min Lee, Jung-Yoon Lee, Chang-Jin Lee, Sang-Gyu Lim, An-Young Jung, Hye-Jin Chung, Tanya Preminger, Tian ye, Pichard Stephane, Peter 'Beatle' Collins

The Sea Art Festival2013

The Sea Art Festival 2013 took place at Songdo Beach in the wake of the Sea Art Festival 2011. The festival 2013 has historical significance in that the event became more united with a consistent composition in accordance with the exhibition concept through the introduction of the artistic director system for the first time since being held independently.

As a pivotal program to mark the centenary of Songdo, the festival contributed to the balanced development of regional culture and assured citizen's rights to enjoy art, underscoring this region's urban context. In particular, its theme 'With Songdo: Remembrance, Marks, People' and concept were harmoniously and organically associated with its venues, which helped its curators display their abilities for planning.

The festival escaped the typical concept of an outdoor art exhibition with viewer participatory and site-specific works, making a foray into communication with viewers. The exhibition stood out with its new attempts to enhance the understanding of artworks not only through the exhibition but also through performances related to artworks, docent programs, and participation from citizens.

Theme : With Songdo : Rememberance · Marks · People
Period : Sept. 14 ~ Oct. 7, 2013
Venue: SongDo Beach
Program : Exhibition, Other Programs
Entries : 34 artworks from 11 countries
Host : Busan Metropolitan City, Busan Biennale Organizing Committee
Artists
Fumihiko Sano, Francisco de Oliveira Zelesnikar, Tallur L.N, Craig Costello, Konstantin Dimopoulos, Coyn Kempster, Julia Jamrozik, Moon Soo Choi, Eun Phil Cho, James Jack, Man young Jung, Hyoung Jun Lim, Il Lee, Su Hong Lee,Sung Ok Lee, Chi Seop Ye & 3 Person, Wang Haiyuan, Wnag Yi, un Seub Sim, Sung Jin Song, Mong Joo Son, Dong Hun Sung, Sanitas Studio,Bees, Jun-Ho Bang, Heon Youl Park, Cheyeon Park, Jun Kim, Matteo Bera, Maria Rebecca Ballestra, Rachela Renate Abbate, Liu Po Chun, Daegu Young Arts Groups, Jae-Young Kim, Sook Bin Kim, Sung-Min Kim, Young-ho Seo, Sang il Kim.

부산비엔날레조직위원회

개요 설립 1999년 12월 23일

회원 회원 84명(2015년 현재)

조직위원장 서병수(부산광역시장)

집행위원장 임동락(동아대학교 교수, 조각가)

조직구성 총회, 임원회, 집행위원회, 사무처 등

걸어온 길

2014	2014부산비엔날레(Busan Biennale 2014) 개최
2013	2013바다미술제(Sea Art Festival 2013) 개최
2012	2012부산비엔날레(Busan Biennale 2012) 개최
2011	2011바다미술제(Sea Art Festival 2011) 개최
2010	2010부산비엔날레(Busan Biennale 2010) 개최
2008	2008부산비엔날레(Busan Biennale 2008) 개최
2006	2006부산비엔날레(Busan Biennale 2006) 개최
2004	2004부산비엔날레(Busan Biennale 2004) 개최
2003	전문예술법인 지정(문화예술진흥법 제10조)
2002	2002부산비엔날레(Busan Biennale 2002) 개최
2001	부산비엔날레로 명칭변경(1월 31일 정기총회)
2000	2000부산국제아트페스티발('2000PICAF') 개최
1999	(사)부산국제아트페스티발조직위원회 설립
1998	3대행사 통합 → 부산국제아트페스티발('98PICAF)개최
1991	부산국제야외조각심포지엄
1987	바다미술제 창립
1981	부산청년비엔날레 창립

조직도

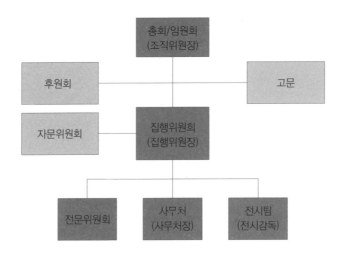

Busan Biennale Orginizing Committee

Overview Establishment December 23rd, 1999

 Member 84 people (as of 2015)

 Chairman Byung-Soo SUH (Mayor of Busan Metropolitan City)

 Executive Director Dong-Lak LIM (Professor of Dong-A University, Sculptor)

 Composition of Organization Organizing Committee, Board of Directors, Executive Committee, Executive Office, etc.

History		
2014	Busan Biennale 2014	
2013	Sea Art Festival 2013	
2012	Busan Biennale 2012	
2011	Sea Art Festival 2011	
2010	Busan Biennale 2010	
2008	Busan Biennale 2008	
2006	Busan Biennale 2006	
2004	Busan Biennale 2004	
2003	Designated Specializes Arts Corporation (Culture and Arts Promotion Act Article 10)	
2002	Busan Biennale 2002	
2001	Change of the Name of Busan International Contemporary Art Festival	
2000	2000 Pusan International Contemporary Art Festival	
1999	Pusan International Contemporary Art Festival Organizing Committee established	
1998	Integrated three festivals → '98Pusan International Contemporary Art Festival ('98PICAF)	
1991	The Busan International Outdoor Sculpture Symposium launched	
1987	The Sea Art Festival launched	
1981	The Busan Youth Biennale launched	

Organization Chart

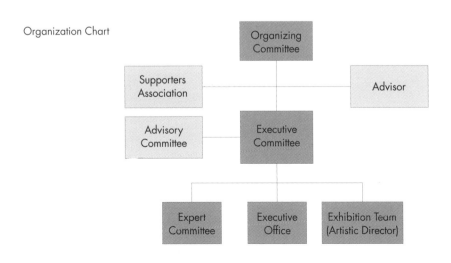

조직위원장
서병수

집행위원장
임동락

사무처
사무처장 이정형
사무차장 박민희

전시팀
팀장 박민희
팀원 민수영
　　　이꼬까

홍보팀
팀장 문주화
팀원 김지윤
　　　김윤지
　　　김현지

총무
나연화

회계
박현아

임원회
김광회
김석준
김세준
김영순
김윤찬
민병일
박옥남
박인관
송영명
신옥진
심준섭
양철모
오수연
우동민
유진재
이태섭
임동락
전준자
정인성
조성제
조승구
하의수
허종하

감사
구본호
박태원

집행위원회
김복기
김성연
김성호
김정혜
김찬동
도태근
윤진섭
이건수
이건희
이근주
이진철
전준호
최승훈
홍경한

전시

전시감독
김성호

작품 설치 자문위원회
김정혜
김현호
도태근
박태원

전시코디네이터
김현지
정수경
홍지영

설치팀장
김종권

설치코디네이터
강지호
성민규
조정현
유진재

축제행사

감독
김정주

코디네이터
배은희

협력코디네이터
곽성규
심종석

Chairman
Byung-Soo SUH

Executive Director
Dong-Lak LIM

Executive Office
Managing Director
Jung-Hyung LEE
Vice Managing Director
Min-Hee PARK

Exhibition Team Director
Min-Hee PARK

Exhibition Team Staff
Soo-Young MIN
Kko-Kka LEE

Public Relation Team Director
Ju-Hwa Moon

Public Relation Team Staff
Ji-Yoon KIM
Yun-Ji KIM
Hyun-Jee KIM

General Affairs
Yeon-Hwa NA

Accounts
Hyun-Ah PARK

Board Committee
Kwang-Hee KIM
Seok-Joon KIM
Sae-June KIM
Young-Soon KIM
Yun-Chan KIM
Byung-Il MIN
Ok-Nam PARK
In-Kwan PARK
Young-Myung SONG
Ok-Jin SHIN
Jun-Seub SIM
Cheul-Mo YANG
Su-Ryun OH
Dong-Min WOO
Jin-Jai YOO
Tae-Sup LEE
Dong Lak LIM
Joon-Ja JEON
In-Sung JUNG
Sung-Je CHO
Seung-Koo JO
Eui-Soo HA
Jong-Ha Heo

Auditor
Bon-Ho KOO
Tae-Won PARK

Operating Committee
Bog-Gi KIM
Seong-Youn KIM
Sung-Ho KIM
Jung-Hye KIM
Chan-Dong KIM
Tae-Geun DO
Jin-Sub Yoon
Ken-Shu LEE
Gun-Hee LEE
Geun-Ju LEE
Jin-Chul LEE
Joon-Ho JEON
Sung-Hoon CHOI
Kyung-Han HONG

Exhibition

Artistic Director
Sung-Ho KIM

**Installation
Advisory Committee**
Jung-Hye KIM
Hyun-Ho KIM
Tae-Geun DO
Tae-Won PARK

Exhibition Coordinator
Hyun-Ji KIM
Su-Gyeong JEONG
Ji-Young HONG

Technical Team Director
Jong-Kwon KIM

Technical Coordinator
Ji-Ho KANG
Min-Gyu SUNG
Jung-Hyun CHO
Jin-Jae YU

Festival Events

Director
Jung-Ju KIM

Coordinator
Eun-Hee BAE

Cooperation Coordinator
Sung-Kyu KWAK
Jong-Seok SHIM

후원 및 협찬 Sponsors

주최

후원

협찬사

MAIN

PREMIUM

LIRIKOS

LEADERSHIP

PARTNER

미디어후원

ΛROUND FRAME KOREA

DdHm 2015바다미술제 🔍

도움주신 분들　　Thanks to

강정훈	Gachi 예술운동	주한캐나다대사관
권용희	KBS부산방송총국	지구인시장
김관대	광고기획MR	청년문화단체 그리고
김병권	국제신문	크래프트스토리
김성호	낭독서점 시집	㈜티에스엠
김수영	㈜다음카카오	프레임 코리아
김은숙	동아연필㈜	픽스
김찬익	두성종이㈜	㈜하이플랜
남숙희	메카조형	한국공항공사 부산지역본부
박상옥	문화소통단체 숨	희망의 그림者
백상훈	부산MBC	F STUDIO
선시훈	부산관광공사	
송창경	부산관광협회	
안시형	부산광역시	
안영주	부산교통공사	
이건의	부산시설관리공단	
이민아	부산영어방송	
이상민	부산은행	
이성국	부산일보사	
이송희	부산중구청	
이용우	부산진구청	
이은비	부산항만공사	
임승현	빨간집	
정주선	사하구청	
조영희	상원전력	
차재근	석조형연구소	
한창훈	송상현광장 관리사무소	
	스페이스 움	
	㈜쏘카	
	㈜아모레퍼시픽 리리코스	
	어라운드	
	연일 PP&B	
	㈜올리브크리에이티브	
	유수연번역회사	
	㈜KNN	
	㈜명성미디어	
	조광페인트㈜	
	주한네덜란드대사관	

LIRIKOS

고농축 수분으로 힘있게 살아나는 수분피부

리리코스 마린 하이드로 앰플 EX

리리코스 마린 하이드로 앰플은 작습니다. 605m 깊은 바다가 응축하고 응축하여 만든 심층수를 그대로 담아 낸 수분 앰플이기 때문입니다. 그래서 크기가 크지 않아도, 피부가 아무리 건조해도, 촉촉함이 힘있게 살아납니다. 이제 작지만 강한 바다 수분 앰플을 만나보세요.

구입처 문의: (주)아모레퍼시픽 고객 서비스 센터 080-023-5454 www.lirikos.co.kr www.facebook.com/lirikos.kr

그 남자 그 여자의
쏘카 드라이브

3시간 5,000원

발행인 서병수

편집인 임동락

발행처 (사)부산비엔날레조직위원회

611-809 부산광역시 연제구 월드컵대로 344 아시아드 주경기장 38호

Tel : 051-503-6111

Fax : 051-503-6584

busanbiennale@busanbiennale.org

www.busanbiennale.org

사진 김찬수, 최규복

인쇄 사문난적

디자인 F STUDIO

Publisher	Byung-Soo SUH
Editor	Dong-Lak LIM
Published by	Busan Biennale Organizing Committee
	38 Busan Asiad Main Stadium
	123 Worldcup st. Yenje-Gu, 611-809, Korea
	Tel : (+82) 51-503-6111
	Fax : (+82) 51-503-6584
	busanbiennale@busanbiennale.org
	www.busanbiennale.org
Photographer	Chan-Soo KIM, Kyu-Bok CHOI
Printer	Samunnangeok
Catalogue Design	F STUDIO